# My Dear Stieglitz

# My Dear Stieglitz

## Letters of Marsden Hartley and Alfred Stieglitz, 1912–1915

EDITED BY JAMES TIMOTHY VOORHIES

University of South Carolina Press

© 2002 University of South Carolina

Published in Columbia, South Carolina, by the
University of South Carolina Press

Manufactured in the United States of America

06 05 04 03 02    5 4 3 2 1

Library of Congress Cataloging-in-Publication Data

Hartley, Marsden, 1877–1943.
  [Correspondence. Selections]
  My dear Stieglitz : letters of Marsden Hartley and Alfred Stieglitz, 1912–1915 / edited by
James Timothy Voorhies.
      p. cm.
  Includes bibliographical references and index.
  ISBN 1-57003-478-8 (alk. paper)
  1.  Hartley, Marsden, 1877–1943—Correspondence. 2.  Stieglitz, Alfred, 1864–1946—
Correspondence. 3.  Artists—United States—Correspondence. I. Stieglitz, Alfred, 1864–1946.
II. Voorhies, James Timothy. III. Title.
N6537.H3633 A3 2002
709'.2'273–dc21                                                          2002005544

*For Professor Mathew Herban*

# Contents

# Illustrations

# Preface

This collection of letters written by Marsden Hartley and Alfred Stieglitz from 1912 to 1915 has long been referenced as primary source material for reconstructing chronologies of both their lives, particularly Hartley's, during these pioneering years in the history of modern art. In fact, entire narratives about Hartley have been written based significantly on this particular correspondence to Stieglitz.[1] Although excerpts of these letters have been published in prior scholarship, this compilation presents for the first time the complete exchange of correspondence between the two men while Hartley was living in Europe between 1912 and 1915.[2] The letters are chronologically organized in serial format; this is not always possible with archival collections of correspondence, but, fortunately, the preserved documents serve well here to illustrate for us a vigorous and dynamic interchange between Hartley and Stieglitz. My sincere appreciation is extended to the Beinecke Rare Book and Manuscript Library at Yale University for permitting access to this correspondence and giving permission to publish it in this volume.

Hartley's letters are all hand-written, while those of Stieglitz's that survive are carbon-copies of typescript originals. Every letter has been scrutinized with the intent of maintaining the integrity of the correspondence and reproducing it as faithfully as possible in a typographical format. The correspondence has been transcribed from facsimiles of the archived documents, as well as from the actual manuscripts at Yale.

Hartley's style of writing was indicative of his expressive, original and emphatic use of the English language. His letters are erratic, containing run-on sentences, incorrect punctuation, misspelled words, and random capitalization. A dominating element found in his writing was the use of a dash (—) to indicate a pause where one would expect either a period or comma. This form of closure or pause used by Hartley has been retained where possible by the use of an em dash, as it is strongly characteristic of his writing style. He inconsistently used a plus sign (+) to represent the word *and*. In every instance, the plus sign has been replaced by *and* for the purpose of adhering to a consistent and fluid presentation. Hartley rarely used commas. For the purpose of clarification, I have added commas only between proper nouns and names, usually found in the sizable lists of best wishes in his closures. Otherwise, no additional commas are added in this transcription. I have silently provided other proper punctuation where one would find it most appropriate, such as a period to replace extra long dashes that implied a natural finish to an idea, or, for instance, where a blank space was followed by

a capitalized word, thereby indicating another sentence or new paragraph. Appropriate capitalization has been applied.

Standardized headings have been used for the date and place of origin in Hartley's letters. If this information was not specifically written by Hartley (he inconsistently dated his correspondence), I have provided a probable date in brackets usually based on a postmark, content of a letter or date of receipt.[3] I have provided locations for all of Hartley's letters, whether he did or not, as a standard inclusion in each heading. As with dates, those locations which I have added are bracketed. In every case it was possible to determine where the letter was composed. Form punctuation for the salutation and closing of each letter has been used for Hartley's correspondence. The many versions of his greetings for Stieglitz have been retained. Titles for books and journals as well as foreign language words which are excluded from *Webster's Third International Dictionary* are italicized in Hartley's letters unless he placed the titles in quotes, which would supersede italicization. Hartley's letters sometimes referred to (presumably handwritten) letters from Stieglitz which are now unfortunately lost. Hartley's erratic and inconsistent use of hyphens has been retained.

Hartley's spelling errors, accent marks and, as already mentioned, capitalization of proper nouns have been corrected. Exceptions apply in certain instances where his alternative spellings, such as "Amerika" and his personal version of "extasy" are found to be more or less part of the spirit of his correspondence. In all cases where he used the British spelling for words such as theatre, colour and splendour I have kept these, even though he often vacillated between the British and the American spellings. His versions of modern, Cubist and Futurist were sometimes "moderne," "Cubiste" and "Futuriste." These variations have been retained here because, again, they reflect a specific intention on his part.

In his original correspondence, Hartley tried to use as much of each page or postcard as possible. As a result, he rarely used any paragraph breaks, thus creating long continuums of sentences. Breaks based on a general sense of a shift in his ideas have been added to those he made himself. His abbreviations for currencies and months, such as frcs., mks., Nov. and Sept., are all preserved. This general rule also has been followed for N.Y.

Hartley's handwriting can be difficult to decipher and occasionally completely impossible. If a word was found, after much research and consideration, to be illegible, a question mark in brackets ([?]) has been noted. Wherever a possible identification of a word was determined but still considered questionable, it is placed in brackets with a question mark. Fortunately these instances are few and certainly don't interrupt the progression of the correspondence.

The letters by Stieglitz are reproduced here as virtual duplicates because, as mentioned above, his only extant letters to Hartley from this period are carbon-copies of original typescripts. Corrections have been made of misspelled words or names and

punctuation has been corrected in the limited cases where necessary. Stieglitz dated all of his letters, and he indicated the place of origin for all except one, which is also from New York. For the sake of continuity, I've also provided a standardized format for the date and location in each heading of Stieglitz's letters and regularly spaced his closings. The same rules for italicization apply with Stieglitz's letters, except for those titles which he put in quotes, which again supersedes the need to italicize.

In the notes I have documented references and tried to provide annotations for everything that logically demanded further explanation. Some references were simply impossible to address or identify and have been left for future research. I have relied considerably on previous scholarship on Hartley, Stieglitz, and early twentieth-century art in order to construct a context for this correspondence. Many of the letters contain obscure references to exhibitions in France, Germany and New York; I have furnished as much detailed information as possible about these exhibitions so as to help the reader understand the environment for modern art at this time. For the majority of the details about exhibitions at 291 I have used Sarah Greenough's *Modern Art and America: Alfred Stieglitz and His New York Galleries* (Washington, D.C., National Gallery of Art in association with Bulfinch Press, 2000) which is a mine of valuable information. For other relevant exhibition-related material I have referred to Bruce Altshuler's *The Avant-Garde in Exhibitions: New Art in the 20th Century* (New York: Harry N. Abrams, 1989); Donald E. Gordon's *Modern Art Exhibitions, 1910–1916* (2 vols. Munich: Prestel-Verlag, 1974); and Barbara Haskell's *Marsden Hartley* (New York: Whitney Museum of American Art in association with New York University Press, 1980). All these publications have been remarkable sources for deciphering details related to modern art exhibitions.

For additional assistance with the annotations and biographical notes, I am deeply indebted to the following authors for their valuable scholarship which greatly helped to enhance this publication: Milton Brown, Robert Crunden, Barbara Haskell, William Innes Homer, Donald Gallup, Sarah Greenough, Gail Levin, Sue Davidson Lowe, Townsend Ludington, Patricia McDonnell, Ann Lee Morgan, Francis Naumann, Bruce Robertson, Susan Elizabeth Ryan, Gail Scott, Peter Selz, Steven Watson, Jonathan Weinberg and Richard Whelan. The publications by these authors are listed in the bibliography.

A biographical index is included in this book for identification of every figure (if possible) mentioned by Hartley and Stieglitz. If a person mentioned in the letters is not identified in the biographical index, the reader can assume he or she was untraceable at the time of research.

Special thanks is sincerely extended to those individuals who encouraged this project from its inception. I am deeply grateful to Sarah Greenough, Townsend Ludington and Jonathan Weinberg for offering advice and valuable guidance throughout the course

of assembling this book. I am also very grateful for the encouragement of Patricia Willis, Curator, the Collection of American Literature at the Beinecke Rare Book and Manuscript Library; she was enthusiastic about this project and always took time to listen to various updates on its progression. She has my deepest thanks. And, my greatest appreciation and thanks to Nate Padavick for his support and encouragement throughout the life of this project, and for his assistance with comparing the transcription to the original manuscripts for editorial inconsistencies and errors. Thank you for your support, and for understanding the importance of this book to me.

1. For instance, the following scholarship has referenced this correspondence: Robert M. Crunden, *American Salons: Encounters with European Modernism, 1885–1917* (New York: Oxford University Press, 1993), 303–29; Barbara Haskell, *Marsden Hartley* (New York: Whitney Museum of American Art, 1980), 26–45; William Innes Homer, *Alfred Stieglitz and the American Avant-Garde* (Boston: New York Graphic Society, 1977), 157–63, 220–30; Gail Levin, "Hartley and the European Avant-Garde" *Arts Magazine* 54 (1979): 158–63; Levin, "Hidden Symbolism in Marsden Hartley's Military Pictures," *Arts Magazine* 54 (1979): 155–59; Townsend Ludington, *Marsden Hartley: The Biography of an American Artist* (Boston: Little, Brown and Co., 1992), 73–129; Patricia McDonnell, *Dictated by Life: Marsden Hartley's German Paintings and Robert Indiana's Elegies*, (Minneapolis: Frederick R. Weisman Art Museum, University of Minnesota, 1995), 15–42; Bruce Robertson, *Marsden Hartley* (New York: Harry N. Abrams in association with the National Museum of American Art, 1995); Robertson "Marsden Hartley, 1916: Letters to the Dead," in Sarah Greenough et al. *Modern Art and America: Alfred Stieglitz and His New York Galleries* (Washington, D.C.: National Gallery of Art in association with Bulfinch Press, 2000), 229–45; William H. Robinson, "Marsden Hartley's *Military*," *The Bulletin of the Cleveland Museum of Art* 76 (1989): 2–26; Gail Scott, *Marsden Hartley* (New York: Abbeville Press, 1988); Jonathan Weinberg, *Speaking for Vice: Homosexuality in the Art of Charles Demuth, Marsden Hartley, and the First American Avant-Garde* (New Haven: Yale University Press, 1993); Richard Whelan, *Alfred Stieglitz: A Biography* (Boston: Little, Brown and Co., 1995).
2. For comprehensive narratives on Hartley's life, see Haskell, *Marsden Hartley*; Ludington, *Marsden Hartley: The Biography of an American Artist*; Robertson, *Marsden Hartley*; Scott, *Marsden Hartley*. For Stieglitz, see Sue Davidson Lowe, *Stieglitz: A Memoir/Biography* (New York: Farrar Straus Giroux, 1983) and Whelan, *Alfred Stieglitz: A Biography*.
3. The original letters are dated in pencil by someone other than Hartley. These dates are obviously determined by a postmark, date of receipt, or content of the letter. If the postmark was not provided on the postcard or envelope, I have used the receipt date that is marked in pencil.

# My Dear
# Stieglitz

# Introduction

Marsden Hartley (1877–1943) is one of few American artists who steadfastly navigated through the Parisian avant-garde, found respect from the German modernist associations, and cultivated significant relationships in the American modern art circles. His introduction to Europe was in early 1912 when he embarked on a sojourn to France that changed the course of his life, and his art, far beyond all expectations. While abroad, he visited the salons of Gertrude Stein in Paris, attended several annual exhibitions of modern art, participated in the renowned *Erster deutscher Herbstsalon*, or First German Autumn Salon, in Berlin, and intermingled with some of the most influential artistic communities of the twentieth century. This collection of letters is a product of Hartley's two separate visits to Europe that took place between April 1912 and December 1915; the letters were written between Hartley and his friend, mentor, photographer, editor and avant-garde impresario, Alfred Stieglitz (1864–1946).

The Hartley-Stieglitz correspondence is archived in the Collection of American Literature at the Beinecke Rare Book and Manuscript Library at Yale University. The collection presented here comprises 106 items of correspondence, twenty-three letters by Stieglitz and eighty-three postcards, cables and letters by Hartley, almost all sent from Europe. It illuminates the cosmopolitan artistic centers of New York, Paris, Berlin and Munich during these years by documenting a richly concentrated and invigorating period in the history of art. It also illustrates the psychological mechanics between Hartley and Stieglitz, their relationship, and the flurry of activity surrounding them on both continents. The letters bring to life a time when the *isms* of modern art, Fauvism, Cubism, Expressionism, Synchromism, Futurism, and Orphism, were emerging, prevalent, and the talk of the day.

Writing from New York, Stieglitz delivers insight, ever so subtly, into the changing face of modernism in America. He updates Hartley on the development of his stable of artists, changing exhibitions at his gallery and new issues of his journal for photography and art; all the while chronicling the ever-tempestuous façade of New York City, and Modernism, between 1912 and 1915. Stieglitz suggests to Hartley that the International Exhibition of Modern Art in New York, better known as the Armory Show, usurped his reign over modern art, and he complains of a general fatigue from acting in the role of storm center for the avant-garde.[1] Taking on the post of Hartley's fiduciary by default, Stieglitz gives general financial advice and sends Hartley monthly installments from various sales of his (Hartley's) paintings. Stieglitz did all this while providing continual

encouragement for Hartley's artistic development in Europe and even sometimes administering a well-deserved dose of reality to the artist.

Hartley first met Stieglitz in the spring of 1909 in New York during a visit to his Little Galleries of the Photo-Secession at 291 Fifth Avenue between Thirtieth and Thirty-first streets. He went to the gallery, by then known simply as 291, explicitly to ask Stieglitz for an exhibition. The photographer-turned-gallerist was already changing the predominant mission of 291, and its accompanying periodical, *Camera Work*, from solely championing pictorial photography to playing an expanded role in pioneering contemporary art in America.[2] In January 1908, New York had been treated by 291 to an exhibition of drawings by Auguste Rodin, and in April of that same year, saw the American debut of Henri Matisse.[3] In 1910, 291 became the first venue in America to show work by Paul Cézanne, and in 1911 Stieglitz introduced Pablo Picasso with a one-man show of the artist's work.[4] Thus the birth of European modernism in the United States as the Little Galleries and *Camera Work* spot-lighted an advancing avant-garde from abroad and catapulted 291 into the role as administrator of modern art in New York. Hartley, a native of Lewiston, Maine, who came from a family of working-class English immigrants, wanted to be an active participant in this nexus of leading modern currents.

This initial meeting between them was important for Hartley; Stieglitz agreed to consider an exhibition of his work by asking Hartley to leave his paintings of landscapes at 291 for a few days while he finalized upcoming plans for the gallery. Although at first reluctant to mount another show (Stieglitz had been in the process of preparing to close for the season), he found interest in Hartley's work, and immediately scheduled Hartley's first one-man show in New York.[5] *Exhibition of Paintings in Oil by Mr. Marsden Hartley, of Maine* opened in May 1909 with thirty-three landscapes of New England. These paintings were completed by Hartley around 1908 while he was living in Maine and working in a Neo-Impressionist style inspired by the Italian Divisionist painter, Giovanni Segantini. Nothing sold, but the exhibition received warm critical response, and most importantly, Hartley's relationship with Stieglitz and introduction to 291 had germinated.[6] This introduction would give Hartley the exposure and support he needed, along with the honor, from that point forward, of considering himself among the members of Stieglitz's circle of artists.

In March 1910 Hartley exhibited again at 291, this time in a group show with other young American artists.[7] It turned out he was the only artist of the group who had not yet traveled to Europe.[8] This lack of personal exposure to the European moderns became a nagging factor for Hartley, causing him to think more about a trip abroad of his own. As their relationship progressed, Stieglitz and 291 became critical for Hartley's development, not only for promoting his painting, but also for providing an

invaluable introduction to the art of the European moderns, such as Matisse and Picasso.[9] Realizing that seeing more work by these avant-garde artists was crucially important for a modern American painter, Hartley began to obsess about an opportunity to go to Paris.

Stieglitz encouraged Hartley to travel abroad, and in order to raise money for this he mounted another show; *Exhibition of Recent Paintings and Drawings by Marsden Hartley,* which opened in February 1912. A few paintings from this exhibition were sold, one to collector and 291 patron Agnes Ernst Meyer, while the American artist Arthur B. Davies was able convince another collector, Lillie Bliss, to donate funds for Hartley's trip.[10] The noted collector and lawyer John Quinn also purchased a still life by Hartley.[11] These proceeds, combined with Stieglitz's guarantee from Meyer to cover Hartley's expenses for a one-year stay abroad freed the artist to finally prepare for Paris.[12] At age thirty-five, Hartley sailed on April 4, 1912 aboard the liner *La Savoie.*[13]

The letters included in this volume, covering two separate visits to Europe, carry us from this point forward until Hartley returns to New York in December 1915. The scope of the correspondence actually encompasses a very short, but intensely compact period in the lives of Hartley and Stieglitz, giving a sweeping tour de force of these fascinating years. It begins with Hartley telling Stieglitz about his many visits to galleries, museums and exhibitions throughout Paris, and his nascent friendship with the avant-garde icon of Paris—Gertrude Stein. He quickly chronicles his visits to her Saturday evening soirées at the now famous address, 27 rue de Fleurus, and we soon find him writing to Stieglitz about his success with rallying her championship for his new painting.

Shortly after arriving in the French capital, he befriended a group of Germans at the Restaurant Thomas on the Boulevard Raspail which included the sculptor Arnold Rönnebeck and his cousin, an officer in the German army, Karl von Freyburg. These two men provide the impetus for Hartley's increased fascination with Germany and subsequent visit to Berlin in early 1913. Throughout the fall and early winter of 1912, he meandered through the café life of Paris giving Stieglitz steady accounts of gossip on key players in the circles of modern art. In January 1913 he traveled with Rönnebeck to Germany, an experience that left him intrigued and obsessed with the country and its modern capital Berlin. Before returning to Paris three weeks later, he detoured to Munich for a visit with Wassily Kandinsky, the Russian painter and leader of the cutting-edge German Expressionist group, the Blaue Reiter, which Hartley had just discovered in July 1912. He was even invited by Kandinsky and Franz Marc, another member of this Expressionist group, to participate in the *Erster deutscher Herbstsalon,* or First German Autumn Salon, planned for that fall in 1913. Glorying in his contact with these modernist figures, and satisfied with arrangements he made for

an exhibition of his newly created Cubist-inspired intuitive abstractions at Galerie Goltz in Munich, Hartley returned to Paris in late January and quickly devised plans for living in Germany.[14] After receiving the financial stamp of approval from Stieglitz, he packed his things, sent his paintings on to Munich, and headed to Berlin after short stays in Sindelsdorf, then Munich, where he had asked for a meeting with Kandinsky, Marc and other Blaue Reiter members to view his intuitive paintings at Galerie Goltz. He finally arrived in Berlin in mid-May 1913.

In New York, Stieglitz responds to Hartley with funds that keep him afloat and continues to give him commentary on the changing climate of art in America. Although never as candid in his letters as Hartley, one is still able to discern in Stieglitz's letters an imperious attitude and resentment toward his own fading position among the modernists. Stieglitz implies that New Yorkers should not so quickly forget that he was the original champion who heralded the increasingly popular rise of modern art.[15] Some of his aggravation during this period was rooted in the Armory Show which opened at the Sixty-ninth Infantry Regiment Armory on Lexington Avenue in New York in February 1913. This exhibition with more than 1200 modern works of art by American and European artists (in which Hartley was included) became the reigning event for introducing a huge wave of modernism to America. The years immediately following the Armory Show produced a surge of galleries devoted to modern art, and even inspired more conservative dealers to consider showing European radicals. Several galleries opened in New York between 1913 and 1916, including the Daniel Gallery run by Charles Daniel, and Robert Coady's Washington Square Gallery, which had successfully secured an exclusive agreement, through Picasso's dealer in Paris, Daniel-Henry Kahnweiler, to show Picasso in New York. Even the conservative gallery of N. E. Montross strayed toward a more aggressive program with an exhibition of Matisse in 1915 and Cézanne in 1916. Another significant factor that contributed to an increase in the number of modern art galleries in New York was the abolishment in October 1913 of a fifteen-percent tariff on imported art that was less than twenty years old.[16] Thus Stieglitz found himself in a difficult predicament in the aftermath of the "big" exhibition because everything that he had introduced in modern art in the years just prior quickly became en vogue and commercialized, thus stripping him of the cutting-edge crown he once flaunted.

Meanwhile, in Germany, Hartley settled himself into Wilhelmine Berlin by the middle of May 1913 and declared to Stieglitz his extraordinary appreciation for the modernity and cleanliness of the capital. Although outwardly celebrating the beauties of the exciting metropolis that Berlin was in 1913, Hartley would also have found a great appreciation for the city's tolerance of its prevalent homosexual subculture.[17] Of course, Paris surely provided somewhat similar circumstances for freedom of sexual expression, but it was in Berlin that Hartley most reveled in its masculine orientation and dominant

military atmosphere. In addition, he undoubtedly valued the relative ease in which homosexuals intermingled throughout the day-to-day life of Berlin.[18]

In addition to the sexual freedom Hartley found in Berlin, he also experienced a city engulfed by the excitement and pageantry of a number of celebrations in the spring of 1913. There were parades in honor of the wedding of the Kaiser Wilhelm's only daughter, Prinzessin Victoria Luise, to the son of the British Duke of York. This was followed by activities for the Emperor's Jubilee, and finally ceremonies for the anniversary of Napoleon III's defeat at the Battle of Sedan.[19] Hartley was thrilled by the pomp and spectacle of these celebrations, which featured white-plumed soldiers on horseback in full military regalia parading throughout the city. Spending the rest of the summer painting works inspired by this celebratory environment and his explorations of Berlin, he focused more on having his work in a modern art collection of the wealthy industrialist and financier of the upcoming autumn salon, Bernard Koehler, to whom Marc, Hartley's ally in the Blaue Reiter, had kindly provided an introduction. After meeting Koehler, Hartley wrote again and again to Stieglitz about his overwhelming need for exhibitions and sales. So as the lull of summer set in and the ceremonies subsided, he impatiently waited for something to happen with Koehler and looked forward to the ensuing event of the fall season, the First German Autumn Salon. Finally September arrived and Hartley, alternatively focused on financial gains and problems with money, was unable to fully appreciate the fact he was one of only four American artists participating in this significant exhibition of modern art in Germany which featured work by European, American and Asian artists.[20]

Unable to place any paintings with Koehler and selling nothing in the salon, the funds Hartley had amassed for living in Europe simply ran out by late fall 1913 and Stieglitz couldn't advance anything further. In November Hartley took passage back to New York with intentions to stay only long enough to exhibit his recent work from Europe at 291, raise more money, and return to Berlin. Stieglitz quickly accommodated Hartley and opened his exhibition in January 1914.[21] Hartley subsequently traveled to Buffalo with some of the works for an exhibition at the home of Mabel Dodge's friend, Nina Bull. Securing some financial gain with sales of three paintings from his exhibition at 291, he gathered his money and sailed again for Europe in March 1914, making short stops in London and Paris before arriving in Berlin at the end of April.

After he settled into the same apartment, he began a series of paintings on the theme of America with images related to Native American culture. Unfortunately, the short-lived financial and emotional stability that Hartley felt was soon over-shadowed by the looming consequence of war in Europe. The ceremonious city Hartley had celebrated in 1913 during his first stay in Berlin gave way to parades of soldiers now identified with flexing militaristic muscles instead of weddings and jubilees. Hartley found himself living in a tragedy-stricken environment as war was declared in August 1914. Instead of

writing to Stieglitz of the beauty of a modern metropolis, his letters from this time pro-
vide day-to-day accounts of life in a war capital. Hartley tells Stieglitz about the loss of
his close and beloved friend, the officer Karl von Freyburg whom he had met in Paris
in 1912 and who died in battle in October 1914. Experiencing the loss of this man and
seeing numerous other young men go to battle brought forth a grief so strong that he
dropped his paintings on "Amerika" and began his renowned series of war motifs ded-
icated to von Freyburg and the many other lives swallowed up by the war.[22] The letters
to Stieglitz during these months become written documents of this despair found visu-
ally in his military paintings.

   After encountering overwhelming difficulties with receiving money from Stieglitz
because of the war, Hartley came to terms with the fact that it was at last time to leave
Germany. He took passage for New York in December 1915. Fortunately, before doing
so he was able to arrange for an exhibition that September in Frankfurt and one in
October in Berlin.[23] He could confidently return to America with some gravitas; he'd
had a presence in Europe. Because of these European exhibitions and a significant
tenure in Germany, Hartley was moderately satisfied with going back to the United
States, and somewhat pleased that he would be considered among the American expa-
triate set. Along with his paintings, the exhibitions were a recorded substance of his
time away.

   Leaving Berlin, he proudly faced home, but consciously dreaded the gossip and talk
of a New York public which had been recently seasoned by the Armory Show and was
now disturbed by conditions in Germany. This was a public that was outraged by Ger-
man culture and resented the suffering generated by the war. His re-acclimation in
New York was not an easy one because he felt he didn't really belong anywhere; he
detested America and could no longer live in Germany. He had geographically and
emotionally distanced himself from other artists at 291 and as a result returned home
with an air of superiority and resentment toward the United States. Adding to this
stressful situation, his paintings did not arrive from Berlin until March 1916 because of
difficulties with shipping during the war. Therefore, his exhibition at 291 was delayed
until April along with the money it would generate.[24] All this made conditions in New
York seem desperate. Hartley's exhibition of war motifs ultimately proved financially
successful with sales of four paintings, but the critics were reluctant to accept the use
of German military insignia in the works and Hartley's obvious pro-German sentiment.
Some viewers questioned Hartley's patriotism.[25] Although the New York audience
readily detected the pro-military and celebratory spirit of Germany, the art critics, over-
all, dissolved their reaction to the military symbolism and instead concentrated on the
abstract qualities of the paintings.[26] His statement for the catalogue presented a defen-
sive maneuver to forestall any negative public sentiment, and possibly an attempt to
thwart a reading of any homosexual connotations in his paintings:[27]

The pictures in this present exhibition are the work of the past two years. The entire series forming my first one-man show in Europe which took place in Europe last October. These pictures were to have been shown in these galleries as previously announced in February, but owing to blockades, war difficulties, etcetera, they have only just arrived. The Germanic group is but part of a series which I had contemplated of movements in various areas of war activity from which I was prevented, owing to the difficulties of travel. The forms are only those which I have observed casually from day to day. There is no hidden symbolism whatsoever in them; there is no slight intention of that anywhere. Things under observation, just pictures of any day, any hour. I have expressed only what I have seen. They are merely consultations of the eye—in no sense problem; my notion of the purely pictural.[28]

The correspondence presented in this volume between Hartley and Stieglitz certainly suggests the antithesis to Hartley's statement for his exhibition. The record which is found in these letters actually indicates that he truly did create quite an art after himself.[29]

1. For further discussion on Stieglitz's role in modern art during the years immediately following the Armory Show, see William Innes Homer, *Alfred Stieglitz and the American Avant-Garde* (Boston: New York Graphic Society, 1977), 172–76. See also Richard Whelan, *Alfred Stieglitz: A Biography* (Boston: Little, Brown and Co., 1995), 348, and Charles Brock, "The Armory Show: A Diabolical Test" in Sarah Greenough et al. *Modern Art and America: Alfred Stieglitz and His New York Galleries* (Washington, D.C.: National Gallery of Art in Association with Bulfinch Press, 2000), 127–43.

2. Although the Little Galleries of the Photo-Secession opened in November 1905 with the mission of supporting pictorial photography, Stieglitz and his close ally, the photographer and painter Eduard Steichen had agreed at the time that the gallery should also show visual art unrelated to photography. The first non-photographic exhibition at 291 was work by Pamela Colman Smith in January 1907. See Homer, *Alfred Stieglitz,* 38–44.

3. *Exhibition of Drawings by M. Auguste Rodin* (January 2–28, 1908) and *Exhibition of Drawings, Lithographs, Water-Colors, and Etchings by M. Henri Matisse, of Paris* (April 6–27, 1908).

4. Three lithographs by Cézanne were included in an exhibition at 291, *A Loaned Collection of Some Lithographs by Manet, Cézanne, Renoir, and Toulouse-Lautrec; A Few Drawings by Rodin; And Smaller Paintings and Drawings by Henri Rousseau* (November 18–December 8, 1910). A larger exhibition of Cézanne followed, *Exhibition of Water-Colors by Cézanne* (March 1–25, 1911). *Exhibition of Early and Recent Drawings and Water-Colors by Pablo Picasso, of Paris* (March 28–April 25, extended to May, 1911) followed the Cézanne show.

5. Barbara Haskell, *Marsden Hartley* (New York: Whitney Museum of Modern Art in association with New York University Press, 1980), 17.

6. Haskell, *Marsden Hartley,* 14–18.

7. *The Younger American Painters* (March 9–21, 1910) included D. Putnam Brinley, Arthur B. Carles, Arthur Dove, Laurence Fellows, Hartley, John Marin, Alfred Maurer, Eduard Steichen, and Max Weber.

8. Homer, *Alfred Stieglitz,* 154–55.

9. See Homer, *Alfred Stieglitz,* 154.

10. Haskell, *Marsden Hartley,* 26.

11. Judith Zilczer discovered that Quinn had purchased a still life by Hartley sometime before May 1912, (Judith Zilczer, "Alfred Stieglitz and John Quinn: Allies in the American Avant-Garde," *American Art Journal* 17 (1985): 20–21.

12. Homer, *Alfred Stieglitz,* 157.

13. Townsend Ludington, *Marsden Hartley: The Biography of an American Artist* (New York: Little, Brown and Co., 1992), 72.

14. Hartley's letters will detail how he originally arranged an exhibition of his work for summer 1913 at Galerie Goltz in Munich, but due to discrepancies between the dealer Hans Goltz and the Blaue Reiter members, Hartley's paintings were alternatively shown at the Neue Kunstsalon of Max Dietzel in Munich.

15. For further discussion, see Whelan, *Alfred Stieglitz: A Biography,* 348.

16. For a more comprehensive discussion on the activities of modern art galleries in New York during this period, see Judith Zilczer, "'The World's New Art Center': Modern Art Exhibitions in New York City, 1913–1918," *Archives of American Art Journal* 14 (1974): 2–7.

17. Haskell, *Marsden Hartley,* 31. See also Jonathan Weinberg, *Speaking for Vice: Homosexuality in the Art of Charles Demuth, Marsden Hartley and the First American Avant-Garde,* (New Haven: Yale University Press, 1993), 143.

18. Weinberg, *Speaking for Vice,* 143, 147–50.

19. William H. Robinson, "Marsden Hartley's *Military,*" *The Bulletin of the Cleveland Museum of Art* 76 (January 1989): 9.

20. See Peter Selz, *German Expressionist Painting,* (1957; reprint, Berkeley and Los Angeles: University of California Press, 1974), 265–66.

21. *Exhibition of Paintings by Marsden Hartley, of Berlin and New York* (January 12– February 14, 1914).

22. For stylistic and symbolic interpretations of Hartley's military paintings, see Haskell, *Marsden Hartley,* 44–45; Gail Levin, "Hidden Symbolism in Marsden Hartley's Military Pictures," *Arts Magazine* 54 (October 1979): 154–58; Patricia McDonnell, *Dictated by Life: Marsden Hartley's German Paintings and Robert Indiana's Hartley Elegies,* (Minneapolis: Frederick R. Weisman Art Museum, University of Minnesota, 1995), 27–32 and Robinson, "Marsden Hartley's *Military,*" 6–26.

23. Schames Galerie, Frankfurt (September 1915) and Münchener Graphik-Verlag, Berlin (October 1915).

24. *Exhibition of Paintings by Marsden Hartley* (April 4–May 22, 1916).

25. Arthur B. Davies, Mabel Dodge, John Quinn, and the critic, Paul Rosenfeld, each purchased a painting from Hartley's exhibition. See Bruce Robertson, "Marsden Hartley, 1916: Letters to the Dead" in Greenough et al. *Modern Art and America,* 238–40. As quoted in *Camera Work* 45 (January 1914, published June 1914), the critic J. Edgar Chamberlain called Hartley's paintings "past the comprehension of the ordinary mind, and must be given up as an uncrackable nut" in an article in the *New York Evening Mail,* while Charles Caffin of the *New York American* said his paintings were "the vapors from the bowels of a medieval world."

26. Robertson, "Marsden Hartley, 1916," 238–40.

27. Weinberg, *Speaking for Vice,* 157.

28. Hartley's statement for his exhibition in April 1916 as quoted in *Camera Work* 48 (October 1916): 12.

29. An autobiographical text by Odilon Redon entitled "Confidences d'artiste" was printed in 1909. Translated as "Confessions of an Artist," the text begins with the statement "I have made an art according to myself" which Hartley quotes in a letter to Stieglitz, n.d. [February 1913].

1912

n.d. [March, 1912]
79 Shawmut Street
Lewiston, Maine

My Dear Stieglitz,

Can you send me at once by return mail, $10.00 via money order which is most convenient? I was stuck for a sleeper when I took the train Friday night and this I had not anticipated though I rested well and was inordinately tired. I am here with my parents, whom I find very well, and a few friends who are glad to see me and are delighted with my European prospects. I shall be glad to return to N.Y. next week Wednesday or Thursday—for I find it so dull here with so little to interest and divert one, and then I caught a cold in Boston as a result of change of atmosphere—the stretch up this way being in fearful shape.

I shall hope to hear from you by return with enclosure—so that when I am ready to leave I can be sure that I have enough for emergency cash. I have a few unexpected outlays too which are imperative—and this is the reason for my being obliged to write you. I wish I were returning tomorrow as far as my own feelings go for it is most dreary here with the humdrum of small city life.

Best wishes to yourself and each and all—also to Mrs. Stieglitz and Kitty.

As always,
Marsden Hartley

ℰ

n.d. [March, 1912]
79 Shawmut St.
Lewiston, Maine

My Dear Stieglitz,

It is just possible that my letter of Wednesday last didn't reach you and as the matter is imperative I write again. I need $10 to get down to N.Y. with owing to several unexpected and necessary expenditures. It leaves me exceedingly scant. Will you send the same by special delivery on Sunday so I can be sure and have it first thing Monday morning? I am exceedingly anxious to get back and see the Matisse stuff—and get rid of my boredom here.[1] It seems as if I had been here months. Please then favor me by an immediate response and we can square the matter afterward.

Best wishes to all.

Your friend as always,
Marsden Hartley

1. Hartley was eager to see the current show at 291, *Exhibition of Sculpture–The First in America–and Recent Drawings by Henri Matisse* (March 14–April 6, 1912).

*❧*

April 2, 1912
Photo-Secession
291 Fifth Avenue, New York City (letterhead)

I herewith give Alfred Stieglitz the power-of-attorney for myself during my absence in Europe.

Marsden Hartley
Witnessed by,
Marie J. Rapp

*❧*

n.d. [April 13, 1912, Paris] (postcard)

Hello—A.S. and all the others,

Arrived duly in Paris on Thursday Apr. 11th after a gentle sea voyage. Found Simonson had gone to Italy for a few weeks so I hunted up Maurer and another American on the Blvd. Montparnasse and I got a small hotel there tomorrow until I can tell where I am going to be. I saw 8 Van Goghs this afternoon—several fine one "La Berceuse" a beauty—others—landscapes—four Cézannes at Vollard's (funny place).

Tomorrow I shall go on to the Louvre—then the Salon des Indépendants.[1]

11:30 P.M. Have just been walking here.

1. The Salon des Indépendants (March 20–May 16, 1912) that spring featured work by Matisse, Wassily Kandinsky, Robert Delaunay, Fernand Léger, Stanton Macdonald-Wright, Francis Picabia, Gabriele Münter and many others. For a complete list of artists, see Donald E. Gordon, *Modern Art Exhibitions, 1900–1916* (Munich: Prestel-Verlag, 1974), 2: 559–62.

*❧*

n.d. [April 24, 1912, Paris] (postcard)

My Dear Stieglitz,

I know I should be writing something to you and yet I know that you realize how difficult it is to get at it with so much going on in the way of new experiences. I am doing nothing but looking and have seen about all the big things—except Pellerin's which I go to on Saturday next. Next to the Louvre this is the most important in my esteem. The

Luxembourg is quite ridiculous after the Louvre—have seen the Indépendants Salon—perfectly terrible—the Salon des Beaux Arts merely a National Academy of a better class. Have seen Notre Dame—perfectly beautiful—Sainte-Chapelle—Panthéon—and am already familiar with most of Paris. I am beginning to feel now like getting to work. Studios are most difficult to find until June—so I shall have to wait. If I do not get anything Simonson offers me his during the summer season. He is very kind to me and he is the only person I really know here. I find much to interest one—and a deal to disgust one in the art life here, a great deal of talk and gossip and no work—I shall keep by myself a lot I can see.

I will be writing more soon as possible. Remember me most cordially to Mrs. S., Lawrence, Kerfoot, Mrs. Meyer—Haviland, De Zayas, Halpert and all others.

Best wishes to yourself always,
M.H.

⁂

n.d. [May 8, 1912, Voulangis] (postcard)

Dear A.S.,

We are all sitting in the studio at Voulangis—Steichen—Mrs. S., Mary and Kate and the dog.[1] S. and Mrs. came into Paris on Saturday hunted me up and brought me back with them. It is certainly all that I have heard about here at the place. The garden is really wonderful—Steichen shows real genius in this line—quite wonderful. It is an ideal spot for living too. France is certainly a lyric country—a land of gardens and soft light. I return to Paris in the morning and feel refreshed with the quiet and sweetness of life here. I find Mrs. S. so attractive and hospitable and the children adorable—very unusual children and they are very fond of me already.

I will write you soon and tell you of the studio I am to have which is no other than Simonson's—very cheap and wonderful. He goes to the South to live for a year or more and does not want to rent it to a stranger, which he could do for much more money.[2] It will be perfect for me—and a fine location—very near all things yet isolated—in a large garden. He leaves before June 1st. S. and Mrs. send love and best wishes. Extend my best felt sympathy to Mr. and Mrs. Meyer. It is all so shocking.[3]

As always,
Hartley

A great Renoir show is now on. Very fine.

1. Eduard Steichen lived with his wife, Clara, and their children Mary and Kate in Voulangis, just east of Paris from 1908 to 1914, and periodically after World War I until 1923. The country setting

stimulated Steichen's love for gardening while still giving him easy access to developments of the European moderns in Paris, thus creating a significant conduit between Europe and Stieglitz at 291. Steichen used the original spelling of his first name, Eduard, until about 1918, when he began using Edward.

2. Beginning in June, Hartley sublet Lee Simonson's studio at 18 rue Moulin de Beurre. Simonson was going to Cassis to paint with Stanton Macdonald-Wright (Ludington, *Marsden Hartley: The Biography of an American Artist,* 74).

3. Hartley's reference to Eugene and Agnes Meyer is too obscure to fully identify.

ᑐ

n.d [June 20, 1912] (three postcards)
18 Rue Moulin de Beurre
[Paris]

My Dear St.,

I used to think postals were a fine idea but I am growing to hate them as I can't seem ever to get down to a letter—but I must write something if only that you may know I am alive—working—and absorbing what Paris has to give. Artistically there has been nothing but the two recent Renoir shows at Durand-Ruel's—the first—much still-life with portraits and figures the last closing tomorrow entirely of portraits from all periods. One marvels continuously at his productively—but most at his wondrous artistry. Vollard is now showing a group of drawings that are really astonishing in their expression of volume. Apart from Renoir and the Cézannes one may see occasionally there is absolutely nothing worth looking at. I have been quite shocked of late with the mediocrity of men like Flandrin, Friesz—Manguin—it is too dreadful. Matisse becomes one of the gods after this terrible stuff. Even Monet's late exh. of Venice at Bernheim's seemed like a real thing.[1] Perhaps France is in the descendant—for one man cannot save a country—and Picasso and Matisse could not save the art of Paris.

One has a sense somehow of the mere timeliness of the Cubistes and the Futuristes. I see them often and have met several—have been to Delaunay's studio and seen his "latest"—but so far it is like a demonstration for chemistry or the technical relations of colour and sound. They all talk so glibly but what do they produce. But the French are not all Cézannes and Picassos—Rodins—they do not all effect one as profoundly—but who shall say. I only know there is a terrific deal of talking and I avoid it whenever possible. The charming fact is that one can shut one's door and be as far as one wishes from it—right here in Paris, and the real value is in being close to the great things and in such quantity.

I am so glad that nothing happened to "291."[2] You don't know how I miss it—there is nothing of the sort one can turn to here. By the way—please send a draft at once as I wish to have enough on deposit for security. I am low now as a result of having paid 6

months rent and the necessary expenses of getting established—and whoever says Paris is a very cheap place to live does not know. It is not—I don't care how economical one is—one gets more out of life but the money cost is quite the same as N.Y. The tourist has ruined the conditions which may once have existed—and one can be quite as bored with nothing to do here as in N.Y. or anywhere. The world is all the same when it is too obvious, but if one can dream then certainly Paris is a dear place.

I went to the Quatres Arts Ball last week—quite the most wonderful spectacle probably in existence—2000 people in Arabian Nights costume—myself as gorgeous as any in effect.[3] It remains the last word in splendour and abandon the kind of thing one expects to come only out of books, but that again is the French genius—it could not have happened anywhere else on earth—the utter absence of moral code could not be understood elsewhere.

But please write me something about 291—I want a breath of you all there and at home. Tell Mrs. S. that I will be writing soon. Do send the draft at once as this is important. I hope fortune will continue to smile favorably for the advancement of work and growth—as that is the only excuse for being here. Love to Mrs. S. and for yourself always the same admiration and best wishes. Write soon. Regards to everybody especially Kerfoot and Keiley.

As always,
M.H.

1. The exhibition at Galerie Bernheim-Jeune, *Claude Monet: Venice* (May 27–June 8, 1912), included twenty-nine paintings by Monet.
2. This may be a reference to the impending fate of losing the building that housed 291 to a new skyscraper; the building was eventually demolished in 1919.
3. The Bal des Quatres Arts, a masked ball and parade, was an annual event in Paris.

ᘓ

n.d. [June 20, 1912] (postcard)
18 Rue Moulin de Beurre
Paris

My Dear St.,

One word more. Vollard has out a new collection of letters of Van Gogh well printed with many illustrations mostly new at 25 frcs. Shall I get it for you? Also I can get you a copy of Gauguin's *Noa-Noa* at 10 frcs.[1] It is rare and I think you will want it as it will probably never be printed again. It is the *La Plume* edition, a small book—but it has its place in the literature of the modern movement. One sees so little of Gauguin and Van Gogh now. I have only seen four Gauguins since I came and none of them are his greatest. Write at once and tell me if you want the Van Gogh letters. I want them

myself but I must wait awhile. It is quite a thick book and the pen and ink drawings are superb in it.

As always,
M.H.

1. Paul Gauguin's autobiographical novel, *Noa-Noa*, is roughly based on his life in the South Pacific in the 1890s. It was first published in *La Revue Blanche*, fall 1897.

ᔓ

n.d. [July, 1912]
18 Rue Moulin de Beurre
Paris

Let me warn you the length of this letter. I've had it in my bones ever since I came.

My Dear Stieglitz,

I have your letter with the draft enclosed—and have deposited the same for use—and today I have your other letter which seemed fresh and fuller of hope. I felt in it somehow a sense of the ancient fatigue of the soul which comes over you and over all sensitives. I have had some of it more or less lately and under those conditions neither Paris nor God nor the Devil can comfort one completely. One has to sort of remain upon one's own Golgotha until one can get down of oneself. And I too feel fresher the last week and quite fit for work—I almost dare to say that I am doing good work too—even though I am working slowly—I do find an increase of visual vitality which I am confident will come to something real and mayhap, soon.

That most extraordinary exhibition at Manzi, Joyant and Cie of Cézanne I think about 20—as many or more Manets—beautiful Degas—and such Renoirs—superb Lautrecs—not to mention Monet, Berthe Morisot—Forain, Mary Cassatt who come to quite nothing in the same place with the former. I even feel a commonness in Manet —barring the splendid "barmaid" picture.[1] But O the Cézannes and the Renoirs!! and how much of Renoir we have had of late—two wonderful shows—one of portraits and the other of still-life and portraits landscapes and [?]—there in Vollard's now—incomparable drawings.[2] I go regularly to everything that I can see or hear of—to be perfectly familiar with the situation as it moves and I assure you if it were not for the big things—I should feel in a way despairing—beside men like Flandrin, Friesz—Manguin, Jourdain, and such. Bonnard and Vuillard look like great ones and they are so ineffectual somehow and indeed beside all these how truly fine is Matisse. He is veritably a meteor of high luster in the milkiest of ways. I like the glimpses I get of Redon—he has a very chaste vision if it is little over-delicate. He voices flowers in a rapturous manner and gives forth the real ecstasy that flowers give one. But like a spiritual Gibraltor

stands always the Louvre. I have been in no fit position to give forth anything like my real feelings but now I have fully sensed what it is that one gets in coming to Paris—and it is certainly rare. There is an "aliveness" stirring in the air—a reverence of the people toward beauty which is truly comforting. I do not know that as yet I find the French genius itself an altogether sturdy one—but it is certainly refined to the highest degree—and one feels one's every sensation sort of pitched to a truer register.

Now and then I have a longing for a great breeze such as one gets from that which is truly American. One certainly does not get it from the motley that float about Paris which one must admit is American. And I am so enjoying the small German coterie which I am with always—at the little restaurant where we dine.[3] A most charming and excellent young German officer was one of the group and we saw him off this afternoon for Berlin after going to the Musée de Gustave Moreau in the rue de La Rochefoucauld—an interesting though utterly curious admixture of Prix de Rome draughtsmanship and superheated sensation.[4] If the man had only possessed what he really wanted to express—if he had only had such a gift for colour as Monticelli his things might have really had the jewel-like brilliancy—but as they are they look to speak figuratively, like jewels suddenly gone daft—as if at a blast all the diamonds and rubies and emeralds had all been diverted of their luster.

And I must relate a curious incident. We were walking from room to room and as we entered a small room—suddenly I felt a terrible depression in the atmosphere of the place. I said to the German sculptor—"I am positive someone has at some time or other died in that room." He casually asked the guard if the family had lived in these rooms and he replied "O yes—they all died here." It was quite uncanny for I never make a practice of emphasizing sense experiences but somehow suddenly it seemed as if the air was full of grave-damp and I could think of nothing else.

But such prodigious productivity—the house is packed with canvases and draw-ings—huge canvases just begun—or half way on—filled with an infinitude of the minu-tist detail—after all painted literature. One sees now and then the effusions of his followers—but it is distinctly literary material always. And how readily one turns to merest trifle of Renoir or of Cézanne—or even Van Gogh and Gauguin though one sees so very little of either. Vollard keeps two Gauguins in his windows as sort of screens to hide the junk-shop effect within. And so it is I keep myself on the *qui-vive* with a keen eye out for all that is to be seen merely to know the situation here. I have so enjoyed a lovely Seurat in Bernheim-Jeune's window. I have gone several times to see it—beneath it are Signacs and Henri Cross and as for Signac he is quite impossible and beside Seu-rat, Cross looks so ineffectual. Seurat was so talented for the thing he wished to express.

You see it is such a pity that one must write for one could talk all things so readily and I have naturally a flood of things to run off. I wish for instance I could describe to you the Quatres Arts Ball in all its gruesome splendour. I am certain no orgy of ancient

history was ever more gorgeous or presented riotry more vividly—the very nostalgia of beauty—beauty that sickens and which would make one madden if continued for a period—but how wonderful as a spectacle of complete abandon. I looked quite gorgeous myself and received many compliments from strangers and believe me there were wondrous costumes there—all this was the result of my old stage experience in learning how to create out of nothing—something real.[5] I will send a picture even though it is very bad. It is at least a record and forms an interesting feature in my general experience here.

Did I tell you of going to the Mallarmé Celebration—the placing of a tablet on Mallarmé's house—in the rue de Rome? I went with some literary people I had met and seen often—Madame Mallarmé present in front of the house. Henri de Régnier delivered a short but effective speech—and then they went to the Café de Paris in the Place de Clichy at which all the literary lights were present as also others—curiously Léon Dierx—"Le Prince de poètes" a dear old man who sat at Mme. Mallarmé's left—died two days afterward—others present—Debussy—Francis Vielé-Griffin—Paul Fort—[?] the caricaturist—and a host of others all so interesting. There is certainly a zest to the aesthetique life here—so natural and progressive even if it is a trifle hectic and over stimulated. It produces finesse of sensation while it may lack in vigor and strength. One sees why they turn so readily to Poe and Whitman and I'm told there is quite a cult of the *vers libre* now—a group on this side and one also over on Montmartre.[6] I shall get closer to these things in the autumn when everyone assembles for the winter and soirées are in order. I went at first nearly every Saturday evening to the soirées of Fritz Vanderpyl also poet of the modern school and there I met some of the people of the day—but the really fine and gratifying thing is that one can be as remote from all these cliques as one likes or as close as one wishes.

As to the Van Gogh letters—I will get them for you and give them either to Carles or Miss Rhoades also *Noa-Noa* and if anything else turns up. I am overjoyed at having the Van Gogh letters myself as a gift from you—I like things of this sort as gifts. You are kind to make the suggestion for I haven't felt as yet that I could put 25 frcs. to lay away in a book—and then one runs chances because these French editions run out and one has great difficulty in getting them. A friend today to my great delight gave me a copy of a book *Monsieur de Phocas* by Jean Lorrain—said aesthetically to be the book which Oscar Wilde has Dorian Gray read and which is his undoing—you perhaps remember that. I think Dorian speaks of this wondrous book and has it bound in many different ways. Wilde knew Lorrain and it is said to be wonderful. I will get that too and send it to you—you may know of it. I remember when I read *Dorian Gray*—I was terribly curious to know what the book could be—and this is it.[7] I shall have to work hard on the French but it will be a stimulant.

And by the way I have amused the German contingent with my occasional outburst of quite real German. I didn't know that I knew as much—my long association and intimacy

with the Strauss family helped me much for this. Now I am eager to go while I am over here to Berlin and Munich—especially since I met the German officer and the sculptor. The officer is so handsome and looks a great deal like the fellow in that portrait of Eugene's who was to marry someone's equally wonderful daughter—was it [?]? Since I have been here and seen the hideous French men—I turn to the Germans as to the gods—if there was ever a more ridiculous lot of males as a clan it is these French men. Perhaps I shall sometime see the fine types that we are accustomed to at home and in Germany I am sure—but as yet only these little China dolls horribly dressed—occasionally a French woman but a French man, almost never.

How gossipy I seem tonight, but I feel like I must get this thing out of me and then proceed on the business of absorption. Altogether I find this Paris thing very fine— though of course all things pall on one under certain conditions. I have seen the Steichens several times—met Carles and S. at the big exhibition and had a moments talk at the taxicab wheel with Mrs. S. and Miss R. and Miss B.[8] I was eating supper at the Restaurant Thomas on Raspail where I always go—eating with the German officer—all at once I saw these queenly ones draw up at the curb—I had been to Versailles but a few days before and for a moment I thought it must be a little coterie of the Louis. Suddenly to my amazement a hand waved at me—I looked twice and it was Mrs. S.— I was amazed to think I should know such a royal party and they all looked wonderful. I think they were going to dinner somewhere—I was suffering terribly that night from indigestion and melancholy—and I can't really say if I talked intelligibly or not. Anyhow I guess I was rational. Do you have states of being when you feel as if your very voice was alien to yourself and one feels like an empty lute on which one may wrap one's fingers? Well I get them at times and I think I had one that night. But I feel much better physically and I suppose one recovers something mentally and spiritually also. I shall endeavor to keep it up because it is productive.

I am glad that you find Walkowitz as pleasurable as ever. His talent is surely a real one and one sees much of the reverse here as well as there too. He is perhaps small— but he is wholly conscious of what he wishes to do and works for that. Here one finds more cliques and groups than could be imagined—and such groups as for instance the Fergusson-Estelle Rice group which exploits itself in *Rhythm*. In one of the last numbers of *Rhythm* is a treatise on Gauguin's influence in which Kandinsky is talked of among others. He is evidently one of Gauguin's pupils and is I believe a modern light in Berlin or Munich.[9] He has lately brought out a new magazine called *Der Blaue Reiter* which I shall look up—very likely they talk much of modernism—and God knows they talk much about everything here.[10] It is in a sense an advantage not to know French well as one escapes much even though one loses much also.

One sees very little and hears less of Picasso and Matisse—they keep distinctly to themselves. I hope to go to Picasso's sometime when I make connections with Haviland's brother.[11] I have been to his place twice but at that period he was out of Paris. I see new

and lovely things of Manolo's at Kahnweiler's galerie in the rue Vignon. This place has a freshness with the new Picassos, but his imitator Georges Braque—I can't see why exactly that a man should so deliberately follow another. Picasso's new things are not as interesting I think but one accords him his own right to variations—just now he is doing things that have running over and across these network designs—names of people and words like jolie or bien and numbers like 75.[12] I remember in one in vivid blue against this geometrical arabesque in browns ochres and blacks, usually very small often in oval frames. Braque has followed literally all his divagations in seeming copy-cat fashion. This is the new Picasso effect.[13] Of course this is only a very rough impression— sometimes I think it gets closer to the Futuriste idea and then again I don't know. Anyhow there is everything classified and unnamable here and one has but to speak and he may have his choice.

And here are forty-eight hours intermission. I was dumbfounded last night while sitting at the Café de Lilas with my friend the German sculptor and a little girl friend of his as someone walked straight up to me and said hello! It was Gretta Williams the beautiful English girl that I took to "291" several times you remember. I was too delighted for she is the one girl I know that I had wished for in Paris because she is such good company so fresh and natural and comfortable to be with and God knows she is a beauty. She has come to stay for her parents live here not far away. I expect her in a little while to take lunch with me. Unless one has a mistress or a wife here one misses company for everyone sort of pairs off here and so there are groups of lone men all around—some through preference and some through necessity. I could have had one of the most fascinating girls in all Paris—but I told her to be sensible and stick to the man who has money—not just as pretty as some but adorably fascinating and a clever without knowing too much. I hate them when they know too much and it is almost as bad when they are such idiots as some. But the English girl and I are very good pals and so I can enjoy her companionship without the encumbrances and without complications.

But I won't continue in the ramble. I have worked off most of the surplus anyhow and nothing of moment remains. You'll be needing a reader by the time you get to the end of this letter. I can't say when I shall ever write such another as this, so you can forgive. I thank you profoundly for the copy of the Van Gogh letters. I ordered the two copies yesterday at Vollard's. V. was out and the girl didn't know what he had done with them. I don't see how anyone can in that shop. It is too ridiculous—but then—with all reverence New York has 291—and we always have a way of finding most of what we want.

Give my love to Kitty and Mrs. S. and my very kindest wishes to Mrs. Meyer and Mr. Meyer also. I hope Mrs. M. is recovered now and is her wonderful self again. She stands out like a wondrous Greek against the background of these French women.

Very kindest wishes to Walkowitz, Halpert, Marin whom I hope is recovering too, De Zayas especially whom I so much admire Haviland also and to Lawrence. I shall send

love because he is a grand brick. Tell him I hate him for not dropping me a line. I can prove that I am busy and I am young and foolish but he is young and wise and all wise people have time. Be sure and read this part to him.

For yourself you know always my esteem. I am too delighted naturally that you are getting your own work done. It is best for you to vary your creative product by producing yourself. You are one of those creators who produce human beings. From the ethical standpoint then you are a genius also but it leaves the soul so stiffened, and you need all the influx of power you can get. Your own work will give it to you. Write when you can again—and do tell Mrs. to write. She may care to read this letter.

As always,
Marsden Hartley

1. *Bar at the Folies-Bergère* (1881), by Édouard Manet, is now in the collection of the Courtauld Institute, London.
2. An exhibition at Galerie Durand-Ruel included fifty-eight portraits by Pierre-Auguste Renoir.
3. This group included sculptor Arnold Rönnebeck, his cousin, a young German officer, Karl von Freyburg, the Swiss poet Siegfried Lang, American singer Alice Miriam and American artist Charles Demuth. They all met at the Restaurant Thomas on the Boulevard Raspail (Ludington, *Marsden Hartley: The Biography of an American Artist,* 75).
4. After his death, Gustave Moreau's home was turned into a museum dedicated to him.
5. Hartley worked as an extra and toured with Proctor's Theater Company, New York, from 1904 to 1906.
6. Hartley refers here to a group of modern poets, led by Paul Fort, whose prose followed an unrestricted, fluid style called *vers libre,* or free verse.
7. Since *Monsieur de Phocas* by Jean Lorrain was published in 1901 and *The Picture of Dorian Gray* by Oscar Wilde was first published in 1891, Hartley is mistaken. In fact the book which Wilde refers to in his novel is *À Rebours* or *Against Nature* (1884) by J. K. Huysmans.
8. Based on the dates, the "big exhibition" where Hartley saw Arthur B. Carles and Eduard Steichen was probably the Salon des Indépendants (March 20–May 16, 1912), or perhaps the May Salon (May 1–15, 1912). For further details about the participants in both exhibitions, see Gordon, *Modern Art Exhibitions, 1900–1916,* 2: 559–62, 582–84. The initials stand for Mrs. Steichen, Miss Rhoades and Miss Beckett, respectively.
9. Hartley first learned about Kandinsky in Michael Sadler's article, "After Gauguin," in *Rhythm, Art, Music, Literature* 1 (spring 1912) published by John Duncan Fergusson. Sadler presents Kandinsky as a disciple of Gauguin. See Gail Levin, "Marsden Hartley and the European Avant-Garde," *Arts Magazine* 54 (September 1979): 158.
10. The almanac, *Der Blaue Reiter,* was published by Franz Marc and Kandinsky. The publication sought an unconventional format that included work by modern and other influential artists, such as Vincent van Gogh, Gauguin, Matisse, Picasso, as well as, among others, those artists who exhibited with the Blaue Reiter group. It also featured a spectrum of art from an array of periods and cultures, such as medieval art, African masks, pre-Columbian sculptures, Bavarian glass painting, and children's art. The composer Arnold Schoenberg even contributed an article on modern music. For an authoritative discussion on the almanac, see Selz, *German Expressionist Painting,* 219–22.
11. Paul Haviland's brother, Frank Burty Haviland, lived in Paris.

12. According to Gail Levin, Hartley first saw Picasso's painting, *The Architect's Table* (1912), at 27 rue de Fleurus which Gertrude Stein had purchased that spring. The painting is now in the Museum of Modern Art, New York. See Levin, "Marsden Hartley and the European Avant-Garde," 158. See also Bruce Robertson, *Marsden Hartley* (New York: Harry N. Abrams in association with The National Museum of American Art, 1995), 38.

13. Hartley made a sketch of Picasso's painting here in his original letter to Stieglitz. This drawing is reproduced in Weinberg, *Speaking for Vice*, 160.

<p align="center">℘</p>

<div align="right">
July 30, 1912<br>
18 Rue Moulin de Beurre<br>
Paris
</div>

My Dear Stieglitz,

Your card came this morning. I am heartily glad to hear something from home. From what I hear of New York the weather must be tragic. Paris is most comfortable as regards heat. It is a little too much the reverse if anything for it rains much and is damp and raw—and it is October already for the trees are so brown and bare and melancholy looking.

I got the two "Lettres de Van Gogh" at Vollard's yesterday with my German sculptor friend Rönnebeck. V. showed us some pencil drawings by Cézanne and said that he was also to get out a Cézanne book of the character of the V.G. He had out several Cézannes—one perfect wonder—a boy sitting at a table with a skull. The boy in dark blue—with a wonderful piece of gray-old-gold draping behind him—superbly expressed in perfect C. style. Another of a little girl well expressed and two landscapes not so great.[1] C. has such a wonderful "baritone" sense of color—I like to call it—such fullness and iridescence. I saw also the other day when we went for the books—a beautiful and impressive Picasso—quite good size two standing figures two women conversing—done in 1904—all in blue tones—very gothic in feeling.[2] Even the blue trick is not new with Weber is it? I discovered this first in the Picassos at Stein's. I shall be glad when they come back again so I can see over again the fine things they have.[3] After the long siege of wish-wash *tableaux* moderne one turns with relief and pleasure to Picasso.

Albert Groll is here and says that Kraushaar had an exhibition of Cézannes since I left.[4] Is it possible!!! I can hardly credit this—and yet he is surely intelligent enough to know what he was looking at. Whose were they? Perhaps those that Glackens got.[5] He said the show attracted but little attention which again makes me skeptical. I have even thought that he might be stupid enough to mean Cazin. As for the Van Gogh book and Gauguin's *Noa-Noa* I will see that they go to Carles or Miss Rhoades.

I have discovered recently that I have been dining every day with Elie Nadelman the sculptor. He has been bowing to me every day almost since I came but this is the custom in Paris and one may never know whom one addresses. He has invited me to his studio for tomorrow afternoon so of course I shall go. He is very nice looking somewhat like a Rossetti type—long wavy hair, smooth face clean-cut with a very engaging presence. I go this afternoon to Jo Davidson's to see his bust of Doris Keane whom I met with them the other night at Laverine's which place I seldom go because I hate to hear Dakota telling Arizona what she had for breakfast in Mizzouri. I go for coffee more often to the Café d'Harcourt on the Boul-Mich—for there one gets the real real thing. I have not yet been anywhere in Montmartre as the places are so expensive but I shall get there somehow—sometime.

As it is I am very happy in Paris—I feel like I am being born over again—the heart and soul of one feel so free here. I am convinced that it is wrong for one to live anywhere where one cannot breathe freely, and there is a substance in the air which creates life in one at every move. I feel as if I want to live here always and after all why not? America is not the only place—and other people manage to do it—why not I? One is so close to the culture of the ages here, so close with realities which engage the artist and the poet. I am working slowly but there is a new crescendo in what I do—a vital something which if allowed to proceed naturally will I am sure come to something—come to its own. And one gets such joy here! out of the common things. It is in no sense cheaper for a poor person like myself but God! what one gets for one's money and for one's mind and spirit!! This is in itself the priceless thing. And after all it is to <u>live</u>, not spending a lifetime in <u>trying to live</u>. There comes a time later on when one can only wish to have lived and to watch others living and so one must embrace one's youth eagerly while one has it—and my real youth is now with me—for I am much younger than my years and after all age is but the accident of one's experience. It hasn't as much to do with one as many wish to think. It only presides where one fails to live. Then naturally age has something to busy itself with.

I have been pleased with the recent bust which my German sculptor friend Rönnebeck has made of me. It is I think an authentic presentation of me inwardly and outwardly. It is utterly free from trick and partakes of the substance of real sculpture. It is now in the hands of the *fondeur* to be put into bronze for the Salon d'Automne. I am sure it will get in. He is to bring me the photos today and maybe I can send you one. It is at any rate a much finer more representative thing than Davidson's bust of you which had only externals and not typical at that. Davidson is not deep but he is clever and he is really a decent sort of a fellow. His wife is a marvel of style here. She always looks wonderful—yet so simple. She is so gifted with taste and personality and how they do spend the money!! They do the real American stunt over here. It is all right if one can but it takes the art out of me. Such is the grave danger of success. For myself I do not

want mansions and motors—I want merely peace and freedom—and this is the natural inheritance of every man. I do hope you will all be coming over next summer. How lovely it would be to be here with you and to go about with Mrs. Every time I go by Rump-elmeyer's I think of her. I sneak up to the window and look at the wondrous cakes and that is as far as I go.

I am hoping strongly that I can go to Berlin to see the galleries in the early spring, for since I have made the friendship of these fine German boys—the sculptor and the handsome officer they are anxious to have me go there and the sculptor goes back for two months service then. I could have such a grand time with these fine fellows. O! I know I shall live here always. I know that where the heart is happy there is home. Mani-gault, the Canadian boy whom you remember is over here now and he was with me the other day and I said to him—"O I wish I could know that I could be here for the next five years" and he said "O you will—all you have to do is to wish well for it." I could have embraced him for that, for it seemed like divine intelligence. I feel as if it were such a vital period just as childbirth is vital to a woman. It is so with the soul. One must pro-tect it well from accidents and evil circumstances so that it may flower and be pro-ductive and that is all I want—natural production—not phenomenal—and exceptional. And this comes only out of life and the chance to live it.

It delights me to know you had a letter from Kenneth Miller. I take it that you are upon amicable terms. Once I knew that he felt a little alien to the place and what goes on within it in a superficial way—but he has real insight and he is wondrously just and with such perception it is easy to see that 291 has great beauty. I am certain that Paris would be happy beyond all with such a place. There is nothing just like it. Even though all the business places are delightfully informal—none of the gruesome red velvet game. I look forward to the winter season when everybody will have returned to Paris for work. Just now it is very dull and lonely. I shall be going out to Voulangis soon myself for a couple of weeks as my friends here are leaving and Paris is terribly alone. I shall go to the little hotel near Steichen's as it is cheap and there it will not be troublesome to Mrs. S. for she has so much to do always. By that time the Carleses and Miss R. and Miss B. will have returned and it will be pleasant. Think of so many of us together out of one place. Wouldn't you love to be here then—you and Mrs. and all of us in the garden?

So it goes—I have reeled off so many lines merely because I have these longings to talk to you. I am not yet accustomed to the absence of "291" and the loss of our times together, and it is still strange not to be dropping in at 1111.[6] I hope to see Mrs. Schubart when she comes to Paris as Groll came over on the S.S. with her and says she comes later.

Otherwise no news. You will enjoy the Van Gogh book as the reproductions are prac-tically all new 100 in all. I will get you also the book of memoirs by Van Gogh's sister which is out. You may even have it. It is more or less uniform with the Meier-Graefe.

Best wishes to you always. Love to Mrs. S. and Kitty. Very best wishes to Lawrence—Walkowitz, Halpert, Keiley, Haviland and anyone who asks for me. Especially love for Kerfoot. Tell him to write me about the surviving puppy.

Always,
Marsden H.

The enclosed postal will amuse you.[7]

1. Based on Hartley's description, the painting he saw by Paul Cézanne was probably *Boy with a Skull* (1896–98) now in the collection of The Barnes Foundation in Merion, Pennsylvania. The details given for the other paintings are far too insufficient for full identification.
2. Hartley's description, along with a very small drawing he made here in the original letter, both match that of Picasso's painting, *Two Sisters (The Meeting)* (1902), now in the collection of the State Hermitage Museum, St. Petersburg. He is mistaken about the 1904 date.
3. Gertrude Stein and Alice B. Toklas were on a tour of Spain at the time. They returned to Paris in August 1912.
4. Kraushaar Galleries in New York did have work by Cézanne in the inventory during this time, but it is inconclusive if the gallery had a small exhibition of Cézanne or Jean Charles Cazin during summer 1912.
5. William Glackens traveled to Paris in early 1912 to purchase works by Cézanne and Renoir for the American collector, Dr. Albert Barnes, who later founded The Barnes Foundation in 1922. At that time Glackens bought one Cézanne landscape from Galerie Bernheim-Jeune. For an account of this transaction, see John Rewald, *Cézanne and America: Dealers, Collectors, Artists and Critics, 1891–1921* (Princeton: Princeton University Press, 1989), 161.
6. 1111 Madison Avenue was the home address of Stieglitz and his family.
7. Unidentified and now presumed lost.

ॐ

August 19, 1912, Paris

My Dear Stieglitz,

I have your fine long letter from Deal which comforted me very much in one of my tragic dark periods out of which I am just emerging—and this morning yours again with the Painters and Sculptors Ex. invitation enclosed.[1] I am certainly interested as it seems as if we were to have at last something of worth on a decent scale in America. I will of course send something and will ask for particulars as to time of sending in—the number of things one is entitled to etc. If you hear in the meantime please let me know. I shall be obliged to refer them to you in which case I know you will get the best there is of me together. I think of the pastels you have as being an indication of what I may do and am doing. If you want to send some of the oils such as those flower pieces or possibly if Mrs. Meyer would be willing to send hers and John Quinn his—these would give a

sense of what I am driving towards. Maybe if the time for receiving is far enough off I will have some new things that could be sent from here. I have things now which I am not ashamed of and which I would enjoy showing to you.[2]

I am getting into the game of work and find in the product an increase of 'sensibilite' which augurs well for the journey over here. It takes some time to get over this long siege of new sensations—and to find oneself among them and this I am beginning to do at this stage. There is certainly a peculiar something in the air which makes work easier and life a more simple thing. I have looked over the ground pretty well—have kept my eyes open and keen toward all that passes here and I think I know in one sense the art situation here—but this is only general of course—special knowledge can only come out of time as it passes and in what happens with the day and with the moment. One thing is sure—one has a sense here that they are all working for the sake of the thing and are not playing the merchant game as we know it in New York. Of course there is that here also but I speak only of the real people.

And I come now to that point upon which I have been trying for some time to write and which I find myself absolutely driven to do. It is the old question of finances. I have got to know this phase of the thing definitely and for the first time since we have been together, you and I, I am going to really ask you to cooperate with me in this matter. It is without question the most valuable thing that has happened to me in my life—this coming here. I feel it is of the utmost importance at this stage—I feel myself growing stronger and more effective in myself with every day's stay here. I have never felt so free for development and have never developed as rapidly as I am at this time and in this immediate period when what I am doing shows an immense jump over anything I have yet put forth. There is in the work a spontaneity of expression and a greater clarity of vision than ever. I need not dilate to you upon the utter importance of freedom at this time—of continuance without disturbance—and so I state facts at once—which are these that I have remaining funds to last me until the last of September and then I am completely broke. I have paid my rent until December 1st, and am under obligation for another six months as all studios here must be taken for a year. I know now what it costs to live as I live according to the lowest basis of economy—and I have proven the utter fallacy of the much fabled cheap living in Paris. It is quite a thing of the past—thanks to the American tourist who has taught the French how to be still more grasping—and I have it besides from other students who have lived here for some time—and that with food and the ordinary expense of materials which again is not any longer a small thing—it costs me $15.00 a week or just what it costs me in New York. It is the necessities here which are so costly all things being practically double—such as tea coffee, coal, oil—laundry. I have had my siege of melancholy over this problem and have suffered most terrifically under it—but there is really no use in it—I have gone through these things often enough to know that there is a way out of all things and

so there will be out of this problem too. I am intensely eager to stay out the year at least and it seems almost as if I am entitled to it—and I find too that everyone I know over here who is working either American or foreign are sent here under patronage—artists—singers and musicians etc. There seems never to be a solution of this problem for the creative worker otherwise—even all the modernists are men of private means otherwise they could not work.

I am so eager to keep on under the influence of what is round me here—and develop myself—I know it will be worth it to myself and to anyone who may be interested—I am past the point of having ambitions other than for my work—I have but the one object and I have learned economy through experience and do not interest myself in the game of being the well to do artist—I merely want to prove my right to what I venture to believe may be true—and what you yourself generously say, that I am an artist. I do not as you know also—aspire to greatness or outward success—I merely aspire toward perfecting myself—and I can do most toward this end at this time here where the atmosphere and general conditions are conducive to growth.

May I ask you therefore boldly and unashamed with your faith in me as an artist and our faith in each other as friends which has long since proven itself—ask to you see what ways and means you can devise to keep this good thing going for at least another six months? Can you not find someone or several who will either take the stuff I have on hand at any price or perhaps advance in what I have and what is coming for there is much coming—so that I may be assured of $75 a month for the next six months? I am fairly fixed for clothes as with those I brought. I have had some good things given to me here by Simonson who was glad that I was willing to accept them. It is a thing that I could not readily do with everyone—but I know him well and so it is all right.

Perhaps you may be wondering if I have been extravagant—I can only say that I have done the best I could with the strangeness of conditions generally and it is not easy to get into a new game at once. But I have learned that what other careful students say is true that a person can't get on with less than $75 a month—pay rent—have a model occasionally buy materials and have food enough to keep from being hungry. Of course if one never pays for anything as is the miserable fashion of some of these mediocre Americans (and others too probably) then it is not difficult but I have never been able to live on that basis. I have sometimes wished I had the genius for it as many well known people have not to speak of unheard of individuals who spend their time escaping persecution.

Here is the matter as I have given it. Naturally I must be kept in a troubled state of mind until I hear from you again. I must depend utterly upon chances at home as there is no one here to whom I can turn in an evil hour—and I cannot go hungry. I am determined in my heart and soul—that this shall be what it is intended to be—my golden opportunity and I am certain that now is the time of all when I should be free

to perfect my sense of creation and attain freedom which is coming to me so well under the influences of the conditions around one here. You know them well and understand them and know their importance at any time and most of all to me at this period. I recall you saying too, by the way that the Meyers offered to assist in the matters of the Photo-Secession and those connected with and also that at the time they bought the still-life they were willing that I should have as much again.[3] I no longer feel like a culprit in speaking of such points to yourself who knows me now beyond accusation. It is an impersonal thing I am after and always will be—and if there is anyone who feels an interest in the matter I should not feel myself above the matter, for I am convinced that I shall be able to offer returns either now or later.

Please therefore see with me the importance of the issue and help me in this period. I write you with a finer faith and greater confidence than I could have a week ago when I was suffering acutely from blackest despairs—but these are not wise. I am ill for days when they come and can do nothing—and so I have had to recover myself with work—working continually—and going nowhere away from it. I haven't even been out to Voulangis since June for I haven't wanted to go away—feeling the importance of keeping on the job in periods of insight and productiveness.

I shall wait then most eagerly for an immediate reply. It must be as immediate as possible for at best it will be a matter of nearly three weeks and I shall have to have some definite source of assistance. It is not like being in New York where one is on the ground when things happen.

Don't hesitate to go ahead and sell right and left anything there is lying around of mine—if you can see a least chance of getting cash out of them. I am absolutely determined in my soul that this thing shall come to a perfect head—and yet I cannot perfect it alone. I would sell the whole outfit for six months keep if I had to—and yet I need to get all I can out of it.

You understand all this too well and I needn't continue. I only know that you will see a way out with me on this thing somehow—for there is a way.

I am giving your Van Gogh letters and the Gauguin *Noa-Noa* to Miss Beckett who says she is leaving for home in September—earlier than Miss Rhoades. You will no doubt be glad to see her and be glad to have both of these strong and fine girls walk in upon you occasionally. I have been sorry not to see them here—but I am so bad at the social business and they are busy also.

Give my best wishes to Mrs. S. and also to all the others—Kerfoot—De Zayas—Haviland—Halpert—Walkowitz—Dove—and all others—not forgetting Lawrence. For yourself always the same. I look forward to seeing the new number of *Camera Work* and the special number also.[4] I shall be able to speak of it to Miss Stein when she comes from Spain—I found her very delightful—I did not see Leo S. that night—but I met him once for a moment in front of the Madeleine with Steichen and Carles. I

long to go to their place and see their Picassos which are lovely—he remains for me the big thing I felt in America. The Salon d'Automne will open soon and I look forward eagerly to this—as I suppose it will have everything in it that is modern.[5] I hear Matisse is back in Paris and I want to go to his place some time—also to Picasso's when I can get either Steichen or Haviland's brother whom I have not yet seen for he was out of Paris when I went both times before.

Please write me at once—you well know the importance of a letter. I shall be very much in need by the time you can write.

As always,
Marsden Hartley

1. Stieglitz vacationed with his family in Deal, New Jersey. It seems that Stieglitz included with his now lost letter an invitation to Hartley to exhibit with the Association of American Painters and Sculptors in New York. The association was in the process of organizing the Armory Show. See also note 1 page 42.
2. Eugene and Agnes Meyer purchased a still life by Hartley to help finance Hartley's trip to Europe. John Quinn purchased *Still Life (The Faenza Jar)* (1912) by Hartley sometime before May 1912. For further discussion on Quinn and his relationship with Stieglitz and 291, see Zilczer, "Alfred Stieglitz and John Quinn," 20–21.
3. Hartley is referring to the painting that the Meyers purchased in early 1912 to help cover his expenses abroad.
4. Hartley was expecting *Camera Work* 39 (July 1912) and was eager to see the special number of *Camera Work* (August 1912) which featured two word portraits by Gertrude Stein, one of Picasso and the other of Matisse, along with reproductions of paintings and sculptures by both artists.
5. The Salon d'Automne (October 1–November 8, 1912) exhibited work by Gauguin, Cézanne, Edgar Degas, Maurice Denis, Pierre Bonnard, Renoir, Matisse, Alfred Maurer, Édouard Vuillard, van Gogh, the Salon Cubists (Albert Gleizes, Jean Metzinger, Fernand Léger, Juan Gris, and Alexander Archipenko et al.). For a complete list of artists, see Gordon, *Modern Art Exhibitions, 1900–1916,* 2: 619–24.

✌

n.d. [September, 1912, Paris]

My Dear Stieglitz,

Just a line at this time to acknowledge *Camera Work* and the Matisse-Picasso-Stein number which are excellent. I like De Zayas's article very much—please tell him so for me.[1] I shall see Miss Stein soon as they are now back in Paris.

I am hoping you got my last letter in which I stated the conditions at this time—as the days go and with them the little I have on hand I suffer a great deal from general nervousness and I am not very well at this time due to an attack of indigestion which have been frequent since I have been here—I am told this is a common experience the

first six months—I shall hope to be all right soon. I am working very well but I cannot work much as after a morning's work I have no energy left—this is temporary and will I think pass off. It is the anxiety that keeps me perturbed physically and mentally. I want so terribly to stay here—it is good for my development at this time. Naturally I must have the assurance of freedom if I am to work. I told you in the letter what the expense is here—that it takes $75 a month to pay rent and food materials and all the rest which is incidental and necessary. I repeat this here because letters sometimes go astray. If you got my letter you will have time to write me before my money is gone. On this I am utterly dependent. I am obligated to another six months in this studio anyhow as one must take them here for a year.

So here it is. If you find you have not time to write please cable me enough for a month anyhow and relieve the issue. Please make the effort and sell right and left everything so that I may at least make as much of this experience as possible. Fortunately my rent is paid so I am sure of a place to sleep until then. You will be seeing Miss Beckett soon and this will be enjoyable to you. I am sorry I did not see her oftener but it was not possible.

Very best wishes to everybody as well as yourself. Please answer at once—as I have money enough only for two weeks expenses.

As always,
M. Hartley

Received a nice letter from Kerfoot yesterday. I hope he is better by this time.

1. Marius de Zayas, "The Sun Has Set," *Camera Work* 39 (July 1912): 17–21.

⌐

n.d. [September, 1912, Paris] (three postcards)

My Dear Stieglitz,

Your letter with enclosure arrived duly and in good time. I will comment later in a letter. Enough now for thanks. I am better generally and shall recover from this extreme nervousness soon. I think of going out to Voulangis for two or three days while the Carleses are out there as it would be a nice way to rest up a little and visit them and the Steichens. Saw Miss Rhoades for a few minutes and she is to take a fine book to you— a copy of Kandinsky's *Der Blaue Reiter*—which has turned out to be a fine thing. It is expensive, but necessary for you to have over there and for me to have too—as I am taking a very sudden turn in a big direction owing to a recent visit to the Trocadéro.[1] One can no longer remain the same in the presence of these mighty children who get so close to the universal idea in their mud-baking. The results in me are proving themselves and

I am showing a strength unknown in past efforts. These revolts must come and until they come one can only proceed according to one's artistic conscience. They must be revolts of the soul itself if they are to mean anything other than intellectual imitation.

And so it is that Picasso is still the wondrous power here—and best of all I am told by Epstein, the sculptor who is here looking after his Oscar Wilde monument over which there is some municipal difficulty—and who met Picasso at Gertrude Stein's last week that P. says he has no theories—but only does these things because he likes to.[2] This places him among the immortals already and he would be immortal anyhow if only for one gift of genius—and that is—he talks very little of art or anything—a fine and inspiring contradiction to the lighter ones who talk continuously. I admire every line Picasso makes just for this one quality—it has the beauty of the inward seeking and is not attempting to be merely novel or bizarre.

I shall be going soon to Stein's as I did not see the books of drawings in the spring.[3] Kandinsky's other book—*The Spiritual in Art* is proving itself very interesting and this I will send you as soon as Sagot gets more of them.[4] It is cheap and excellent. I will keep watch for anything else that comes out so that the Photo-S.—may be as close as possible to things.

And now we are all waiting for the Salon d'Automne—I hope it will be good. It will be interesting anyhow for it will be a show and there hasn't been anything to see since June. Miss Rhoades tells of a great show at Cologne with 100 Van Goghs—a room of Gauguin and many Cézannes.[5] I wish they would repeat it here, as it is especially difficult to see V.G. and G. I will write of the Salon as soon as I can. I believe Hodler the Swiss painter is to send his most important things done recently.

Anyhow very best wishes to you to Mrs. and K. and to Kerfoot, Haviland, De Zayas, Lawrence, Halpert, Walkowitz, Miller if you see him, and tell me something of your plans.

As always,
M.H.

1. The famous museum in Paris then known as the Musée d'Ethnographie du Trocadéro displayed African, Oceanic, and other "primitive" collections.
2. The sculptor Jacob Epstein was commissioned to design a large memorial tomb for Oscar Wilde, to be installed in Père Lachaise cemetery in 1912.
3. For Hartley's letter to Stein inviting himself and Rönnebeck to 27 rue de Fleurus to see drawings by Picasso (Paris, fall 1912), see Donald Gallup, *The Flowers of Friendship: Letters Written to Gertrude Stein* (New York: Alfred A. Knopf, 1953), 64.
4. Stieglitz was one step ahead of Hartley in regards to Kandinsky for he had already translated and published an excerpt of *Über das Geistige in der Kunst* (Munich: R. Piper Verlag, 1912), as "Extracts from 'The Spiritual in Art,'" in *Camera Work* 39 (July 1912): 34, which had not yet reached Hartley. Gail Levin suggests it is possible that Stieglitz also read Sadler's article on Kandinsky in *Rhythm, Art, Music, Literature* which he could have purchased at Brentano's bookstore in New York's Union

Square (Levin, "Marsden Hartley, Albert Bloch, and Kandinsky in Europe," in Gail Levin and Mari-
anne Lorenz, *Theme and Improvisation: Kandinsky and the American Avant-Garde, 1912–1950*
(Boston: Bulfinch Press, 1992), 49. See also note 9 page 21.

5. The exhibition in Cologne was the International Art Exhibition of the Federation of West German
Patrons and Artists, or commonly known as the Sonderbund (May 25–September 30, 1912). It
included a retrospective of 125 paintings by van Gogh, and smaller retrospectives of twenty-five
paintings by Gauguin and twenty-six works by Cézanne. Picasso was represented with sixteen paint-
ings. It also featured works by Georges Braque, Blaue Reiter artists, Fauve painters, Neo-Impres-
sionists, and others. Because Arthur B. Davies and Walt Kuhn visited this exhibition just before it
closed, it became the model for the great Armory Show in New York. For more details on the Son-
derbund exhibition, see Selz, *German Expressionist Painting,* 240–49.

ℭ

n.d. [September 27, 1912, Paris] (postcard)

My Dear St.,

Your card this morning. I am feeling better though the food business is still trouble-
some—after a German and American diet for so long the French system is very weak
in its sustaining qualities. However—I look forward with intense interest to the Salon
d'Automne which though it will doubtless have much that is bad will yet have some-
thing good. I did not send as I don't want these things on my mind. Work is the only
important thing and I am working well. Was at Gertrude Stein's last Saturday to see the
pictures by daylight. She is delighted with the special number and wants me to com-
pliment you again even though she has written. She offers to give me a note of intro-
duction to Picasso so if I do not get in touch with F. Haviland I can go anyhow—also to
Matisse's, but Picasso remains the real and serious thing to me. It is a beautiful pro-
duction of his with a great significance. I will write after the Salon—as I shall go to the
Vernissage—with my friend Rönnebeck the sculptor whose bust of me is in. He intends
doing me in stone this winter. Your friend [Bruguière?] called on me. He seems very
nice—and promises to come soon again.

Love to Mrs. and best wishes always to you and the crowd.

By this time you will have the *Blaue Reiter.* It has a good character.

ℭ

n.d. [October 2, 1912, Paris] (postcard)

Dear A.S.,

The Salon is open—very ordinary—nothing remarkable—I shall write at length of it—
only a card now to speak of it. The Cubistes say very little almost nothing. The real artists
not showing—not Picasso—but he has no reason to—he is fine enough at Kahnweiler's.

Steichen's two things well placed—also Maurer's—one very nice—a deeper sense of his old idea. Van Dongen much better but nothing of moment—Matisse's two things good but not thrilling and oh what a mass of awful rubbish besides. Tell De Zayas he is right—art is dead—and now expression is beginning in earnest.[1] I see little outside of Picasso—Cézanne—Derain—Rousseau, Manolo to interest me deeply. Manolo is lovely at Kahnweiler's too, but Paris is a dead issue for art. Nadelman is awful.

I will write soon—I go this afternoon to take a quiet look.

Best wishes everywhere,
M.H.

1. de Zayas, "The Sun Has Set," 17–21; de Zayas begins this article in *Camera Work* with the declarative statement, "Art is dead."

∂

n.d. [October 4, 1912, Paris] (postcard)

Dear A.S.,

Can you do me a favor by sending me an extra copy of the special number with the Matisse-Picasso-Stein things? I would like so much to give a copy to my German sculptor friend Rönnebeck who is so much impressed with its beauty. I do not want to give him my copy without knowing that I can have one for myself. Perhaps you could do this. He is very kind to me and if I should have the luck to go to Berlin at Christmas he would make my visit a very beneficial one. I am told the collections are excellent there. Anyhow, whether I get to Berlin or not I would like so to do this thing. I will be writing about the Salon soon. I hear from Leo Stein that the Grafton Galleries have opened another show—many Picassos, Matisses and Cézannes.[1] It is such a pity all these great things happen out of Paris.

Best wishes to you—and Mrs. and to all the others at 291—Haviland, De Zayas, Marin, Kerfoot, Lawrence, Walkowitz.

1. The exhibition at the Grafton Galleries in London was *Second Post-Impressionist Exhibition* (October 5–December 31, 1912) and featured works by Matisse, Albert Marquet, Picasso, Henri Rousseau, Kees van Dongen, André Derain, Cézanne, Braque and many others (Gordon, *Modern Art Exhibitions, 1900–1916,* 2: 624–27). This exhibition was subsequent to Roger Fry's first show on Post-Impressionism, *Manet and the Post-Impressionists* (November 8, 1910–January 15, 1911).

∂

n.d. [October 9, 1912, Paris] (postcard)

Dear A.S.,

Your letter with draft received. Thanks. There seems to be something indicative of art excitement in New York doesn't there? I hope that it counts for something—I suppose it cannot always be futile. Anyhow for yourself—keep your fine faith—augmented by the faith of those around you there and us here. I am working hard—everyday—I think well—and when I see the Salon I think very well—for there is so little to really inspire one. And in all Europe there are but a very small number who count for anything—a handful only.

I will write at length soon—letters are difficult for me—but I will take a time off and say something on the Salon. Remember me to Mrs. and Kitty and to all the crowd. Yes—one can always find the real thing at the Trocadéro. These people had no mean ambition. They created out of spiritual necessity.

Best regards to Miller. I will try and write him. Also Daniel.

M.H.

⌁

n.d [October 26, 1912, Paris] (postcard)

My Dear A.S.,

Your card and the two special numbers are here safely. Thanks exceedingly for them. It is your usual generosity—my friend Arnold Rönnebeck will be delighted when he knows he has a copy of his own. The other I will hold and if I find a really interested one I will place it. Rönnebeck is a fine fellow of excellent breeding and with real promise as a sculptor. His bronze head of me has been spoken of with enthusiasm by strangers and friends alike. I am satisfied well with it as an interpretation of me—and shall own one one day. The art of the casting makes it impossible for Rönnebeck to give me one or I should have had one long ago—but I shall have photos and that will be something. We are together always after work and at meals. I find no one else possible for more than casual words—apparently I am difficult—for I find it difficult myself to be a good fellow among light ones—but I am very happy in the few good friends I have in America and two or so here. It is enough to keep one in countenance with life. I meet all sorts and many are charming but in the last analysis one is alone—and work is the solution.

Thanks so much for the numbers.

M.H.

⌁

n.d. [October 30, 1912, Paris] (postcard)

Dear A.S.,

One of the events of the season to my notion is the superb exhibition of Henri Rousseau at Bernheim-Jeune—such true beauty.[1] I am extremely enthusiastic about these beautiful things—a portrait of a child standing is surely one of the most truly beautiful pictures to be seen anywhere—the show has just come from Berlin. I met a close friend of Rousseau's—Wilhelm Uhde—also knows Halpert and he has written beautifully about him.[2] I am sending his book to you by an American boy who goes to the N.Y. on Nov 23. Uhde has invited me to his house to see more Rousseaus. He owns ten—he says he has also a portrait of Rousseau done by Halpert. But the show is so beautiful. Went to the Cubistes show which closes tomorrow.[3] Will write of this. Jacob Epstein writes that I should go to London to meet Augustus John and others with the idea of exhibiting with them. I must do this.

Best wishes.

*Toujours,*
M.H.

1. The exhibition at Galerie Bernheim-Jeune included twenty-nine paintings by Henri Rousseau (October 28–November 9, 1912).
2. Wilhelm Uhde, *Henri Rousseau* (Paris: Figuière, 1911).
3. The Salon of the Section d'Or was held at the Galerie la Boétie (October 10–30, 1912). It included over 200 works by thirty-two artists often referred to as the Salon Cubists, such as Marcel Duchamp, Gleizes, Gris, Léger, Metzinger, and Picabia, with an apparent absence of Picasso, Braque, and Delaunay. The name, Section d'Or, alludes to the "golden section" because of the artists' popular interests in pictorial perspective, architectural design, geometry, and ideas on the fourth dimension.

∾

n.d. [ca. October 31, 1912]
18 Rue Moulin de Beurre
Paris

My Dear Stieglitz,

I have been trying to write a letter ever since the Salon d'Automne opened but somehow it has not been easy for me. This morning I feel a little under the weather so I think I will give the morning to a letter and store up energy for tomorrow.

I had been extremely eager for this show to come off as I had been given to understand that it is the show of Paris. Naturally then I was given to believe that I might take this as a criterion of what Paris produces—I did not place my expectations too high as no conglomerate show of art can ever produce an even impression. So I went and found what I consider a mediocre presentation—I never had anything give me so great a faith

in myself as this. I never saw any show that so quickly set aside the idea that art springs from any one place or from any given source beyond oneself. I went home not disgusted, but elated—elated with just this idea—that one can dispense once and for all with all dogmas—and all standards—dispense with the idea that art can only come from Paris. Then I went to the exhibition of the Cubistes called the "Section d'Or" which is now on—there again to learn that any man who has anything to say is a free man—and that one can proceed upon whatever basis one wishes without the slightest consideration of individuals or schools—that the artist—the serious person—is at this time utterly a free person—he has but to set up his ideal and work.

The season has opened now somewhat vigorously with the Salon—the Section d'Or—a group show at Manzi, Joyant and Cie of the Bonnard, Vuillard, Roussel clique—including about fifteen Odilon Redons which are for me the only things of character. He is an artist of the very first quality and if he is not vigorous he is so fine and so genuine. But how like gods the others seem—Cézanne, Picasso, and even Matisse who is of all things an artist if not as great as Cézanne or Picasso. I myself turn with eagerness toward everything I can see of Picasso for I find him to be quite the best and most serious producer of the time among the young ones. Of course Renoir is still working but he has found his place long ago and one simply says O yes Renoir. Picasso goes on still with his psychic patterns leading the public nowhere—and only the occasional artist following him—and looking all the while as he passes in the quarter often—so like a splendid amiable boyish man. I shall go to see him soon as Gertrude Stein has offered me a letter to him—and I shall go also to Matisse's as I want to see his Cézanne water-colors and some of his own things too. He has two things at the Salon d'Automne which raise the character of the show highly. Van Dongen has two things—more in a decorative plan—but he falls entirely flat in my estimation—as does every one but Cézanne, Picasso—and a lesser man André Derain who is doing beautiful things which show a fine depth of character and simplicity—in no sense involved in their vision but direct and noble. But still—Picasso—I say Picasso over and over—because in my esteem he has proved himself to be the most gifted in visualizing his sensations of any man at this time. It is the pure artist's vision lofty and profound simple and with a power which produces so directly his every simple concrete or abstract sensations. It is phenomenal in a sense that a man so young can have so deep a psychic insight into things, but after all there is no age to the soul and one may have the wisdom of prophets at any periods if so it exists.

For my own work you will find immense advances there—advances toward direct expression—I work constantly and search for one thing and that is to produce my deepest sensations and organize my vision as much as possible—leaving out all reliance upon the emotional aspects of one's temperament—seeking but one object, real expression. Naturally when some see my work they will say Picasso—well I say it too—but I say it

first with meaning. If in a month or six months time something would say it is all a mistake, well and good—I shall have been faithful to myself and my ideal.

I know mainly this—that the importance of my having come here is incalculable—it has done more for clarity of ideas and sensations than I could have done at home in years. I am glad I did not come before—I am glad I am here now. I have found my place in the art scheme. I would not hesitate to show with any of those who expose here—because if much of this work passes for art—then I could certainly show myself and shall whenever I can and feel like doing so. I am thinking over now a prospect for exhibiting in London in company with men like Augustus John. He is the head of a group of artists there who have a show place of their own and Jacob Epstein the sculptor who spoke to me of it—says they are very successful in all ways. The public go anywhere to see a John—and only those can exhibit with them who are invited. It is an excellent opportunity for an entrée into London and I shall investigate the same. If Epstein remains in London I shall go over soon for a few days and make the important connections. It is essential that I make these efforts for myself for it would certainly benefit all around.

And by the way—do you want to get a superb Picasso etching for 40 francs? I have seen a little beauty at Kahnweiler's galerie—a still-life with many objects in the period just before the abstract pattern things. It is beautifully etched and is very handsome—printed in the center of a large sheet signed in pencil on the border of the plate—with the number of the impression #5 in the lower left hand corner. If I had had any ready money I would have bought it at once on speculation. I almost took it yesterday for you as I know you would love to have it—but I lost my nerve at the last—thinking you might not feel like investing—and I had no money for it myself. It is an opportunity and I hope you can take it. Do let me know at once. A real Picasso of this first water for $8.00—and all the poor etchers that bring such fancy prices!

Anyhow—write when you can—Simonson is here now—on his way to New York—he sails on the 10th of Nov. He is glad to go home for the winter and looks forward to seeing you and Mrs. Meyer and others that he likes. He will tell you something of my work.

Carles came up to the restaurant at lunch yesterday to see if I wanted to send anything home but I didn't have anything. They sail tomorrow for N.Y. He had one of his New York still lifes in the Salon. It looked very badly to me—so thin—one of those with the red bananas he had at the exhibition at 291. The Salon is full of things of similar character—'thin' and with nothing to say. I have written to Steichen to go out to Voulangis with Simonson to spend the day—and expect to be hearing soon. Just now I am busy with drawings—paintings—and preparing etching plates—and I shall get a lithograph stone in my studio soon—as I want to know the process—remembering De Zayas's suggestions—so you see I am working—I think of little else. As I want to make

the most of my stay here. The thing which makes Europe important to an artist is the peculiar state of ferment which exists everywhere—the thing itself lives here and has a being by itself—it doesn't need encouragement as at home and elsewhere.

Anyhow for yourself—keep in peace—never mind the people who disappoint—I know what this is—I have had something of the same thing lately. One must work—and devote one's soul to the thing that is all one can do, and art is like religion, one must be faithful and devoted if one would express something real. I am shutting out all superficial attachments and associations—all ideas except those of the mind and those of the spirit. I find it necessary for me. I find growing in me and I think to more purpose—a recurrence of former religious aspirations—taking a finer form in personal expression—so much for art and idealism.

Best wishes to Mrs. S. and Kitty—to Kerfoot—Lawrence—Haviland—Marin, Walkowitz—De Zayas—and any others who inquire. For yourself always my faith that you will one day find a real recognition for all you have done—it is inevitable—it may not be necessary—one does one's work and that is enough. Faith in oneself and one's ideal are all that is necessary.

Always your friend,
Marsden Hartley

<p style="text-align:center">↗</p>

<p style="text-align:right">November 4, 1912<br>291 Fifth Ave., New York</p>

My dear Hartley:

I have not been well and hence the delay in letting you have enclosed. The draft includes $8.00 for the Picasso etching you speak about in your letter, which I just received and with which I was very happy. I hope that in a couple of days I will be in shape again to write to you myself. Not only have I been under the weather, but much that has been very trying in family affairs outside of "1111" has weighed rather heavily upon me.

Marin has just left me. He has been through a siege of illness again. He requests me to send you his regards.

The Little Gallery is at last being put into shape and if I remain on my feet we will open up with the caricatures of Alfred Frueh about November 15th.[1] Marie is taking this down for me so the typewriting will not be quite as automatic as it would seem.

Always your friend,
[Stieglitz]

1. *Exhibition of Caricatures of Popular American Actors and Actresses by Alfred J. Frueh, of New York* (November 20–December 12, 1912) exhibited forty-nine caricatures at 291.

✦

n.d. [early November, 1912, Paris]

My Dear Stieglitz,

I have been trying for long to write you—there is very much to talk of—and yet somehow it gets difficult for me to get down to writing even though I want to be talking to you. The season has opened with a flush and there is much to see—I only wish you could see the Rousseau exposition. It is too lovely and so timely for me as this man leaves an indelible impression upon me—if there ever was true piety in painting it is in this man. Aside from Renoir and Cézanne there is little else to stir one but Picasso and Rousseau and it is in communion with these spirits that I am working.

Renoir is so lovely at this time—the things he is doing are so simple and so pure and the color so beautiful. He is perhaps at his best in color just now, there is a peculiar youth about it a freshness which only a child would show. Cézanne is always, the ever admirable the austere and the splendid, dignified thing. I am following his water colors with special interest at this time—there is in them a new sense of the universe I believe. Picasso proceeds in his splendid fashion producing always an art product. I believe him to be the first exponent of an absolutely modern expression in art—it is really the first thing in the way of psychic painting and there is here an unlimited opportunity for anyone who is intelligent in these things to evoke—fresh and inviting results. The Cubists likewise proceed—mostly by intellectual processes I think—there is little of the actual intuitive—little of the true art vision. They seem like able demonstrators of a theory with now and then an artistic one among them like Metzinger and also Léger whose quality is finer than that of Fauconnier or Gleizes. There are several new men—Picabia, Juan Gris—Duchamp—who as yet do not show me they are artists. They are all thinkers but art goes only a certain way with the intellect and then it demands the vision. I am working hard and well from the same basic point of view being like them an issue out of Picasso—and yet I believe I shall get—something which is closer to true vision—true art intuition. I am making many many drawings and painting all along and you will see an immense stride toward something much bigger—something which corresponds more to the true mystic in me which is paramount.

I was wholly amazed yesterday afternoon with a call from Arthur B. Davies and Walt Kuhn who as you know are over here getting stuff for the show in February which from all accounts bids fair to be an electric show to America—really most encouraging to us Americans.[1] Kuhn tells me he has Van Goghs from Germany and Holland—Cézannes and Gauguins from Vollard—and they are to have the Cubistes and I suppose Futuristes

as well.[2] I truly believe it will be a most excellent thing—and will wake America up ter-
rifically as the two Grafton shows have aroused the English. Davies spoke very well of
you—said he had received a note with some copies of the special number and asked me
if I thought you would be willing to cooperate and assist them on the show. I told him
he had only to approach you and that I was certain you would do anything that you
could to help perfect the thing. He spoke highly of what you had been doing for art in
America and that perhaps the outside world of art in New York had not always under-
stood. I ventured the assertion that no man could be met and wholly appreciated with
a prefixed prejudice—that if one wants to know and understand any idea any theory or
any man one must meet him or them on absolutely open ground. It is obvious that they
believe in me—and they observe also my unbounded faith in and devotion to you. I use
no trumpets—I make no sounds about these things—if I believe—I believe and my
silences must be my eloquence. I think I have been a medium for real justice toward
you and if I have then I shall know that I have at least performed kind of service for this
fine faith in me which will one day prove itself. I am gaining ground in a way that will
surprise you—merely because the atmosphere here is such that it would clarify any
man's perceptions if he really has them. It takes time—it doesn't happen overnight—
but it does happen and you will find an entirely new quality of expansions, in what I am
doing—an elasticity of sensation which is the result of the freedom which is mine here.

Davies has selected two still-lifes for the exhibition—a large one and a smaller one
of flowers—they show a sense of color which I have not brought out before and he
speaks highly of them.[3] I would not have chosen them myself—chiefly because I am so
interested at this time in the directly abstract thing but Davies says that no American
has done this kind of thing—and they would serve me and the exhibition best at this
time. I am to send six drawings and these will be the abstract thing of the present time
or later after I return from London. I leave next week for a week in London because I
see the importance of taking up Epstein's suggestion to exhibit at the gallery which is
operated by Augustus John and others. I am told it is the best in London—that every-
body goes and that they are very successful financially which God knows is encourag-
ing. If I should have the luck to sell something I could then take the burden of support
on myself which would gratify me highly.

I go on working however not thinking too much about anything else conserving all
my forces for production. Davies assures me that I will "get" London as the Grafton
shows are making all things possible for the young men. And I want also to go to Berlin
the first of January to look into the situation there—I want very much to feel myself
expanding in all directions. It will help me—and be profitable—my sculptor friend is
anxious that I should go and says that I shall have little expense outside of R.R. fares as
his family want to entertain me. This has so many aspects of importance—socially and
in a business way and then I will be seeing the galeries. One might as well believe that

all things can happen to one—for it is with faith that all things come. I only wish now I had struggled to go to Cologne for that was a show that no serious person should have missed—it will never happen again. As it is I have yet to see a real Van Gogh or a Gauguin—but I certainly am enjoying the privileges here. There is certainly something in the air which makes supremely for freedom and art never was in better conditions for real creation in the truest sense.

I go to Stein's frequently and find Miss Stein a truly charming person—a real personality and it is so good to be in that room with such good things. She is very kind to me and seems to understand my silences—for in such a place I don't seem to have any words. Last Saturday night I went with Simonson and Maurer was there. I had not seen him since I came but once. I believe he is to have a show in Philadelphia and will also show some things in the "big event." He had a small still-life in the Salon which I liked very much. I am going soon to his place as I would like to see what he is doing. I don't know of anyone else who is attempting to carry on the Matisse color principle—maybe he would turn out to be it. At all events he is an artist and God knows that is something.

I seem to have written much and nothing. I have tried to give touches of what is going on at this time and will try and do the same from time to time.

I met Delaunay at the Rousseau show and he asked me to go to his house some evening with my friend Rönnebeck—he acting as my interpreter in a sense as I do not feel capable to carry a whole conversation through without help. Delaunay is a charming person and his work is interesting though when I saw it last it didn't seem to be over impelling—but he is most earnest and sincere.

Had the pleasure last week of an afternoon at Wilhelm Uhde's house—to see more Rousseaus on whom he has written a book which I think I may have sent you—if not will do so by Simonson or one other fellow. Uhde has a whole room full of superb Picassos and another of Braque who keeps close to the Picasso system of expression though he varies as naturally two personalities must he being French and Picasso Spanish very different sensations. He also had a number of Herbins which up to now give me nothing—they lack real character and have only a surface and momentary charm and not that for me. I shall get a note from Gertrude Stein to Matisse as I want to see his Cézanne water color in which I see something very very big.

Otherwise nothing. I am eager to know what is coming on at 291—and what is doing. Do give me a breath of the place. It is so much home to me—I miss it always and am eager for its success and welfare.

Tell Halpert if you see him that I am trying to write him but it is very difficult for me to find time. He knows how absorbed one is here in work and in things themselves. He would be happy with the Rousseau show. I saw his portrait of R. at Uhde's and liked it. Uhde is a very refined, an artistic German. Delaunay asks after Halpert and would like to hear from him. Give my love to Mrs. S. and tell her to be patient with me and I will

write. Also my best wishes to everyone—each and all—and always for yourself. I will write you of what happens in London. I look forward to the galleries exceedingly.

Always your friend,
Marsden Hartley

[Bruguière?] comes to see me and he is nice.

1. The show planned for February was The International Exhibition of Modern Art at the Sixty-ninth Infantry Regiment Armory in New York, known most commonly as the Armory Show (February 17–March 15, 1913). Now historic in the annals of American art history, this exhibition was the first large scale presentation of modern art in America. Scaled down versions traveled to The Art Institute of Chicago (March 24–April 15, 1913) and to Copley Hall, Copley Society of Boston (April 28–May 18, 1913). It is noteworthy that Stieglitz during this time mounted a solo exhibition, the only one, of his photographs at 291. Prints from 1892 to 1911, with views of New York, were shown in *Exhibition of Photographs by Alfred Stieglitz, of New York* (February 24–March 15, 1913). For a comprehensive account of the Armory Show, see Milton W. Brown, *The Story of the Armory Show* (New York: Abbeville Press, 1988).
2. The Italian Futurists actually pulled out at the last minute because they were not offered their own exhibition space.
3. Davies selected two still lifes and six drawings for the Armory Show. *Still Life No. 1* is the only work by Hartley specifically identified in the show's catalogue raisonné (Brown, *The Story of the Armory Show,* 273). It is now in the Columbus Museum of Art, Columbus, Ohio (see plate 1).

℘

n.d. [mid-November, 1912, Paris]
Dear Stieglitz,

The bearer of this note and the Rousseau book is [Mordecai Barbour?]—an American fellow who has been with me considerably here. You will find him to be a person of refinement—talking but little yet having that kind of eloquence we both admire. I introduce him because it will be pleasant for him and because he likes '291'—this is surely enough.

Best wishes always to you and to Mrs. S.

*Toujours,*
Marsden Hartley

℘

n.d. [November 20, 1912, London] (postcard)

Dear A.S.,

I have been in London for a few days to look into conditions generally. I will exhibit a little later doubtless at a small but select gallery well known here. I have met the officials of it socially and they are interested in seeing what I have. It has not arrived from Paris yet but may tomorrow. London is huge and most depressing—I don't like it. The Grafton show is most disappointing, after Paris it is nothing really. The British Museum is phenomenal. Such Assyrian and Egyptian wonders. Very thrilling! I go back to Paris tomorrow gladly. Will write more at length from there.

ᕫ

n.d. [November 25, 1912, Paris] (three postcards)

My Dear Stieglitz,

I am back in Paris again and it feels so good—I know now just what I feel toward Paris—it is celestia itself as compared with London. I found London interesting of course as all experience interests me, but I found it also too repellent in its grandeur and over oppressive in its atmosphere. I made my connections socially in London though I did not meet John. He was very busy on a decoration for the coming exhibition of the New English Society of Painters—and saw no one.[1] I did see however many etchings and drawings which showed exceptional skill uncommonly virile for one living in England—but he is Welsh and there's the difference. I was told by the manager of the gallery that I hope to show in—very like "291"—that conditions were very good for young and new artists in London and from all accounts the financial aspects very encouraging—certainly a feature.

My pictures had not arrived there when I left but this was not essential and it was not necessary for me to be present with them so I left because London was so depressing despite the superb things in the British and India Museums—The National—well it is classic and one accepts it entire without demur. I remember a most beautiful Lorenzo di Credi and a glorious profile portrait of a woman in yellow of Piero della Francesca. Then a fine battle piece by Uccello—splendid movement with clear promises of the Cubiste-Futuriste idea in it. Other than these places London is very stodgy. Two so called Post-Impressionists with nothing in them as yet—one placed very near Cézanne—between two Matisses—being a protégé of Roger Fry's.

There is an immense party friction at the present time in London—which I can speak of in a letter. No individualists working. The English are in no sense innovators—the pulse is not a quick one—and the temper is either sentimental or literary but they seem to be open generally for new and personal things. I suppose the Grafton shows have done this.

Anyhow—I spent an afternoon and took tea with the manager of the gallery in question—a person of fine quality with an understanding of artists and the problems generally. He expressed a real interest in seeing my work and spoke freely of the good conditions for new artists in London. I do the rest now by correspondence with them. It feels good to make conditions for oneself as you can understand especially on simple and genuine terms. I leave the work on its own merits which I am certain are creditable after seeing what I saw there—outside of John there is little but academic production. London seemed so full of commerce and suffrage with little to relieve the oppression. I liked the omnibuses however—it is the city for them and in the general teem of them there are pictorial ideas to be expressed. I have things in mind which I shall do.

Best wishes to you—I hope you are better by now. Best wishes also to Mrs. S. and to Marin as well as the others. I am most interested to know the effect of the big Davies show. I have seen him twice—and he is full of enthusiasm for the thing. It promises to resuscitate America.

The new *Camera Work* is here, splendid!! Particularly the literature—Galsworthy is fine and Van Gogh is so good by way of Mrs. Meyer.[2]

M.H.

1. Augustus John was preparing for the 48th Exhibition of the New English Art Club in London at the Royal Society of British Artists (winter 1912–1913).
2. John Galsworthy, "Vague Thoughts on Art," *Camera Work* 40 (October 1912): 17–26 and Agnes Ernst Meyer, "From Van Gogh's Letters," *Camera Work* 40 (October 1912): 37–41.

ᶜᵖ

n.d. [received December 20, 1912, Paris]

My Dear Stieglitz,

There seems to be much I should like to tell you—if I could suddenly walk in upon you in the little place of 'home' I know we would have much to say to each other. Naturally I find much outside myself for stimulation. The progress of the art system here is a constant source of interest—not because it is so great but because the energy itself is so great and so prolific—one feels here always how important really art can be—and is to people in Europe. I feel daily like thanking some unseen deity or other for giving sustenance and a beating pulse to this thing which is so fine and elevating to those who practice it faithfully or those who believe. One learns with ever increasing magnitude what the real significance of this fine thing is which we call art. I am rich naturally in many new and vitalizing sensations which were gathered in London. I suppose there is nothing more wondrous and beautiful than the British Museum—one gets into such close touch with those civilizations which were so prolific in the production of art—the

Egyptians—the Assyrians—the Africans in quality if not quantity. In all these people there was such a need of art—by way of glorifying the specific genius of each either for purposes of religion or for symbolism or pure mysticism. I am sorry to confess that the Greek sculpture left me unmoved, that is in the way I like to be moved—I find too much aestheticism in these 'Elgin' marbles too much of over refinement and sweetness— with the Egyptians and the Assyrians there was a deeper and more satisfying impulse. I am only speaking for myself of course—merely analyzing my own sensations for myself.

And so I came back to Paris with only a great memory of the art I saw—otherwise London left me cold generally. I find it to be a good field to venture into—because there is exceedingly little there to stimulate and edify one truly. The Grafton show which was very disappointing seemed still to be like a fresh and green oasis in the most parched of deserts. The English seem only to be mulling over and over the same senti- mentalities in the mildest variations. The so called Post-Impressionists or the Roger Fry group were anything but refreshing—not to speak of the Camden-Town group which is a collection of decent men—painting oh so discreetly and decently.[1] I can see how Augustus John must have seemed for long to be like a giant from the wilds for at least he lives and has being and paints from a definite connection with life—but there is even a sense of academy in him. Of course I have seen only small paintings and quite a good many drawings and etchings in the house of Mr. Slade a nice young fellow who is well to do and devotes himself mainly to thinking about art managing the family estate and being manager of the Chenil Gallery in Chelsea where I hope to exhibit this winter. He was very nice to me and wanted to see my work. Unfortunately through an error of the Art Co. my pictures did not leave Paris until ten days after I got back so they are now on the way. It was not necessary for me to be there with them however. Jacob Epstein the sculptor very kindly offered to receive them at his place and send them to the gallery after.

They are all in together—John—Epstein—and a few of the younger men. I found them in a direct revolution against the Roger Fry group—Fry it seems has a terrific power for good or evil there and he has been of late a little insulting to John and to Epstein—all of which created manifold complications. I simply have dropped in on London and shall find my own way there without partisanship. The men whom Fry takes trouble to boost would have little show here in Paris for they have only an out- ward and puny semblance to individualism—I am certain they don't comprehend Picasso—not even Cézanne in his highest. Fry seems to talk much of Matisse.

So it goes—anyhow Mr. Slade told me that London was a very good field for good work and that money was spent freely. I shall be interested to know what their impres- sions are. The young men whose work I saw there in the Chenil Gallery were weak solu- tions of John—I don't know what effect I as a stranger will have—it may work two ways. I may find myself in favor with them because I am vigorous and new—with a vastly

different tendency and viewpoint—and then it may work reversely as John seems to have supervision over the Chenil Gallery somewhat. Anyhow—I shall rely upon Mr. Slade to do the right thing and doubtless I will have a show there.

In any case—my stuff is there and a curiosity brewing. They are all still-lifes—the which I have entirely departed from in favor of intuitive abstraction—I am rapidly gaining ground in this variety of expression and find it to be closest to my own temperament and ideals. It is not like anything here—it is not like Picasso—it is not like Kandinsky not like any "Cubism"—it is what I call for want of a better name subliminal or cosmic cubism—it will surprise you. I did these things before I went to London as a result of spiritual illumination and I am convinced that it is my true and real utterance. It combines a varied sense of form with my own sense of color which I believe has never needed stimulation. I am convinced of the Bergson argument in philosophy, that the intuition is the only vehicle for art expression and it is on this basis that I am proceeding. My first impulses came from the mere suggestion of Kandinsky's book *The Spiritual in Art*. Naturally I cannot tell what his theories are completely but the mere title opened up the sensation for me—and from this I proceeded. In Kandinsky's own work I do not find the same convincing beauty as his theories hold—he seems to be a fine theorist first and a good painter after. I have shown the half-dozen things I have on hand of this nature and one German painter from Munich who is working on the musical principle says he thinks I am probably the first to express pure mysticism in this modern tendency.[2] He may be right—I had been convinced that my sensations are a very different thing from those expressed by any others. I am devoting myself assiduously to the cultivation of these experiences as I think I am ripe at this time.

You know Dr. Maurice Bucke in his book on *Cosmic Consciousness* says that these varied illuminations come to the individual between twenty-five and forty—sometimes later.[3] You know what they are for you have them yourself. They are apart from aesthetic vision—they are pure vision itself. You will be highly interested to hear this fine anecdote on Picasso—a conversation held with Wilhelm Uhde at whose house he had been to see his own pictures. He said as follows "you know it is strange—but I understand my own pictures best six months after I have done them—as a human being I am in no way extraordinary—I work merely from intuition." I was very enthusiastic about this as it is proof that he has all along relied first upon his vision as Greco certainly did and upon his talents afterward and the talents have been strengthened and perfected by the vision and not vice versa as is the common belief, so that we are getting purer vision these days than probably ever before.

And by the way I presented Uhde with the extra copy of the special number you sent me and he was very pleased with it and spoke well of its get-up. I thought this would be the best place to open up new channels for the magazine—Uhde was at my friend Rönnebeck's studio yesterday for tea in company with myself and another friend a young

Swiss poet Siegfried Lang who is writing lovely things. I have an autograph copy of his new collection just out—in German—the which I do not read fluently, more than the French—yet my friend Rönnebeck translates well and freely for me many things and so I get something out of it.

I have been thinking lately of Van Gogh and his exceptional color sense—with his intensified vision he would doubtless have done remarkable things under later influences than the Japanese. He was eminently a spiritual being and would have done thrilling things I am certain. I have been thrilled of late with Cézanne water colors—I have discovered for myself in them a new aspect of vision the which I am intensifying in myself in connection with what I want to do. There is a splendid exposition of them at Bernheim-Jeune's, Avenue de l'Opera—many of them being what we had at 291— together with others—forty in all I should say—I think they are his finest expression as pure vision. They have little in them of aesthetics for aesthetics sake—they are registrations of pure sensation out of a peaceful state of mind. Whereas in his large oils there is a great turba which in itself is stimulating. For myself again I call him the first cosmic painter—and what there is in this line will proceed from him largely also—I think he would shudder considerably at all these intellectual cataleptics. They are stimulating in some sense but they don't go much of anywhere. They are all in a bunch here—talking each other to madness—despising each other's work sipping drinks together and smiling like children. I see them often—especially on Tuesday evenings at the Café des Lilas in the quarter where I meet my friends as it is quiet and free from prostitution and art mediocrity.[4]

And so this is what my European experience is doing for me—actually creating me. I am convinced that no one is benefiting more from it than I am doing at this time—I am doing nothing but grow, doing nothing that hinders that growth and I feel like I were a shrub dug out of a dry desert and set to sprouting vigorously with blossomings at every point where the sun enters. I am making every effort by way of concentration and faith toward going to Berlin early in January and if it is in any way possible to come back by way of Munich as I would like to meet Kandinsky and size up the Blaue Reiter group and its activity there. My German friends ask me why I don't exhibit in Munich as they would appreciate what I am doing. I want to do this—and so if conditions and circumstances are right I will do so. It is best to know all things on their own ground and it would be profitable generally for me to see what the opportunities are. All I need is practically the extra railroad fare. If I could make a bit somewhere in London by then the whole thing would be accomplished—I want to do all this and a lot of work by April when I suppose I must go back to America. In some senses I want to—but in the serious all around sense it would be so excellent if I could stay longer. I am so free here and never so full of development. Perhaps a miracle will drop from the skies—however— every day is sufficient unto itself.

I find great stimulation in the fragments of English translations I have of the great German mystic Jacob Boehme about whom I have had an eager curiosity for several years. I have only just succeeded in getting a little in translation as there is very little and in German it is next to impossible to get only to look at in libraries. He is wonderful and greatest of all in his pure mysticism—it is helping me to perfect these ideas I am working on—I only wish you could be here to take a look at them for you would be interested. I am not showing them except to the boys as they come to see me, a group of young and fine Germans some of whom speak English—and with whom I find myself congenial—one a lecturer at the Sorbonne (23 years old) another an etcher etc.

Well here I must close as you will be tired of all this talk and I am fatigued myself. I find work and the constant thought about it quite enough for the energy I have. Give my love to Mrs. S. also to Keiley when you see him—Kerfoot. Kindest regards to Marin—Halpert—Walkowitz—Dove—Haviland—De Zayas all others—Mrs. Meyer—Simonson, Miss Rhoades—Miss Beckett—quite a fine collection after all. For yourself always the same esteem and devotion. I look forward always to any word from you as you give me the only real sense of home I have otherwise I would be houseless spiritually speaking.

O yes I have the Picasso etching here in my studio now and it is lovely. You will be so glad to have it and I am enjoying it meanwhile. I suppose Davies is at home by now and will doubtless drop in on you sooner or later. They had fine success in getting things for the mammoth show. Picasso has a big show in Munich in February.[5] I might get to see it if I can manage it. You might send me Frank Eugene's address there so that if I go he could help me make connections etc. and I would like to meet him naturally.[6]

Love and best wishes for a happy Christmas and a splendid New Year.

Always your friend,
Marsden Hartley

I do wish somebody would buy a still life or two of mine so I could have a pot for travel. 75 or 100—would do wonders.

Took Thanksgiving dinner with the Steichens at Voulangis. It was so nice and the children so lovely. All are well and happy—Mary talkative and Kate so still both so lovely and amusing.

1. The Camden-Town group, an exhibiting society in London, employed styles reminiscent of Post-Impressionism and Impressionism in their paintings of genre scenes and landscapes.
2. Marc and Auguste Macke are known to have been in Paris in October 1912 to meet with Delaunay. Hartley may be referring here to Macke because Macke was painting works with musical associations at this time, especially since he mentions this in the context of Kandinsky; Macke was an artist of the Blaue Reiter circle (Levin, "Marsden Hartley and the European Avant-Garde," 159).
3. Richard Maurice Bucke, *Cosmic Consciousness: A Study in the Evolution of the Human Mind* (Philadelphia: Innes and Sons, 1901).

4. Hartley is referring to Paul Fort's Tuesday evening gatherings of writers and artists at the Closerie des Lilas café on the Boulevard du Montparnasse.

5. In late February 1913, the Moderne Galerie of Heinrich Thannhauser in Munich hosted the first large retrospective of Picasso in Germany with seventy-six paintings and thirty-eight works on paper (William Rubin, *Picasso and Braque: Pioneering Cubism* [New York: Museum of Modern Art, 1989], 414).

6. Stieglitz's friend and colleague, photographer Frank Eugene, had been living in Munich since 1907 teaching portrait photography at the Institute of Photography in Munich-Schwabing.

1913

<p style="text-align: right;">n.d. [January 14, 1913, Berlin] (postcard)</p>

Dear A.S.,

I can only write a card at this time to say that I have been in Berlin a week now and like it exceedingly. I am sure it is an interesting place to live in—I like its ultra-modernity and I like the calmness of the people. It is so refreshing after the unceasing gesture of the French—and one sees such fine types all about—a fine extravagance of physical splendour. I think nature is especially interested in her German product. The general type is so well formed and equipped with energy—there is here a fine creative tendency in the race. None of the sickliness of the French—it would seem as if there would soon be no French if appearances count for anything. There seems to be a very encouraging trend toward modernity in art here. I came too late for the two secessions—new and old—have seen only one show at the New Secession by Münter which argued nothing of moment.[1] I believe they open a show of Delaunay the French Cubiste the last of the week.[2] I go next Monday with my sculptor friend Rönnebeck to Munich where I hope to see something. Paris will look grey and sickly after all this well-keptness and healthful system. I have seen the museums and they are good—a wonderful lot of primitive art—much more than at either the Trocadéro or the British Museum. The National Museum is full of awful Feuerbachs and Böcklins which shock one with their mediocrity—several fine Cézannes and Renoirs saw this show—fine Cézannes at Cassirer.[3] Berlin must really be beautiful in summer. I want to live here sometime—I like the keynote.

Best wishes to all,
M.H.

1. Hartley means Herwath Walden's gallery Der Sturm in Berlin. Championing modern art in Germany, Walden presented exhibitions of work by the Blaue Reiter, modern French painting, the Italian Futurists and the Russian Constructivists. Hartley makes a sweeping reference here by calling Walden's gallery the "New Secession." In fact, an exhibition of The New Secession was held at Der Sturm in December 1912, and following this was a retrospective of eighty-four paintings by Gabriele Münter in January 1913 (Nell Walden and Lothar Schreyer, *Der Sturm: Ein Erinnerungsbuch an Herwath Walden und die Künstler aus dem Sturmkreis* [Baden-Baden: Woldemar Klein Verlag, 1954], 257–58). The "old" secession to which Hartley refers probably is the Jury Free Art Show (Juryfreie Kunstschau) held in Berlin from November 26–December 31, 1912, which he also arrived too late to see. This exhibition included work by Braque, Léger, Picasso, Gris, Othon Friesz and others. For a complete list of artists in the Juryfreie Kunstschau, see Gordon, *Modern Art Exhibitions, 1900–1916*, 2: 638–40.

2. Delaunay's paintings were exhibited at Der Sturm with the Italian Futurist painter, Ardengo Soffici (late January–February 1913). See Walden and Schreyer, *Der Sturm*, 258.

3. The gallery of Paul Cassirer showed paintings by Cézanne, Renoir, Degas, Gauguin, Manet, van Gogh and others in January 1913.

✧

n.d. [February 1, 1913, Paris] (postcard)

My Dear Stieglitz,

I returned from Germany nearly a week ago and have started a letter to you but I have so much to tell that I cannot finish the same at once so I send a card. I cannot esti-mate to you the worth of this German trip—it has given me my place in the art move-ment in Europe—I find in this my really creative period. I have something personal to say and that no one is saying just this thing—it all 'comes' out of a new growth in my life—a culmination of inward desires of long standing. I went with my friend to see Kandinsky whom I found to be a splendid man with a fine mind and a most generous and constructive attitude toward art.[1] He asked to exchange photographs of his work and mine with me and wants to see my work. I am making arrangements now to send some things to the Goltz Galerie—Neue Kunst—through Eugene. I found also that I had a reputation in Munich already through a woman from Stuttgart who had been to New York at "291"—so much for the work there. I shall go to Germany as soon as I can make arrangements—to live and work there for a time. It is more constructive and I am so weary of this French *verbosité*. Will send the letter shortly.

Best wishes to you and Mrs. and all,
Marsden Hartley

1. For an interesting compilation of correspondence from Hartley to Kandinsky and Marc which com-plements some of the letters published here about these artists, see Patricia McDonnell, ed., "Mars-den Hartley's Letters to Franz Marc and Wassily Kandinsky, 1913–1914," *Archives of American Art Journal* 29 (1989): 35–44.

✧

n.d. [February, 1913]
18 Rue Moulin de Beurre
Paris

My Dear Stieglitz,

I started over a week ago to write to you of the great significance of my German trip but I have had numerous interruptions—so I start again today—to disclose to you the

beautiful surprises that awaited me there—chiefly from the professional point of view. As I have told you on cards of how I like Berlin as a city—without question the finest modern city in Europe. I found likewise so much in Munich that I was not looking for— surprises that became at once the best of good fortune for me—for it was during the five days in Munich that I found my place in the art circles of Europe.

In the first place—I went to see Eugene—and he asked me if there was anyone special I wished to meet—and I said yes—I know of one man whom I want much to meet— Kandinsky—E. said—well we will go to my friend Erbslöh the painter for he knows him—and so we went—found Erbslöh fine—after a short visit in his elegant apartments on the Ohmstrasse in Schwabing—we went upstairs to his atelier—and while there he said let me ask which one of you is Mr. Hartley and on my reply he said—"you are famous in Munich." I said oh no it cannot be—you have made a mistake in the name—he said "Oh no you are Marsden Hartley—and we were made familiar with you by a woman from Stuttgart who had been in New York and seen your exhibition and she told Franz Marc all about you." Marc is the man who arranged the Blaue Reiter with Kandinsky and paints splendid things.

This happened to me first off. Erbslöh said Kandinsky was in Russia so I thought my chief reason for going to Munich was of no avail—but my friend Rönnebeck and myself went to Goltz's galerie and he told us K. had returned gave us his address and said we would find him very nice and kind and interesting—so we therefore wrote K. and on the following day went to his place and spent a long and most interesting hour with him and Fraulein Münter who has a studio with him—she also paints well. Kandinsky asked if I was a painter and my friend Rönnebeck proceeded to describe to him the nature of my new work and he evinced a great interest and asked to exchange photos of work with me—and wished to see the work.

I likewise met some literary people in the Stefan George circle who had heard of the nature of my work and they expressed great interest in seeing it and asked if I would not be exhibiting in Munich soon—so here at once I found a direct connection for my ideas and I am sending three or four of the new things to Goltz in Munich just as soon as Eugene writes me that he has seen Goltz personally to tell him that I am sending things. This you will observe is a perfect creative condition and it is with these men that I will find my place in the European scheme and it is to Germany that I will go after Paris because I found conditions so agreeable all around—good friends—great activity of life—everything so clean and healthy after the awful filth of Paris—and such nourishing food the which I haven't had since I came to Paris. I have managed to keep from being ill—though I have had some mean spells—but the conditions of Paris for living are about as bad as they could be.

Anyhow as I think over my experiences, it is with Germans I have always found myself—both in New York and in Paris—and now it is in Germany that I find my creative

conditions—and it is there that I must go. You would like Kandinsky very much I know—I have never been in the presence of an artist like him—so free of convention with a hatred of all the traditions that cling to art—bohemianism—uncleanness—lack of mental order—this chaos which makes Paris so charming to those who love looseness. For myself I am weary of it—I am in no sense a bohemian—I have not the slightest characteristic. It is why I have so little in common with what is Parisian in this sense—Paris itself is a lovely place to come to—but it is so fearfully over-ridden with art cults who do little else but feed on each other. For myself naturally I do not under rate this Parisian experience—it has freed me intellectually and spiritually—I have discovered my essential self here—but this has been due to nothing or no one but myself. The sources that have helped me to my newest means of expression are without geography—it is a universal essence—I came to it by way of James's pragmatism—slight touches of Bergson—and directly through the fragments of mysticism that I have found out of Boehme—Eckhardt, Tauler—Suso—and Ruysbroeck and the Bhagavad-Gita. This has brought me to my present means of expression which in its essence is absolutely as near to myself as I have ever gone. I have felt this great necessity in painting of leaving objective things—and after a summer of still-life I found myself going into the subjective studying Picasso closely finding a great revelation in the Cézanne water-colors—a peculiar psychic revelation to my notion—that is a purely spiritual rendering of forms in space—and from this artistically I proceeded and out of the heat of the reading which for years I have wanted to get I started to work—and here I have a series of canvases nearly fifteen 30 x 40—which those who have seen them say is the first expression of mysticism in modern art. So far as I can learn no one has presented just this aspect in the modern tendency—Kandinsky is theosophic—Marc is extremely psychic in his rendering of the soul life of animals. It is this which constitutes the most modern tendency which without knowing until I had been to Munich—I find myself directly associated—and it is there that I shall find my immediate success—for not only is there a new public in Europe for these things—there is likewise the new dealer who knows how to present them and the new collector who understands them. The result is that they are all highly successful financially—Picasso—Matisse—Kandinsky and Kandinsky especially—the more remarkable since he is probably the most abstract. Goltz, the dealer in Munich tells us that he is successful and sells rapidly—and of course there is all Europe to choose from—this also has its deep significance. I would find my work in due time going to Russia—to Holland—where the most is bought and I would be taking my place among the European moderns. This is inevitable—it has been established already—Kandinsky has about him practically all the modern culture of Europe—Schoenberg in the new music and it is certainly new from the little I have heard—deeper than anything in the way of new experience in music—and I would find all these connections immensely valuable at this time—and strangely enough it is Munich which is the hotbed of ultra-modern art.

I saw Franz Marc's show at the Thannhauser Galerie and it was most interesting—a new sense of life—I am very sorry that Kuhn did not get something of his for the show and more of Kandinsky but K. was not in Munich at the time he told us and knew nothing until after. I am sorry for the sake of the idea as the new German tendency is a force to be reckoned with—to my own taste far more earnest and effective than the French intellectual movements—Picasso is still the only force of movement here in these sensations. I find Matisse very good—certainly a fine artist—one whose product wears well—and has character—but I like Picasso because he remains true to the intuitive processes which are the most creative naturally. I know now that what I see in his work is a pure rendering of thought forms as they present themselves to him and with them he creates a consistent harmony. Leo Stein says it's not art—but metaphysics just as he says of his sister's writing that it is not literature—but fortunately for the world art is the freest of elements—and wanders whither it will—into all spheres and domains—but nevertheless is master of itself and remains true to itself everywhere.

I am just as certain as I can be that if Van Gogh had lived and continued painting he would have become one of the first psychic painters of the time—as in spite of his assertion that he was a naturalist he was still more the visionary and it is precisely this visionary quality that gives his canvases their beauty and not their painting or their ideas—just as I am convinced that Cézanne would have gone into higher ethers and attempted to render the cosmos. These are my own personal deductions and are derived from nobody—I feel these ideas as truths for myself. For Van Gogh when he painted flowers or fruits or mountains or people—had only the universal in mind—so also Cézanne—when he painted fruits and flowers and people and trees—left upon them a wondrous big sense of the cosmos which overrides any aesthetic perfection as defect in them. It is the vision in them all which is the art—just as in all great art it is the vision—just as in Rousseau it was his vision. I see a kind of vision likewise in Picasso as in Matisse. I see perfectly logical sense of the effect of color on color—I know it to exist in Kandinsky—I know it is the primal motive of Marc—and I know as you know too—that it is the motive of my own intuition—until now I have only had the opportunity of giving the hint in the work at home. Here it has blossomed out in the last two months as a direct departure from all aesthetic desires into the desires of the spiritual—the result some say is a new sense of art—and without conceit I am willing to believe it—for I do not trouble myself with common egoisms. I simply have the one object in life and this is to attend wholly to the dictations of the ideas that come to me through inner personal experience—for when a spiritual idea presents itself—it is of much more importance in its first state than afterward when if allowed—the intellect dictates. Just as Odilon Redon writes in his beautiful *Confidences d'artiste*—"I have made an art after myself."[1] I was going to quote you some of his sweet thoughts but I have mislaid them. In any case he has all his life followed the vision as it came from his soul—and his product has been a most beautiful spiritual thing—one of the

loveliest figures in all art and so refreshing here after the floods of rubbish one sees—utterly devoid of earnestness and no art at all.

This is one of the things against Paris—there is too much art here—I came too late ever to be affected by the tradition—I have remained ever since I came the observer on the outside of all movements and it has been a happy and sober position for me. It has left me free of ambition and free of prejudice in the large sense. I have learned that what I came for is not to find art but to find myself and this I have done and I want to go somewhere away from the art whirl and produce myself—and in Germany I find the creative condition and it is there that I must go. It is essential to productivity—I am not ready to go to America for this—the condition is not right for me—and besides it is too negative as yet as after all these discoveries which are so beneficial it would be destructive to go there at this time. It affects in no way my ideas as what I have to say is not local or material—I could never be French—I could never become German—I shall always remain the American—the essence which is in me is American mysticism just as Davies declared it when he saw those first landscapes—they were so expressive of my nature—and it is the same element that I am returning to now with a tremendous increase of power through experience. I know Davies said to me here that he hoped I would not find it necessary to live always in Europe. I told him that I would not—also that what I have to say can be affected by no one—and it has no relationship to cults or individual systems—of course when he was here—the only thing he saw were the still-lifes and two other paintings which were progressing under the Picasso principle—but you will observe in the drawings of mine at the big show in New York an attempt to get my own rhythms and in several I succeeded well—from these drawings I have proceeded into my present and future state which is still closer to vision and creation.

It was Davies who chose the still-lifes—he said—you can send whatever you like but I would advise sending these two—as I think it would do you good to send them and there will be nothing just like them. I had a feeling that "do you good" meant being good for me financially—which is most necessary. I am rather hoping—counting in a way on a sale of one of these two pictures through Davies. I have even thought of writing him—touching on the subject as I know he knows one or two who believe in me and I would like him to know of the conditions in Germany which they missed. He would I know like the work of Marc and Kandinsky—Marc especially which is close to his own thought without the literary tendency.

Anyhow I am living entirely by faith these days as only a confident person can—I know (by faith) that when April comes and I must move out of this atelier—that it will be right for me to move to Germany and take up my position in the ranks there and that I shall win a place at once through Kandinsky and Marc who are probably the most constructive element in modern art. And by another year or part of a year I shall have produced enough work to appear well in the art centers of Europe and go to America

equipped with the knowledge of what I wish to do and can meet the negative conditions there in a more fortified way. I feel so much the importance of this immediate move to Germany that I do not allow myself to create negative conditions—of course if it were absolutely necessary that I return to New York in April I would have to do so—but it would be so destructive—killing so much time and energy when for months I could do nothing.

However apart from faith, it is necessary for me to know facts by April 1st. On a second thought I think I will write to Davies and see if he can't raise money for me by selling the large canvas of mine there—I priced it at $600—but naturally I would take much less for it if necessary. I have heard nothing from London either. I think I will likewise write over to Mr. Slade who is connected with the Chenil Gallery and who was so nice to me and see if he can't do something. I know there is a creative condition somewhere and I want so much to affect it—so that I can proceed to develop in the clear atmosphere of Germany which is so well prepared to receive me.

Now I have a letter from Eugene today in which he says that Goltz was out of Munich when he went to see him but that he knows he will be glad to show my work and that he has told a number of his friends about my work and they all want to see it. So I am getting four of the large canvases ready and perhaps several of the small ones and these I will send to Munich.

So it is—I give you in a fragmentary way an idea of the success that has come to me over here—there is but one thing necessary and that is to follow it up by working where the conditions are the most creative. As to the practical issues the cost of moving to Berlin is so slight as compared to going home to New York and studios are cheap there— and life itself offers enough there to make it agreeable—as after I have worked I must find some kind of simple diversion and one has so much there for lustre—there is a spirit of natural gaiety in German life itself whereas if you don't want the exotic kind of thing in Paris there is nothing. I suppose I have never been so bored in my life as here in Paris in the evening—the cafés are so dull and most of them so filthy and after the cleanliness of Berlin—nothing is possible in Paris. Etc.

So I am leaving the conditions—and the final results to something beyond myself. I drew a strong lesson from one of your letters where you said—"don't trouble over the future or the past—but work" and likewise Davies when he was here—and I was troubled about the financial uncertainties as is usual—he said "one must always have faith." These two advices seemed enough and I have lived on them. I thought for months and believed so strongly in the possible benefits of the German trip without knowing anything—knowing that somehow I should get there—and it happened so wondrously—and benefited me without doubt more than anything else in all my career. For this—my unceasing gratitude to Haviland—if letters were not so difficult for me I would try and write him a letter—but as we are all of us after all a kind of

spiritual family—working together with a common bond—I know that it will mean the same if I express my thanks through you.[2] Naturally I write you first—I have so often wished that we could be together here—it would be so splendid if while I were in Germany you would be coming.

Anyhow—I have only the highest and strongest faith that when April comes—fortune will find it expedient to transplant me over into the nourishing conditions of Germany and that I can proceed to establish myself in the field in which I have entered so well. I know that as soon as the Munich people see the pictures I shall have letters or words from them—Kandinsky especially as I know that what I have to express coincides perfectly with his notion of *das Geistige in der Kunst*.

I can only ask you to concentrate for me on the financial conditions as in this phase of the work I am still helpless though I find more promise than ever before for helping myself. If I could sell the large still life I sent to New York for $500—I would be willing even some less for the sake of creating a pot of money to start in on the new field. I shall have no great expense getting to Berlin as the railway fare is very little—and then I am there ready to begin. My German friends will help me to get an atelier as they are not hard to get and cheap—in a very central location near the Zoologischer Garten—Kurfürstendamm. I found so much in Berlin that was agreeable the fine climate—the good food—the clean conditions and the wondrous love of stillness. There is probably no city which has done more to suppress ugliness than Berlin. Ugliness in the way of unnecessary noise and undue congestion. It is large—and intimate without being village-like as Paris is—which is but a series of villages one next the other—quartiers—and how noisy and restless they are—always talking—arguing over nothing—multiplying pretty phrases to no purposes.

I do not criticise the French genius—I only criticize the French character and habit. It has not been my fortune to meet what I would consider a really cultured French person—one seldom meets anyone in fact—but the concierges—the garçons and the petite *marchands*—and one can hardly take these bourgeoisie as representative. However there is a grace to the French sense—and if it is not a vigorous and sturdy thing—it is delicate and amusing. But I am inclined always to want hardiness and fineness of inner-character and if the Germans and the Americans have not always the finesse they surely have the more durable and abiding qualities and at their best they are splendid races—and for the present I find the quiet conservatism of the German refreshing in lieu of the French restlessness and in the American what William James classifies as bottled lightening.

So then I close after this most lengthy epistle—knowing that things will happen right with me and that I can still look for your personal co-operation to affect conditions somehow—and the co-operation likewise of others who believe in what I want to do and who know also that actually I want nothing for myself but to perfect that thing

which I know will one day count well in the universal scheme as it is counting well in lesser degrees at this time.

In any case I must make positive and definite plans for exit from this studio April 1st and then I am on the air again. I would like to see myself free for at least another six months so that by next October or November—I would have worked sufficiently to produce work enough to get myself out among the others in Berlin—in Munich and go to the other exhibitions that will occur in Amsterdam—and doubtless in Russia as these things are wondrously organized among the ultra modern dealers.

I am so glad to hear about Marin's fine show.[3] I know it would be fine. He is for me alone in the field of water color—not Whistler—not Turner excels him—I think of only one other man Dodge Macknight—of Boston—but he does not produce this quality which in Marin is more melodic and spiritual. Give him my best wishes and congratulations—I am late I know—but not too late. Doubtless before this you will have had Steichen with you. In a way I envied him seeing you all at 291 and 1111—I miss these home places more than you would think. There is absolutely nothing in all Europe like 291 nothing of its fineness and sincerity. You would be a great event in Europe if you ever wanted to come over.

And now as you get this the big "wild west" show will be on.[4] I tremble with fear for the methods they employ—but I do have faith in the effect—partially in any event. It cannot help but prove something of an earthquake to the sleeping villages. I hear somehow that Davidson is to have many things in the show which proves his cleverness again. This type of American artist over here is certainly a common lot. I see them most every day and have nothing to do with them. I don't know if Mrs. Whitney cares in the slightest what her protégés do with their money but surely $25.00 a week is a splendid income to play billiards and poker on—and they do little else.[5] I wish someone would come along with this sort of freedom for me for two years. I would show how one can live and work on it. They are a sorry lot and will inevitably come to nothing.

Anyhow give my love to Mrs. S. and Kitty and best wishes to Steichen—Kerfoot—De Zayas—Haviland, Marin—Lawrence—Miss Beckett and Miss Rhoades—to Simonson and ask him why he doesn't write me. I haven't had a letter from him since he went home—and I must know some things soon. He should be coming back in March or April—as his studio lease is up. I think he intends coming then anyway. Best wishes likewise to Mr. and Mrs. Meyer and to anyone who knows me and would like to hear. Walkowitz and Halpert if he still comes around. For yourself always my deep gratitude and best wishes. Keep up your faith always in the little place—and draw together all you can the constructive elements around you leaving the others to go at will. I think you can't always know the big things you have done and are doing—it is not necessary to a creator to know how much he creates—it is the quality only that he must have care for—and you will always count yourself as among the best and truest creators.

I will write soon again when I have more to tell of importance. I proceed at once to place myself among the German mystics and am happy in the same.

Always your friend,
Marsden Hartley

1. Hartley refers to an autobiographical text by Odilon Redon that appeared in 1909 as "Confidences d'artiste." Translated as "Confessions of an Artist," the text begins with the statement "I have made an art according to myself." Redon's autobiography was later published under the title, *A Soi-même, journal, 1867–1915: Notes sur la vie, l'art et les artistes* (Paris, 1922; reprint, 1961). For a translated publication, see Odilon Redon, trans. Mira Jacob and Jeanne L. Wasserman, *To Myself* (New York: George Braziller, 1986), 7.
2. Paul Haviland gave money through Stieglitz for Hartley's trip to Berlin (Homer, *Alfred Stieglitz*, 287n. 103). Haviland had a history of helping with matters related to 291. In early 1908 Stieglitz was about to lose the lease for his gallery and he gave $1500 to guarantee another for the space directly across the hall. Interestingly, this was actually in the adjacent building at 293 Fifth Avenue, but entered through 291. For further discussion about Haviland's contributions, see Sue Davidson Lowe, *Stieglitz: A Memoir/Biography* (New York: Farrar Straus Giroux, 1983), 137. See also Homer, *Alfred Stieglitz*, 46.
3. *Exhibition of Water-Colors–New York, Berkshire and Adirondack Series–and Oils by John Marin, of New York* (January 20–February 15, 1913).
4. He means the Armory Show.
5. Gertrude Vanderbilt Whitney, a wealthy patron of the arts, supported Jo Davidson, Andrew Dasburg, Morgan Russell as well as other American artists living and working in Paris during this period.

✑

March 4, 1913
[291 Fifth Ave., New York]

My dear Hartley:

I have started several letters to you and torn them up. I simply cannot get a moment for myself. You have no idea what is going on at New York. "291" is still the storm center in spite of the Big Show. I am determined to write to you soon. I know I will create an opening. Enclosed find draft for March. I do not know whether you have written to Davies about yourself or not. I have been so bound to "291" that I have not seen him in ten days. He too is tied hands and feet. I am going to see him tomorrow and see if he has heard from you. I want you to stay in Europe until autumn. It is solely a question of how to raise the cash. I had hoped last autumn when I guaranteed you a stay until this April that somebody would be forthcoming to help make my promise go. The main thing is you have had your stay. I shall see to it that you get your few months in Germany. How I really don't know. I had been virtually promised not directly, a certain

amount for the Secession. This amount, which in itself was minimum, one third in actual cash. Of course I make it very difficult for people to do anything for "291" because I feel that the thing should be done spontaneously. And there seem to be but few in this city who feel, or rather who know how to do this thing. You shall hear from me within a week. So be ready to move from Paris to Berlin by April first. This is sent to you in all haste so as to catch the *Mauretania*. Steichen leaves with her. If you can manage to see him before you leave Paris, he can give you some idea of what is going on over here.

I am forced to dictate this letter and I know you will understand.

[Stieglitz]

∽

March 13, 1913
Thursday
Paris

My Dear Stieglitz,

I have your letter this morning with enclosed draft. My profound thanks for the same. I have naturally understood all along that you were busy and I know just what it all means anyhow—and explanations would not be necessary. For myself I have likewise been busy, living more to myself than ever before in my life—being as far removed from all that pertains to Paris and all outside influences—apart from one or two friends, whom I see daily and Gertrude Stein whom I have enjoyed of late—I have had no outer events. I work continually having intermittent spells of fatigue—but working always from the one point of view which I have chosen for myself—namely the mystical element from which point of view I believe I have something to say. Lately some of the people here have heard of what I am doing—Delaunay for instance—and Gertrude Stein is to come next week. I would not have thought of asking them to come—it would be quite natural for me not to—but since they have asked I shall of course show them—apparently it is more or less phenomenal in Paris—for one not to show—but after all what does it matter—those who really need to see a thing get to see it and the general public sees sooner or later—the important thing is to get the work done. I have made the proper connections.

Anyhow—coming in close touch with those whom I know will understand—will get the point of view—some will say it's not art—but they say that of Picasso too—but it will always be that way—the groups gather—and the individuals separate—this is the law of entities anyhow—elements separate from elements and recreate themselves and are a law unto themselves.

So it is that jealousies and hatreds arise and Paris is full of hatreds and jealousies—but the individuals go alone—just as Cézanne went alone—Renoir was alone—Redon likewise—Picasso and Matisse—they go alone—and so it is sooner or later each man must go alone and in the wilderness of himself find his own depth and height. This is the road I am on—I am learning a language which is being given me to learn—and I must learn it alone—*einsam mit den Einsamen* the German mystic Eckhardt calls it—this is what it comes to. So it is that there will be inspiration in every source of life and nature—and art will go where it pleases as I have said before—and will remain itself in spite of all outward demands—just as with Schoenberg music is going into deeper chambers of the self—so will art go—and literature go and there will be no one to command or withhold—and like all natural growth it wanders where it thrives best and schools have nothing to contribute. So it is Gertrude Stein digs up new depths in words—Picasso makes form and color say new things—Kandinsky finds new significance in the relation of arts—Marc finds something to say for the interior nature of animals which has not been said in this time—and so on—artists are being shuffled off on to themselves.

I had a nice letter from Marc yesterday—asking me to call on him when I go to Munich on my way to Berlin which I must do to be present when my pictures appear next month. I am sending on six or eight of them to the newest galerie in Munich—Galerie Goltz—it is the storm center of Germany at this time—the German equivalent for 291. You will find it amusing if I have not already told you—that Goltz said he had to remove a picture from his window because the public were so excited with laughter. All this seems singular and yet it proves that even Europe does not get everything though it does travel with a terrific rate. It is the same always—all new ideas must wait.

Naturally I am anxious to hear something of the influence of the "big show" on the New Yorkers. It can't help but have made some change in the general attitude—even if only among the artists it shows them their own hypocrisy and their commercialism. It is not an easy thing to refrain from popularity and success and social position—and in New York especially where so much is required to be anything in the social game. That is the fine thing about Europe—a man gains his place at once by his own personal gifts and by his talents and nothing is asked of him but these—not quantity either—but quality. They know in the case of art when a thing has a personal power and that is the one thing they ask for—but I'm afraid the American public will be skeptical of all things for long to come. Still I do believe this exhibition will have had the effect of at least loosening up the minds of everybody to the point where they must realize that they must accept Europe still as an art producing center—until such time as all nations have learned to produce art and artists of their own. This is the attractive feature of life over here—they travel rapidly with new ideas and are not afraid to stand by them and there are new searchers springing up everywhere—chiefly in Paris and Germany—of course—

the creative Germans are remaining at home—and after all anyhow—the thing is—that the more interior an art it is the less national it is—it becomes universal because it goes into universal ideas.

Picasso is less Spanish than he ever was. In his earlier things of course he showed the Spanish temper but he has put aside all emotional expression for deeper sensations—and Cézanne at his profoundest could have been anything but French. These things depart from racial into universal qualities. As for the smaller people the Cubistes, the Futuristes—they remain minor in their essences because they prefer the exploitation of the ego instead of something larger and more impressive.

Delaunay is a type of this thing—the ego-mania which expresses itself more fanatically in Weber. Delaunay spends most of his time talking about Delaunay and his gifts. I went to his place on Sunday last at his request with my German friend—and there we saw a huge canvas with much sky—part of the Ferris wheel—the Eiffel Tower—some football players—life size—at the left a little above the center—the word "Astra"—two feet high—the name of some aero co. and to the right over a foot high in vermillion letters on an emerald green ground—the name "Delaunay-Paris"—surely a perfect confession of ego-mania—that after the discoveries of the times—the wheel—the Eiffel Tower—the aéroplane—the world must next look at the name Delaunay.[1] And he said to my friend "Ah it's a long time since the blue sky has been painted." He left us both speechless with his talk among other things that Bergson's system was "blague" and so on. He is entirely typical of these Frenchmen who spend their time stabbing each other in the back—the place is full of factions and cloques—each with its group of daguers.

In the meanwhile—Picasso says not a word—Matisse remains alone—and Delaunay spends his time sneering at Picasso and smiling at Delaunay. I know when he comes to see my things he will say *pourquoi*? But I don't care at all—I am going where the elements I seek are in their right place. There is no place for a mystic in Paris—the life is too overwrought sensually and intellectually and France has never been famous for its mystics anyhow. They have produced very little of this quality in anything—but they love to play Beethoven and Brahms and play it badly too because they have no depth for it. They must always be well credited however for the sensibility to art. It does grow here. If they were as strong in every way as they are in their understanding of art they would be greater—but one feels the thinness of them—the over refinement so keenly.

However—as to my own intentions—I only know that my German move is the wisest thing I can do at this period. I shall be dropping into conditions which will be more helpful all around—bodily health especially which is most difficult to maintain in Paris. I can understand why De Zayas could not endure—I have managed to keep from being

ill—but one sacrifices much here—especially the food question is so troublesome whereas all the food anywhere in Germany is made for energetic human beings with bodies alive.

I know I shall get much out of the life there—a stronger sense of design and decoration is existent in the life. Paris and its life is preeminently tonal—the German element is distinctly structural—they have an architectural structure for ideas—the atmosphere itself is so much more creative, a sense of pushing forward and not a leaning backward on past splendour as in France. It is the kings and cathedrals of France which give it its living character—and one can't live forever on what was—one must look to what is and what is to come.

As to the matter of writing Davies—when I wrote you I had every intention of doing it—but it seemed so unfair in a way to attack him immediately with the needs of one person with such a monstrous business on his hands. I think now of writing him—and I do hope you have by this time conferred with him on the matter. It means so much for me and as you can see I am quite helpless. I want to push through the plans I have until October or November and then go home to New York with my things. I shall then have gotten well into the channels I am working in and would feel free which could not naturally be at this time.

I have had a very nice letter from Mr. Slade of the Chenil Galleries in London—which was in no way negative—and I know him well enough to speak frankly on matters he knows what an artist has to go through—and I know if I press matters a little more he will see what can be done tangibly. If you see the slightest chance in New York for selling the large still life—of course take what you can get—I would like to get $500—together at once somehow so that I can proceed without relying upon you so much—this you know—I need not dilate or attempt to express thanks. It all seems way beyond mere thanks and kindnesses with us. I only know that I shall have verified any confidence that has been placed in me—because I am coming to my own in the scheme here—which certainly is worth all the effort that has been made for it. I have canvases here 20 of them—large—which show that I have gone into a new sphere and attempted to express what came to me from it. I know that as soon as I get them to Munich they will find their place at once in the movement there—as being a natural expression in that movement—this is sufficient—all I have to do is proceed with my researches quietly and I shall come to my place. I have an audience at once in Munich of Kandinsky and Marc for artists—and a group of literary people some of whom belong to the Stefan George circle—all with an understanding of this esoteric etc.

So with this I leave you for the time being. I shall not leave Paris before the 15th or 20th of April as it is not possible with what I have to do—and I have learned from Simonson that his lease of the studio isn't up until June 1st and he himself doesn't

return until that time so I have more freedom than I expected. I have some work I wish to get done before breaking away for Germany—after that I shall be more free for the task of packing up. I go to Munich for some days to get a better connection with Kandinsky and visit Marc—meet the literary people—the poet Wolfskehl—Frau and Herr Petersen—and others—also Wedekind probably as I know a fellow in Munich that knows him very well. I shall also meet Schoenberg in Berlin—and hear his music which may be of use to me. I have heard a little which is most singularly subterranean in its quality.

I got an invitation from Gertrude Stein to take dinner with them on Friday evening (tomorrow) which is very kind of her.[2] It is just possible Picasso may be there as they are great chums and I believe he goes to the south soon. I have to thank somebody for sending me some of the newspaper clippings of the Show—of which Hapgood's was the most profound—naturally.[3] Do give Hapgood my heartiest wishes. I have thought of writing him but I find correspondence difficult with the inrush of experiences of varied sorts.

Give my love to Mrs. S. and Kitty and kindest regards always to Haviland—De Zayas—Kerfoot—Simonson—Mr. and Mrs. Meyer and all others—Marin—any others. I was amused with the special number on the big show—"An Interview with Jo Davidson" too funny—but Jo is such a good advertiser and inferior products always need boosting. I speak for his work which is and must remain mediocre with the attitude he takes.

As for "291"—naturally nothing changes that. You will see that all these things work for its good and the minor influences for evil perish of themselves. All to have to do is to keep your fixed faith and courage. I will tell you more later when things happen. The Salon des Indépendants opens soon—I was too late for it is I discovered that one must apply Jan. 1st for admittance.[4] But it doesn't matter for the thing is so huge and disjointed that unless a thing is skyscraper size it gets lost.

I shall see Steichen soon and see what he has to tell me—of everybody and the show.

Always yours,
Marsden Hartley

1. Delaunay completed a series of paintings on the theme of the Cardiff team. The painting Hartley describes is called *Cardiff Team (No. 3)* (1913) and is now in the collection of the Musée d'Art Moderne de la Ville Paris.
2. For Hartley's letter responding to Stein's invitation to dinner, see Gallup, *The Flowers of Friendship*, 70.
3. The Armory Show created quite a stir thus producing a number of newspaper articles. Hartley is likely referring to Hutchins Hapgood, "Life at the Armory Show," *New York Globe*, February 17, 1913, 8.
4. The Salon des Indépendants (March 19–May 18, 1913) showed work by Delaunay, Gleizes, Macdonald-Wright, Picabia, Elie Nadelman, van Dongen, and many others. For a more definitive list, see Gordon, *Modern Art Exhibitions, 1900–1916*, 2: 689–92.

n.d. [April 9, 1913, Paris] (postcard)

Dear A.S.,

I have tried to get a letter to you for over a week but it's no use—I'm up to the eyes packing with everything to do for myself. My pictures are gone to Munich and I leave for there on the 19th. Gertrude Stein came twice to see them—and says they are the most refreshing things she has seen in a long time—that I have restored colour to its original meaning that I am entirely new in Paris. At her suggestion I have sent four to her house to keep in Paris and she says she is sorry it is not possible to exhibit them here now.

Wilhelm Uhde came also and says that they have a singular supernatural quality which far excels Redon at his best and that I am doing what Kandinsky would like to do. Delaunay and Bruce and cie came the day of Gertrude S.'s second visit but she kept them speechless. She says she is so glad she saw them first so she can see what Delaunay takes from them. She is very suspicious of him and she knows him for years. She says she will write you herself about them which I prefer she would do.[1] When I told her you had bought the Kandinsky she said "why doesn't he wait and get the real thing"—I only give you all this as her own words.[2] She says I have done in every picture what neither Matisse or Picasso have done—to make every part of a picture life—and not since Matisse's *Femme au Chapeau* has color been given its true significance until in mine.[3]

M.H.

1. See Appendix One for an edited version of the letter from Stein to Stieglitz as quoted in Donald Gallup, "The Weaving of a Pattern: Marsden Hartley and Gertrude Stein," *Magazine of Art* 41 (1948): 259. Today the original letter is in the Collection of American Literature at the Beinecke Rare Book and Manuscript Library, Yale University.
2. Stieglitz purchased Kandinsky's *Improvisation Number 27: The Garden of Love* (1912) for $500 at the Armory Show, which today is in the collection of The Metropolitan Museum of Art, New York. By the "real thing," Stein implies, according to Hartley, that Stieglitz should have waited to buy one of Hartley's recent paintings instead of this work by Kandinsky.
3. *Woman with a Hat (Femme au Chapeau; Madame Matisse)* (1905) generated a great deal of controversy in the 1905 Salon d'Automne in Paris, and is the first Matisse painting purchased by Gertrude and Leo Stein as well as the first to enter an American collection. Hartley would have seen this painting at 27 rue de Fleurus. For an interesting account of its purchase, see Alfred H. Barr, Jr., *Matisse: His Art and His Public* (New York: The Museum of Modern Art, 1951), 57–58. The painting is now in the collection of the San Francisco Museum of Art (see figure 8).

<p style="text-align:center">℘</p>

n.d. [April 11, 1913, Paris] (three postcards)

Dear A.S.,

In my rush of these days—I haven't, I am sure, acknowledged your latest enclosures—or the new number of *Camera Work* which is splendid. The De Zayas stuff is

so intelligent—and interesting and I am so glad to see that "291" is showing a fine literary side—a good start with Gertrude Stein and De Zayas.[1] I suppose you have seen her last portrait—of Mabel Dodge at the Villa Curonia I think she calls it—she gave it to me with the *Three Lives*—I have read the former and like it very much.[2] I have also read a newer one which she gave me to read privately—and which is a superb study of the individual whom I know so much of here. Gertrude S. has four of my new pictures at her house as she said I should have some of them in Paris. I got a note from her yesterday saying—"come to lunch on Saturday as I think you would like to see your pictures by daylight with the others."

I am thinking hard of ways to have a private show in Paris next fall—and one plan is possible—I shall confer with G.S. on this point—also Uhde—both of whom are strong on the idea of a one man show here. François Kupka a modern theorist of rhythm and the logic of harmony etc. who showed in with the Cubistes in the Salon d'Automne, also in the present "Indépendants" came to see them the other day and said—don't exhibit in the Salons—but they must be seen by the people of Paris. I give you all these things from the outside just as they are spoken—I shall have more reports from Munich after I have been there.

I leave Paris in a week and shall be glad to leave the drudgery of packing which is so strenuous for me alone. The pictures are on the way to Munich and four are with Gertrude Stein—so this is not bad for four months work and I know exactly what I want and what I am doing—and G.S. says they show that I am unquestionably on my right road. She says she will write about them to you herself as she intends writing you anyhow. I will doubtless have things outside my own interests to tell after Munich—but naturally I am gratified that critics who are well known here say good things of them. I have kept utterly away from all the groups and have nothing to add or take away from them. I need now only work and this is sure to come and with that promises of something assuring. I have been "one being struggling" and there is something coming.

Best wishes to all,
M.H.

P.S. I like the Picabia in the De Zayas book much more than anything I saw in Paris.[3]

He too benefited by going away from things—and this winter here has been so full of intrigue and politics even I, an outsider, can detect it. Picasso goes on getting simpler and more delicate with an extraordinary realization of objects just for themselves. Matisse has a show at Bernheim's next week after a longtime in Tangiers—I am told that most of his things are bought ahead by Tschoukind of Moscow who is organizing a remarkable modern museum—so with him and Osthaus of Hagen—modern art is finding its open recognition.[4] I am hoping hard for a substantial European recognition so that I can take chances with other artists who succeed by working much and selling

reasonably after all Cézanne proved the artistic importance of production and with quantity comes quality too with earnestness.

I am exceedingly sorry to hear of Boursault's tragic fate by like you I believe in this immediacy of ends in such cases.[5] I hope too that Kitty is recovering well.

Best wishes always to Mrs. and Mr. O. at 1111 and everybody at 291.[6]

M.H.

1. Hartley received the most recent issue of *Camera Work* 41 (January 1913). This issue had an article by de Zayas titled "Photography," 17–20. He refers here again to the special number of *Camera Work* (August 1912) with Stein's word portraits of Matisse and Picasso.
2. "Portrait of Mabel Dodge at the Villa Curonia" (1912) was written by Stein during her visit to Dodge's home in Florence in autumn 1912. Dodge printed an edition of 300 bound with wrappers of Florentine wallpaper. Stieglitz later published Stein's word portrait of Dodge in *Camera Work*, special number (June 1913): 3–5. *Three Lives*, written in 1906, originally titled *Three Histories*, was Stein's first book, eventually published in 1909.
3. *Star Dancer on a Transatlantic* (1913) by Picabia was reproduced in *A Study of the Modern Evolution of Plastic Expression* (1913). This book, published by 291, was written by de Zayas and Paul Haviland.
4. Galerie Bernheim-Jeune hosted an exhibition of recent paintings and drawings of Tangiers and Morocco, plus sculpture by Matisse (April 14–19, 1913). See Biographical Index for details on Osthaus and Tschoukind.
5. Hartley is probably referring to Albert K. Boursault, photographer and original member of the Photo-Secession.
6. Emmeline Stieglitz and her brother Joseph Obermeyer.

᠊ᡣ᠊

<div align="right">April 21, 1913<br>291 Fifth Ave., New York</div>

My dear Hartley:

I have just heard form Walt Kuhn that your paintings and drawings had to go back to Paris because you failed to follow out instructions. That is you failed to go to the American Consul and make an affidavit on a proper entry form, that the pictures you sent were your work and that you were an American born. I am sorry because I had hoped to have them up at "291" and possibly do something with them. Our Custom House is certainly a diabolical institution.[1]

I wrote you a letter in care of Gertrude Stein yesterday and requested her to forward it to you. I am mailing this to your old address where I suppose you left instructions to forward mail to wherever you are. I am dictating this letter to Marie as I want to get it off and I don't see an opportunity to write myself.

As always,
Your old,
[Stieglitz]

1. A reference to Hartley's works that were sent to New York for exhibition at the Armory Show.

⌁

n.d. [April 29, 1913, Sindelsdorf] (postcard)

Dear A.S.,

I am visiting Franz Marc here for a couple of days. It is lovely here and Marc is fine and Frau Marc also. I am making arrangements here for exhibition—that is in Munich and also for Berlin—conditions fine and promising.

Best wishes to Mrs. S., Kitty and yourself always—De Zayas, Haviland and all others.

M. Hartley

Campendonk lives here also.

(Franz Marc scribbled an illegible note at bottom of card.)

⌁

n.d. [received May 11, 1913, Munich]

My Dear Stieglitz,

Only a hurry up line at this time—I am in Munich and have made arrangements for a show at the Neue Kunst Salon of Hans Goltz—to take place in June. I wanted it at once but the Munich people assure me June is a very good time—the artists and aesthetics are very keen on then. Kandinsky and Marc come up from the country next week and will see them—Baroness Werefkin who is a painter a Russian—says it is pure mysticism and that every picture is a picture by itself—and the motive power is new in art. They say it is the first time an artist has shown this kind of personality.

After Munich Franz Marc says I will get a show in Berlin with Der Sturm and they will send them over Germany after—and he will also introduce me to a collector of ultra-modernes in Berlin who buys the work of these men.[1] Heaven knows I shall be glad for I must work and go on and stick out the fight somehow. Baroness Werefkin says only those who are sensitive to spiritual things will comprehend them. They are all saying "please come to Munich and be with us"—Kandinsky, Münter—Marc—all say this—and they seem to be glad of my personality.

I know they are talking much of me because of what they say to me. Today Karl Wolfskehl of the school of new German poetry says it is what he wishes he could do in his work. He characterizes it in English as "crying ecstasy" "fire without smoke"—this is a nervous equivalent of Gertrude Stein's statement that every picture is a living thing—and that it lives everywhere in the picture which even Picasso does not do or Matisse. Both G.S. and Wilhelm Uhde in their separate ways say it is what Kandinsky would like to put in his work but can't. Of course I can't tell this to anyone here—I speak it privately to you—it has no relationship to Kandinsky's form and color whatever. He is not a mystic—and I am entirely without theory—he knows exactly why everything—I know why nothing.

But everything I express in an inward conviction—I know I am on the way to something big and G.S. says it is my own personal production. At her suggestion I left four of them in Paris with her as she said it would be very wise—I am highly flattered with all her overtures as not since Picasso and Matisse began has she given her interest so liberally. By this time you must have a letter from her. She said she would write to you and speak of the work—I don't know what she said but she would be honest. I was at her house to dinner several times and once to lunch because she wanted me to see how my things looked on the wall with Picasso, Cézanne and Matisse and she said—"you see—they stand every test here and this room of ours is certainly a test for the art of anyone."

Munich is much alive to *Kunst* moderne—three Neue Kunst Salons—I chose Goltz because he has experience and a connection with outsiders in Germany. When Kandinsky and Marc have seen them—I will write you—I know they will understand them and see their qualities and their potentialities. Perhaps Kandinsky has written you by this time on business in connection with the picture you bought. I took tea with them the other day and he was so interested to know that a friend of mine had bought his picture and that if you had not already paid for it—to send him his part separate and Goltz—his. They have all had some difficulty or other with him and yet they advised me to show there because of his business ability—but not to make any arrangements with him outside of Munich as they would make better ones for me through Herwath Walden of Der Sturm whom I met in Paris. I want oh so much to establish my place in the European scheme—and my debut is perfect. I have entrée at once and there is a fine fellowship existing here in Munich—a kind of spiritual bond which is most pleasant.

But all these things are most fatiguing and I want to get to work in Berlin. The problem there will trouble me at first as I must pay three months rent in advance—with Simonson I paid him month by month at the last. But now I have only railway fare saved and enough to pay for my things which I had to ship—two trunks—a box of goods etc. Can you arrange to send me enough to pay rent for a place—for three months—75 frcs. a month—and then send after that 300 frcs. a month instead of 375—that makes it

possible for me to settle at once as otherwise I can do nothing for I can't hope for a sale so soon. So I will need the June allowance of 300 frcs.—or the equivalent in marks for June—at the equal of 75 francs a month for 3 months rent.

I am invited by friends in Berlin to stay with them until I find a place, so I am carried over some of the bad places. I am sorry to make you so much trouble but I can do no other way. I do wish it were possible for Davies to help a little more so I can have enough materials—as I consume much more than ever in my life before. The struggle will be great for a time but shall win out as my faith is stronger than ever. I hope in the autumn to send over some things for a show at 291 which I hope will be possible. My future as an artist is here for some time and I must try and make a go of it somehow. I now have pictures in London, Paris—Munich and Berlin—so that is not so bad for so short a time. At least my name is out as a possible force—they are not skeptics here— if they believe in a man's soul—they accept his product on the face value of himself— and this gives a serious person a chance to grow and strengthen himself. I know I shall succeed as an artist here—but I want to live on my own account—and this must be accomplished somehow, so I can be wholly free—heart—mind and soul.

I will write you when Kandinsky and Marc have seen the things so you may know what they say. I shall probably get in to the Blaue Reiter shows later.

I see Frank Eugene nearly every day and he is helping me all he can to make me known here. He is fine and they are all so kind and generous spirited and if they accept a man that is enough—and I know they have accepted me.

May I urge then that the money be forwarded to me at once so that not later than May 20th. I can know that I can take a place and get to work—I shall not wait for my exhibition here as it is not necessary. By next week I shall have seen all the artists and literary lights here—and the rest is for the public condemnation. Goltz assures me I shall be considered mad—but that is a hackneyed convention of the present day. I want only to work and prove myself to be that which I know I am. I say all these things without stupid egotism—only with the conviction of the soul.

Very best wishes to each and all and to Mrs. S. and Kitty and yourself.

Always,
Marsden Hartley

Address me Chez Herr Prof. Rönnebeck
Johann Georgstrasse 20
Berlin Halensee
Germany

1. Bernard Koehler, a wealthy Berlin industrialist, was the collector Hartley hoped to meet.

❧

n.d. [mid-May, 1913, Munich]

My Dear Stieglitz,

I feel the need of writing you today because the event of Munich for which I have waited so long here came off today—Kandinsky, Münter (Frau Kandinsky), Marc and Bloch were at the Galerie Goltz to see my pictures with me. I confess to a little uneasiness as I did not know what they would mean to them—but I found them most generous in their praises and they seem glad to have found me. Quite naturally as I expected Kandinsky volunteered a discourse on the law of form—that of the individual as applied to the universal—mainly a discourse on technical indiscretions which however left me unmoved. All most friendly of course—it was an interesting conference—the one a complete logician trying so earnestly to dispense with logic and I a simple one without logic having an implicit faith in what is higher than all intellectual solutions—knowing that intuition if it be organized has more power to create truly than all the intellect ever can.

It was an interesting parallel as I watched the scene impersonally. In myself and K. I saw the likeness of the situation between Emerson and Whitman discussing *Leaves of Grass* on the Boston Common. Whitman listening with reverence to all of Emerson's ideas—and leaving him with the firm decision to change nothing in his book—or again a possible conference between the two mystics Swedenborg and Boehme, Swedenborg—consumed with the logic of his mysticism—so organized that he could always have a vision—Boehme the ignorant one listening with his ear to the ground and his eyes toward the light waiting for the intelligences which came to him. The parallels are not incongruous, I have no knowledge—only an organized instinct. Kandinsky has a most logical and ordered mind which appeals so earnestly to the instinct which has been over mastered. In other words in my heart of hearts I think he is not creative—I think he is an interpreter of ideas—he knows why everything and that simply must not—cannot be in real creation—this is itself illogical. Gertrude Stein is right when she says that true art cannot explain itself that Cézanne could not—Picasso cannot—that I cannot—that Matisse can explain everything and it probably accounts for the fact that all Matisse's pictures now are studied logic and studied simplicity. Kandinsky also—all legitimate enough naturally—but not products of creation that element of life which insists on self-expression before the mind has power.

However—we had a fine day and they finished by saying that what they admired so much was the intensity of personality in them—the sense of truth they give and their real naiveté of spirit—this is the exact translation of Münter who speaks very good English—Marc also—Kandinsky a little—Bloch is an American and one of the Blaue Reiter group. Kandinsky said at tea that he and I should go together to the mountains and learn each other's languages. Marc writes to Berlin to arrange for an exhibition there and then also to send them out over Germany and also he will write to a collector of ultra-modernes

in Berlin—perhaps this will come to something—God knows I hope so for I am so hung up with the problem of getting settled in Berlin. But I have faith that things will settle themselves—I am quite powerless to do anything myself at present except wait for developments. If it does not cost too much perhaps you could cable the money over to me in Berlin—so I could get started to work at once.

However—my German debut is complete—I stand alone—I cannot be described as a product of any school or any system—the product is personal—I need only the chance to work freely. I want to exhibit in New York in the fall—so you can all see what I am driving at. I am glad you read Gertrude Stein's letter to all the people—the Meyers, De Zayas, Haviland—it counts well. I know this—that it is a long time since Gertrude S. has gone outside of Picasso and Cézanne to interest herself and this is the art compliment. She came twice to my studio to see them and then put the four of them on her walls with Cézanne, Picasso, Matisse and Renoir to show me they had a strength all their own and she said they were like nothing else going, and that every one is a live issue by itself entirely separate and different sensations. This cannot be said always of Kandinsky who is not very alive and not so very different. I am afraid he is by way of being an aesthetic philosoph who has a kind of power of expression—I can say that his later pictures live more than the early ones which for me are entirely still-born. But he is splendid—you would enjoy knowing him—and those who like discourses would find him the part grand master and all with extreme simplicity. There never was a cooler headed being—though he is very warm hearted.

I go there to tea tomorrow and to Baroness Werefkin another day. They want me to stay in Munich but I don't know—it is all so village-like and domestic for a homeless one. There is more in the way of life in Berlin. I shall meet Arnold Schoenberg the last word in music there—through Kandinsky who knows him well. You would like Kandinsky and Marc very much—both so fine.

Best wishes to everybody—yourself. Frank Eugene likewise sends his to you and Mrs. S.

As always,
Marsden Hartley

Chez. Herr Prof Rönnebeck
Johann Georgstr. 20
Berlin Halensee
or Am. Express Co. Berlin

❧

n.d. [week of May 18, 1913]
Johann Georgstr. 20
Berlin Halensee
Chez Rönnebeck

My Dear Stieglitz,

I write you today from Berlin—having received your letter with enclosure for which I thank you profoundly. I am stopping with friends the family of Prof. Rönnebeck father of my best friend in Paris Arnold Rönnebeck sculptor. It is extremely fine of them to have me here for I have been inordinately fatigued these weeks past—getting out of Paris—staying in Munich under trying conditions—being able to do nothing for myself for two weeks really through Kandinsky's absence etc. That is all past now and I have accomplished that part of the trick—I have found my place in the modern scheme and it is a place alone—Kandinsky and Marc have been most kind to me and are doing many kind things for me. It is through them that I make my German debut and have my professional success—I need only now some practical gain—and how surely I need this I cannot say. I have a mean problem on my hands now of getting settled in Berlin—hunting a cheap and nice place to live and make things go.

I am very glad to be here however for I like it very much and hope to establish myself for a long time to come. There is no reason other than practical why Germany should not be my home. I like the German people—I am more at home with the German character whereas I regret to say I was not with the French. I apologize for this by saying I had not the privilege of meeting fine French people with one or two exceptions. They are most difficult to meet unless you want to be French with them and that in itself was distasteful to me. However—I have every sense of being at home among Germans and I like the life color of Berlin—it has movement and energy and leans always a little over the edge of the future instead of leaning so heavily on the past as other nations and places must. It is essentially the center of modern life in Europe.

These few days have been filled with vivid European gaiety for the King and Queen of England—the Czar and other celebrities are here this week for the wedding of Prinzessin Victoria Luise on Saturday—tonight Gala Opera—etc. It makes a very gorgeous street picture and I have always loved these public spectacles. The military life adds so much in the way of a sense of perpetual gaiety here in Berlin. It gives the stranger like myself the feeling that some great festival is being celebrated always. Besides all this I like the extreme cleanliness and order which is oh so fine after the filth of Paris—and the German face is a restful one to look at here—it is jovial and healthy and at its best most refined and intelligent looking.

I want so much to establish myself in the ultra modern scheme here and this is all possible now with Kandinsky and Marc and their group. They have invited me for the Neue Herbst Salon which will be a big thing here and doubtless arouse fierce opposition—but

there is a strong element also in its favor among the modern collectors.[1] Here I will make a copy of Franz Marc's letter which he wrote me from his home in Sindelsdorf near München—a few days after he saw my pictures.

> Dear Friend—Allow me to say you how much pleasure I find in your valiant pictures. I said you that in my opinion you get not out all in color and form than you could with more experience of painting—but I am sure you will do so soon or late, when you will have worked more. But I am profoundly fond of the high sincerity of your art which is of a great holiness and pureness and your ideas are always strong and absolutely personal. This is the main point. Excuse my horrible English. I hope you will discern my feelings about your art and the sincerity of my approbation and wishes.
> Heartily with best greetings.
>
> Yours,
> Franz Marc

I give you an exact copy of the letter which is I think very beautiful and I am very grateful for it. They all speak with one accord of the kind of quality—Kandinsky and Marc both made technical criticism—Kandinsky on form and Marc on color—Marc saying he thought the color too simple—Kandinsky giving a little treatise on the law of form which was of course interesting as he always is. The theory of his criticism might be all right but I do not ask so much of a picture—I only ask of a picture—is it a picture—does it awaken any kind of an interest, an emotion—if so it is a picture—if not it is dead. Kandinsky would stir the mind to action—arouse a thought—I seek only to arouse the self as I myself am stirred. I am convinced I succeed and Gertrude Stein says I do—I am not convinced that Kandinsky ever does. It never quite comes to the point which makes all things perfect—it is without (for me) the life germ—it is the philosoph painting—the theorist demonstrating—not the artist's soul bent on creating. He gets it in his writing but not in his painting. Therefore technical perfection is as much a failure as anything can be to my notion when it is not accompanied by spiritual enthusiasm. For myself, as I have written Marc—I only ask one thing of an artist—and that is that he express himself first and ideas afterward—and that in my case I am working to express what my soul would say to someone because it has need of speaking and the terms employed are only such as my inner needs demand. I do not think first but after— allowing the spirit to do its own dictating—as the particular sphere I live in when I work has a language of its own and is not allied to aesthetics as much as related to itself.

I am told also that I succeed in bringing mysticism and art together for the first time in modern art—that each canvas is a picture for itself and there the ideas present themselves after. This is my desire—to make a decorative harmony of color and form using only such color and such form as seems fitting to the subject in hand. I have one canvas 'Extase d'Aéroplane' if it must have a title—it is my notion of the possible extasy or soul state of an aéroplane if it could have one—likewise that same soul quality of an

automobile.[2] These are of necessity symmetrical in design because the objects themselves are such. In the pictures which are of the nature of individual interior states—the forms are naturally varied. I am told by symbologists that there are forms in my pictures which occur in the earliest languages—the which I know nothing of because I read nothing. I only know that when the thought "golden triangle" comes into my mind—I "see" that triangle—I have a real vision of it—and so with the other shapes.

I am most anxious to have you see the new things because you will get the point of view at once and you will see how typical they are of my personality and that it could only come from one like myself who lives the interior life almost altogether and whose point of view must necessarily be that which is most characteristic viz—the visionary point of view—the power of "seeing" the idea. It is a natural evolution because new phases of my life are a natural evolution. I cannot talk of them because they are too intimate and personal—they have to do with religious attitudes—attitudes only to be sure not convictions for I believe nothing except that I believe all things are good and bad false and true for somebody. Also as I told Marc—my present art product is young and like all youth is full of possibilities and possible defects. This must be—the only thing I ask of them is do they convince the spectator of their reality and their personal conviction and the replies are unanimous everywhere with those who have seen them. Many say they do not know what I may mean. Well I don't either and don't profess to have a lecture for every idea—I think more about them afterward—while I work in is by way of being a kind of dictation from somewhere. The occults will have a definite name for it all and I expect to meet them here—Dr. Steiner—Eduard Schuré perhaps—I have only one thing to confess to them all—and that is ignorance—I find it stimulating enough not to know anything. It is only a common fact that when the mind starts to work on a certain line of thought—it gathers its material from that source—so with the soul—so with the senses—so with the emotions. They seek their own nutriment for their own welfare.

I shall hope by next fall to add another group of 20 canvases to the collection so that the body of them will give a good idea of my general idea. You see how freely I talk of my work these days. It is because I feel as if it were not mine. I look at them as a product by themselves which exist for their own sake. They do unmistakably contain an element which has never been painted before by a modern—that is merely because these are my two chief personal elements the artistic and the mystical. My religious and emotional experiences have given me the mystical outlook and if I have art it came to me. I only want now to arrive at conditions which will permit me to work without suffering and that is not accomplished yet and by suffering I mean anxiety for the necessities such as materials to work with etc. However I have lived on faith to look to be outdone now and I know that things will come somehow.

While I think of it—I have a notice from the shipper in Paris that my things arrived from the New York show and await my disposal. For these errors I have Walter Pach to thank. I went to the consul—made out a paper—stating that I was an American and that I had lived in Paris a year which I had at that time or nearly so—gave the price of the pictures and gave 291 Fifth Ave. Photo-Secession as address for delivery, also paid 5 frcs. for the fee. Then I gave my paper to Pach who said he would send the pictures with the sculpture as the main bulk of the pictures had gone, so I am free of the accusation of neglect and stupidity in this instance. As it is the pictures will go to my sculptor friend's studio for cold storage until I know what to do with them. One is so fearfully helpless with all these formalities of life and they make it so difficult for one like myself who have no one to do anything but myself and with the concentration upon interior things I feel the care of all these common duties very much.

Now I have the business of hunting rooms to live in and this will be so troublesome. Then I must pay over 75 frcs. for shipping of personal goods from Paris—all dead money you see—but it has to be done. It leaves me in such bad shape always—always crawling on my knees as it were. I need now $25.00 for materials to work with and there isn't a ghost of a show for getting it—I must buy a bed—oh well all these details are too much—you have enough. I have always to be profoundly grateful—way beyond words that I exist at all—to you. Such people exist in all phases of life—but where else in art save yourself. If uniqueness is any compensation then surely you can be satisfied with fame enough. I only wish you were coming here so we could have a long talk and you could see my work.

I shall surely make the effort to send a show to you at 291 Fifth Ave. in the fall—and perhaps go with them although I am keen just now on sticking to Europe somehow because it is I believe the place for production, that is for me. I don't see Americans going mad over them to possess them. It hasn't occurred yet over there and isn't likely to come especially to an American. They haven't gotten over the foreign label idea yet—but of course I would be glad to show just the same.

In any case I want to get settled in Berlin now and hope to do so at once. I remain with my friends the Rönnebecks until that time and you can always use this as an address for special things. I give the American Express to my family as being simple and direct for them.

Have seen the Secession here in Berlin—nothing except Cézanne, Van Gogh—Renoir, Matisse, Seurat—Kokoschka—of any moment, an entire roomful of Trübner and what for these days!—Leibl also—what for!—they are ancient history.[3] And the Secession der Refusierten ridiculous—nothing at all—only about 30 pictures with no excuse either for acceptance or exposition.[4] The Neue Herbst Salon will be a jolt for Berlin all right. It is so sleepy and yet it is keen too. The interesting feature of Germany

is that one feels art itself to be so much a factor of existence. The state itself is so alive to the art idea—it is <u>in</u> the German to think of art. Alas for the American.

Give my best wishes to all—De Zayas—Haviland—Mr. and Mrs. Meyer, Marin, Walkowitz and Kerfoot especially. I have every intention of writing him. Also Mrs. Stieglitz I guess she thinks I'm impossible by this time. I can only plead lack of time for all but absolutely imperative letters. Berlin is so beautiful now with the lovely shade trees everywhere and the Tiergarten is simply superb. I went to Potsdam and Sanssouci the other day with Prof. and Frau Rönnebeck.[5] That too is so choice and exquisite. A great creation as a summer place for a king. Best wishes to you always and profoundest thanks.

Your friend,
Marsden Hartley

1. The *Erster deutscher Herbstsalon,* or First German Autumn Salon, (September 20–December 1, 1913) in Berlin included 366 works by ninety artists from fifteen countries. Five paintings were included by Hartley which made him one of only four Americans to participate. For an in-depth account of this exhibition, see Selz, *German Expressionist Painting,* 265–73.
2. Gail Scott suggests this painting is *The Aero* (c. 1914) now in the National Gallery of Art, Washington D.C. (Gail Scott, *Marsden Hartley* [New York: Abbeville Press, 1988], 49). For an alternative interpretation of the painting, see Levin, "Hidden Symbolism in Marsden Hartley's Military Pictures," 158.
3. The Berlin Secession presented an annual summer exhibition. The 1913 show concentrated on exhibiting the European modern and avant-garde artists in conjunction with work by members of the Secession. See Peter Paret, *The Berlin Secession: Modernism and Its Enemies in Imperial Germany* (Cambridge, Mass.: Belknap Press of Harvard University Press, 1980), 220–21.
4. Thirteen Secession members organized another exhibition because their work had been rejected by the jury of the Berlin Secession. As a result several leading members resigned, including Max Liebermann, and founded the Free Secession. For further details on this break, see Paret, *The Berlin Secession,* 229–34.
5. The 18th-century palace retreat of Frederick the Great, Sanssouci ("without cares") is located just outside Berlin in Potsdam.

✑

n.d. [June 5, 1913] (postcard)
Nassauischestr. 4
Berlin Wilmersdorf, also
American Express

Dear A.,

A card at this time to intimate something of myself. I will write more as soon as I am more settled—I have found a nice little apartment cheap and very serviceable in a very nice part of Berlin—two rooms bath and kitchen—one room for living and the other

for work. I had to take a lease for 1¼ years usually it is two years—however I find myself living in Berlin a long time. Sometimes I think I may find myself living a European life because one is so readily understood here.

Saw a fine collection of modern things yesterday, Van Gogh, Gauguin, Cézanne, Rousseau, Seurat, Greco—Kandinsky—Marc—Campendonk—Kanoldt—Münter—Hodler—Munch, and others, Delaunay—Picasso—the collection of Herr Koehler of Berlin.[1] He and his son very fine. I hope to be represented in this collection as he seems to want new personal expression. He is also keenly interested in and working for the Neue Herbst Salon in September perhaps backing it. It is so encouraging to know such men exist. Berlin is fine now and many festivities going on. Next week the Emperor's Jubilee—streets being prepared. My address will be as below.

Best wishes to you and all.

Will write soon,
M.H.

1. Much of Koehler's collection was destroyed in World War II; those works that survived were given to the Städtische Galerie im Lenbachhaus, Munich in 1965 (McDonnell, ed., "Marsden Hartley's Letters to Franz Marc and Wassily Kandinsky, 1913–1914," 44n. 36.

ᜒ

n.d. [June, 1913]
Nassauischestrasse 4
Berlin Wilmersdorf

My Dear Stieglitz,

I started a letter to you a week or more ago but I couldn't finish it—so I must begin again—as it is I can only give you mean details of which you have enough already. I am quite exhausted physically and mentally with the problems I have had and will have according to the outlook. At the present state I am too fatigued to get started on new work—sometimes I think I never will it has been so far away so long—nine weeks now since I stopped working—and since then one succession of the meanest most trying details perhaps in my life. I feel as if this German project had all but cost my life such a terrific expense of the spirit—with such a series of negative problems surrounding me one after another and I see an entire summer of the same before anything much can change—and I am up against the problems alone—which makes it still more difficult.

And to add still further to the general distress I had a letter from Hans Goltz of Munich—two letters—the first saying he begged to announce my exhibition from June 20 to July 5—with one Egon Schiele some sort of landscape stuff. The very next day he wrote again saying the collection of Schiele was so large that he would be obliged to

postpone my exhibition "but that I could dispose of my pictures if I wish to do so." This was so queer I wrote Franz Marc at once and he replied I have had trouble with Goltz (Kandinsky also) and he knows you are a friend of mine—therefore tell him to send your pictures immediately to Herr Dietzel—Neue Kunst Salon also Munich and doubtless he will give you July. I wrote Dietzel at once last night. This morning a nice letter from Dietzel saying he does not know if he can arrange for July on account of a prearranged exhibition. I have written today to see if he can give me three weeks in August—now I must wait and see.[1] In the meantime my pictures must lie in a cellar many weeks more—as they already have five weeks and over. This you see is disheartening because they are a totally dead issue in the dark naturally—and I need the publicity of exposition at once.

This is but one of the rush of troubles I have—I don't feel as if I would ever try to go from one country to another again at such a cost of trouble—but it would be the same if I went home to Amerika only I feel as if somebody were near me there. It has taken me five weeks to get into my flat—and I had to pay nearly four months rent in advance—the which had to come out of my money of course—then the cost of getting my belongings and necessaries from Paris was terrific and made worse by the stupidity of the packer who packed a whole box of goods belonging to Simonson which I had tagged expressly for his uncle's address in Paris—and shipped the damned things to me at my cost—utterly useless and disgusting—and things of not the slightest worth to me—them *polizei* papers—American citizen papers etc. Well—I am actually sick with it all—and now I must buy an easel—canvasses and paint and I have no money for this—only barely enough for food and if I buy things I must go hungry—so here it is. I can't go hungry and I must work and all for a little money. Really sometimes I get sick of the game—it is too hard on one's system and I cannot work well under such conditions. Now not a thing can possibly happen to me before September and then I cannot say except that something <u>must</u> happen if I am to live and if I am not—well there are greater issues in the world. I am only trying my best and giving the best in me and I can't do any more. I have to give up life always and see it go by me thankful for the privilege of looking on and for a chance to express a little of the great inward struggle. It needn't be supposed that life in Europe is any different than at home—one must pay for everything one gets and Europe is Americanized as to the cost of most things— cheap rents are cheaper but otherwise I see little difference. It is perhaps a little pleasanter to be poor here than in America because there are many people of position and prominence who are poor. The American is responsible for all these things here. He comes over and splurges money everywhere and the notion is that all Amerika is running over with gold that you have only to pick it up. However—there is an important side to this German situation for me—and I must stick it through somehow. I haven't lost faith but I must confess I am a little weak over things generally. It is all I can do to work and

give up what I have in this way without being deluged with a lot of matters that are so troublesome and take one's vitality so. And it does seem ridiculous that history must always repeat itself that one must always be struggling for a simple existence—I have had it for a long time now. I need the freedom of plenty of materials and enough food to keep me well.

My problem now is that I am forced to ask you to send me the last two months of the money at once. What I have will hold out until the 10th or 12th of July and then I haven't a Pfennig—of that I must take out $40.00 for rent from October so I shall be sure of a home and then there will be enough to hold me scantily until perhaps the middle of September and then I am at the mercy of things. If you could see anyway of adding $30 or $40 I could allow myself canvas and paint freely. It costs me more than it ever did to paint because I paint larger and more and this is an expense which cannot be controlled. It must be so much for every canvas and colour is not cheap anymore. I can tell you that the notion of cheapness in Europe is a myth—it has all gone by and I have no indulgences whatever. My only diversion is a cup of coffee at a café and that surely isn't much.

But what a mournful letter this all is—I had to write it because my situation is a mean one—I don't dare think too much because if one thinks one makes decisions and in a crisis one mustn't make decisions but only wait patiently. My problem isn't lessened a bit just because I have had a little recognition professionally. I only have a little hope because many of the moderns are successful—but many are rich also. Kandinsky must have private means I think. People like Delaunay and Picabia and now Matisse and Picasso are very successful financially. Anyhow September will tell all things for me and I must find a way to live and work until then. In the meantime I have nothing to rely on but what is to come from you for August and September—and if there could be an extra possible you can be assured that I am not wasting anything—I do the best I can and the best anyone can with what I have. I do not know how to write Davies again— he is so difficult. Perhaps he could have sold the large still-life if it had remained in New York as it should have done. I can only hold Walter Pach responsible for this trick of fate. I gave him my consul papers for which I paid so I know I did get it—and he must have lost them. Anyhow there they are in Paris in the studio of my friend Rönnebeck and also the group of still-lifes in London from which I get nothing or hear nothing.

So you see how loose all ends are with me. I have to keep myself very quiet to keep from nervous breakdown which I could easily have under these trying conditions. I haven't the kind of energy which thrives anyhow under adversity—I have to give up strength to all the issues and so I don't have it naturally. And what is really trying is that it is all for want of cash. I know how fortunate I have been to get over here and all that but I know how necessary the whole thing has been as a spiritual investment which heavens knows I would gladly have paid for if I could have. And too my life is just

exactly the same here as in Amerika—I see different things around me—but my own private life is precisely the same as it was—and as I suppose it always will be. I am not happy interiorly and this as far as I can see cannot be changed. Like every other human being I have longings which through tricks of circumstances have been left unsatisfied and I am not the kind to brush them by—I feel them and feel the loss of them. These are the things which few in this world but myself know—it is not necessary now to begin telling them they would help no one—but it leaves me with an inner need unsatisfied and the pain grows stronger instead of less and it leaves one nothing but the role of spectator in life watching life go by—having no part in it but that of spectator which of course is diverting but not satisfying to the soul of one which longs for a human place to be. Here you find me confessing which I think I have never done before but you are my friend and it doesn't hurt anyone to speak of it. I don't tell much to anyone.

Anyhow here I sit—on another spot in Europe—knowing it as Europe and knowing also it is but another place to pitch the tent—for I am homeless actually—spiritually and every other way—and I have all the instincts for home and for peace and find neither of them anywhere. Perhaps it's why I like the Germans—I enjoy seeing them so much at home looking so warm and genial and so friendly without great inward struggles— apparently they don't have them much because they seem to give themselves up largely into the family idea and live in that or into the military idea and live in that so they go outside themselves always which is a blessing.

Anyhow here I have written pages—and I have given you the phases of the situation in Europe for me. I do not altogether despair but I do struggle and the struggle produces nothing in me but fatigue and nothing for others—not even for my work for that proceeds from another kind of inward activity. And there's no saying "buck up and be different" for it is myself and I must always be that and be true to it—and live with it the best I can for I am eternally alone with it.

I know then that you will understand and know that my complaint is not unkind— I want to live and I want to work—but just now I find both difficult when only for want of extra money I could go on and defy these outward powers and free my soul so it and I could work together for that is how the work is done—by contemplation on things and when the soul is not free to contemplate then nothing can come. No intellectual striving will achieve it for it is not the work of intellect—that must be left to the schools and groups who advertise themselves so advantageously and leave real art a wanting quantity.

I am thankful that at least I am not hearing the Parisian art mongers talking of themselves and the greatness of what is not great but would be great if they were really great men. A true art needs no speech—it speaks itself—and I find the ultra-modern German tendency is toward a much more dignified end and the men themselves a much more dignified and respectable body—leaving the arguments to themselves—looking only for

the one essential real sincerity and sincerity of soul not of intellectual ideas with which
the French are so free. You have only to meet men like Delaunay to know what I mean—
who have only the sincerity of surfaces and like all French—refining on surfaces always—
naturally the result must be thin. If you fill the air with personality always then the air
has most of it naturally and art gets less of it. And you will find the real men always leav-
ing these shouting groups and going away—as Matisse does—as Picasso always—as
Cézanne found he must also—I am away from it—of course men like Kandinsky and
Marc and the others talk too but it is a talking toward the constructive whole and not
the petty assertion of petty egos. For myself I think Paris is in a bad way artistically—
full of good ideas which is always true of the French—but too impetuous to follow any
of them out seriously. It is so with the poets and the literate—they all insist on the nov-
elty of themselves.

So you have some tiresome pages to go through here. I shall not write you often like
this—but I must write and at this hour I can only give you all phases of myself and of
conditions. I see a fearfully dry time ahead of me until September when Marc and
Kandinsky come to Berlin to arrange the Herbst Salon and then I must rely on them to
help me make connections. Now you see—my pictures lie around in Munich—they
cannot go elsewhere because I want to accomplish what they are there for not speak-
ing of the shipping expense. If they must wait now until August then they must come
to Berlin and of course only part of them can be shown in the given space which breaks
into the idea of a one man show here for a time—then they must be here for six weeks
doing nothing until they can go on tour again—and I want to get them to New York for
the best of the season. So I must leave the whole business to the trick of fate and see
what happens.

The main thing now is to exist and get to work somehow. I am dry of funds—so I
hope you can send the remaining two months at once on receipt of this and if you see
any way possible for an extra for materials it will improve the situation wonderfully—as
I must work and under present conditions I am hampered for materials. If I spend it
for that then I must go hungry and I cannot do that—and there is no credit for me here
whatever. I am a stranger and must take the consequences.

Give my kindest wishes to all. I am so sorry Kitty is having so much trouble—poor
girl—she seems to get everything doesn't she—I hope she is better by this time. I sup-
pose poor Mrs. S. is worried to death also with all these things. Give her my kindest
wishes. For yourself always the same gratitude and appreciation. I am grateful to the
Meyers for making development possible—it is all I want and I need it more now than
ever.

Always your friend,
Marsden Hartley

1. Because Hans Goltz and the Blaue Reiter members had disagreements, it is probable that Goltz extended the exhibition of Egon Schiele's and as a result cancelled Hartley's exhibition (McDonnell, ed., "Marsden Hartley's Letters to Franz Marc and Wassily Kandinsky, 1913–1914," 44n. 23). Several of Hartley's intuitive abstractions originally slated for Galerie Goltz were finally exhibited in a group show in Munich at the Neue Kunstsalon of Max Dietzel, July 1913.

ᗢ

June 16, 1913
291 Fifth Ave., New York

My dear Hartley:

I have just a few hours before taking the family out to the Jersey coast, and I want to get out a few letters. I am dictating this as I won't get a chance myself to write. I received your card and I am glad to know you have settled in Berlin. But above all I am glad that you have come into touch with Herr Koehler. I had heard of his collection, and I do only hope that he will add something of yours to it. Above all I hope that you will reap some material benefit from your German connections. It makes me feel a little home-sick to think of Berlin; I spent such wonderful nine years there as a student.[1] I liked Berlin then for the very reasons you like it today. I liked the order, the cleanliness, and the whole atmosphere of go-aheadedness; and that was all nothing more than a preparation of what Germany was to reap after the year '90 when I left. I remember well the days of June twenty-five years ago when the Emperor Frederick came to Berlin but to die, and the day when the present Emperor took charge of affairs. I sat on a balcony of Café Bauer and saw him ride down the Linden at the head of his troops. It was an impressive sight. What an eternity twenty-five years really are, and yet it seems but a few days ago that all this happened.

With kindest regards from the little bunch still left at "291,"

Your old,
[Stieglitz]

N.B. I came near forgetting to give you a bit of exciting news. On Thursday morning four A.M. the telephone drummed me out of bed. This was the message: "291 on fire!" Somehow or other the notice hardly affected me. Curious—remembering the similar circumstance of a year ago and how I felt then—and still not curious if one realizes what I have been through during the last year. Well, I went down to the place and found the fire-men and engines in front of the building and also found Mary Elizabeth's kitchen entirely burnt out. It was due to Mrs. Rodgers, you remember her, who sleeps underneath Lawrence's place, that the whole building did not go up in flames. She being a light sleeper,

having been awakened through the crackling of the burning wood, and seeing flames shooting up, she yelled for help. As it was a very warm morning and all the windows of the neighboring houses being open many people heard her yells for help and so the engines were on the spot promptly. Our little place once more escaped untouched.

1. Stieglitz, aged 17, moved to Germany in 1881 with his family. Initially attending the Realgymnasium in Karlsruhe for a year, he subsequently enrolled in studies for engineering at the Polytechnikum in Berlin and chemistry of photographic processing at Berlin University. He returned to New York in 1890.

⌐

n.d. [June 28, 1913, Berlin] (two postcards)

My Dear Stieglitz,

Your typewritten letter came yesterday. I had just left Café Bauer having had coffee there. That is what I find to keep me moving—is just that go-aheadedness you speak of. People who have the Greek ideal or any other poetic ideal seem to think there can be no poetry in this push toward the day after tomorrow. When the Hansa or the Victoria Luise *Luftschiffs* pass overhead so majestically and so close that you see the people waving their handkerchiefs there is surely something poetic about it and there is surely some poetry in cleanliness—Paris is certainly lovely as a romance but as a reality it is so unhealthy—as I see it from Germany it is fanciful and magic in its character but that is all old Paris—[?] and automobiles and dressmaking don't add anything to it—it is a wonder of the ages gone. You don't feel the age of Berlin anything like as much as its youth and the energy of its youth. And there can be no city so well organized in the ordinary ways. The people don't fill the air with nerve wreckage as they do in New York, London and Paris. But as a group of life movements they are all equally interesting— and there is more color to the movement of Berlin than any of them. Paris is the mistress of black and white subtlety London is mistress of black and white dramatically— New York—well it is more iridescent in its character but Berlin is color contrast—owing chiefly of course to the military design which dominates it.

From these sensations I hope to produce something in time. After these long weeks of fearful fatigue with things objective—I think I shall soon get something working. My last letter was a bad one I know but it is truth and I have to rise above truth if I am to proceed naturally. The situation is more the less a difficult one for me and must be met. My only hope is a possible connection with Herr K., but not before Sept., whose collection is fine—but no battle is ever fought alone as my own career slight as it is— proves—I can only give myself to the idea—and after that—co-operation of forces is

the essential. You must know how little I want in life because the great things have been denied me—not fame—not riches—not luxury not idleness—only peace inwardly and the intelligence for work.

My pictures in Munich are now out of Goltz's hands and in the more honorable ones of Dietzel who is a fine fellow—perhaps not a good business man but a clean character and this does count so much. I am leaving that situation to clear itself—I can do nothing myself. When the pictures get to Berlin I shall feel as if they were mine and can perhaps have a word over them. I am sure we owe Mrs. Rodgers high thanks in saving the little gallery—there has always been a fire under it—but I think always a star over it. I am seeing eight-pointed stars here by the thousands—a symbolist friend says it is a fine star for me—on the Kaiser's breast it is always—on the helmets of the thousands of soldiers—on the pavements on the tablecloths. I like Potsdam so much and the artistic soul of Friedrich der Grosse. I shall hope for your letter by July 10th—the need of which I explained.

Thanks—and best wishes to you and all,
M.H.

Gertrude Stein has written a portrait of me I hear.[1] I had a long and cordial letter the other day from her.

1. Stein's word portrait of Hartley was possibly excerpted from her play "IIIIIIIII" in which he plays a part as M—N H—. Some of Hartley's lines in this play were used as Stein's foreword, titled "From a Play by Gertrude Stein," for the catalogue for his exhibition held in January 1914, along with his own foreword and Mabel Dodge's. All three texts were reproduced in *Camera Work* 45 (January 1914, published June 1914): 16–18. Stein's "IIIIIIIII" was later published in *Geography and Plays* (1922; reprint, New York: Something Else Press, 1968), 189–98. For her contribution as reproduced in *Camera Work,* see Appendix Two.

⌒

n.d. [July 5, 1913, Berlin] (two postcards)

My Dear A.S.,

I have word now from Munich that my pictures will be exhibited in the Neue Kunst Salon of Max Dietzel in company with some graphik. I am very glad for this as this problem is settled. After July they will come to Berlin—I think possibly they will go on show in the galerie of Der Sturm which is the Kandinsky-Marc station here—then some of them for the Neue Herbst Salon—after that doubtless to Hamburg, Dresden etc. I hope. Dietzel in Munich is a fine fellow and clean which I fear Goltz isn't—I think Dietzel will be <u>the</u> man after a time. His galerie is only a few months old—I don't hope for much there financially as they say Munich doesn't buy—it is the outside Germans. I

count more on Berlin first because of Koehler thru Marc and K. They will both be here early in September. The Neue Salon will be a great surprise and bring out new people like myself.

I wish the fairies would walk in and smooth out the main problem for me a little—I shall do the best I can for work but I am much hampered at this stage. I look forward much to sending my things to New York for your next season. You will be much interested. I hear from Gertrude Stein and she says she is so sorry I am not in Paris and they miss me very much. I hear it from other sources too. It is the only thing I would go back for—she is a wonder and such a jolly good companion, and all the world walks in to her place. She has written some plays—one in which I talk a great deal—at least quite some—I have read some of it—and there is a great deal of my environment in it. It has been whispered that her plays are to be put on in a new little ultra-modern theatre in New York—and it is whispered still softer that they want me to paint an idea for a curtain—don't tell anyone. The producer is new—the playwright new—and the project of course daring. I just whisper it all to you. You will hear of it later from the producer herself—a very clean girl whom you have seen in '291'—a friend of G.S. and Mabel Dodge. I would like much to see one of these new sensations of mine on a curtain scale—and I shall do something as soon as I can with the idea in mind for my own pleasure. I could not do the curtain of course—only the idea—don't tell of it freely because all concerned want secrecy. I tell you because I know you are highly interested.

It is very cool here in Berlin—rainy and cool—a great contrast to several weeks ago, though I didn't find it disagreeably hot. I think it wouldn't be as bad as Paris or New York. Mabel Dodge is in Paris and the Picassos came back to Paris because Céret where they were is being deluged with art-y people. He told G.S. he had to come back to be alone and get away from Americans and Russians and all kinds—terrible to be a fad in art of all things! What news in New York? Berlin is very quiet now after the festivities of last month. One sees little of the Kaiser now—and the rest. The streets are quiet, and all the music and theatres are about over.

Best wishes to you and all.

As always,
Marsden Hartley

ℐ

n.d. [July 18, 1913, Berlin] (postcard)

Dear A.S.,

Your letter received with enclosure for August. Many thanks. The exhibition is on in München—through July. I do not think it will amount to anything but publicity. The

pictures come here in August and lie around until Sept. and then only some of them are for the Neue Herbst Salon. I am rather confident that there will be connections in Sept. when Kandinsky and Marc and Herr Koehler are here—but now—I am entirely alone and will be until Sept. 1st. You see what this means—I shall need the draft for Sept. by the 7th of August—this will carry me over until other issues present themselves. I do assure you I shall be happy if once I can make my own way myself.

Gertrude Stein has written that she wants to buy one of the drawings which she saw in Paris which came back from New York.[1] She likes it very much—she is much interested but says she cannot buy pictures these days. The drawings are in care of my friend Rönnebeck the sculptor who goes to Florence in Sept. to do a portrait of Mabel Dodge at her request in Paris. Gert. S. is one of the few big and discerning people of the day. Her portrait of me in her play is very interesting.

I will write a letter soon. Berlin very quiet—and quite empty, weather comfortable. Please send the last draft for August 7th here—as I haven't the slightest connection here yet.

Thanks and best wishes,
M.H.

The last *Camera Work* <u>splendid</u>.[2]

1. Current scholarship on Hartley has not identified this drawing.
2. *Camera Work*, special number (June 1913).

⌐

n.d [August, 1913, Berlin]

My Dear Stieglitz,

I have your letter today and it is strange that somehow I who used to write letters so easily find it next to impossible too. My family has long since given me up as a hopeless proposition—but in the case of family—I have never all my life long confided personal problems with them—they know little of my life except as one merely attached to them. Unfortunately my friends I find are compelled to suffer in place of the family. You especially because you have been rather nearer to my existence than anyone else much to your distress doubtless are this.

I have felt sorry that I wrote you that last letter—I should have been more considerate—and while my cares and anxieties are but the trifles of one simple life—I assure you the problem for me is no less strenuous. If I had not the art conscience you speak of I could have settled the problem long ago—but it is long since too late now to make changes for the sake of a possible practical success. I shall have to continue as it is and

get on as I can, but when I did write I assure you I was in a black state. I had been so long besieged with negative influences and not one constructive one except the far off one at that time of Sept. when Kandinsky and Marc get here—which thank the gods is very near now, and then too when you wrote in July—the wording of your letter gave me the idea that the enclosure at that time was the last—and this gave me a positive chill as I could not see a space open anywhere and I really did think the end of things had come. No joking. This clinch game with life is no pleasant thing and I have had it a long time now.

As for being in Europe—well I can only praise the gods and thank all who have seen fit to contribute to my welfare. I am convinced more and more that I must stay here and work out my ideas—from many points of view. I am freer here in Germany and in Europe—and there is here just what you say is lacking in New York—there is a con-science—there is an art concept—and there is a reverence for it and a living faith in the idea in all parts of Europe. It is a part of the people—this is evident everywhere—and as for me personally it doesn't matter where I live so long as I can get some degree of pleasure or at least interest out of things. My life is barren enough in itself—I must be where the passing moments contribute most to the freedom of my spirit and the general welfare of my inner nature and so far I find it over here. I do not see that New York offers anymore now than ever only the same chances—perhaps a few more people near at hand with an interest—but these I hope to get here too—and soon—and there is every reason to have faith.

Kandinsky and Marc are very kind—Herr Koehler is extremely hospitable and highly disposed toward new art and new painters and I just feel as if I knew that there would be a connection there. Marc told me that it is through Koehler that Campendonk is able to work and I am sure Marc himself also for K. owns easily 20 of Marc's pictures and that indicates always. I would like to make such an arrangement too at any price. At all events I have got to pay for my little apartment for a year and a quarter—anyhow —that is fixed—I like Berlin extremely. It is healthy it is lively—gay and joyful and still it is not that mad thing New York is which you know too well.

The Germans from the American point of view are deliberate but they are in no sense stupid—they are sure and powerful and constant. The German is a fixed value— for me artistically it is stimulating strange to say. I find it full of mystical ideas and col-ors and I have begun to paint them—and temperamentally the Germans are good companions for they are seldom nervous and restless like the French—they always have a reserve power at hand, I like them—they are congenial spiritually to me. Of course the winter will be much more interesting than now, for my friends will be here—Arnold Rönnebeck sculptor my best friend who goes to Mabel Dodge's villa in Florence in Sept. to do her portrait returns to Berlin to live. He is now in Schleswig-Holstein doing a portrait there among the counts and dukes. He is a sterling fellow—

extremely intelligent with a decided talent for portraits—pupil of Maillol and Bour-
delle—in Paris. Then I am to meet Arnold Schoenberg ultra-modern musician—he
being very intimate with Kandinsky.

I only wish you were over here in September at the Neue Herbst Salon—I think it
will be a very interesting show full of life and newness—K. and M. come to arrange it and
I am asked to assist somehow. The Munich show is on and maybe over now—Laurvik
wrote me that he saw it—several times found it a great surprise and while it interested
him very much—found it cryptic and not altogether intelligible.[1] He says he thinks that
art like mine—like Kandinsky's and some others will have to wait a while because he
thinks it will be best understood by the one who is doing it. Dietzel is a superb fellow
and all to the good—I was glad to get finished with Goltz—I didn't like his face.

Yesterday I was taking my coffee in Café Bauer when I saw Laurvik pass so I went
out and got him and was glad I did for he had only about 20 minutes as he had to leave
for Hannover and Köln. Apparently he is over on an art job—he is enthusiastic about a
group of men in Buda-Pesth but I never heard their names—perhaps they will appear
in the Neue Salon—of course I don't know what Laurvik considers important. You never
can tell what the art critic actually knows—they write so well on what they don't know
generally. I was glad to see him however and rather thought I would see him for a few
days. I had been invited to go to the sea two hours north by a friend—and was waiting
for Laurvik as I knew he would be going to N.Y. and he could at least say he saw me
and so far he is the second New Yorker to see my work—the other is a fellow named
Demuth who will call on you in September. He knows Gertrude S. and is also enthusi-
astic about my work—he says G.S. has said some splendid things about what I am
doing. I do know that she believes in it—she very kindly took Rönnebeck aside one day
and asked him how I was fixed—that I was not a man who could earn a living and work
too and that she hoped I would send my pictures to N.Y. soon. She is in Spain now
according to her last letter to me—she is really a splendid person and so gifted with an
unfailing sense of values, qualities and depths and knows just where to place them, and
knowing her preferences I was naturally flattered with her overtures toward my work
as I am the only American she has given this attention—in fact the only other outside
of Cézanne, Matisse and Picasso—and all these favors were proffered—if it had not
been for her solicitations one evening I might be unknown yet. She was very anxious for
me to exhibit in Paris—but I told her there were only two places—Bernheim's and
Druet's and I couldn't afford either of them, but I shall show there some time.

And as I told you some time ago François Kupka who is another theorist of the
Kandinsky type came to my studio with Walter Rummel—pianist intimate friend of
Harold Bauer. Rummel being versed in occult things of which I know nothing saw
something unusual in them, and Kupka too said that they must be seen in Paris. I would
like all this very much but I can't do it alone—I would like to go to Paris in the winter
for this purpose and if there should be great luck it could happen—I bank on nothing

but existence and work—these must be given me—and it is costly business—I have to work larger now much—and every canvas cost me $2.00 alone. Naturally you see I haven't much leeway when I must count materials. I used what I needed in Paris because my credit was good and I have still a big bill to pay there sometime.

However my dear Stieglitz, I want to give you a feeling of hope—I want you to take your freedom—I am only too sorry that my life has been thrust on you—I have relied upon your perfect understanding—otherwise—how many times have I feared I might be imposing or perhaps ruining a too fine friendship—and I should only have myself to blame—but I know you <u>have</u> understood and have always had faith. How happy I shall be when that moment comes that I see myself making my own way here—I simply say to myself—<u>it must be</u>—it will be—I am in earnest I am not faking anything—I am living the life of one individual truly—there must be success here for me as anywhere else. The Germans must live just as I do—by faith—they have no more surety than I—I shall take my chances with them. I <u>know</u> there will be a change for I have more courage now to talk of myself. I can talk to Marc and to Herr Koehler and they are both human—the conditions and terms are simple anything at all—even if I send to N.Y. I shall fix European prices—because it is best in the end. It helps to create public interest and a better chance of getting money quicker. It is just possible that I may find myself a European in the end living over here and visiting America when I can—I really don't care. Life is life anywhere—and it is more stimulating generally here. Eventually I want to get about some too—I haven't traveled a bit yet artistically speaking. I really want a few weeks in Italy and it is not far really.

By the way before I forget—I want to tell you how fine the last *Camera Work* is—I think it splendid don't you—and about the Steichen number—I want to take a liberty.[2] Mary Steichen gave me some of her poems when I was at Voulangis last—and they are simply beautiful. I think Steichen would not object to your printing the one called the "Sky-lark." I have read to a lot of people and they all say it is exquisite—I think it would be a very pretty idea to print it in his number. If Mary keeps on she will be a real poet as she is in fact now. The "Sky-lark" is so simple so sweet—very like a Wm. Blake "Song of Innocence." If you write him on the matter tell him I say he must let it be printed. I love it—and have it in my pocket-book and read it often. Here it is:

> "O the Sky-lark! The Sky-lark!
> The beautiful Sky-lark!
> I heard in the month of June!
> It was nothing but a dark dark
> Speck. And nothing but a tune
> And oh! If I had some wings
> I would fly up to him
> And I would look down upon the things
> Until the day grew dim"

I think it extremely beautiful and for nine years old a splendid thing. It was with Mary and Kate and Steichen and Mrs. S. that I heard my first sky-lark and Mary gives a lovely feeling of it—absolutely a natural child's idea—a little soul's enthusiasm.

O as to that theatre curtain—well of course that is just a suggestion—the whole thing may never happen—but Florence Bradley is especially interested in having a theatre of her own for new ideas of lighting etc. and she wants to put on one or two of Gertrude S.'s "plays" and some other new things. She has money back of her—she was herself with Richard Mansfield. You will remember her well when she appears at "291"—a very chic dark-eyed tailor made girl with a slight tendency to mannish dress. I myself used to see her there. She is a very good friend of Mabel Dodge and Gertrude S. G. writes she was sorry I could not be present at a dinner she had for the Picassos—Mabel Dodge—Berenson the Italian art critic—Rönnebeck and some others. She said it was wonderful—the "set-to" as she called it between Berenson and Picasso—I can imagine it can't you.

I do hope Mrs. S. will find it possible to see me if she comes to Berlin—surely she will—I would so like to see her. If she does she has my address and can write me. Laurvik is the first breath of 291 I've had since I saw Mr. Obermeyer in Paris and that was so pleasant.

Well—you see I find it just the same this letter writing several days have elapsed since I wrote these other sheets. I can't seem to find the energy to write a better one— the days go on—quite in routine nothing to break the similarity of them. I go over in a while to the "movies" too and they are very wonderful here—probably the finest theatres for this in the world—of course typically German—ponderous in style or too ornate—the usual combination of purple carpet green upholstery and cerise and emerald green decorations—but apart from these details—they are so comfortable and it is so nice to see the American films—which are a feature here—and I like the *Wochen Chronik* very much—bits of life from all over Europe. Kandinsky and Münter (Frau K.) are very fond of the "movies" and they said in Munich O you will have such fine cinemas in Berlin—later they said but come to Munich and be with us here—Berlin is so *verrückt*. Although Münter has been in the U.S.—in Texas and elsewhere—she doesn't realize how simple Berlin is after New York.

There is a great deal to be enjoyed here and I know the winter will be very agreeable for I shall have entrée to a number of the theatres through friends etc. I wouldn't object in the least to living over here—there is more for such as myself to enjoy in general— and if one can do any traveling one can get for less money to much more interesting places. Instead of Phila, Chicago, and Pitts, it can be Florence, Venice, Paris, London etc. I only know that now it is absolutely essential for me to keep close to the European problems—it takes time—and it only needs but a few individuals who believe and they have a greater faith here—a greater discernment. The American prefers the negative point of view first—he is by nature skeptical—the European knows values.

I was looking forward to seeing Laurvik here as I thought he would have a deal to tell me about everybody in N.Y. and what he has seen here—but in fifteen minutes one hardly says hello—and so he was off—just by chance I saw him at all—as he was passing Café Bauer—and he said he had put my address in his trunk and couldn't have found me anyhow. He likes Picasso very much—thinks Matisse is the vulgarest of rotters etc. I must say that though I like Matisse for certain things—his last show in Paris showed a decided "slip-up"—they had a Van Dongen look which is in itself enough—no one can be more ordinary than Van Dongen. He gives up all his time to painting French demi-monde in bathing at Deauville—and other resorts. One or two of the Matisse's were very rich—but even Gertrude Stein said Matisse doesn't interest her as he used to. Outside of the "Femme au Chapeau"—and one or two others I have seen I wouldn't care to own them—though he always has a certain quality—though it never comes up to the Picasso thing. He is still the artist par excellence—as to quality nowadays I don't know that I always like all I see—but I always like his depth. It doesn't come out in any of the other men—none of the Cubistes have it—nor Delaunay nor Picabia—who still is for all I can see intelligent but has no depth.

In one of her letters to me G.S. said "I wish you were here to meet the Picabias. I see quite some of them these days—they are very charming socially and he is really a drawing-room version of Picasso—he is intelligent but has no genius"—"he has harmony but no depth." As for a show of Kandinsky in 291—it is a good idea—but nowadays he is painting so large—and I think not very much. I don't know if you could get his things up on the wall there—Marc also. I like Marc's things very much—but he too is painting great big things. K. is I think writing very much and thinking a lot—his last letter said—"I find it very difficult to get the work done—in theory very simple—etc."

You would enjoy Koehler's collection very much—it is very interesting—only one Kandinsky—and that not very much to me—"Impression Moscow." I wish I could feel a little more warmth in them—I wish I felt that they were really "creations" and not laboratory demonstrations—because after all a painting still must have that quality of "picture" about it. The same with François Kupka—in Paris—there is nothing whatever in them of life—they spring out of philosophy and do not burst out of experience. And to me this is what this kind of thing must be—everything I do is attached at once and directly to personal experience—it is dictated by life itself—as a result each thing is different—it doesn't repeat a theory or a harmony. O well so it goes—I like Kandinsky because he is essentially constructive—he is ever ready to give credit to all things according to their worth. I still think though that later on he will have proven himself the theorist of the period.

I am so glad to know you find time to do a little work of your own—and glad too that you will do a print of me for Gertrude Stein—as I know she wants it and will be glad to get it. She won't be in Paris much before October 1st I think—they are in Spain this summer—she and Miss Toklas who lives with them and who is a charming person and

stunning looking—extraordinary—very dark—gypsy-like. They are a great team on the street—G.S. all round and fat—and Miss T. slender and angular and both individual dressers. G.S. always with a cane.

I hope next time I write to have real constructive news to offer you—something will certainly happen I know. In a few weeks now the Neue Herbst Salon will be in preparation—I will see that you get the catalogue of it. They have asked me for photos for the catalogue but I am never able to indulge in this expense. Perhaps this winter it will be possible—I have long since wanted to send some to you in N.Y. but it has not been possible. I shall make plans however to send the pictures over so that they have the chance of being seen. Naturally you and the others are interested—you will find them alive—with a new life in them—new as regards myself for they are the result of a personal interior development. I should like much to see Walkowitz's work and Marin's too—I have very great admiration for Marin as an artist—I think he is the greatest water colourist of the time—without doubt, for sheer mastery artistry and all. There is nothing anywhere over here that touches them.

Give my very kindest wishes to Miller when you see him—also Rockwell Kent if he should show up—I have corresponded with him ever since I came over irregularly. He is such a sterling chap so genuine and fine and his wife so lovely and such babies!! I told him once just to make babies and nevermind art that will come to him—his children are the loveliest I ever saw I think. Best wishes also to Haviland, De Zayas—Kerfoot—Lawrence—Marie—and all others—Mr. Obermeyer also. For yourself always my deepest thanks and best wishes. I hope the Lake George season will do you good. I know you need rest if anyone does.[3]

Always your friend,
Marsden Hartley

Eugene writes he has accepted professorship at Leipzig I think. Better conditions.[4]

1. Hartley refers to the group exhibition which included his paintings at the Neue Kunstsalon of Max Dietzel in Munich. See also note 1 page 86.
2. At that time Stieglitz was working on an issue of *Camera Work* devoted to Steichen. Eight-year-old Mary Steichen's poem, *The Skylark,* was printed in *Camera Work* 42/43 (April–July 1913, published November 1913): 14.
3. The Stieglitz family estate, Oaklawn, was a large property at Lake George in upstate New York and a regular retreat for extended family and friends. It was purchased by Stieglitz's father in 1886.
4. In September 1913 Frank Eugene was appointed chair of nature photography at the Royal Academy of Graphic Arts and Book Design in Leipzig. He later became the head of the photography department until the school's closing in 1927.

❧

n.d. [August, 1913, Berlin]

My Dear Stieglitz,

A line from Café Bauer to acknowledge letter with enclosure—thanks so much. As regards the remaining 200 mks. if I could have them not later than Sept. 12th it will keep things going—after that I hope to make good connections—and most of all I hope to rid you of the nuisances in general of sending and thinking on my behalf. It's no use wasting words—you know my gratitude. Perhaps it is some satisfaction to you that I have come a little into my own in Europe through all your faith and through faith in myself. I am arriving—as Whitman has it—"serenely arriving arriving sooner or later." There need be no great hurry about a real thing—some flare up in the light with a flash—some come to a flame slowly and surely—I am one of the latter. I have much to do for the ideas I have—but it is all a quiet natural expression—nothing overwrought— nothing highly specialized—nothing hectic in the least—I have more of this in my make-up. Berlin is helping me much—I am getting a something from the German life impulse which is most excellent for me. It gives a new crescendo to my sensations.

When I send my things to New York later in the winter I hope to send some of these done in Germany. They are in all cases myself with little outside reference—except one I am finishing large—a mystical presentation of the number 8 as I get it from every- where in Berlin.[1] Of course you know that mysticism was very strong in Germany— and the element remains although not as strongly religious as once. One instance is that everywhere in Berlin one sees the eight pointed star—all the kings wore it over their heart—the soldiers on the forehead—I find also the same stars in the Italian primitives. There is a real reason for all these signs but it remains mystical—and explanations are not necessary.

I am taking a few days off at this time just to see Berlin—just as if I had just come to it—and it is quite fine. It ought to interest the tourist eye—I am very much a citizen of the place—I am at home—I have no complaints to make of it. The season of theatre and opera opens this week. I am going tonight to see Reinhardt's Faust (1mk.). Later I will have free access through friends—so I think the winter will be very pleasant.

Gertrude S. writes from Granada that she will be so glad to own my drawing. I know she liked it—she will write me more of Spain soon. She will be glad to have the photo you have made of me—I am so glad the plate is not lost as I like it so much as a por- trait and it seems to me so expressive of your "straight goods" photography. I have a feeling that real photography is coming into its own yet. I think the camera itself is able enough without prestidigitation. Don't you? Surely you do.

Had a nice half hour with Fraulein Frohberg from Brentano's—you remember her of course—she went home to Dresden—is very keen about the Neue Herbst Salon and is coming to Berlin for it. I hope to go to Dresden when my show is on there and it will be nice to find a friend—I used to see her at Rockwell Kent's house.[2] I saw Franz Marc

and Messrs. Koehler a week ago for a moment and they are all eager for the Salon—
Koehler is backing it I am sure. They have asked to see me early in Sept. and want me
to help in it. Later I will of course have more to tell you as in two weeks things will begin
to hustle generally.

Best wishes to each and all. I hope you will enjoy your Lake George sojourn. You of
all people ought to go somewhere and just do nothing for a spell. I will write Mrs. S. in
Paris, am sorry not to see her. It would be so home-like to see her. I hope Kitty is fully
recovered too. Best wishes.

As always,
Marsden H.

1. *Painting No. 48, Berlin* is now in the Brooklyn Museum of Art, New York (see plate 3).
2. Brentano's bookstore was located in New York's Union Square. An exhibition was being organized
   for January 1914 at the Galerie Arnold in Dresden with many of the same works planned for instal-
   lation that fall in the *Erster deutscher Herbstsalon* in Berlin. It appears as though Hartley was
   invited to exhibit in Dresden; however, in a letter from Hartley to Franz Marc (n.d., November,
   1913), Hartley implied that he was unable to submit additional pictures for this show. He told Marc
   that he could not leave any more paintings in Germany. See McDonnell, "Marsden Hartley's Let-
   ters to Franz Marc and Wassily Kandinsky, 1913–1914," 42. See also Klaus Lankheit, ed., *Wassily
   Kandinsky–Franz Marc Briefwechsel* (Munich: Piper Verlag, 1983), 239.

<center>℘</center>

n.d. [September 22, 1913, Berlin] (postcard)

My Dear Stieglitz,

Just home from the opening of the Herbst Salon, and Café Josts with my sculptor
friend Rönnebeck. The lights have just come on down the Leipzigerstr. and it is so
beautiful. The show is great. I am splendidly hung with five pictures. I should like to
have been in the catalogue but I had no photos of the stuff. The banquet was last
night—very nice group of awfully simple people—Monsieur Delaunay and Madame D.
in an orphistic dress—Delaunay's display is really lovely. I am very fond of this man's
work Paul Klee. He is very fine as a person. Will write at length soon, and send cata-
logue—etc.

Best wishes,
M.H.

Had a lovely letter from Mrs. S. from Paris.

The banquet was very nice and little was said of art though of course Delaunay had
his usual discussions. Everybody got happy and then we all went to a *Ballhaus* in

another quarter and finished the night. I was the only American present, Germany—Swiss—Austria—Armenia—France, Amerika. Kandinsky not there—but Marc—Macke—and many I did not know. The Messrs. Koehler of course.

<p>ℒ</p>

n.d. [September 28, 1913]
Nassauischestr. 4
Wilmersdorf, [Berlin]

Now my dear Stieglitz—let me ask of you—patience and indulgence. I've <u>got</u> to get over this rotten spot in my experience—I am literally in a hell of a state and I've got to survive it somehow. After waiting five whole months with the hope of talking matters over with Franz Marc and then as I expected—Herr Koehler—Marc writes me to excuse them from leaving Berlin so abruptly but that they were very tired from arranging the Salon—etc. and that they would come to see me in January he and Frau Marc. You see this left me alone with the problem—so I braced up and wrote Herr Koehler a frank straight forward letter stating my precarious condition and asking if he would find it possible to take some of my work at his own price so that I could continue. I have waited nearly a week for a reply—being terribly nervous all the while—when the son's letter came this morning and I read it I fainted from the shock of the negative reply—(in English) that he was sorry he could not add any more artists to the list he was already helping and that besides the Herbst Salon had cost him a great deal etc.

My dear Stieglitz I assure you it was a terrible blow as I had every reason to believe he would want something of mine—he having been cordial—the son telling me how much he liked two of the pictures especially. Herr K. senior showing me the various pictures he had bought in the Salon—Chagall—Boccioni—Léger—Feininger etc. I have been literally sick for days with nervousness as you know well how I suffer through and through under these crises—and I simply reeled over when I read what he said because the decision threw me into immediate chaos when I firmly expected it would lift me out of it.

Now I simply have <u>got</u> to <u>survive</u> the situation—I can't go under when professionally I am having good success—I simply can't—I must live—I must progress—there is a way somehow. As a last resort I cabled to you to raise $100—for immediate expenses. I have <u>got</u> to pay 160 marks for my *Wohnung* in spite of everything—and keep afloat until the next move. After I recovered from my sickness the word America came across my mind—that I had better go over with my pictures in Nov. and try to raise money to come back and strengthen my European career. I can't hope for practical success until I have established myself—and this takes time. I have ready access to all opportunities.

But I've got to make decisions at once. Do you advise going over with the pictures? Perhaps by being there myself I could connect somehow—perhaps through Davies perhaps otherwise.

I can't afford to live in New York after a place like Berlin—I could not go back to that awful life in those old 14th St. houses and all other places are too expensive. I could never get rooms such as I have here for such money 160 mks. *vierteljährlich*—and apart from all that I find material for suggestion in work here—I have spiritual freedom such as I have not known before. I could not accomplish in New York what I can here because life is against me there—and I simply <u>have got</u> to go on. I can't give up a game at the beginning. There is a way out of it. I know the cable will be a shock to you but I am in most terrible distress and I've got to get out of it, and I felt that perhaps somehow the Photo-Secession could make one more effort, or that you personally would find a way out. My dear Stieglitz—I am testing a friendship in a way that it ought not to be tested—I know that, but can't you see my position here—with financial obligations—professional success—and not a sou to meet either of them.

I suppose I should have looked still deeper into the problem but I had been lured here by every sort of indication chiefly through the commercial success of all of the men here—and I know that in time there is a practical success because people are buying modern things—but you see I haven't gotten about yet professionally and it takes time. But in spite of all that I've got to go on—I have gotten into my own field of expression—it is like no one else—it is essentially personal. It is as one Munich painter said Baroness Werefkin "the first time the mystical element and art have come together in modern art." All this I know. I have simply got to take the courageous point of view and hope frantically still—I have got to go on and perfect my work.

I beg of you therefore see the problem with me not as simply helping a man to eat but as helping a being with ambition to keep from sinking. I can't end a game so auspiciously begun—that you know. There will be some kind of remuneration somewhere—I would have to take my pictures out of the Herbst Salon at least three weeks before the close and forego temporarily expositions in Hamburg, Dresden—Leipzig and elsewhere—but that could come later. I have had success enough now professionally to establish me as one of the individuals of Europe among the moderns and one of the two or three Americans really doing anything.

I shall go into the steamship co. tomorrow and find out what the rates are and maybe I could leave here Nov. 1st with my pictures and be there when they are opened. This strikes me as one practical way though I do it only with the absolute faith in getting back so I can live and work naturally. Other Americans have to do this for their progress—perhaps it is what I have to do also. Anyhow I can only make continuous apologies for asking you to help me get through this awful experience, and I am absolutely alone here—not a soul to confer with.

I have to look at this problem objectively—I simply cannot suffer the mental distress that overtakes me and the physical pain too under these conditions. I am a single person fighting a fierce stream and I can't swim without help. Help me therefore all you can until I get my head above water again and I shall hope to make some kind of amends for all things. I can't give up a good life game—I must live it. It is my right.

My thanks to you for your efforts and any advice you have to offer as to going to N.Y. will be appreciated.

Your friend always,
Marsden Hartley

∽

October 2, 1913, Berlin (cable)
Led Alfred Stieglitz,
291 Fifth Ave, NY.

Koehler says not now conditions hopeless will you cable <u>sixy</u> [sic] dollars see letters shall I sail with pictures November first. Hartley. 7:15 PM

∽

n.d. [early October, 1913, Berlin]

My Dear Stieglitz,

Your nice letter from Lake George this morning. It is so fine that Walkowitz could be up there—I am sure life must be also a monotone for him—but he is a very simple being and very genuine—I am glad you had him as an associate. I have never gotten over the loss of the place—there is not anywhere and cannot ever be anything like it. It would not exist in Paris because everybody is for himself there. It has a kind of replica in the Koehler contingent here—because Herr K. is decidedly interested though I think he has to rely largely for his intelligence upon those around him—but it is an organization here as only Germans organize. Herr K. is the substantial head apparently. Herwath Walden of Der Sturm a very keen business manager and then Kandinsky, Marc—Macke—and all the others for features. They seem to have a whole chain of galleries all over Europe—Germany chiefly of course. Walden as a manager sends them round etc. but for all that it is not just like our '291' and could not ever be—but there is a strong spiritual bond among them for all that. And they only ask for earnestness and

sincerity on the part of the artists and let the greatness take care of itself. That is what makes the Herbst Salon so fine.

I do not quite see the importance of the Delaunay exhibit as to size—though I must and can say his show is a pleasant thing to look at—but his wife Sonia Delaunay-Terk has also a big collection—pictures—book covers—sofa cushions lamp-shades—all demonstrating the Delaunay method "Simultanie." There is a table full of books—leather backed—and pasted with patches of colored papers—charming color effects but coming to little as real expression. A big placard on the table "Premiere Livres des Simultanie" and at the banquet she was dressed in her own creation—a dress of simultanie color effects, amusing but not outside of the most ultra circles of Paris where aesthetics run mad.[1] They don't seem to understand—these aesthetic people—that aesthetics are foreign to the majority and art not so far off from them as one thinks. And one is not more wonderful for a wonderful dress—or a new trick. I don't care only it has a look of politics when <u>one</u> person figures so openly in a universal show. Even Kandinsky with his eight large pictures—one of them enormous—still remains in his proper place.

So here was a pause—naturally I have much on my mind. The letter of Sunday is doubtless a bit frantic as I was in a frantic condition. Affairs are more the less strenuous today however—my cable will have shown that as I certainly would not think of cabling otherwise. It is difficult to know what to do, I shall have to know this soon. I shall in any case send the pictures in November—if not all at least enough to give a full idea of the trend of ideas—I think strongly of the idea of going over with them in the hope that my presence would help some to effect future conditions. I even think it would be possible through Davies to accomplish something. For some reasons I ought to go over—my father is old—it is now a year and a half since I saw him—I may never see him again unless I go to him—but the cost is so great—and since I cannot help myself—it seems impractical in one way to raise expenses for travel and lose all the time when I could be living quietly for the same money here. But I must continue my life and my work somehow. There is some way out of this crisis—if you advise my coming over with the pictures I would do so—but of course I must keep before me the one idea of returning as I have my *Wohnung* here for which I must pay anyhow and it is not possible to keep two schemes going.

I have found a source of creation in German life—I have established myself in the European art scheme. I can have exhibitions everywhere—all this I would have to forego by staying in America. It cuts progress in two—the idea of not remaining, but I have hopes that what other people can do I can do also. If a man like Davidson can go over there and raise thousands—surely I can raise a meagre existence. It is a great shock to me the refusal of Koehler—but I know too that the Herbst Salon must have cost him a big price for it is in a huge new *Möbelpalast*—and everything is carried out to a perfect finish—of course I still think that later all these things will come—because the German public is keenly interested.

Just this morning a letter from my friend Rönnebeck in Paris says he recently saw Wilhelm Uhde and U. said that Cassirer the Berlin dealer had just been to see him to make arrangements with him for a lecture on the modernists dealing especially with Picasso and what comes after him. This is of course obviously a sensible business trick as he had engaged Meier-Graefe on the subject in January when I was here and M.G. disclosed himself openly on the question—and explained why he had not written anything on Matisse or Picasso even. Neither he nor C. would go beyond Cézanne, but they both realize that something is happening and that there is a percentage of public ahead of them and a great urge forward among artists. Naturally Cassirer doesn't want to find himself a back number it would spoil business.

Then the Herbst Salon must prick their intelligence some. It is a great stroke really this show—it proves that there is beyond consciousness—another consciousness—"that beyond the eyesight is another eyesight" as Whitman puts it. For myself I know that art has never before gone so deeply into psychic sensations as it goes now—it is more noticeably so among the Germans than the French whose problems must of necessity amuse the intellect—but there is something beyond intellect which intellect cannot explain—there are sensations in the human consciousness beyond reason—and painters are learning to trust these sensations and make them authentic on canvas. This is what I am working for—it has its best expression in the last work of Cézanne especially the water-colours which are from my point of view pure mystical expressions—without symbolism of course—but they are excursions with a new sphere. It is from these that I jumped off into my ideas though for me there must always be a symbolic shape or an approximate—because that element is strong in my nature. It is this element in German life which stimulates me to express my ideas and sensations. The German is most essentially a symbolist and there is every evidence that mysticism has had its home here. England had Blake but Blake was not English—he was mystic which is without nationalism. I am mystic too, but what I want to express is not national but universal.

It is in these last six months that I have come fully into the consciousness of this element in life and in myself. You will when you see the pictures see, also the authenticity of the sensations. For this reason it is I find myself so at home here in Germany, and for this reason I must live here. I had hoped for a perfectly free winter so that I could work well after so many months of general turmoil getting here—getting here materially— and getting here spiritually. I am "here" now—and if I must go to America and be surrounded with a whirlwind of unnecessary influences my winter is spoiled. If it were summer it wouldn't matter so much as summers are apt to be interrupted. It is so essential that I go directly on here—but how? I cannot solve this alone—I must attach somehow to a supporting influence and at once.

Here I must seek advice on the practical side—do you advise going to N.Y. with the pictures? Do you not think that my mere presence would help some? I could talk a little to intimate persons of my ideas—though I could not and would not attempt the

French style in any event. What I have to express is not handled with words—it must "come" to the observer—it must carry its influence over the mind of the individual into that region of him which is more than mind. The pictures must reach inward into the deeper experiences of the beholder—and mind you they are in no sense religious tracts—there is no story to them no literature—no morals—they are merely artistic expressions of mystical states. These in themselves being my own personal emotions as drawn from either special experience or aggregate ones. You know that I have the belief that this is the only element in Van Gogh which will hold him great as an individual. I am formulating some ideas of all this on paper—following as well as I can the mystical tendency in modern art. It is the paramount essence of Van Gogh—it was far greater as an influence in Cézanne than his aesthetic ones. At least those things which the artists have taken out of him and "abused" to my notion artistically speaking for they have perverted the original meanings of them which were not intellectual in Cézanne—they were subconscious—super-normal—because he had an eye which "saw" a new depth—and this was vision whereas they have made only new intellectual surfaces.

I have made interesting parallels in literature—Van Gogh with Francis Thompson—Whitman with Cézanne—they are all cosmic—mystic in their quality—varying in degree of course—so far as I have seen I have never found Van Gogh interesting aesthetically—always spiritually. It was his soul which was paramount. He contributes "himself" to art—which is after all is said is the greatest contribution—it is better than ideas and intellectual subtleties. And then among the mystics proper—Boehme—Silesius—Tauler—Ruysbroeck, Novalis—etc. one gets again qualities of self—as the reading matter or ideas in them is always inclined to monotone. It is the distinct personal essence which pervades their writing which makes them direct contributions. Blake is derived from them too—aesthetically he was not so great because he followed the academic Flaxman too closely. So it is after all just this quality which makes an art great or greater. It is what beautifies a man like Redon for instance—artistically he is charming—but not great. He is much greater as spirit because he is a visionary.

You will not forget that when I came to N.Y. with the landscapes—Davies said of them that it was essentially the mystical idea of color. I balance it now with Gertrude Stein's declaration that I am the first since Matisse in his early career to express color just for itself, and that my pictures as pictures are essentially mine. She sees also that there is in me an element separate from all others. I name it mysticism because I know that is its essential characteristic. If I had been an ardent Christian in early times I suppose I should be painting vivid ascensions and crucifixions—as I am not I am simply painting vivid sensations of finite and tangible things. It comes into the modern tendency therefore and harmonizes with it—so far I am alone in this special variety of expression. My nature itself is in direct contrast to intellectualism—to all attempts at scientific problems in paint. I keep to my sphere which is certain, which I understand

perfectly and do not allow aesthetics to carry me off into groups and schools as it does nearly everyone who lingers in Paris any. Paris is essential to every artist for a little— Paris is the most dangerous place for a real artist to remain in, unless he has the personality of a Picasso which established itself perfectly all along in spite of Paris. There is absolute personal development all through Picasso as there was all through Cézanne.

So it is that spiritually speaking I have wisely chosen Germany. My vision was a true one as it is proving itself—it is the place of my freedom as artist and as individual. It stimulates the roots of my being. Paris would have stunted me—America would stifle me in the present condition—and besides I am American anywhere and I am not American at all. I am of no <u>place</u> really.

So it is I mean that perhaps my presence there among the pictures would effect something. If you think it important of course I would go with the pictures, but it is the practical issue that troubles. It means $100 to get there—and then to live all the time besides which is more expensive—though in this sense I have more friends to be with— I should like to see my friends dearly. It would be a good investment spiritually—but I have to see the value of the idea. I await your decision—I have no money, not a sou. It would have to come from the genius of good—either if I go over or remain here—I must do one or the other thing. I must live and continue. There is a reason for my being. I would be willing to sell the stuff very low—if I could raise a fund to live on a year. I have put $200—on the pictures here in the Salon. They are much larger than I have ever done before, but that doesn't matter. Perhaps the lowness of the price would induce purchases, and it would only take the sale of five to allow me to live on practically a year—though I would like if possible to feel free with materials and travel a little. You see how I am reaching out to the true proportions of the ideal. It is not so ridiculous. It is as artist I ask indulgences the luxury of freedom—and freedom <u>now</u> is the one essential.

Anyhow I have presented you the problem—you have some of my ideas—I would like exceedingly to be with you a few weeks if only for this reason to express myself to you and be of record if possible to the beautiful idea of "291." This would be worth the expense rightly seen. I am a part of it and feel myself a spiritual factor inasmuch as my heart is more in it than any other organization in the world. It was there that I found spiritual shelter and food. Why should I not be ever devoted? I am reminded in all this too of the struggles of Van Gogh and of the devotion of the brother but for whom doubtless he could not have arrived so positively. He had yet to say his say and if his mind had not deserted would have done some lovely things. All this I hope to do. The present output is an indication of what can come with freedom. I can only ask you to think for my problem—I can only create the vision as you see—I need supporters around. It is not unfair to ask it of the genius of good will. Therefore think and advise and I will act. I simply present the practical and spiritual necessity of either returning

here or remaining. I have all Europe before me—I have made a favorable entrance into the art world—I have the rest at my disposal—I could not operate in Amerika as I can here—so that is why all in all Amerika is so negative as a permanent issue at present. Maybe in a year from now it might be the heaven of heavens for a modern—as yet it is not as you know.

Very best wishes to you and all. You will understand the cabling so I will not attempt apologies. I had to take the only course open. Write at once what you think of the whole business. See how I can build some kind of structure for my problem. It is possible somehow somewhere.

Always your friend,
Marsden Hartley

1. Delaunay used the term "simultaneity" as a means to explain his painting from this period as a fusion of ideas and subjects often separated by space and time. His method employed a synthesis of visual imagery by combining those objects associated with the past, present and future thus creating a simultaneous viewing experience. For a greater discussion on Delaunay, see Virginia Spate, *Orphism: The Evolution of Non-Figurative Painting in Paris 1910–1914* (Oxford: Clarendon Press, 1979).

⌐

n.d. [early October, 1913, Berlin]

Dear Stieglitz,

I write you frequently at this time only to give you conditions complete—a note from Franz Marc this morning—I had written to him knowing he is most intimate with Herr K. and asking advice for immediate action.[1] His note is as follows:

Dear Friend,

Your letter which tells me of so great bitterness gives me a painful emotion. I hope that K. will help you in this moment. I have spoken of you to him and of your situation. He feigned to give not much attention but I know his manner in those things. He hears all very well and one day he comes with an offer or he will buy everything but it is not allowed for us to persuade him. Good luck! I hope to receive a better letter as soon as possible of you. etc.

So here is the situation—possibilities all around surely for a later time—but nothing doing anywhere now and now is vital. I know by the many Marcs in K.'s collection that this is how Marc lives. I know too that Macke is in his train—Campendonk too—all married—this means something—and I don't know who else. Kandinsky has private means evidently for he has a large apartment and lives well—of course all this is much cheaper over here—servants cheap, and rents. I know well that Marc could not tell me

all this if it were not so. You see K. has done a big thing in getting the Herbst Salon before the public and then he had bought at least six pictures before I approached him and doubtless he has his peculiar ways too—as I know his son and all of them attend him like a king. He is a very simple German person—extremely so—kind and tender—but I suppose he has to wait until his emotions move him. All this would come to me in time because I know he likes the work and sooner or later would make a proposition. I am the only one in the show among the specialized individualists whose work he has not bought and I know he would come to it. In the meantime I shall have to proceed somehow and get on. I have come into a good proposition generally—and can have exhibitions everywhere as Marc told me in May—and all these conditions are highly satisfactory.

I shall send the pictures over early in November and if you advise my coming too I would want to do so. Of course I haven't a sou for passage or for living here as you can see. I simply watch and wait developments hoping all the while ardently that some influence or other will let me go ahead and work as I cannot now because I cannot buy materials—and when I think of how all these expenses would double in returning to New York to live it is impossible. By remaining or going over and returning I could carry on a logical scheme in a systematic way. If I go over there would be a pile of money consumed all with complete idleness for weeks and yet it might be practical. Do you think it would help—my being there? I don't know—it might—inasmuch as there are those who would be interested in seeing me. Then there is Davies and that lady friend of his who took me to Havemeyer's and bought from D. one of my still-lifes—at least I think so—I know she came several times to 291 and showed real interest. I would make a point of meeting her.² Perhaps it might magnetize and pull together enough to return and proceed on—but the expense would be great.

I leave all this to you to think over and advise, but you can now see the problem—the favorable for remaining here where I can work well and where all things will come and of New York where all things are unfavorable for living. I have all the advantages of European life—coming in contact continually with all the art of Europe—and in another six months or more I am confident practical good would come of things. I am doing little but contemplate the problem these days and completing what I have on hand so they will be dry and ready for shipping early in November. I cannot start new things because I can't buy the materials—every canvas costs me 12 marks just as it is—and then I have to buy colour and I use much there is no way of economizing on these things. The expression calls for freedom in this respect and I haven't it. It is very inspiring in itself to see raw canvases standing waiting for ideas—it creates vision—and that is the only way I work. I have no preliminary processes I go directly to the idea.

Anyhow write at once after you have received all these letters—and tell me how to act. I must get the problem of rental off my hands this next Monday—200 mks. for

three months—and then think how to get on otherwise. In many ways I favor the trip to N.Y. and yet I think of the cost and the time—at least 6 weeks or over of idleness— and I've already had a great deal since April—enforced through conditions.

But you see Marc knows K. and he knows his ways—this is certain to come sooner or later but now is not the psychological moment. I have not replied to Herr Koehler Jr.'s letter as yet as I have to think how to do it tactfully and yet impress the idea of necessity gracefully. It is a great pity when one purchase would settle the immediate difficulty.

So it is—I am recovering from the shock though I am not feeling well as these nervous suspensions are not good for my make-up—I don't get fat on them—try as hard as I will. The ever present shadow of disaster does come in a little and blight my courage some—though I am thinking only constructive thoughts—knowing that good must and will be the result. But of course I know that only co-operation can effect anything for me.

Best wishes, you know well enough how grateful I am for any constructive efforts you can conjure up.

As always,
Hartley

1. Hartley sent a letter to Marc on September 26, 1913 detailing his financial problems and desire to place his paintings in the Koehler collection. For a transcription of this letter see McDonnell, ed., "Marsden Hartley's Letters to Franz Marc and Wassily Kandinsky, 1913–1914," 41–42.
2. Davies was very close to Lillie P. Bliss, a significant collector of modern art. Bliss purchased a work by Hartley from Davies to help finance Hartley's trip to France. She had also been the one to arrange for Hartley to see the Impressionist paintings in the collection of Louisine and H. O. Havemeyer, which happened to be his first actual viewing of paintings by Cézanne.

∽

October 6, 1913
291 Fifth Ave., New York

My dear Hartley:

I can imagine your consternation at the outcome of the Koehler matter. I am awfully sorry. Naturally your cablegram staggered me. It was impossible for me to cable you any money. I didn't have it. I hope your friends have helped you along until you receive this. Prepare to come home. Of course come home the cheapest route, even if you have to take a slow steamer. Some of them are very reasonable and first class, even though slow. Possibly you coming home will be after all a blessing in the skies for you. I shall write to you as soon as your letter arrives.

Yours in haste,
[Stieglitz]

October 11, 1913
291 Fifth Ave., New York

My dear Hartley:

Your two letters arrived. The one written after Koehler had dashed your hopes to the ground and which caused you to cable, and the other written a couple of days later when the panicky feeling had somewhat evaporated. I have weighed the matter thoroughly. It has been uppermost in my mind in spite of the great demand upon my time from all sides seeking help in the shape of money and advice. Money is scarcer than old masters. As for advice, even that takes time, wherever it is of practical use I am only too glad to give it. Otherwise it is so much time wasted. I feel that you should come over with your pictures. The rest will shape itself. Of course I can understand your desire to get back to Berlin and continue your work over there. My advice is to bring all your paintings etc. along with you. Keep your *Wohnung* so that it is open to you to return when you are ready. The risk you take is but small. The main thing is to have all your best work here in New York. It won't do just to have some of the good things. What you are after primarily in your coming is cash. And cash must be raised. And in order to raise cash one must be able to tell those people when approaching them, that they are having the choice from all your work. They are a suspicious lot over here. Of course your coming will give us, you and me, an opportunity to talk over many things which may be of real practical value to you, and make your future just a little easier.

You forgot to mention how much it will cost you to return, but I have figured it out that on a slow steamer where there is but one class and that class is good, the price is very reasonable. Steamers of the Pennsylvania class Hamburg-American Line, I believe are of the type I have in mind. I have had good friends who were wealthy, who came over with their families that way and who were very well satisfied with the boats and the food. My own sister-in-law and her children traveled on such boats.

I am enclosing a check for $150.00 which ought to bring you over and pay your extra freight and incidentals. As a matter of fact you ought to have money left over. I am taking this money out of my own very small capital as I did the $60.00 I sent you. I will take this equivalent in paintings. I don't know now that there is free art, whether you must go to the consul or not to get papers to bring over your own property. You can find out for yourself. If there is anything of interest in the art line that you think ought to be shown at "291" and you can bring it along, why it would be welcome. But remember to let anybody know from whom the things are loaned, that they are loaned at the party's own risk and we assume no financial responsibility. Of course this is just an idea of mind. Don't waste any time over it. Should you see Kandinsky or any of his friends, tell him I have not written about his show as I have been waiting for the tariff bill to be passed.[1] I will wait now until you come back before I write to him.

Drop me a postal or a letter on what steamer you are coming. Mrs. Stieglitz returned day before yesterday. She was very much surprised when I told her you would be here in November. With kindest greetings, always,

Your old friend,
[Stieglitz]

1. Thanks to John Quinn, lawyer, noted collector, and crusader for the moderns, on October 3, 1913 a bill was enacted that no longer subjected art less than twenty years old to a fifteen percent importation tariff.

⌒

n.d. [ca. October 13, 1913, Berlin]
My Dear Stieglitz,

I want to give you all points of development—Friday came a telegram from Gertrude Stein—"Go to Am. Exp. Co and call for 200 frcs." I had written to ask her for 100 frcs. the price I had made on the drawing she wanted and explained my difficulty as a reason for asking her for it—that I had three months rent to meet. She very kindly sent me double the amount which covered my rent and which I paid gladly yesterday with great sense of freedom.[1] That is one relief.

Today she wrote me most sympathetically—and said she wished she could be the one to make things right for me and that I ought not to have this trouble—for "I consider you one of the important men of the present time." She said isn't there someone in New York who could give you $100⁻ a month—you need that, she said to my friend Rönnebeck who saw her Saturday. Naturally he knows my condition being my closest friend. She said she thought it would be better if I did not have to go to N.Y. as I was not the one she thought who could "explain" my work—that it did not admit of the usual method of explanation etc. Also she said she had written you from Granada saying she would send you the play in which I figure—and she asks me if you would not be interested in publishing it together with reproductions of my work. I wrote today to tell her to write to you and speak of it and that I would do the same. I know you said once you would reproduce something of mine—now is a fine time and I would love it so much to be an accompaniment to this last thing of hers which she herself considers one of the best she has done so far. I am very glad of the things she wrote me and the things she said of me to Rönnebeck which he sent to me today. I know she has me very much in her interests and she told R. that I was to her "the most important man of the moment." I give you this as her statement—it is worth just so much. I don't over-estimate it—I know what it is worth to me just as I know what it was worth to Matisse and Picasso when she was perhaps their discoverer, certainly one of the very first to see into them.

So this is how it stands, rent paid and new appreciations, the former very comforting—the latter very inspiring. I cabled you last Friday as to the exact conditions—also wrote you what Marc said—to be patient—that one day Koehler would come and make an offer or buy everything—that he knows his manner well. So here I am—with so much that is positive directly and so much that is negative. I wish to God there was someone who would take up this proposition of $100 a month for a year or two years. I could easily make it to their advantage later—and it would send me spinning on the road to success in work and all ways, because first of all the Germans believe if they don't understand—and belief is a tremendous asset.

I have written you in the other letters of all things—of the possible good of going to N.Y. with the pictures and of the better good of staying here with the propositions around me sending the pictures to N.Y. then later having some of them come back here for the other German cities. I want to work so much and I simply cannot. I can't even buy a tube of paint simply because I must not go hungry until something else happens. All this is wretched—winter comes soon too and I have not even clothes to keep warm enough. All these issues come at once naturally. Luckily the two overcoats Simonson gave me have kept me from displaying conditions to everyone. These are phases of the general situation. I want a winter of good work after a summer of nothing but interruption from various causes unavoidable. If I went to N.Y. there would be a great deal of pleasure for me to be with you and all the others—but no work and the same expense—getting there and living and getting back—I could do better on that by simply staying on and working.

I have thought strongly of one thing and I may as well speak of it—it will do no harm—would not someone like the Meyers take up the proposition for a time or by some group system make it possible for at least a year—two would be so much better. In that time I would have become well established or maybe before. Perhaps it all sounds irrational but it happens to others who are in Europe—many doing absolutely nothing but playing poker in the quarter in Paris—or bluffing along and accomplishing nothing. Here I am on the way to an art, and I am at a stand still with it and cannot move the [van?] an inch alone. This same thing happened to me when I was a student in the schools—I was given in all $2000 without the slightest conditions.[2] It effected a beginning and from that I have struggled up to this point. I know it's all cruel in a sense to suggest these things to you who have problems enough, but I want to get free and free you of it all as soon as possible. Other people who are rich could do it and might only need the suggestion. As a human being I don't ask any favors—but as an artist— giving up the best I have I need assistance and now more than all. It has taken me this whole year and a half to get myself out into the light artistically and here I am now where people of understanding have absolute faith in what they see. Surely there can be a further faith.

If I went to N.Y. I could only talk a little and expose myself to those whom I am sure would understand and would not find my thoughts ridiculous. New York is such a hard place to be personal in—especially when the subjects border on something more than the intellectual—but that has to be—it comes with every original struggle. I can talk with candour to you always and to some others but how many of the general public would I be able to talk to. I feel like an open book to you—and to one like Arthur Davies—and to Miss Stein because you all understand ideas in general and have in varying degrees somewhat similar qualities else there would be no communication and no connection. Just as in the reverse—people like Delaunay shut me up tight and I lose all sense of conversation even, a man like Kandinsky or Marc open me up and I am as free or feel I can be as free as the air to them. It is because you all possess something of this quality—the power to go into someone else's condition or consciousness. That is why I am so free here in Berlin or Germany—there is no argument necessary—art has its place—and if it is not understood—it is allowed its freedom. There is the element of revolt too—but there is the element of expansion also and they can lean toward an idea more quickly.

But as I say—I want it all not for myself as one social being—but for the art I know I can give up—there can be ways of compensating those who might take such an interest. It would not be a great problem for the rich and it would be achieved success for me. I know there is no one in Amerika who would offer to buy the pictures in a lot or I would say yes at once to the idea—it can happen here but not yet. The time has been proved to be not right.

I know your views on the money question—that you do not want to ask anyone for anything—but the possibility is there and when Miss Stein said surely there is someone who would give $100⁻ a month—it came to me in this way. I know how much money goes into the air in N.Y. for God knows what. There could be some avenue opened up for the problem somewhere—somehow surely. It needs the faith of someone besides myself. Cézanne had his father—Van Gogh had his brother—I have had friends—I need them still and I can guarantee that they will never be ashamed of their faith and their trust—and whatever efforts they have made. When I went to art school—the money came right out of the darkness to me—and continued regularly to the amount of $2000—during which time I created nothing. Montross's little $4.00 a week did a great deal for it brought into being a revolt against things generally—and a concentration toward self.[3] Europe has now perfected this—and it only has to go on—I know a year would prove all that has been said. I don't argue a whit for greatness—I argue for genuineness—and for pure personal expression.

So it goes—there is interruption here. I wait on the few remaining marks to hear from you. The delay of a week seems strange—perhaps you are waiting for the letter I wrote which by now you must have. I have bridged the difficulty of 3 months rent till

Jan. 6th, now I must somehow accomplish the rest. I wait eagerly to hear what you have to say on going to N.Y. or remaining here. You can see the general quandary I am in—I can't work because I have no materials—I can't go or I can't stay. Therefore I have to get out of the difficulty.

I hope and hope daily to get word from you—but nothing comes. I don't know what can be the matter for you are always prompt—I hope there is no calamity of any kind. These thoughts go through one's head.

Anyhow I simply trust—daily and hourly for a solution and go carefully—eating as little as I can to keep up and being as careful as possible.

Best wishes to you and all.

Yours,
Marsden Hartley

1. For Hartley's letter of thanks to Stein (Berlin, October 1913), see Gallup, *The Flowers of Friendship,* 84–86.
2. In 1899 while studying at the Cleveland School of Art, Hartley's talents were recognized by one of its trustees and he was offered an annual stipend of $450 for five years of study. Subsequently, he enrolled in the New York School of Art that fall, and the following season transferred to the National Academy of Design (Marsden Hartley, ed. Susan Elizabeth Ryan, *Somehow a Past: The Autobiography of Marsden Hartley,* [Cambridge, Mass.: MIT Press, 1997], 59). See also Haskell, *Marsden Hartley,* 10–11.
3. The art dealer N. E. Montross was impressed by Hartley's painting after seeing his first exhibition at 291 in 1909. Concerned about his cost of living, he offered Hartley a $4-a-week stipend to help with expenses. Montross also provided an impetus for a stylistic shift in Hartley's work by introducing him to the marine paintings of the American artist, Albert Pinkham Ryder. For a greater discussion on Hartley's experiences with Montross and Ryder, see Ludington, *Marsden Hartley: The Biography of an American Artist,* 61–65.

∽

n.d. [October 18, 1913, Berlin]

My Dear Stieglitz,

Just a line in haste to say that if I am to go to N.Y. the best rate I can get is $67.50 from Berlin to N.Y. exclusive of incidentals—on the "Amerika" Nov. 6th 9 days—and the next sailing is Nov. 22nd. I want to get off earlier than the 22nd and the 6th is the only decent date. It will be all around the best for me to go on the 6th Nov. So if I am to sail you will have to cable the money for passage as I haven't enough naturally as I must pay running expenses with what you sent last, and I am all upset too. I can't do any new work—only finish up what I have on hand. So be sure and cable just as soon as you get this letter so I can make connections all right, and get a decent room. I hate

the sea so and dread the voyage. I nearly died when I went to Paris 7 days and this is 2 days more. I could travel forever in a train but a boat is just Sing Sing for me.

No news otherwise. I have had quite some trouble getting the last two checks cashed as they have both had to go directly back to N.Y. Fortunately Prof. Rönnebeck was willing to take the chance—but I don't know him that well—and he doesn't know anything about you except what I say and money is such a damnable thing anyhow. I have been hungry for ten days because I didn't know whether I would hear from you or not—it was so long and you know how one can suffer. However—I look forward to N.Y. as a solution to the problem and shall think of but one thing and that is to accomplish somehow that which I need for the next year or two years if possible. I can't drop a living problem and one so promising. I have got to be with it and help it grow and one can do nothing on the other side—and besides Berlin is the only place I have ever been at home in in my life—and I intend making it my home for a time. Other people accomplish what they wish and I must too—it just needs a little engineering. There is much that we shall have to talk over you and I too. I know the art game in Europe from A to Z now and I know its virtues and its hypocrisy and its politics. It was for the latter that I left Paris gladly—there is too much "paid machinery."

Yesterday a most terrible accident out at Johannisthal—the *Marineluftschiff* exploded killing 25 officers and best men—too terrible![1] Lately nothing but horrible catastrophes—all expressing the utter helplessness of man against nature.

Rönnebeck returns to Berlin on Monday. He has been seeing much of Miss Stein lately and has been to Picasso's to see his African sculpture and a new Rousseau he has got recently. I missed Picasso because when I got to know Miss Stein well he was out of Paris—but after I saw him everyday on the Boulevard Raspail. He is very handsome and simple—always walking with his chic little lady and his dog. He is awfully successful financially now.

Anyhow if I am to sail—on Nov. 6th, you must cable at least by Nov 1st. Otherwise I can't go until the 22nd, and that is so late and the money won't all hang over—and I can't ask anybody here for anything.

Best wishes always to you and to all.

Yours,
Hartley

Rönnebeck's bust of me will go also.

1. On October 17, 1913, a naval Zeppelin airship exploded shortly after take-off from Johannisthal, an air field located ten miles south-east of Berlin. According to the *New York Globe* (October 17, 1913), twenty-seven of the twenty-eight passengers on board were killed.

October 20, 1913
291 Fifth Ave., New York

My dear Hartley:

Another letter from you. The letter in which you tell me all about Gertrude Stein's ideas. How she thinks you ought to have $1200.00 a year; and how you don't see why some rich American should not be willing to let you have that amount for the coming two years. And how kind she was in sending you $40.00 for your drawing instead of $20.00 (I don't see why she did not send the $20.00 before you had to ask for it). Of course I read the whole letter in the spirit in which it was written. I never take anything literally. But all you wrote, and all Gertrude Stein advises and says, all those things and much more I had thoroughly weighed when I wrote you last and sent you the necessary money to come to New York. You are not to come here to <u>explain</u> your pictures. What a horrible idea to even think of that. I simply want you over here with your pictures to get you in touch with some people possibly who may, instead of holding forth hope in the future, actually, of their own accord, do something <u>practical</u> for you <u>now</u>.

You went abroad, as you remember, with one idea, and that was to study. And by studying I mean working and seeing. You yourself stated at the time that selling and exhibitions would not be in your mind. Please don't misunderstand me now. I know the importance of sending work around and of having it introduced in the right sources, and to follow all that might lead to recognition, and what is more cash. And I repeat, it is cash that you need now. All the rest has to be side-tracked for awhile. It may seem a break to you and a chance missed, but I see it in a different light. You must remember that so far, little as it may be, your European trip was made possible through American cash. Cash which was forthcoming because a few people felt you were entitled to a chance. Now I personally don't see any reason why any American should be called upon to give you additional cash without seeing what you have done. Gertrude Stein's appreciation is awfully fine. What Kandinsky says and what Koehler thinks, all is valuable. And what you yourself say of your work is of great value. But people who give money without seeing are very very rare. The Meyers have been more kind than you realize. They are the only "rich" people who have really done anything at all for "291." How I ever manage to keep things going is really a riddle to me. I shall see it through as long as I can, to the last ditch, and when I quit it will not be because there is not much more to be done, but on account of lack of funds. And I am not going to ask for funds.

I say again, come over with your pictures, but remember don't do so if you don't think it wisest. I am not on the spot in Berlin. And also remember that if you come you must come without any expectations. I am not opening the little gallery until I know definitely whether you are coming or not. Everything is held in abeyance for you. You are to have the first chance. A certain responsibility toward the others rests on your shoulders. There are other poor devils here struggling just as hard as you are and who

are entitled to all you are. They too must be considered. You may be the most important of all. You may be the most important painter in the world today, but that all does not make any difference to me. I look at things from a different angle. And if "291" means anything at all, and you have gotten anything out of it, it is because of this very fact that I see things from my own particular angle.

Gertrude Stein will have probably sent you a clipping from one of Hapgood's articles.[1] He was at "291" when Mabel Dodge came up and I related your story to her. You see everything is being prepared as if you were coming, but <u>don't come</u> simply because I am expecting you. I neither expect nor otherwise. I am simply prepared. You must remember that, although New York may not be as sympathetic and inspiring as Berlin and Company, yet things have not stood still since you left. Especially is this so with the men who congregate at "291."

Gertrude Stein wrote to me about her play in which you play a role.[2] She said she would send me a copy, but I have not heard from her as yet. Of course it would be fine to publish a play and reproduce some of your things in color, but I cannot promise anything or undertake anything without seeing or weighing. For instance the special number of *Camera Work* which I got out during the summer, so far represents an actual loss of $1000.00. People are very grateful for the token of a copy. And they are very proud of showing it to other people. But how many are there who will give up one penny to help along this thing they are proud of. And so it has been with me for the last thirty years. And still I struggle on believing in an awakening of some people. Not for me, but for the world generally. Of course it is but natural that people who conclude I am able to "blow in" a $1000.00 for a number of *Camera Work* that I must necessarily be well-off pecuniarily. How stupid! They may not know that it is my last cent I am spending on a mad hope. They may not know that under the dress suit, which may be twenty years old, there may be no underclothes. They may not know that instead of three meals there is only one meal and so they may not know innumerable things that they take for granted and know nothing about. It may be stupid of me not to pass around the hat and fill it with shekels for myself and for my friends. But if I had been built that way all I have ever done would never had existed. It might have been of more "practical" value. It is too late for me to start doing anything I do not <u>feel</u>. And it is because of this very fact that I can do nothing I don't <u>feel</u> that I can understand a lot of you fellows.

Let me know at once of your decision. I must go ahead with the work to be done here. I cannot let everything go because I don't know where I am at.

With kindest wishes, as always,

Yours,
[Stieglitz]

N.B. What do you think of the idea of having Gertrude Stein write a few words for your catalogue which will accompany your exhibition at "291?" You could write to her and let her send whatever she writes to me at "291." This is merely a suggestion. A few words by her, in view of her great appreciation of you might be helpful to you in a practical way. Of course she would have to do this at once as I suppose you will want your exhibition as early as possible after your arrival.[3]

1. Hutchins Hapgood's article, "Fire and Revolution," in the *New York Globe* documented the fire that broke out below 291 in June 1913 (see Stieglitz's letter of June 16, 1913). Stieglitz was so pleased with the article that he reprinted it as a pamphlet. An excerpt can be found in Hutchins Hapgood, *A Victorian in the Modern World* (1939; reprint with introduction by Robert Allen Skotheim, Seattle: University of Washington Press, 1967), 340.
2. See note 1 page 88, and Appendix Two.
3. Stieglitz subsequently wrote a letter (November 3, 1913) to Stein asking if she would be interested in providing a few words as a foreword to Hartley's exhibition catalogue. See Gallup, *The Flowers of Friendship*, 87–88.

n.d. [October 22, 1913, Berlin]

My Dear Stieglitz,

I am full of things to tell you—and just this very moment comes a letter from you with check for sailing which cleans up all problems for the present. I sail if nothing happens the first week in November—and will arrive I should think about the 15th or 20th. Your letter is so encouraging after all my uncertainties of late—but the whole thing has sent me spiritually onward to new expressions and the last work I have done has taken on a new visionary quality as the result of it. But what I want to tell you now is of a very wonderful nature—and I tell it to you with extreme privacy. If you tell it to others you do so because you want to and not because I would wish to publish it abroad. Rönnebeck came back to Berlin from Paris yesterday and he came to me at once because he had these things to tell me. I have already told you that Gertrude Stein has said to him that she considers me the most important man of the moment in art—this in itself is good—but there is more—she has told Rönnebeck that she thinks I have gone miles beyond them all—Picasso included because I have succeeded in leaving out the physical element and giving for the first time the pure spiritual. Now then—she has hung my drawing in her collection next to the Cézanne water colors—with a Manet and a Renoir above it and she told R. that it gave her unqualified pleasure daily and hourly.

Now then again—Picasso has seen the drawing there—said to Gertrude that he could not understand it—(you know it was one of those in the New York show) pointed to it—and said "where are the eyes—and the nose" etc. Gertrude told R. that I had

gone beyond Picasso himself and into a sphere infinitely removed from him and them all—that she sees in me a new and great factor in modern art—etc., etc. Now I can tell you this because my work is as if it didn't belong to me in a sense. It comes from some other thing or place I can't say where. I don't like Blake praise my work and say that "I can do so because the authors are in eternity"—I don't make such declarations. I only know that all this new work is the result of new inward experiences the result of having come into touch with the great mystics of the universe and with having come to Berlin where for some reason which I don't know I feel myself in a "higher" place—there is a something here struggling always toward the light—I can't name it—I only see it—and this state is perfected in me. Read Bucke's *Cosmic Consciousness* and you will see what it is—I identify my experiences in his book and in Wm. James's *Varieties of Religious Experience*.[1] This was my first real contact with Miss Stein, was when I asked to borrow her copy of this book. I can tell you all about this stuff in person and a thousand things more—and the reason why art is failing so dreadfully in Paris—it is without soul my dear fellow—and the mind can go only so far. The East Indian mystics say that the "senses are high—but beyond the senses is the mind—beyond the mind is the understanding and beyond the understanding is the <u>self</u>."

Well this is where I started off and you will see the results in a few weeks—and there is no end of it to come from me if I can be freed. And how all this makes my heart leap with gladness—and your letter so bright too with faith and promise. It is all I need—I have faith in myself—I need only the faith of others. If I can secure two years freedom—you and all the world will see what will come—and all this struggling will have had its raison d'être.

But you know the best asset I have had all along over here is Gertrude Stein because she herself being like Picasso and like me also—has seen into both of these depths and proclaims mine a higher thing. I too know that but I only needed one other to believe it. She told R. that was "Pablo's" chief trouble—that he must see a human figure before he can begin to work. All this you know is too remarkable since one knows of the tremendous adoration she has for him as artist and man. It shows her wondrous fairness that she can go beyond that which she admires and admire something more. So you see my dear Stieglitz—I am placed by this woman in the art scheme of things in Europe and it won't be long before I shall be in the ascendancy in all ways. There is everything here for me. I have all Europe at my hand—I can have London through you and her and she is very friendly with Roger Fry and she would only have to say the word and it all comes to me there. I have all Germany and I shall get Paris later. I could get it now but for the expense—all the rest of Europe is free to me.

So dear Stieglitz—you can see what is coming out of all your wondrous faith in me—and the faith of others. I am grounded in the quality of what I wish to express—and everything is constructive except the practical side and this will come too because

it must. You see what for instance $3000 or $4000 would do for me—two solid years of freedom and some necessary travel. I need for instance to come into touch with the soul of Giotto and Fra Angelico and this I can only do by going there, and these things don't cost much but I must be able to pay for them—and after all how little this is for the New York people if they will only see it right. Only now R. tells me of a boy we know in Paris from Chicago who told him that three C. millionaires had written him to say how much he wanted or needed—for several years and that he would only have to ask—and he is an art protégé of Cottet. Can you imagine at this day and hour being a protégé of Cottet? Then there are the protégés of Mrs. Whitney living like little lords and doing nothing whatever—one other there I know well has just been given two or three years freedom—and these men are entirely outside the modern development. I only speak of this merely because it has a right to happen to me, and spiritually I say to myself always that it must and so it will. I have a big work to do and it is on its way and I myself am in my prime creative condition—I do not doubt in the least the success of the work for the future. It will have its effect—it will show that beyond the intellect there is a greater intelligence which fathoms many things the mind cannot approach.

I hurry these lines off to you so that you too may enjoy the things G.S. says of me. You can readily understand that its only effect on me is to stimulate my vision and make me still more eager to create what I "see." I will let you know exactly when I sail, and will tend to the bronze etc. I will go to the consul and get particulars.

Very best wishes. Thanks for check and for faith and encouragement. The sky is so blue today and so full of promise. The only shadow over it is the funeral of the *Luftschiff* victims. Too, too, sad all this youth and intelligence laid waste.

Always,
M.H.

1. William James's *Varieties of Religious Experiences: A Study in Human Nature* was published in 1902.

❧

n.d. [October 29, 1913, Berlin] (postcard)

My Dear Stieglitz,

Your long letter reached me yesterday. I feel from it as if I had annoyed you generally from talking too much of myself—but you know how feeble letters are. I look forward more than anything to getting to N.Y. so that I can talk with you. I have passage second class on the S.S. *George Washington* N.D. Lloyd—Nov. 15th—8 days to N.Y. a little bit cheaper than the *Amerika* and one day less. The pictures here cannot leave

here much before the 29th as I cannot get them out of the Herbst Salon before the 20th, and the next boat is the 29th. So the show could not take place much before Dec. 10th, but I will be there two weeks before it which is good.

I had word from Marc that they want very much for me to show in two expositions in Dresden for January and to please leave some pictures with Der Sturm for this—but I will have in all at least 17 pictures for N.Y. all large and this is enough.[1] Gertrude S. is going to ship the four she has from Paris and they are very expressive of what I am after—so that these 17 pictures will show [?] up in all ways. I have written to G.S. of the foreword idea for the catalogue but I don't know if she will be at all inclined—and then it might be utterly abstract and I don't know how much good it would be for the public— though I would be very happy if she did. Perhaps De Zayas or Hapgood would be more explicit. Shall write once more before sailing.

Best wishes always,
M.H.

1. Hartley did not participate in these exhibitions in Dresden; see note 2 page 98. See also Haskell, *Marsden Hartley*, 195.

⌒

n.d. [October 31, 1913, Berlin]

My Dear Stieglitz,

Just one more letter in a hurry—to say that I have taken passage second—on the S.S. *George Washington* Nov. 15th, 8 days—or, New York on the 23rd. It was better all around and a little cheaper—with one day less on the water which I value. I will arrange with Herr Walden of the Herbst Salon to ship my pictures at once after the 20th of November. They cannot leave as I see it before the 29th, on the "Kronprinzessin Cecilie"—so that the exhibition could not be much before Dec. 10th, but that is all right as far as I am concerned. Miss Stein will ship the four she has in Paris by the French line. I wrote you a card ahead to tell all this.

Marc wrote me that the directors of the January exposition in Dresden are very desirous of some of my work and would I please leave some of them with Walden and they will take care they go to Dresden etc. and Marc adds "it is of great importance that you show in Dresden at this time." So I make all connections right and take 17 large pictures to N.Y. which is quite enough to show what I am up to. Rönnebeck's bust of me will be sent soon and may arrive before I do.[1] I will bring the Picasso etching to you— also a few Bavarian glass *Bilder* which I own and which are wonderful expressions of

religious symbolism. I bought them for 50¢ each at the *Dult* in München—but they are 100 yrs. old and are part of the art expression of Europe. You have seen reproductions in the *Blaue Reiter*.[2] I think how fine it would be to show them among my own simply to show the public another species of art expression. I am fortunate in having these few as they are very rare now—Kandinsky owns over a hundred—Jawlensky has a fine collection—a Munich brewer owns 1000—so you see they can't be got much now. I have six three larger and three smaller—2 mks. and 1 mk. each, but so beautiful. You will enjoy seeing them.

I shall not attempt to say anything in reply to your last letter. I am only sorry I have talked so much—I shall not embarrass you with any ridiculous ideals—you will find me just the same person as always—with only faith and hope as my two assets. I don't want anything at the expense of anybody else—I mean that I don't want anyone else to suffer. I hope to get to N.Y. if only for just these things that we may talk and understand at once what letters cannot possibly convey. All I said to you was only because I felt it to be told you in secret as bits of constructive information after a long siege of negative experiences.

However—this to say best wishes to you and to all and that I am only too glad to know I can see the dear old place again and all that belong to it. I have not lost my sense of home there. I never give up things which mean much to me. Kindest wishes to Mrs. Stieglitz and to all at 291—not forgetting Lawrence and Marie, and yourself.

As always,
Hartley

1. Arnold Rönnebeck's bust was shown with Hartley's paintings at 291, *Exhibition of Paintings by Marsden Hartley, of Berlin and New York* (January 12–February 14, 1914). Its present location is unknown.
2. As many as eleven Bavarian glass paintings (*Hinterglasbilder*) were included in the *Blaue Reiter* almanac that Stieglitz would in fact have already seen. The practice of painting panes of glass on the reverse was followed by Kandinsky and members of the Blaue Reiter (Levin, "Marsden Hartley and the European Avant-Garde," 161).

❧

n.d. [November, 1913, Berlin]

Dear Stieglitz,

I find one more word is necessary before I sail—a change of conditions—the pictures are going to New York with me on the 15th. Those in the Herbst Salon must remain there and they go to Dresden for the show there Jan. 1st and Walden of Der Sturm says it is planned to keep the show traveling over Germany complete as it is until

July 1st.[1] So I have to leave the five there, but I have a great plenty anyhow. Miss Stein writes that the four she has are gone to the packer and will arrive when I do by the French line. I write all this as it may help you in your plans some.

Miss S. has also written with reference to a foreword for the catalogue. She says for that purpose she has selected from her last "play" all that she has me say in it—and put it together—three type written pages—and that she thinks it very good for the foreword. I like the idea myself—and in fact I don't see that she could say anything else.[2] I would like very much for her name to be on the program—especially since I haven't much in the way for titles to offer for the pictures. I don't see that there can be much more than numbers for them. She sent me also the Hapgood clipping which is very rich in its feeling.[3] I don't know if it meant anything to anyone outside of 291—but it is Hapgood all right. He is probably the one who will write best for me since he knows my quality as a person and understands me—that is I mean among the writers.

But I look forward so eagerly to it all and am packing up for the journey—I have only 9 days now before sailing. You will get this just about sailing time I think. I wrote because I think it may benefit your programme. As it is now I could exhibit as early in December as you like. I leave it to you. Perhaps you have other plans. Anyhow I will arrive Nov. 23rd and we can then talk much and arrange everything.

Best wishes to Hapgood—Mrs. Dodge, De Zayas, Haviland—Walkowitz—Lawrence, Marie, Marin—Simonson and to Mrs. S. at home, Kitty and Mr. Obermeyer. It will be so fine to be at 1111 once again. You don't know how I look forward to it.

Rönnebeck sends his bronze bust of me also at the same time.

I went to the American Consul and he says with the new bill—I need only to send the stuff along. I also saw this statement in the *N.Y. Herald* by John Quinn which I cut out.[4]

*Auf Wiedersehen.*

As always,
Hartley

Miss S. says she is sending you her MSS.

1. Hartley was invited to participate in the exhibition in Dresden; however, current scholarship does not suggest that the opportunity fully materialized. See note 2 page 98.
2. See note 1 page 88; see also Appendix Two.
3. See note 1 page 117.
4. The statement by Quinn is probably related to his recent efforts with enacting a bill that abolished the fifteen percent tariff on art less than twenty years old.

1914

My dear Stieglitz,

I should have written something before but it has not been possible—I have had plenty of time but I have been somewhat obsessed with the general desolation of Buffalo. I think I cannot ever endure quietness again—it brings up those cruel silences of the old days too vividly and you know how well I hate them—and how well I love laughter—and the common noises of human things. I have given up that "fair deceit of nature" for more fluctuant and comforting things. That is why I love movement the coming and the going—because it is creative and the keeping still is deadly as you yourself know.

You will be pleased to hear that the show is being a success from the ordinary point of view and Mrs. Bull has decided to have others later on—to keep the idea as a kind of institution—since the Albright refuses as all galleries and committees refuse new notions.[1] The room is superbly adapted to the purpose full of light—and I have never seen my pictures to better advantages as to light—perfect all day long without artificial light at all. It is hardly likely there will be any material success—though there was one inquiry about the price of a small one—but there is very serious interest shown by those who come and they walk in quite like they do at 291 in two and fours and sevens machines driving up all day—so that it is doing that much.

We have telegraphed Florence Bradley for directions for shipping and they will go on from here without me.[2] I cannot think of sitting around any more—I must get at other problems—settle them and get out of here and home where I am so much at home. It has been so good to have Mabel Dodge and Andrew here they are so fine and we are such a good three together. M. D. is really the most remarkable woman I ever knew taking it all in all. She is so intelligent and so sympathetic and like yourself a real creator of creators. Mrs. Bull is likewise exceptional in her way and it has been good for me here in this large house with every comfort and every freedom. I have chafed much with the stillness of Buffalo but I know it has been well to rest from too much stimulus— but I know now that there is only one American place and that is N.Y. There is something so oppressive about these cities of homes to one like myself who has not and never will have one—God forbid that I should ever find myself attached to any one spot or thing. I know too well now that I am a kind of rover in quest of celestial beauty and wherever I find it there my heart is and there my home.

I have the dearest note of thanks from Baby Engelhard saying such sweet things about the horse I sent her. I will read it to you when I get there. I must persuade her

to give me a set of her drawings to show—so the world can see how one child pictures her heaven of delight.[3] They are true vision true imagination—and that is enough. It will be so good when painters understand how fine it is to see beauty—and how much mere labor it is to affect to see.

I expect to get into N.Y. on Saturday night late—and will be up to the house Sunday for dinner—and I shall be glad to see everybody. Love to all.

Yours always,
Marsden Hartley

1. Selected works from the show at 291 traveled to the home of Nina Bull of Buffalo in February for an exhibition. Hartley refers to what was then the Buffalo Fine Arts Academy's Albright Art Gallery, which became the Albright-Knox Art Gallery in 1962. Today, the Museum's collection includes two paintings by Hartley.
2. The same works by Hartley shown in Buffalo were exhibited at the home of Florence Bradley in Chicago, early March.
3. In fact 291 later mounted an exhibition of work by Stieglitz's niece, Georgia Engelhard, entitled *Water-Colors and Drawings by Georgia S. Engelhard, of New York, A Child Ten Years Old, Showing the Evolution from Her Fourth Year to Her Tenth Year* (November 22–December 20, 1916).

⌒

May 1, 1914
291 Fifth Ave., New York

My dear Hartley:

Not knowing whether you are in Berlin or not, I am sending this to the American Express Company registered. I hope all is O.K. with you and that you are feeling more cheerful. That you had arrived in London I had heard from Donald Evans, who was up here a few days ago.

"291" has been unusually lively for this time of the year and I have had my hands more than full. I was hoping to hear from you. I shall write as soon as I get a chance. All wish to be remembered.

[Stieglitz]

⌒

May 5, 1914
291 Fifth Ave., New York

My dear Hartley:

I have had to ship you by express prepaid a case with your pictures. Two of those still belonging to you I have kept to show people who might come to "291." Nearly every day there is somebody who comes in and to whom I show them.

Special news there is none. Today Simonson and the Lees are leaving. Yesterday Marion Beckett sailed. The exodus for Europe has started in for fair.

A few days ago I sent you your draft but sent it care of American Express Company, Berlin. I sent it registered. Of course I often wonder how you are getting along. Whether you are beginning to see any real day light or not. As satisfactory as your stay was here, from a certain point of view, from another it was quite as unsatisfactory to me as I knew it was unsatisfactory to you.

With best wishes for your welfare, I am as always,

Your old friend,
[Stieglitz]

⌒

n.d. [received May 14, 1914, Berlin]

My Dear Stieglitz,

A hurried line—but I must write if only to announce my safe arrival then three days in Berlin which is at this time very fine—in all the brightness of spring—Paris too was a vision and London superb. It was worth much to me to see London actually in its real character. I can say little at this early stage except that I am glad enough to get back into my own place—for it is quiet here and restful and I am fearfully tired and unduly nervous after so long a time in New York. It is really an unspeakable place.

In many ways I do not in any [?] regret the visit—in some ways I think it was not good—it was a fearful material and spiritual extravagance—for I was so cut off in my connections with work and self expression and I feel as if I had been depleted at the wrong time—but one can't know actually what is right and what wrong for no sooner does one say <u>right</u> and <u>wrong</u> than they become the reverse by consideration. But New York does take willfully so much out of me and give so little—that you well know—but in the great flow of life and experience it doesn't matter I suppose.

I shall not speak of disappointments—but shall continue as of old because faith is necessary to my progress and to my existence. Just now I am surfeited with negative states of mind and they are trying. I have only to project myself into something more constructive—the worst difficulty I have is not knowing where my feet are secure—however, I go to the business of the vision again and see where it will be stronger if I understand things rightly.

I must speak directly now of moneys. My rent is due very shortly—this is $40—with it you had best send $70—for living—and please don't forget draft—Am. Express as I can't get any checks cashed here. As to the Simonson matter—please speak of it to him at once unless you think there is more cash in the picture elsewhere—but there is an imperative need of every surety as you know. And I do hope you can urge upon Daniel

the importance of his taking the big landscapes, even if he gives me so much a month—so that I can see my way on to other actual conditions. In course of time the connections here will come I am sure though it is not to know just when—but I shall make the effort to get them out on exhibition here with Walden and get established with the rest. If you find it easier for yourself to send draft for two months—it is the same to me—as you may be sure I shall be careful—after the expenditures in N.Y. so heavy and unavoidable.

I think you can be assured in any case of a good season at 291 as far as the character goes—it was I am sure quite up to the standard, and I think generally better all round. Things go on over here as usual—London dead enough—Paris the same tiresome place as to art—the Indépendants disclosing nothing—a huge and dull canvas by Morgan Russell—the Delaunays seeming like masters after this and the rest, but the whole was very dull.[1] I saw Miss Stein frequently and she took me to Picasso's which was an interesting disclosure—a simply huge atelier packed with work of much the same nature—no radical and insane departures as some have suspected but all entirely logical from his standpoint. It is perhaps an aesthetic obsession to express actually the objective—subjective but otherwise perfectly simple and consistent. He is a fine simple boyish person with no ideas about his work—no discussions whatever and no way of explaining them thank heavens!

Kahnweiler's is still the distinguished place of Paris—all the others dull and tame—only one addition to his group of personalities—Léger.[2] Miss Stein is very much interested in the book of hers which is about out in N.Y.[3] She says she is glad to get someone to publish at last and hopes she can continue. They leave for Spain in June and have decided not to move from 27 rue de Fleurus.

Give my best wishes to all. Love to Mrs. S. and to Mabel Dodge—I suppose M.D. is thinking of coming over soon. Have you shipped my pictures yet? Let me know at once as soon as you do. How is Steichen? I do hope better. My best wishes for his good health. Please send moneys at once by <u>draft</u>.

Best wishes to you always,
Marsden Hartley

Miss Stein spoke with much gratitude always to you for making her known as she says—in *Camera Work*.[4]

1. The Salon des Indépendants (March 1–April 30, 1914) featured work by Delaunay, Patrick Henry Bruce, Bonnard, van Dongen, Paul Signac, Metzinger, Picabia, Gleizes and others. For a complete list of artists, see Gordon, *Modern Art Exhibitions, 1900–1916*, 2: 804–8.
2. Fernand Léger signed an exclusive three-year agreement with Daniel-Henry Kahnweiler in October 1913. As his only dealer, the contract guaranteed the purchase by Kahnweiler of all of the artist's oil paintings. Braque, Derain, Gris and Picasso had similar agreements with Kahnweiler.
3. Stein's *Tender Buttons* was published by Donald Evans at the Claire Marie Press, June 1914.

4. By that time Stieglitz had made Gertrude Stein quite well known in America through *Camera Work*. Her publications in the journal included word portraits of Picasso and Matisse in the special number (August 1912). Stein's "Portrait of Mabel Dodge at the Villa Curonia" and Dodge's essay on Stein, "Speculations," were both in the special number (June 1913) issue. Stein also wrote a foreword titled "From a Play by Gertrude Stein" for Hartley's January 1914 exhibition, reproduced in number 45 (January 1914, published June 1914). Adding even more to his publicity of Stein, Stieglitz reproduced Picasso's *Portrait of Gertrude Stein* (1906) in the special number (June 1913).

⌐

May 14, 1914
291 Fifth Ave., New York

My dear Hartley:

Your letter from Berlin arrived yesterday afternoon. So you are back in Berlin. Yes London and Paris must have been beautiful. They are always beautiful in spring. And so is Berlin at that time of the year. That you should be tired and nervous after all you have been through since you left Berlin last November, I can well understand. I suppose this was inevitable. You speak of New York as an unspeakable place. It is truly that. But it is fascinating. It is like some giant machine, soulless, and without a trace of heart. And still I doubt whether there is anything more truly wonderful than New York in the world just at present. It remains to be seen whether your trip over here was a real benefit to you or not, but the trip had to be. The more I weigh what was before the trip and during the trip the clearer it becomes to me that all was as it could not be otherwise. All I had hoped for to happen as far as money success was concerned did happen, and it happened about in the manner in which I thought it might happen. And yet the unfortunate thing is, that for some reason or other, the reason I clearly see, and which I feel you may possibly not see, the trip after all, in its finality, did not achieve that financial success for you that it should have. And by that I mean that instead of your getting back to Berlin with a mind perfectly free of money cares for at least a year you are back there worried about money, and what that means for you—and for that matter for all those who have to worry about money; and who doesn't nowadays?—I know only too well. There is hardly a soul that I come into contact with, whether rich or poor, who does not feel pretty much as you do— no one seems to know where he is at. I know I don't. I know that my old mother doesn't. I know that nearly every member in my family doesn't. I know that Haviland doesn't; and so on ad infinitum. And I see only too well why this is as it is. I saw clearly many years ago that it would be as it is. In ninety-nine cases out of one hundred this uncomfortable state of mind is brought about through one's own shortsightedness—some people let themselves off easily by calling this shortsightedness, temperament. Opportunities are not recognised as opportunities and so opportunities are wasted. And the tragedy of it all is that these opportunities frequently do not recur. But to the man who learns through

experience and who keeps his vision clear and does not lose his faith through his own "temperamental mistakes," why all experiences will be gain and will come out in pure expression. You say you feel as if you had been depleted at the wrong time. I hope not. As a matter of fact if you are that which you yourself believe you are, and which I believe you are, what you call depletion is not depletion, but is something entirely different. A debauch, whatever type it may be, if clearly recognised as a debauch, may result in a new strength. Yes, no one knows better than I do how readily New York takes willfully from one without a thought of what it is taking. But giving is really all there is of life as I see it. And as every real artist must see it. Of course it is frightfully hard on one physically at times. And physical depression is apt to fog one's vision temporarily. But that too doesn't matter provided the faith is genuine and the vision pure. As for your material prospects, all I can say is that you are virtually secure for seven or eight months, if you husband your resources. Your future will much depend upon what you create during that time. I would not worry too much about what might come after the eight months. In doing that you would be preparing yourself for some trouble, possibly real trouble. You will have to forget, and you can forget everything but the fact that you have sufficient to live on for eight months. And during those eight months you certainly can do a great deal of work if it is in you. I am enclosing another draft for $75.00 as per your request. In other words it is your June money. It means that after you have paid your $40.00 rent for three months you'll have $110.00 left for two months living expenses, and that when I send you the July draft you will have that full amount without any rent to pay for that month. So you can arrange your life accordingly.

I was up to Daniel's this morning, but found no one in. The place was locked. I have written to him that he should come down to see me, that I want to talk to him about your case and others. About things quite as important to him as to you. As a matter of fact when he was down here last, and he was here a few days after you had left, I spoke to him again about you. I urged him to do something definite for you. I proposed that he buy the landscapes outright. And I proposed a very, very low price. Somehow or other, he always seems interested, but it is most difficult to get him to do anything definite. I suppose he too is carrying a bigger load than his circumstances allow, or possibly he is not anxious to take any very great risks so as not to jeopardize his future. But I hope he will come down soon. I do hope something will come out of it for your sake.

Simonson finally took the landscape for $100.00. He is going to send me a check for it some time in July. What a pity it is that I haven't money of my own, for I would have been only too happy to pay you more for this painting. It is very beautiful. But maybe it is just as well that Simonson should have it. It means a great deal to him and who knows whether his enthusiasm for it won't bring you material advantage at some future date.

I do hope that you will finally connect in Germany. America supporting abstraction in the near future seems impossible. Those few who profess to be interested are really

at heart not interested. With most of those few it is all a passing sensation, a novelty. They simply don't see. Nor do they feel. What do they really see? And what do they really feel? Do they see anything at all? And as to feeling do they feel anything? The interest is all so hectic, so superficial. I fully believe that in this country art is really the appendix of society. It has the same relative value to the social body that the appendix of the human being has to the physical body. The appendix only recently was considered absolutely useless to the individual, but of recent date scientists are beginning to feel that it may after all have a certain function to perform, possibly not a vital one, but a subtle function. And so with art in America; as yet it is not vital to the American.

I can well imagine what the Independent Exhibition in Paris must have been. What you write of Picasso is but a verification of what I found myself when I spent a few hours with him a few years ago.[1] He is thoroughly genuine. And he will never be anything else. Gertrude Stein's book ought to be out any day now. Donald Evans was up at "291" to get Picasso's picture of her. It is being used to advertise the book. I hope that the publishers will give her not only this chance, but others. I don't doubt that this first book will meet with a seeming success. Gertrude Stein has been much talked, and written about. The American people are always waiting for a novelty. I am glad that she feels that "Camera Work" has been helpful in bringing her before the public, and having achieved this for her finally found a publisher for her. What I can't understand is that so few people are interested in creating opportunities for those who are struggling for new expression. What greater pleasure is there than to create opportunities for those who are deserving. And that means creating opportunities for all those who are honest, sincere. And it is not so difficult to find out who is deserving and who is not deserving. But it takes time. And people will not take time.

Steichen is back in Voulangis. He felt somewhat stronger when he left. In his garden I hope he will recover his strength. The more I see of Steichen the more unusual I find him to be. Every inch a man in the finest sense of the word. His path is not as rosey as it seems to others. The future to him is also grey, just at present at least, grey as it is to so many of us.

Mabel Dodge has been having all sorts of illnesses. The winter has been possibly a little too strenuous for her, and she is now paying the price. Today her tonsils are being removed. She was up here the other day with Mrs. Bull, who is in New York on a visit.

You ought to see Lawrence's place. Everything has been cleared out of it except one or two pieces of necessary furniture. He is removing everything to his country place. This moving, this clearing out, is a constant reminder of what is to happen to "291" within a year.[2] But even with this constant reminder I am going to go ahead with the work in the little room just as if the place were to stand forever. It is not easy, but I have been through this phase of things more than once. I wonder how much "291" will be missed when it no longer exists. I have no idea what I shall do after April 30th, 1915. I

am going to make no preparations. Were I to make any I would introduce into "291" that which is foreign to it and I want to keep it absolutely pure to the very last day. In thinking over what "291" has been, and still is; what it has done, actually done; and what is had meant to others; and in view of the fact that it is ten years since we are housed in the little place, I have been thinking that it might be a good idea of publishing a special number of "Camera Work," which would be devoted to twenty-five or thirty short essays on "As I see '291'" (or something like that).[3] In publishing such twenty-five or thirty little essays, possibly some of the spirit of "291" would go out into the world in a new form. It would do work. I spoke to Hutchins Hapgood about the idea, and to Mabel Dodge and Dasburg, and others, they all wish to write something. They were enthusiastic about the idea. They saw the point at once. Each one is to have a page of say five hundred or six hundred words. Should anyone feel it necessary to write a little more, why they could write more. Should anyone want to write but a few lines, they might write but a few lines. The book should not have the tone of an obituary. It should reflect the very essence of life, the living idea. And a living idea can only be expressed through what people have felt. Of course I hope you will be amongst those to write something. You express yourself remarkably well. "291" has meant something very definite to you. De Zayas is going to write and so is Mrs. Meyer. It is my hope to publish this book late next autumn. And so I will have to have the material by September first. It may be that through this book the new form of "291" will be found. It may be that through the intensity of feeling expressed in its pages something positive will be created.

Your pictures, as I wrote recently, left last week. I hope they will reach you in good order.

All wish to be remembered to you. As ever,

Your old,
[Stieglitz]

1. Stieglitz had met Picasso during his last trip to Paris in 1911 (Homer, *Alfred Stieglitz and the American Avant-Garde*, 285n. 84).
2. As early as 1914 Stieglitz faced threats from his landlord of leveling the building that housed 291–3 for a larger office building. It was finally demolished in fall 1919.
3. Stieglitz published an issue of *Camera Work* 47 (July 1914, published January 1915) dedicated to the question, "What Is '291'?" Contributors included artists, critics, collectors, poets and many others whose lives were touched in some way by 291. For Hartley's contribution as quoted from *Camera Work*, see Appendix Three.

ॐ

n.d. [May 15, 1914, Berlin] (postcard)

My dear St.,

I write hastily to acknowledge letter and draft and to say I feel better generally—more rested under the quieting influences of German life—there is something soporific about their ways of going on. It makes it seem as if N.Y. were quite the most ridiculous place on earth—and I think really it is—and I think you of all can admit this also. A remarkable private *Ausstellung* of old masters is on here—really superb—like a little Louvre it is—in the Royal Akadamie—Pariser Platz—beautifully hung. It was fine to see the Louvre again too—with a fresh eye—it is truly remarkable for its quality and variety.

I am at work now on a large scale again and it seems good and quite novel to be actually wielding pigment—I want so strongly now a long season of creative effort and hope that much can be accomplished. I shall write at more length soon. If you have not shipped the pictures—can it be done at once—and if possible prepaid also the head of Rönnebeck unless for any reason you think it should remain. Berlin is fine at this season—and healthful. You have my letter before this—so you can still send the money asked for—in any case the 40 for *Wohnung.* Write when you can and tell me something of 291—and anything else.

Love to Mabel Dodge, Mrs. S. and Kitty—to Zoler. How is Steichen?

Best wishes to you always,
M.H.

᧡

May 26, 1914
291 Fifth Ave., New York

My dear Hartley:

I have been on jury duty for the last week and I am still so. That simply means that "291" sees practically nothing of me. Furthermore that in turn means that everything is being delayed as far as my work is concerned. But I have just got a moment to get off a note to you, to tell you that Daniel came down to me shortly after I had mailed my last letter to you. I had a long talk with him. I am delighted to say that he finally decided to buy outright three of the old landscapes and the two unfinished "dark period" things you took up to him. These five together with a little still-life I let him have for $600.00. This $600.00 he is to pay in monthly installments of $75.00 per month after the money I have for you on hand is exhausted. Of course the prices are low, but $600.00 gives you eight months more of freedom. I feel that you ought to be very much delighted. I know I would be in your case. As soon as I am through jury duty I am going to write you more fully. I feel much relieved since Daniel came to this decision, as I believe I have worried

a great deal more about you in the last few years than you did about yourself. But now please don't forget that all your old work is practically placed and you can't fall back upon this any longer. In a way I think this is a good thing. I advised Daniel to try and get your things out into the market; that it is <u>essential</u> to him as much as to you. But as I said more soon.

 With greetings, as always,

Your old friend,
[Stieglitz]

N.B. I have just received your postal and it sounds more hopeful. Berlin certainly seems to settle your nerves.

<div align="center">℘</div>

<div align="right">n.d. [May 31, 1914, Berlin] (postcard)</div>

My dear Stieglitz,

 By all that is kind and good—pardon my silences—I want to write but I want to write respectably and I have not been able to so far—a 12 page letter lies in the folio now there many days but I cannot seem to send it, knowing how truthfully it has registered the despairs of my being the past weeks. It is all a sickness I must recover from before I can express myself rightly. I am feeling better however and feel less the oppression of isolation which is so much the part of my existence—an aloneness which is neither warrantable or tolerable—it lies deeper than the surface—it is fathoms deep in my consciousness and I have to come up to the top before I can know where I stand with life—so have I been too depleted and this is what I mean by that word—a life has been at stake and I have tried to argue for it with reason against it. It is an isolated individual issue the alone with the alone. However I am working—and very well I think—I hope it will matter someday to someone as much or more than to myself. I am writing thanks for the long kind letter, enclosures received. I am writing also for the special 291 number. I think it expressive and so—good.

 Best wishes to everyone around you. Could you not send me some of Becky Steinhardt's drawings? I love them. Love to Mrs. and to Kitty.

Always,
M.H.

<div align="center">℘</div>

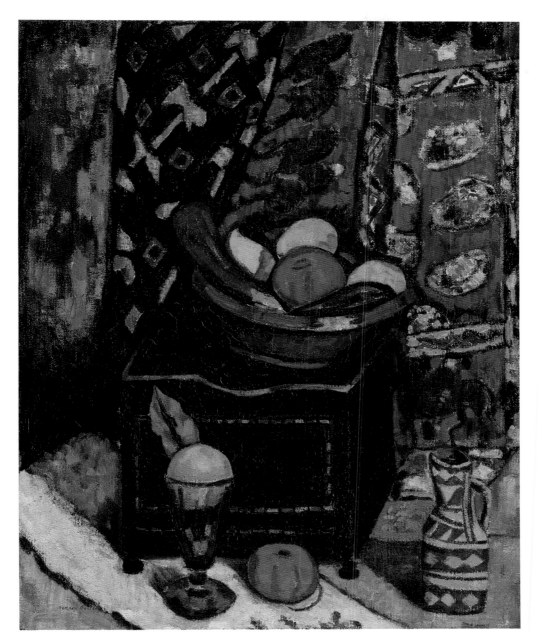

Plate 1. Marsden Hartley, *Still Life No. 1*, 1912, Oil on canvas

Fig. 2. Eduard Steichen, *Alfred Stieglitz at 291*, 1915

Fig. 3. Alfred Stieglitz or Paul Strand, *291: View of Exterior*, before 1913

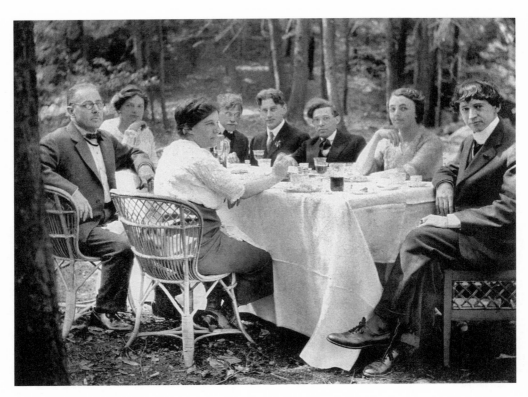

Fig. 4. *Picnic at Seven Springs Farm, Mount Kisco, New York,* 1914

*Left to Right*: Eugene Meyer, Agnes Meyer, Emmeline Stieglitz, Alfred Stieglitz, Paul Haviland, Abraham Walkowitz, Katharine Rhoades, John Marin

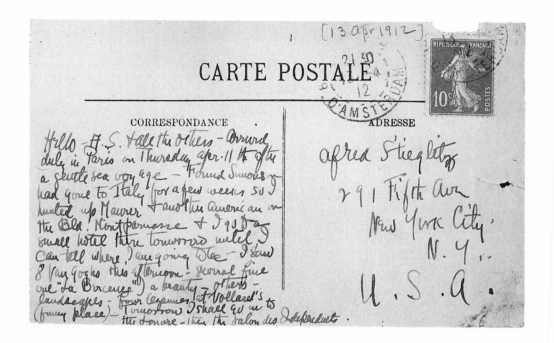

CARTE POSTALE

[13 apr 1912]

RÉPUBLIQUE FRANÇAISE 10c POSTES

CORRESPONDANCE

Hello – H.S. + all the others – arrived duly in Paris on Thursday apr. 11th after a gentle sea voyage – Found Simons had gone to Italy for a few weeks so I hunted up Maurer + another American on the Bld. Montparnasse + I go to a small hotel there tomorrow until I can tell where, I am going Stee – I saw 8 Van Goghs this afternoon – several fine one "La Berceuse") a beauty – others – landscapes – four Cezannes at Vollard's to (funny place) – Tomorrow I shall go in to the Louvre – then the Salon des Independents

ADRESSE

Alfred Stieglitz
291 Fifth Ave
New York City
N.Y.
U.S.A.

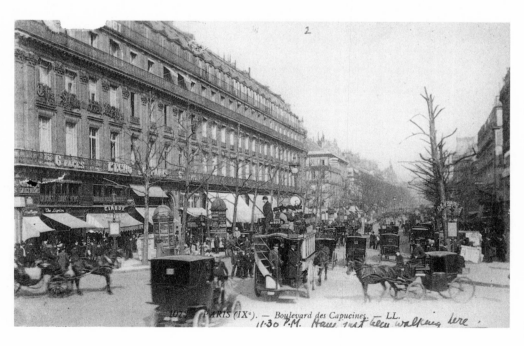

PARIS (IX°). — Boulevard des Capucines. — LL.
11.30 P.M. Have just been walking here.

Figs. 5 & 6. Marsden Hartley to Alfred Stieglitz, Postcard, Paris, n.d. [April 13, 1912]
*Back (top) and front (bottom)*

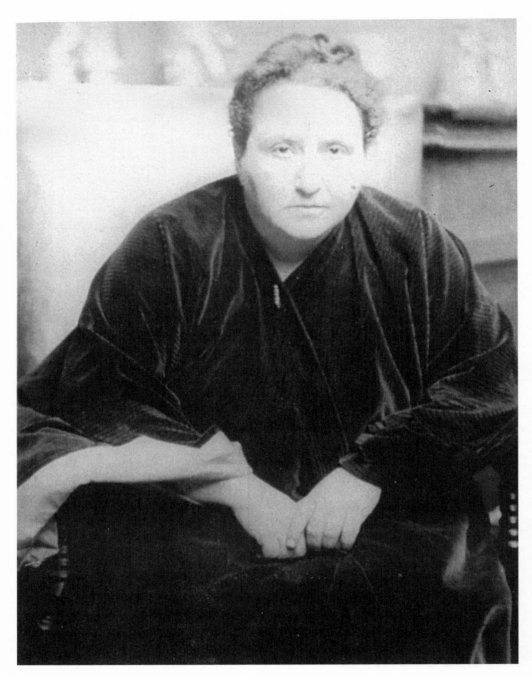

Fig. 7. Alvin Langdon Coburn, *Gertrude Stein*, 1913

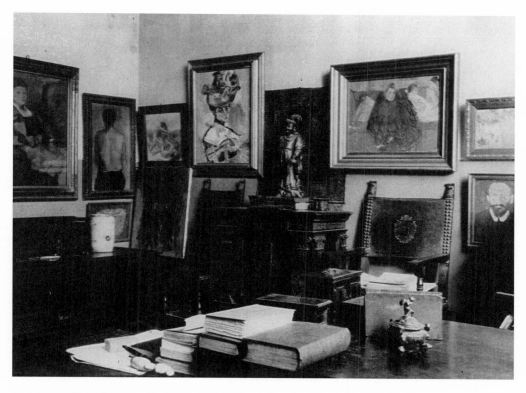

Fig. 8. *Studio of Leo and Gertrude Stein, 27 rue de Fleurus, Paris,* early 1906

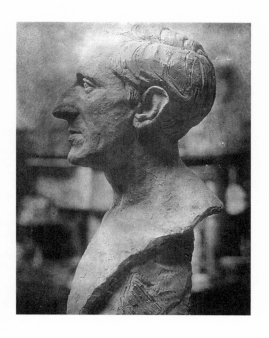

Fig. 9. Arnold Rönnebeck, *Portrait Bust of Marsden Hartley,* 1912

# M. H.

My dear Stieglitz — It's no use — I shall have to begin again — my
conscience troubles me too much. Two letters have gone
into oblivion here for want of time to finish them — I
have got to get something off to you if only to say one exists —
I didn't suppose I would so soon see the time when letters would
be difficult for me — but I suppose it is chiefly when one
isn't living very much that one can write more — and I have
lived through so much that is gay and grave these past
months that I have kept still in all matters of my spiritual
universe And one has heard much from me — Doubtless
you may have heard through Demuth or someone of that great
grief I have — the loss of one of the dearest friends I ever
had — Karl v. Freyburg — cousin of Rönnebeck bei Arras
gefallen —. It seems like a great lie I am always telling
when I write or say what I have to accept in truth —
You know what friendships are to me — how slowly I make
them and when once made how I almost worship them
I had every reason in this wide world to adore this fellow
because it was a friendship begun in Paris the June that
I arrived there — he has gone about a deal together there
and here in Berlin we three were much together and
it was a very beautiful triangle — If there was ever

Fig. 10. Marsden Hartley to Alfred Stieglitz, Letter, Berlin, n.d. [March 15, 1915]

n.d. [received June 6, 1914, Berlin]

My dear Stieglitz,

This a hurried extra to say—that you better send me $75—to reach me <u>July 1st</u>. I have had unavoidable expenses since my arrival here—over 100 mks. for materials and incidentals—mark by mark for things to go on with that must be bought. You may be sure I spend only what must be—as I know well the importance of saving—but at $2.00 to 3.00 each for canvases—this is soon counting up and I have to have the things.

As always,
M.H.

Did you by any chance ship the bust of me by Rönnebeck? He wants it for a show later in Frankfurt. Send it soon if you have not done so, *nicht wahr*?

✑

n.d. [received June 12, 1914]
Nassauischestr. 4
Wilmersdorf, Berlin
*erster Teil*

My dear Stieglitz,

Well—I am thinking that you are putting me down as what an Englishman would call a 'rotten lot'—or in ordinary English an ungrateful wretch—but really Stieglitz—I give you my word—I have just had to keep still as still as I could keep—to recover myself thoroughly—I have been sick—and truly sick—for there is no sickness whatever that can vie in acute agony with this thing which comes upon the mind and stays there like a leach drawing every atom of marrow out of what ought to be in all senses a fair and comfortable state—leaving one absolutely dregged. I have been grateful enough for what I think now to be as fine a moment of discretion I have ever enjoyed in not sending you the letter I did write you weeks ago. It has been the one obligation I have held myself to ever since my arrival here—this writing to you—but I could not—and so I vowed I could not until I could find a fresher state of being than that which overtook me some time before leaving N.Y. and remained with me until now. I owe much in the way of recovery to the sunshine that went with me all along—in Paris—in London—and here—I repeat—there is nothing worse than this state of being when the mind is so fatigued and the senses so distraught that the whole world and all in all despite one-self takes on the nature of something merely diverting previous to some minor catas-trophe that never takes place. Anyhow—I will try and not allude to these phases—since by some miracle I am released from them and the days take in their natural visage and the nights are simple as the days shine.

First I will say at once that I am grateful enough I can assure you for the decision of Daniel—it makes possible to a decent degree that which I wanted above all to accomplish—the freedom for a given space for work and living of an intelligent kind—a kind worthy of one who wants to be free from everything that is picayune and miserable in this game of art. How one comes to despise all these little tricks of diplomacy for personal benefits—and how one grows to thoroughly hate the prevailing systems as they are employed in Paris—and to a more ridiculous degree comparatively in London where modern art is striving so pathetically in the hands of a few young painters—who sit at home and watch slyly for what happens over the channel so they won't be caught off the scent—and Paris itself so like a menagerie *vicieux* all sitting showing their teeth with politesse extreme [?].

One wants to get away higher than all this—one wants to be superior to all these silly quibblings—one must—even if a kind of hauteur be necessary—as for expression it takes care of itself—and it is great or not great as the individual is who creates it—and no amount of discussion will benefit or change. This is one of the reasons why Berlin suits me. I sit here in my little *Wohnung* and it is as if I were leagues removed from all that stuff and nonsense. I work daily—to my own satisfaction—because when one sees constant growth and development toward the purification of one's ideal one must have a fair sense of satisfaction.

Just ten minutes ago the box arrived from 291 with my pictures after no difficulties except the expense of 12 marks—and now I am prepared for any connections that may be made and will doubtless soon as I am writing Franz Marc and Walden to see about putting them in charge of the Blaue Reiter for circulation over Germany—then later have a *kollektiv Ausstellung* with new and old—but later—for now I want to keep free of all ideas of exhibition as much as possible. I suppose they will be having their usual Herbst Salon and I will get in in this also—these things are fine when one has them—but one cannot count on them actually for anything definite until one is well known.

Before I forget here—I want to say that I think it advisable if you have not already done so to put all that Daniel business on paper and have him sign it—because you know what failure would mean to me—and the risk is possible—inasmuch as after raising the hopes of Rockwell Kent to the nth degree when the poor fellow had all but sailed on a two year project—Daniel informed him quietly that he could not keep the agreement. Fortunately R. K. fell into another little streak of luck at the eleventh hour and saved his life—but instead of coming here to Switzerland with his wonderful family to open up the vision of them all and expand generally—he had to find solace in Newfoundland among lost and forsaken things—wastelands and thoughtless seas—and a vastness of diffident nature generally—the which not generous enough for a young mind and a soul eager for fresh life. It will help him of course but it does not help one enough. I assure you that one's creative instincts do not thrive on rigidity and conservation and diffidence on the

part of nature. There must be a fair amount of taking if there is to be a respectable amount of giving. I can cite you at this time the pathos of a case like Van Gogh which is vivid here with me just now because Cassirer has on view 150 paintings and drawings and because I have just finished the letters in English after floundering barely around in the German and French.[1] I assure you his is the most tragic instance of the ridiculousness of the artist's life—that one must be brought to such a pass for a vision. I know I am absurd to you or anyone who hears me say it if I state that these things are ridiculous—and as if to add a complete sense of the perfect pathos of such a dream as possessed this fine fellow—one finds nearly every painting simply disappearing from sight through lack of discretion and a better sense of economy. One hardly knows at this early stage what were his emotions and convictions as to values and relations—so badly are the colors related to each other by the shifting due to cheap pigments.

Personally I do not thrill greatly with Van Gogh as a painter as much as a superb idealist—he served his conceptions as best he knew how—and one loves the ardour of youth and faith in all his work—he literally believed what he saw and therefore he was a splendid visionary, and one turns to him with relief and freshness after the insufferable mediocrities that invade us now. How, after all—uncommon is personality and how depressingly frequent and prolific is talent—good God how boring it all is—the art business as it goes now. One must simply shut one's eyes and one's ears and turn to the street for newness and originality—and to make note of the laughter on merri faces is like a new species of expression. So it goes—one joins the common throng of ordinary mankind with alacrity if one may evade ever so meagerly the absurdities of those who think themselves the chosen expressionists.

Again before I forget—will you communicate with Herr Merkel and get those letters of introduction he wanted to give me—they will be useful I am sure and it is well to somehow meet people. I shall find myself knowing more of them sooner or later through various sources—Ernst Reinmann—Mrs. Meltzer's brother who is a young German writer well known here—comes to see me every week and when she arrives it will create a little more social life for me as I do not find it good to be alone so much. I see Rönnebeck almost daily—though now he is up in Schleswig-Holstein finishing a child's portrait in stone for Countess [?]. It has been and is very good that I know him well.

As regards the pictures of Daniel—does not this leave one of the "dark" ones free at my disposal—that one with high hills and the little house below—much green—and white clouds—the one Mrs. Bull liked much— I had hoped sooner or later she might take it and get it into the Albright.[2] As I see the pictures—this one is the only one of that period left me—you have the browner one at your house—then the two at Daniel's already and this one. Save it for me if it is possible—though I don't know any longer what is mine and what is not. I don't care much except that if this one is free it would mean a sale later and a placement of the picture. I have in London some seven or eight

still-lifes—and some here—which I consider respectable—and sooner or later will give me something. I am learning that it is wise to keep old things even if at one time there seems little significance in them. It is so easy—and so easy for me to tear up things—but now I keep more frequently things—since each one bears a relationship to another as they must of course.

So I am glad for these later developments, it will form a little minor history too, how these landscapes have gone about begging for consideration. In one sense the money gain is fair counting the $500 Montross gave me outright which must always stand to his credit after the things one hears of him.[3] I have never quite understood his lack of interest in taking an equivalent—but if he has any pleasure in the fact that he helped produce an individual—well—so much to the good. It behooves Daniel now to get wise and take over what there is in the way of original stuff. I should think he would see into the wisdom of getting more Marin and Walkowitz—since we must all depend upon such people for our existence it is well that it is done well—and Daniel would be showing his acumen generally by getting it all first just as the Vollards and the Bernheim-Jeunes and the Durand-Ruels have done it. All he needs is the wisdom to see what the public is looking at and believing in.

*zweiter Teil*

Well three days are elapsed and this letter lies here—I must send it even though it is but a hit or miss effort. I shall hope to write a more coherent one next time. Just a few things to mention at random—Kandinsky's book is out in English and it reads well—though I think it is really more for an untutored public than for the more or less sophisticated in matters relating to the subject. I think some things a little over done on the side of the spiritual.[4] It is what one might say in one's home or privately but in a book it savours too much of creeds that have nothing to do with art proper. However—it will have its effect somewhere and that is all anything or anyone can hope for. It finds favor in England among those of the "Rebel Art Centre" an offshoot of the Cubist-Futurist notion in Paris—but since there has been so much of Marinetti in London with poetic talks and now demonstrations of noise-music in Vaudeville there these young fellows who want to be English—have just these days issued one more of those tedious manifestos—saying we no longer affiliate with the "Cubist-Futurist" movement but will now declare ourselves "Vorticists" by which we intend to symbolize the whirl and movement of our own modern tendencies or words to this effect.[5] Knowing this body of people in London—one can't expect much but I regard them just as vital as any of the others—which is to say not at all as far as art goes. I respect them as I respect all the pages of the dictionary—but I don't think titles have ever made an art one sees this beautifully exemplified in Pre-Raphaelistism there.

I could scarcely believe my eyes when I went to the Tate Gallery to see a big exhibit of Blake which had departed for Manchester.[6] Somehow one feels that at least an original picture holds something—but these Rossettis and Wattses—Millaises—Ford Madox Brown—etc. Well—they are excellent for the Pear's Soap people or the Beecham's Pills as affichés.[7] In Rossetti's case it is a pity a great poet should ever have painted. It illustrates so well my notion—that if you sing a thing you can't dance it—or if you write it you can't paint it—though in the instance of Blake it was pretty well accomplished though I feel that Blake's writing was largely an automatic thing—just as even he says somewhere—"their authors are in eternity"—but Rossetti as poet is certainly fine. I was deeply sorry to miss the big Blake show as that was the chief purpose of my London visit—artistically speaking—if I had dared I would have gone to Manchester to see them but I was afraid of the expense. So it is I have missed two of the great shows of our time this one and the one at Köln. One cannot afford these losses actually for they make history in one's consciousness, and then too authentic personalities are so uncommon.

Did I tell you that the *Egoist* of London (which was until some months ago the *Freewoman*—a paper of good quality with a damning name) has asked me to write an article in the form of an elaboration of what I said in my catalogue as it was seen by Ezra Pound who told me he thought it very good.[8] If you knew Pound you would know that this is really sheer flattery. I am told they pay well too—but as I am writing this for myself—having already began it before London—I shall finish it from increased notes here—and when it is ready send it to them. I think it will be really respectable as I read it over. It has for its present title—"On the Decline of Vision" though that may be changed. I am picking out here and there the types of real visionaries—both material and spiritual—Rousseau, Cézanne, Picasso—Redon—Blake—among the painters—Van Gogh of course who is one of the first since he was actually a visionary—though his was an highly organized earth vision. Gauguin in the religious sense contrasting it all to the men of the French schools of now who see actually only what the camera sees—who simply take ordinary facts out of nature and construe them ordinarily—being not artists in any distinguished sense—lacking in those qualities that set a real picture beyond nature and beyond truth—the lack of power to transpose in the truly abstract sense—being realists of a mean order. Whereas one like Picasso sees the material thing with an exceptional degree of power and is an artist. Anyhow this is but a vague notion—I want to make it felt that it is not that "professorial eyesight" which sees as it thinks—but the truly untroubled one like Rousseau for instance who expresses as well as ever probably the sense of vision—he was beyond the help of nature which is the first requisite. The real visionary is beyond any help that nature can offer him—what he sees is superior to what is seen above and beyond what nature presents. It is he who actually shapes the "soul" of nature for us and for the universe—in the arts—he transposes facts into their spiritual

transports and arranges a harmony of them for us and the farther he sees often the less comprehensive it is—and so on and on.

I am even thinking that if it comes out as I expect it will it might make a good article for *Camera Work*—and perhaps I will get Rönnebeck to do it for me in German for something like the *Blaue Reiter.* I know his Countess patron read one of my letters to him last summer and she then said that the *B.R.* ought to print it. I would like all this since I am confident I shall not ever say much in this world actually in words. I am quite some against poets painting—painters writing—dancers aspiring to Hamlet—etc. for that is what it all amounts to.

I would like much to have some of those catalogue things of my show—if you can search up a dozen or more will you send them. Also don't forget to mail me that clipping from the *London Times* on the exhibition of the insane there.[9] It has very good touches—and I need it.

I hope you are through with your jury duty by now for that must be tedious in the hot weather though I can even fancy that there may be diversion in it for you through the very remoteness of associations though it lies well within your type of expression—administering justice in this world. I haven't heard anything of your summer? Is it Elberon—Lake George or where?[10] I am very glad Steichen is home for I think that would be most of all his desire—and his garden is so dependent upon him.

Have you heard that Maeterlinck has written an essay on those exceptional horses at Elberfeld I think it is—who tell their owner by self-invented signs what they wish to say?[11] I hear a little of them here—people laugh at Maeterlinck of course but though one doesn't know—it may be that all things will one day be talking and we be the dumb ones. I could even fancy the charm of such a state—we keeping on consciousness and listening to all sorts of new conversations of infinite variety.

Thanks very much for the Daniel thing—for everything—many thanks. I feel so much freer with a space of time and freedom ahead of me—but I urge again—get it down on paper—as it after all is business and there must be no illusions about it. I can't afford any change of mind on his part. I hope in that time to have "connected" over here.

Give my love to Mrs. S. and Kitty—also very kindest wishes to Walkowitz—Marin—De Zayas, Haviland—though the last two may be over here in Paris by now. Also to Mabel Dodge love—I had a letter from her—saying she expects to sail for Florence July 1st with Mr. Hapgood and their two boys.[12] I shall know later if I am to go to Florence as she said—she invited both myself and Rönnebeck—but it remains to be seen. I want so fearfully much to get a square look at Giotto and Angelico.

Very best wishes always to you—write when you can. Give my love to Zoler and give him my address.

Best wishes always,
Marsden Hartley

1. In 1914 Paul Cassirer's press published the first complete edition of van Gogh's letters to his brother Theo.

2. The painting could very possibly be Hartley's *The Dark Mountain* (1909) now in The Art Institute of Chicago; The Alfred Stieglitz Collection (gift, 1949).

3. This is a reference to Montross's $4-a-week stipend for two years. See note 3 page 113.

4. *Über das Geistige in der Kunst* was published in English as *The Art of Spiritual Harmony,* trans. and ed. Michael Sadler (Boston and London: Constable, 1914).

5. The Rebel Art Centre was a collective of artists in London associated with the artists' movement, Vorticism, led by David Bomberg, Percy Wyndham Lewis, and Ezra Pound. The Vorticists published a very short-lived periodical called *Blast* (only two issues), with the first issue including a review of Kandinsky's *The Art of Spiritual Harmony.*

6. *Loan Exhibition of Works by William Blake* at the National Gallery of British Art in London closed at the end of December 1913. The exhibition later opened at the Manchester Whitworth Institute in February 1914.

7. These artists' works were used for advertisements.

8. Hartley and Pound became friendly with one another during their discussions about Kandinsky. Hartley refers to his foreword for his exhibition at 291 in January 1914. For a transcription of this text, see Hartley, *On Art,* ed. Gail R. Scott (New York: Horizon Press, 1982), 62–63. Hartley's article, "On the Decline of Vision," was never published in the *Egoist,* which had been called *A New Freewoman: An Individualist Review* until January 1914.

9. Hartley refers to an exhibition at the Bethlem Royal Hospital of pictures by patients of lunatic asylums.

10. Stieglitz summered with his wife and daughter in New Jersey at a vacation resort in Elberon. For explication on Lake George see note 3 page 96.

11. In Elberfeld, Germany, Maurice Maeterlinck conducted a series of odd experiments with horses and numbered cards. His results concluded that these horses he examined in Elberfeld were capable of telepathic powers.

12. Not to be misled by Hartley's statement, Hapgood and Dodge each had a son from their marriages to Neith Boyce and Edwin Dodge, respectively.

∞

June 16, 1914
291 Fifth Ave., New York

My dear Hartley:

Your postal card came to hand a few days ago. It showed clearly that you had not as yet fully found your equilibrium. I suppose my long letter did not help any to quiet your nerves. I certainly did not like to write that letter. I felt I had to. I felt I had to bring you face to face with a certain reality. A certain reality you unfortunately cannot skip. I mean the economic reality. This is the reality that still rules the world. It is a reality which is going to rule the world for quite some days to come. Possibly in time another reality will take its place. And by economic I mean the question of money. But I hope that the letter I wrote you two weeks later, and which you had not as yet received when you wrote your postal, will have helped bring about a quieter state of mind within you. And now

I have further good news. Daniel has been here several times since my last writing and we have had several more talks together. Talks which I know will help him and will help conditions generally. "291" certainly acts as a great stimulant for Daniel whenever he spends any time there. He realizes it himself. No wonder. The more I see the rest of New York, the more I realize how very different is "291." Daniel is certainly an enthusiast, a living being. I hope commercialism will not kill everything fine in him. I told him so and he laughed. While talking over lots of things, he happened to spy a still-life of yours standing on the floor. He liked it so much that I asked him why he did not make a full job of things as long as he was about it. And before he had left he had decided to appropriate another $225.00 for you. For this I let him have two still-lifes, one smaller flower-piece and a small pastel. In short since you left Daniel has bought outright $825.00 worth of your work. You must remember that he had also taken $250.00 worth while you were here. So the $1000.00 that on your arrival from Europe, you thought, Daniel might give you for your things has actually come about. Of course not at the time nor in the manner in which you had imagined. As you see you get even $75.00 more. He is thinking of having an exhibition next winter of the pictures he owns of yours. He asked me whether I thought such an exhibition would be a good thing. I told him that I thought it would. A good thing for him and a good thing for his prospective clientele. And I wouldn't be surprised if New York would finally accept these earlier things of yours. I hope so. I would like to see a real tangible beginning for you. And by tangible in this instance I mean a beginning through a regular dealer. Daniel, as I wrote you is going to pay in monthly installments, $75.00 a month beginning in October. As I see it you have quite a time ahead of you in which you ought to have no money cares. I know how you would like to have a little more money than $75.00 a month, so as to make traveling possible. Perhaps with the <u>definite</u> amount you have now assured you for quite a long time, which definite amount assures you at least a decent existence, perhaps it will be your good fortune that something of yours be sold in Europe. If so such an amount will help you obtain your "luxuries." Personally I feel much relieved to know your existence assured for some time. I know I worried during the past two years probably more than you did about your affairs. I think I understand you thoroughly. I have had such a vast experience, and being of a different temperament than yours, I could readily see into the future, your future, possibly better than you could. At least such has been the case until now.

And now as for a little matter which I want to clear up and to which I referred in my last. A matter which I did not want to mention until I felt that the time was opportune. Now that things have been <u>done</u>, that is your existence assured, I feel I have a right to tell you something which I must get out of my system. You will remember that the day before you left for Europe I gave you a hasty summing up of your financial situation. Somehow or other no chance had offered itself to me before. You were so upset, and

so nervous, that I dreaded the moment in which I had to bring you face to face with your financial condition. I felt I had no right to let you go to Europe without telling you exactly what moneys were yours and what you could expect. You will remember that while you were here, I handed you during the time such moneys as you asked for. The money belonged to you and I felt I had no right to warn you that you were drawing relatively large sums. When finally, the day before you sailed, I told you of the balance which you could draw against, I saw by the expression of your face and by the remark you made to me, that you were terrifically stunned and that you had not understood. It was for the very reason that I had felt that this would happen that I spoke before you went. I said nothing. I had done what I felt I had to do. You asked for no explanation and so I could give none. I felt much aggrieved. I felt that something intensely disagreeable had happened. Something which I wished at the time had not happened. But something which I suppose was inevitable the moment the question of money was introduced. Money eventually seems to have the gift of soiling, even if ever so little, everything. And even now I would not write about this matter were it not for the fact that after you had left, some of our mutual friends asked me whether I knew why you had been so nervous, especially nervous, the last few days before sailing. Many of them are really your friends, and I think my friends. It came out in the course of conversation, and this from three distinct sources who had not compared notes, that you had made the remark several times that you were so upset the last day because you had found out that there was less money coming to you than you had expected. And that the terrible thing was that money had been deducted, from what had come in for your pictures, to pay for your "keeps." In view of the actual facts I laughed outright. The laugh was perhaps a trifle sad. Now, Hartley, this incident has not changed my feeling for you one iota. But how in the world did you get such a ridiculous impression? For since I have known you every cent that has been handed to me for the pictures you sold has been passed on to you. The pictures which I have in my possession of yours where the equivalents for $984 which I sent you of my own cash. I took this money from my very little capital because I felt that I was doing the right thing by you. I didn't feel as if I had a right to give you the money without taking some equivalent. This you may not fully understand. But I have to do things as I see them right. That is the privilege that I claim is everybody's. And for that $984 I took two old landscapes, two dark landscapes, and the one later big thing. You can see for yourself that I have made the price of your pictures to myself very much higher than I made it to either Daniel or Simonson. I know that you will feel very badly about this business. You will feel badly that I have been forced to talk about these matters at all. But I feel that this has come about through no fault whatsoever of mine. Your nervous state undoubtedly was mainly responsible for your not having understood what I had said. And now to close this matter for all time, at least I hope it is closed for all time, let me tell you in figures exactly what all this means.

While here three of your new things were sold for $350.00 a piece. Daniel bought a batch of the smaller things, old ones, for $250.00. Then Simonson took the old landscape for $100.00. I had sent you to Berlin $210.00 in November. It was this money which made your trip possible and which helped pay your rent over there. You will remember that you had hoped to be on your feet in September, relying on Koehler, and that your hopes fell flat and you were left high and dry. You will remember that it was this incident, and the feeling that I had to see you through by hook or crook, that finally induced me to raise $210.00 for you from my own money. And that was not easy, I assure you. I tell you this because you may seem under the impression that I can get money readily whenever I want it. I suppose I could. But I never make any attempt. I dare not acquire the habit. If I did I would be lost for good. When you had left, you had drawn in such cash from your sales to bring the balance due you to $660.00. Since then you have already received two drafts for $75.00 each. That brings us up to date. Mrs. Dodge has not as yet paid the $150.00 due, nor has Simonson, but I am assuming that these moneys will be forthcoming in due time.[1] Thus you see there are $510.00, which means that there are about seven months assured you through this source. And then there are another eleven months assured through Daniel's new purchase. In short you have eighteen months clear sailing at $75.00 a month. I wonder if you can make out these figures, I hope so. At any rate they are correct. And above all I hope that your mind is at ease, and that you are ready to do yourself justice. I wish to add that the shipping over here of your pictures, the shipping back, the framing, exhibitions, and all such matters were never charged up against you. Nor were any pictures taken in return for any of those outlays. Furthermore no commission of any kind has ever been deducted. I add this as it just strikes me.

That letter you referred to which you wrote when you were so upset, you ought to send me. I will understand it. As a matter of fact it will interest me and it ought to be added to your little collection of letters that I have. It is part of you. And that is the reason I am interested. You ought to know by this time that you can be perfectly open with me.

We are out at Elberon again. We are the only people at the hotel. The weather has alternately been very warm and very cold, rather trying. I come into town daily and "291" keeps me pretty busy. I feel a little less tired. I am beginning to see daylight for the coming year at least. For some time I was so terribly tired that I could not think straight. The load I am carrying is a much heavier one than anyone can realize.

Did I write you that Walkowitz sails for Europe tomorrow? He is going to Athens, Naples, Venice, Rome, Paris, and London. He intends to be gone over five months. It is his expectation to do the whole trip on about $400.00. I feel that the change will benefit him greatly. He needs to get away from New York for a time. Marin left for Maine this morning. And so I shall be at "291" pretty much alone with Marie for some weeks. I have a lot of photographic work I want to do. And then I want to straighten out a lot

of other things. Amongst the other things is the fact that I must be fully prepared to get out of "291" on April 30th next. I don't want to have any grand excitement at the time. What we shall do after April 30th is still a mystery. I am not bothering about it. But I keep it in mind. I must be prepared for any emergency. I usually am.

De Zayas is in Paris and is getting about a great deal. He wrote that he had such a wonderful time with Gertrude Stein. He said it was the first time that he ever had had a real laugh with a woman. Furthermore he said that she had a marvelous sense of the comic. I suppose he will come back with a great batch of caricatures. He has also arranged for a Picasso show and several other shows.[2] In short the season at "291" is to be a very lively one. I intend to run the exhibitions not longer than sixteen days. I am going to start in in the middle of October and I am going to push things hard. I see daylight, at least for the year.

I am enclosing your draft for July. Again I repeat that I hope you will take this letter in the spirit in which it is intended. And then forget it. It is just a clearing up of an unfortunate misconception.

With kindest regards,
[Stieglitz]

1. Dodge purchased *Portrait of Berlin* (1913) from Hartley's exhibition in 1914. The painting is now in the collection of the Beinecke Rare Book and Manuscript Library, Yale University.
2. Shortly after arriving in Paris in spring 1914, de Zayas tried to arrange an exhibition of Picasso's work for 291. He found that Picasso's dealer, Daniel-Henry Kahnweiler, had already made an exclusive agreement with Robert Coady of the Washington Square Gallery in New York. In the end de Zayas borrowed works by Picasso and Braque from Francis and Gabrielle Picabia's collection for *Exhibition of Recent Drawings and Paintings by Picasso and by Braque, of Paris* (December 9, 1914–January 11, 1915) at 291. For a further account of this affair, see Homer, *Alfred Stieglitz*, 199, 288n. 20.

⌃

June 25, 1914
291 Fifth Ave., New York

My dear Hartley:

I have received part #2 of your letter and I am hastening to drop you a line before part #1 arrives to let you know that the Rönnebeck bust will be shipped tomorrow. I had not forgotten the matter. Please ask him to excuse my seeming delinquency. Some things you referred to in your letter, especially that part relating to Daniel, I fully agree with. The letter that you will have received from me in the meantime will have spoken for itself on this subject. Daniel is no Vollard, nor Bernheim-Jeune, nor Durand-Ruel. But we must be grateful for what he is doing. Don't fear about my getting everything

in writing. Daniel has bought the things outright. Besides which I have a letter on record. The whole thing has been attended to in a business-like fashion, for you and for Marin. So far little Walkowitz, although Daniel likes his things, is still a little beyond Daniel as far as purchasing goes. I cannot tell you how delighted I am that you are writing for that English magazine. I have always hoped that you would do so. You express yourself wonderfully well in words and have vision. This combination is a rare thing amongst painters. Of course I shall reprint anything you may write. And it would be great if the thing would eventually also appear in the *Blaue Reiter*.

De Zayas is in Paris, and has also been in London. He has written me some very interesting things about Picasso and others. I have also had two unusually interesting letters from Leo Stein. Walkowitz had me send him a copy of "Camera Work." Leo Stein imagined that I had sent the Number to him and in consequence he wrote to me. His letters, highly interesting and perfectly logical from his point of view, show me very clearly why he does not respond to Picasso of today. Stein has no real vision. But I cannot go into these things just now. I have my hands too full clearing up things and actually doing some work of my own.

You asked me to send you the $75.00 by July first. This was done last week before you asked me to forward you the money. I had thought that you might run short on account of the expense of material etc. I know that your recent experience must have taught you the value of husbanding your pecuniary resources. In haste,

Your old,
[Stieglitz]

෴

June 30, 1914
Berlin

My dear Stieglitz,

Well Stieglitz—this last letter of yours seems a deal like a miracle to me—it is a miracle of good will—of consummate kindness and a tribute to the very name of friendship. I feel as if it were high time to sing highest praises in your name on behalf of your capacity for friendship—for the virtues of tolerance—and for that far fairer virtue of sympathetic understanding which at the moment when it should in all honesty condemn to silence forever—but in the crucial hour—by kindness all regrets to literally kill that which insults. Well I think I cannot at this late day after the manifold trials that friendship has been subjected to—cannot embarrass either myself or you—by openly avowing you to be a genius of the earth for this superbest of gifts alone. The power to understand the peculiarities of personality to their ultimate degree—I have long since felt

that you had been too well tried in these relationships to warrant either fresh experience or continuance of the old ones.

However I am truly in the humblest state of apologies to you for the acute pain that my action seems to have created for you. If I did not actually in my heart <u>know</u> that there <u>are</u> moments for forgiveness I should feel too inclined never to write you again out of veritable shame. It is only pathetic that I who have prided myself often on the power of concealing myself at opportune moments—should have at the most inopportune have divulged my weaknesses so thoroughly. I shall have sooner or later in these pages to confess myself—but like all human beings already I find myself searching for fairer defenses than I can justify. I simply can only get down on the block like a man and submit to the axe and metaphorically let any who find it diverting—watch the very blood of me drain itself upon the diffident earth. If this figure indicates in any degree my real mortification then I shall have found some excuse for creating it. I am not weaving words—I am trying my best to say how horrified I am that I have created in your mind a need for statements and figures. Perhaps I am being unkind when I say that I have not read them—I have only seen them. I do not want on my conscience any such problem of arithmetic—I shall only hope that in the future I shall never never again have occasion to be so horribly mortified as in this instance.

You know I am certain how I hate to talk of moneys when they concern myself—you know how I have been so thoroughly honest in these things—that I have known absolutely to the depths of me that when it has been necessary to allude on your part to these things—that my belief has been too complete even to allow a shadow in my mind. If you knew actually how I have all my life loathed the idea of apology you will I think appreciate fully the sadness of its necessity on my behalf. I have always held in whatever relations that a person's actions and attitudes should be such toward mankind that any such attitude is in itself debasing. When I have acted or spoken it has been with the conviction that I have been doing <u>my</u> best—and that I must like all individuals be accepted on my face values. I have hated that impetuousness which has inflicted everywhere unnecessary injuries however trifling—not in any sense to be virtuous—but simply to be in the best sense truthful—there have been rare moments when a spiritual vengeance has been necessary and I have like any other human being wreaked it upon the subject which occasioned it. I have for so long had such contempt for that smallness of character which deals out only pettiness. I have wished so long that whenever I have found occasion for generosity to give only generously—in whatever form—and accept with the same generosity those things which others have offered me.

I think you can therefore appreciate the humiliation I have labored under ever since I returned to this side of the ocean. I think we shall not have occasion ever again to dilate upon such occurrences. You know what I have thought always of friendship—that it never insults—nor ever demands—and on that basis I have made them—I have

wished always to be equal to them—and only in the rarest instances have I found myself not great enough for them. Let this then be for you the indication of what I have always desired to be—and in the name of the stars and the sunlight—in your case certainly. I am living always in the hope that I can surely one day do something that will show exactly the true state of my appreciation—and not always and always be accepting and accepting and saying thanks—but how futile it all seems—one hopes and hopes—and there never seems to be any approach. If I did not know that all these relationships have been for something actually larger than personalities—then I should be despair itself. But all this dissertation seems like vapour itself and need not continue I think. I hope that I have somehow "washed these hands white again" by the weakest of apologies.

As to the decisions of Daniel—all I can say is again thanks—I am glad he finds it is his chance—I am glad it takes a problem off your hands—it certainly is and will add strength and courage to a strangely weak existence—for my feelings about life in this period of it—are not as glowing as I could wish them to be. I have referred to these things in that letter which I still keep in the dark and which since it is mainly of myself I may send you in time. I am finding life a lacking thing—Stieglitz—there is a wrong in it—for there is an evasion of purpose—not on my part but on the part of life. Nature has equipped me with too much that is human and life finds it diverting to evade the main issues—and to stand like an acolyte swinging censers of praise upon the great ceremony of existence as it <u>passes</u>. Well it is not enough—that is all—there is no recompense for all this. I speak to you now as to one who sits behind a lighted grating and listens secretly to deep secrets—I confess that in my experience there is a vacuum—and while it is but the mere problem of one—is nevertheless not so minor as it would appear to be. One cannot live without life itself coming to one—one must have an incentive more than the mere will to live. I think perhaps one takes the notion of truth too seriously—perhaps the highest truth is only a lie after all. I have lived so long on the Max Stirner basis "that my truth is the truth" and find it being one of the comedies of time.

And my feelings about art do not change this phase of the problem in any degree—for expression goes on much of itself—it occurs according to the volume of life that comes to one or it ceases according to the lack of it—and all the mutual insistence is of little avail—one can always work—but the gods know how tragically this is being proven by the artist of today—but to have something to express. Well—I am thinking it is such a rarity—as I am convinced that creators are a rarity today—something to express that springs really from oneself—well it does happen now and then. I am thinking too—how interesting it would be if all these agitated beings who are afraid of not being heard of were by some force struck helpless—so that they could not work for a period—well—I actually do believe that some art could come of it.

As it is—I am convinced that creation is stopped—the spirit of creation is consumptive-like and can find no air that helps it to breathe naturally. Mentality has usurped the

power of vision—and no one is seeing anything—everybody is thinking or thinking he is thinking something and we all know how rare the quality of intellect is—and how prodigiously productive the notion of talent is in life. How much one reverences the Rousseau spirit and all it produced in him—how one comes to adore that power of thought and vision in one that was Cézanne—and too how one admires the actual gift of creation that is Picasso's whether in these late days one follows or needs to follow his digressions and aggressions.

It doesn't matter the slightest bit what there is in a picture—if first of all a picture is then—this can be put down once and for all as axiomatic. When one observes out of what matter peasants and primitives make their pictures and the undeniable quality of their sense of picture making—one simply [?] and justly—all this professorial effusion—nonsense more specially speaking—and then the children—who never fail in their ways of expression to put forth the picture idea in every line—by actual correctness of technique to choose form incidents and line motives which will tell instantly to the observing eye the pictorial intuition. Well it makes all these salons into ridiculous panoramics of wax-works.

I am loving much at this time a pamphlet-book on Rousseau which Simonson has sent up to me from Italy—a few things in it which I did not know at all—when I hear an "all efficient" like Delaunay—describing the lack of knowledge of Rousseau—well it is only one more absurdity in the world that is all—and so it goes—at random all this.

A letter from Franz Marc states that the Herbst Salon will not be this year owing to a tremendous deficit last year. In a way I do not think this so bad inasmuch as it stops this annual game which is so boring—just as the Indépendants is so utterly useless each year. It was such a good show though in its effect that it is a pity in that sense. He says I must go and talk with Walden about showing my things in Berlin and elsewhere and that he has written him about it—he says times for modern art are "very very bad" no one is buying anything—also he says "do you know a Mr. Eddy of Chicago—he might buy some of your things if he saw them—he bought pictures of Kandinsky and myself—though at very <u>moderate prices</u>." I think it only fair to these people to let them in on the Eddy game so that if he tries them again they can be better prepared. There is no use of his being allowed to pose as an American collector <u>without</u> exposing his cheap methods.[1]

The *Luftschiff* "L.V." has just passed over us here as I write—a fascinating thing which transports one somehow every time one sees any of them.

Well—Stieglitz here you have a letter of whatever character it may be—I find writing not easy when once it seemed such an easy thing to do. I have ideas enough I think and time—but occasions for letters are so rare even though they are often more obligatory. I am so glad Walkowitz is getting to Europe. I do want so hard to get to Florence the coming month—all this rests with Mabel Dodge entirely—she can by her decision

make or destroy an epoch of experience—for I don't know if I could venture otherwise and it is so very essential in these times to add experience. You know my European experience has been very limited as to its character—I have seen almost nothing of old world splendour—simply slight variations of the same thing at home. I would like this warmth and richness of Italy to come in just now—however we will see. I can only hope that when she gets over—she decides to open the villa while she is there which at present her decision is not to. As to the money—she surely will either send it you or me in good time. As to Simonson well he must not forget—he is getting it at a much less figure than I intended and he can in all reality pay the original amount you know—but I don't dare mention it because it has apparently been settled. I suppose as to Daniel—you have something on paper surely—I feel the necessity of this for enthusiasms are dangerous as I have and still do experience.

I was amused to think of De Zayas and Gertrude Stein together—I think in all truth she would laugh God out of his importance if he would and did appear in her place. She would I know make such a being more human and sociable. I am more than glad that he is getting some fresh material for next year—I only wish there was something I could get but all there is—is Kandinsky, Marc—Klee and some others and the first two are impossible for the size they work on—Klee you could have through Walden as he is in charge of all that—but you will doubtless be getting enough for the coming year. I do so wish '291' could get a nice place similar to Bernie K.'s—that sort of thing would be so good you know—it will have to be in some such locality too. Walden seems to be to have a very poor location here—even though it is Potsdamerstr.—it is among shops and things that appear out of the way—and one must go through a courtyard and up into an office building. I suppose he gets his public there though such as it is—there are several new places here—but they show nothing of consequence—except as last year the big Picasso show with Manolo's sculpture. I think also—there again—O no—I think it must have been negro sculpture at the same time. Otherwise there is only Cassirer who keeps to the safe side always.

Love to Mrs. S. and Kitty as always—to any and all others—Kerfoot when you see him. I hope you get time to do some good work of your own.

As always yours,
Marsden Hartley

1. In fact, Arthur Jerome Eddy was an American and by this time had become a noted collector of the avant-garde. He eventually amassed a large collection of works by Kandinsky and his circle. Although Stieglitz urged Eddy to purchase a painting by Hartley, Eddy never acquired anything by the artist. See Paul Kruty, "Arthur Jerome Eddy and His Collection: Prelude and Postscript to the Armory Show," *Arts Magazine* 61 (February 1987): 40–47.

July 10, 1914
291 Fifth Ave., New York

My dear Hartley:

Your long letter, which you sent in two parts, the second part arriving three days before the first, through the idiosyncrasy of the mails, reached me about a week ago. The letter was of unusual interest to me. As you know all your letters interest me. But this one was of more than the usual interest as it contained much which showed me over again, for the nth time, how logically you are developing. And that is the chief thing that interests me in any individual, that is, to see the perfectly natural unfolding of the so-called innerself. With the essential things you feel I am in perfect accord. That you also know. I am quite as tired as you are of all the twaddle that is going on in the name of Art & Company. How I hate the Isms. And how people will harp on just the external thing. How stupid! How time wasting! And still I suppose it all belongs to the scheme of things. Stupidity and all.

As for your old pictures, the dark one you referred to, the one Mrs. Bull wanted to buy from you, that belongs to me as well as the other one. Mrs. Bull knew that, I was perfectly willing to let her have it so that you could have the money. I thought it was more important to have you get money than for me to hold the picture, although I had paid for it. I was willing to let Mrs. Bull have it and take something else of yours some future day. I feel she has made a mistake in not taking it. But I suppose she did not have the money and thought she had no right to go into debt for it. As far as your old pictures are concerned there is still that big still-life belonging to you and there are still a couple of fruit pieces in oils, and a few little things. In cleaning up the other day I looked into your affairs with particular care. I know what the Albright must mean to you, and I also know that someday it must have some value, from a pecuniary point of view. Whether you will live to see it, or whether I will live to see it, who knows. The main thing to me is that you get a chance to develop.

What you say of Van Gogh and of his struggle and of the poor material he was forced to use on account of poverty, that indeed is a tragedy. But at the same time there is another side to this question, and one too long to go into just at present. You know there are many painters of that time who had money and who used what they thought was good paint, and the paint in spite of high prices and supposed quality has been proven to be of deceptive value. The paint manufacturers of the present day are not what they were twenty years ago. Some of them have awakened to a sense of their responsibility. But even today artists of means, but ignorant of the chemistry of the colors, are thoughtless of their lasting qualities, and are using colors which will not last. It is not solely the poverty of Van Gogh that is responsible for the colors he used. He was such an intensive nature, so fixed in his purpose of trying to get on to canvas the things he felt, that he did not spend very much time in looking into the question of the permanency of the

colors he was using. But I do feel that any worker, in whatever field he may work, should be given the opportunity of working with good material. But then again the question presents itself, what is good material? To me this is a simple question and I have found that very few understand it. Haven't I gone through all in photography, and what I found there is based upon the same big truth that all other things are based upon.

That is great that you are writing something for an English magazine. Few artists, painters, have the gift of expressing themselves as clearly in language as you have. And I think that it is important for you and for all those interested in art, to have you put down your ideas into print. And it will be great if a translation appears in the *Blaue Reiter*. Of course I shall re-print in "Camera Work" anything you may write elsewhere. And by the way I hope you are not forgetting to write about "291" for the special number of "Camera Work" I wrote to you about. Mabel Dodge has sent her contribution. It is splendid. If I am not mistaken she sails on July 14th. Outside of the MS she sent me a few days ago I haven't heard from her. Nor have I heard from Hapgood. I wonder whether your trip to Florence will materialize. I hope so. I hope so because I feel that a bit of Italy will do you good. If it is not to be this summer, it will be, I hope in the near future. I have had some very interesting letters from Leo Stein. Walkowitz had sent him his Number of "Camera Work." Leo Stein assumed that I had sent it and thereupon sent me a few letters. Of course I don't agree with Leo Stein. But I do see his view point and I do see wherein he fails. He is related to Berenson in his type of mind. When I get a chance I shall write him. For the present I am trying hard to straighten out things at "291." Every day brings a new problem. And as you know me, I never shirk anything in that line. And so much of the work which I expected to do during the summer will have to remain undone. But the main things must be done. I am also in the hopes of doing a lot of photographic printing, but for the past four weeks we have been having nothing but grey weather, fog and cold. We have had no summer. The weather is symbolic of the condition of the people in the country. Special news there is none. Zoler comes around often, and Haviland turns up at lunch time. They are the only two of the guard on hand. Marie starts her four weeks vacation today. That means that I will be pretty much alone in the little garret for the next four weeks. At Elberon Mrs. S. and Kitty are fairly well satisfied in spite of the cold, damp, unseasonable weather we have had since down there. Think of it, a log fire every day at this season of the year! With greetings from Zoler, and Haviland and myself, as always,

Your old friend,
[Stieglitz]

N.B. I have not forgotten that Engelhard drawing. You shall have one as soon as I get a chance to get one for you. The Engelhard kid was pretty ill for four or five weeks,

kidney trouble. But she is on the mend now. The *Times* article I shall send you in a few days.[1] I am having it copied.

1. This article is unidentified.

ᕴ

n.d. [July 19, 1914, Berlin] (postcard)

My dear Stieglitz,

An old familiar corner—but just as it is today. I sent you last week a "paper" on '291' which I hope you will like—it is for that number you spoke of.[1] I wanted to tell what and how I feel in terms applicable to the world—tell me if you like it—I have kept it for weeks but decided I could say it no better. Very very warm in Berlin work impossible so I keep quiet—writing some and thinking lots. A letter from Mabel Dodge this morning. Guess it's all over for Florence with me—just like so many other visions that come up on my horizon.

Love to Kitty and Mrs.

As always,
Marsden H.

1. For Hartley's contribution to *Camera Work* 47, an issue dedicated to the question "What is '291'?," see Appendix Three.

ᕴ

n.d. [July 27, 1914, Berlin] (postcard)

My dear Stieglitz,

Thanks for your nice long letter. I was so glad of it. You have my '291' article by now. I meant to be first—I am glad I'm second—I hope the rest will comply. *Camera Work* came and is good—it is nice to hear so distinguished a record of my show.[1] Yes I am writing quite some these days and I think well. It is at least me—I am only expressing myself—not thinking of anything else. It will bear a relationship to my personal meanings.

Will write soon.

Love to Mrs. and K., to Zoler.

Yourself always the same,
M.H.

1. Stieglitz reproduced in *Camera Work* all three forewords, Dodge's, Stein's, and Hartley's, from the catalogue for his exhibition in January 1914 as well as a collection of reviews as was customary for shows at 291 (*Camera Work* 45 [January 1914, published June 1914]: 16–18).

❧

n.d. [July 29, 1914, Berlin] (postcard)

My dear Stieglitz,

A card out of the intensity of the war conditions—it is new to me and very interesting. I have seen American instinct at its height—I have seen the French also at its height—I am now seeing the German the same—and it is really remarkable—entirely the reverse technique—a stillness which is too appalling—Unter den Linden nightly— many people in a stifling still expectancy—a psychic tension which is superb and awesome.

Monday night thousands of men and some girls marching with much dignity without police direction—guarding and conducting themselves finely through the main streets—strictest propriety and decorum—singing *In der Heimat-Wacht am Rhein* and the National hymn. I am admiring keenly this correctness of attitude in crisis—a complete calm—imagine our streets in such a situation or if you know Paris on a Saturday night or with the least indication of trouble. You of course know that condition here. It fascinates me nightly—the crowds and still groups waiting for the *Spezial Blatt*—all along beyond midnight. I hope it is peace—it seems as if it must be in these our times war is for barbarians and I want to think we are no more that.

Marsden H.

❧

n.d. [July 30, 1914, Berlin] (postcard)

My dear Stieglitz,

I am in Café Bauer outside Unter den Linden crowded with people—mostly men *natürlich*. Everybody is discussing war—I have just walked up to the *Lokal*-[?] to see the latest—and it is *"Keine Mobilmachung in Deutschland"*—this is comforting—I was also in the Hamburg-American office with Rönnebeck's brother—and they are declining to sell passage to America—I don't see what Americans can do over here—but this is the condition. The *Börse* is closed. People's faces look a little severe today, some are smiling but it is for relief doubtless—I cannot see how Europe can willingly plunge itself into a war—especially when it is so directly concerned with two nations. It doesn't seem policy—but here it is—the whole café is buzzing with conversation—most of it

over the war probably—the *Polizei* are very busy keeping the little groups on the go. The Germans are looking grateful for the last bulletin—and in view of Germany's power and position it looks encouraging. A small issue is that I do not like to see my best friends going to battle—Rönnebeck, Lieut. Von Freyburg—and one or two others I know. All are hoping for peace naturally as war is sure to be devastation—minor or major.

Marsden H.

<p style="text-align:center">ᢹ</p>

<div style="text-align:right">

Friday, July 31, 1914
Saturday, August 1—1:30 PM
[Berlin]

</div>

My Dear Stieglitz,

I give you a little touch of the last hours—it is a stifling day. The Emperor and Empress returned to Berlin—looking very sober—I passed closer to the *Kronprinz* and *Prinzessin* later—they appearing gayer, and less troubled looking. Unter den Linden packed and after nine o'clock a terrific mob, hundreds of thousands passing to and fro from the Castle. I have just come home. The last *Ausgabe* is that the Emperor of Germany has asked the Czar of Russia for an explanation of his mobilization and demands the reply in 12 hours, at lunch time this will be a decisive answer. There has been more excitement today than all so far—quite naturally—no riots of course but a very strong sense of united feeling. It is now not a romance but a real reality. The Emperor has spoken from the balcony of the masses asking for their blood and money. It is giving pretty strong. Will try and send copies of the extra *Ausgabe*.

Marsden H.

It is all unpleasant in a million ways. There can be a sudden increase in the cost of living etc. I will see my <u>best friends</u> off to war—perhaps not to see them again—and other thousands that will be doing likewise. I have deep sympathy for the Rönnebecks for even the daughter goes as nurse—their whole family—beside 7 nephews. Will try and send something more.

<p style="text-align:center">ᢹ</p>

September 2, 1914
Berlin—*Kriegszeit*

My dear Stieglitz,

It seems as strange to be writing you as it has for so long not to be writing you. I hurry up today to get off a line because I have been promised the favor of getting letters into the hands of some American officials for an early boat—otherwise as all along the past month—one could tell nothing about mails to New York and cables more uncertain. I have refrained from the latter because of the terrible cost 2 marks a word and not less than ten words—besides allowing five words extra for transport or 30 mks. for what I would have to say.

I don't know what you are all thinking over there—it has been reported that all sorts of things are rumored—that we have suffered and are in danger—etc. Also we can't anyhow make out what all the antagonism of the papers is about—I can only call it American journalism of that cheap kind which creates what it doesn't know—and from all accounts the English papers are no better. Suffice it to say, that the Germans are behaving exactly to us as always—with the same unfailing courtesy and still more friendliness if possible—even *Bekanntmachung* were posted requesting extreme courtesy to Americans and civility as well to people of the various enemies. There are English here who have sworn that they have had better treatment from Germans than from their own people. Anyway it is to be known that nothing whatever has changed to us. I can't think what the Americans may be thinking by now there—from appearances they seem more panicky than is at all necessary—otherwise there is naturally a change in things here. Berlin has like all other cities in Europe lost its charm for the time being—but it must be said that the Germans have shown the most extraordinary calmness and presence of mind under the conditions—even when the declarations of war came—there has never been—in all history probably a more remarkable display of calmness and absolute order—all this I have seen and have taken part in myself. Of course at the first there were a few outbreaks of a not violent nature—more than the breaking of windows in the English Embassy etc. and a few other things for which the *Polizei* immediately apologized in print—but since that—not a sign nothing but the extremist co-operation.

Anyone who knows the French temperament knows how inflammable it is and one knowing Paris is certain to know how *verrückt* Paris must certainly have been and now is more so. It is to be horribly regretted all this strife—it is unthinkable in our time—it has all along and even yet seems still like a modern romance—one reads the reports and listens to the telegraph dispatches with that same sense of real unreality. Doubtless you are getting over there in New York much more news than we are here in Berlin. I do not doubt that all the cruelties of war are being dilated upon—that is typical.

Wednesday—*Sedansfeiertag* 1870—today is a holiday and there has been a parade this morning of the *Ersten Kriegs Trophäen* five Belgian cannons—two French—

eleven Russian and three Russian machine guns—the first that have come to Berlin.[1] I have seen also—last night—the first American papers since action began—the *N.Y. Herald*—Aug. 10—and it is simply not to believe the incredible rubbish that has been cooked up via London—really disgustingly cheap—and when I read "many Americans held as spies in Berlin"—it is simply absurd—there hasn't been a moment when we have experienced the slightest discomfort—excepting of course those who are merely tourists and want to get home—they are having trouble but that is entirely American. It can be said once and for all that reports of mistreatment of Americans is entirely unwarranted and unfounded. I have not been near the American Embassy but merely to get a passport which at the first was necessary on account of the English—we having nothing otherwise. I heard of three English people yesterday in Munich, Dresden and here—who have openly declared their disgust for their own country. One has to explain away as best one can the attitude of the American Press—and to oneself by merely calling it the usual cheap scandal—the only thing which can sell a newspaper. I learn that there is a boycott began in the U.S. papers by the people which if true is good. I can't for the life of me see why all of a sudden the Germans should become as the U.S. papers make them out. It is not to think of.

Apart from immediate causes—it is now evident that a war was to come—even H.G. Wells is a fair prophetic authority—some say it is the last great war. It would be wonderful to think of it so—that which is truly heartrending is to see Germany's marvelous youth going off to a horrible death—this has been the dreadful vision—seeing these thousands simply walk out of homes leaving wives and children and all—never to [come?]—and going too with a real extasy for war is the only modern religious extasy—the only means of displaying the old time martyrdom—one shall not forget these handsome smiling faces going by—waving hands throwing kisses and shouting *auf Wiedersehen.* Now already many are silent and will remain so forever—and many are coming back broken wickedly. All this in our modern day!! It is still not to conceive—but if there is a real heroism instinct—it is certainly prevalent here—and doubtless in other places too—though one must say the English are not showing themselves up to much as to bravery. I think as a truth that England as an impressive monarchy is done for—and she is destined to a long siege of revolution for which she can thank herself—the people of India are merely waiting to be fired up—and at home she is consuming herself. Russia too—as confessed by Russians here privately to friends of mine is in a terrible state of revolution—the beginning is in Odessa and in Poland—in which latter place Russia is now said to be conferring self-government. For the French—well I can't say—I look upon the English as the cad of the world—and upon Russia as probably the most shameful and shameless country of modern time—for Germany I am certainly wanting to believe in its integrity which in the case of individuals one experiences everyday here. You know I have never really respected the French character—I have never trusted it.

I regret of course anything that will happen to Paris itself which as a thing is really a kind of flower of the earth—though one must say that—whatever it has been it is really little more than a sick flower in the 20th-century. You know H.G. Wells says in his book "The World Set Free" or has a character—the "man-milliner" say—"I must get back to Paris" and the other one replies "Paris? There isn't any Paris any more!!" It is strange to see this in print at this time—merely a prophecy of course—but it will not be long before this will be decided.

But apart from the will and the desire as well as the egoism of nations—it is possible that there is something we are wanting to call fate—destiny or something—is wanting and demanding a complete change of human values. It is now and then being called the—United States of Europe—who knows what is happening for what we see is happening is not what is happening. Never have men seemed really so ferociously intelligent and powerful and never have deities seemed more absurd—and to speak of God in war time is merely to mock mankind—so potent is man and so wicked in his potency his strength so cunning.

But whatever you hear or whatever the papers are doing—hear it from me that as Americans we are having every kindness shown us by Germans and Germany up to now. Our only embarrassment is that we do not get our money letters. Up to today I don't hear a thing from you as to anything—and no money comes—I am certain you are conscious that we are more in need now of money than ever—and knowing you have consoled myself that instead of not thinking you are thinking twice as hard—therefore I can only say that unless the German nation orders us away from here which is unthinkable at this time there is not the slightest reason why those of us who have homes here should think of leaving. So I can only in my own case ask you to forward whatever cash I have on hand which I think is not much now—and when Daniel begins payments to have them come immediately on receipt—I cannot with any pleasure trouble Prof. Rönnebeck about moneys—but as I do not get my usual letter from you—I am obliged to do so temporarily.

Another thing I hear is that prices are very high for things in N.Y. It is to be said here that not the slightest change has taken place in all the five weeks of war as yet and no indication—people are giving liberally every day in all cafés and on the street to the *Rote-Kreuz*—and to the allied benefits for the Frauen *und Kinder*—also there is now an elaborate establishment operating for the *arbeiters* and the poor also—a *Mittagstisch* for 10 pfg. which has been described as <u>very good</u> by some who have tested it. All this of course as necessary home philanthropy. Other than looking somewhat empty—Berlin is otherwise unchanged—everything running—all—cafés restaurants—operas—some theatres—Reinhardt and the Schauspiele the two opera houses—and no increase anywhere.

I hope I can hear from you soon with word from N.Y. I have heard that it is panicky but one doesn't know anything—and one reads that there is certain to be great gains for

the U.S. by the war etc. In the meantime one can only wish for the end of this awful and unseemly strife—a word today from the Rönnebecks proves all their children to be alive to date.

Is Lee Simonson in N.Y. now? If so you had better ask him for the cash for the picture—as I have also done Mabel Dodge in Florence—although by now it is not certain if she is there. I need to have all moneys on hand as you know—it should have been done before—if I had followed an early summer impulse to have you send over what moneys I had, I would have been relieved of present troubles. As it is I must creep along on borrowed goods until I get my own.

Give my love to Mrs. S. and Kitty and to all others I know and assure them that up to this writing we haven't experienced the slightest discomfort. The Embassy proves its inefficiency as all foreign embassies seem to do—one can never know anything from them—and there is all sorts of uncertain information for those who are silly enough to ask for it. I am sure you must have written before now—but anyhow make a point of sending the best way possible what moneys I have so that I can meet my bills and not be hungry. 1st October I must pay rent, three months!

Please write soon—insist hard with Simonson and Mrs. Dodge if she is there. I have telegraphed her in Florence—but do not know if with the war she struck at once for home. She would be safe in Italy.

Greetings and best wishes.

As always,
Marsden Hartley

1. During the Franco-Prussian war, Napoleon III and the French army surrendered to Prussian forces on September 2, 1870 at the Battle of Sedan. The ceremonies of the *Sedansfeiertag* were in celebration of the anniversary of this victory which ultimately destroyed the Napoleonic regime and led to the declaration of the Third Republic in France.

ᷥ

WESTERN UNION CABLEGRAM
Received at 172 Fifth Avenue, New York
loco govt Roma 24
Alfrep [sic] Stieglitz,
291 Fifth Ave, NY

September 17 repeated from Berlin quote cable two hundred
dollars helpless hartley [sic] gerard 343
Nelsonpage American Embassy Rome
12:55 PM Sept 17th

n.d. [ca. September 20, 1914]
Nassauischestr. 4
Berlin, Wilmersdorf
or c/o American Embassy
Wilhelmstrasse 7

My dear Stieglitz,

I send this by Robert Jones a friend of Mabel Dodge—and others we know—he has been studying the modern stage in Germany. He goes direct to N.Y. He can give a truthful account of the state of things how well we are treated here, etc. This is only to urge you to attend to money matters for me at once. The moment I write this— doubtless an American Miss Kueffner has called on you—and has told you I am all right except the money business—a letter I wrote two weeks ago should be turning up to you in these days.

On Wednesday this week I cabled you at a terrible expense simply because things are <u>bad</u> with me because I do not hear from you. Perhaps you have thought I was leaving here and didn't want to send anything. You realize how impossible it is for me to leave with a *Wohnung* on my hands—not to speak of the cost of leaving. I have looked daily for a letter from you—everywhere—Embassy, Consulate, Am. Exp. and regular post—at this moment no answer. I can only ask you to see to it that all the moneys I have recourse to—Mabel Dodge $150—Simonson $100—and Daniel $75 monthly be gotten together. Perhaps Daniel could make it every two months owing to the difficulties— though even so soon as this Americans are all getting letters money—telegrams etc. from America. Surely in these days you will know that I am in desperate need because my money does not come. I cannot borrow money here—and there is no credit anywhere for me. I live from day to day and hardly dare to eat and yet am sick if I do not. You know all this—so please bear in mind that I have simply got to have a lump sum on hand to live on. Only in June I thought of doing this as it seemed so silly to be troubling you every month—if only I had this would all have been avoided. You know therefore that I have got to have <u>cash</u> and have it here. Please cable it to avoid delays through the American Embassy at Washington as this is the only way cables can come. Most Americans are getting their money that way and it comes straight.

The war goes on with system—so that one hardly knows here that there is one. The awful thing is knowing of the terrible losses of life—it is really heartrending to think of it—and how incredible in this age. Up to now—my friends in the war are living according to news from them, but how long one cannot know. The operas are all going and most theatres—and this takes away the awful feeling of death.

So please my dear Stieglitz I urge you earnestly to get together all there is to my good and send it on. And get Daniel if possible to give his every two months. I've got bills to pay and have to live and cannot do either without my money.

Best wishes to all at home and in the Photo-Secession.

As always—yours,
Marsden Hartley

⌐

September 27, 1914
Berlin

My dear Stieglitz,

As there is another mail leaving on Tuesday—I hasten to write this Sunday—to further emphasize my great distress in not hearing from you. Perhaps by now Miss Kueffner has called on you—my letter also arrived and then the cablegram which I had to send as I cannot go on in such a helpless way. I had waited and waited for word from you and finally decided through the advice of Dr. Symmes a very well known American physician here to cable—at a terrible cost—36 marks—but I just have got to get connections immediately so I can go on and live and pay my bills. Also before you get this— Robert Jones a friend of Mabel Dodge's will arrive in New York and I have told him to tell you exactly the conditions. You of course know I need my money whatever there is by way of a balance—then the money from Mabel Dodge $150—and Simonson $100. Also see Daniel and make an arrangement so that I have enough for at least two months living at a time. I can't leave here as you can of course realize with a *Wohnung* on my hands and all my things here—and there is not the slightest need to leave as long as you send me my money. I had concluded you must be thinking I was leaving here—and then of course for a long time the connections have been bad—but they are all right now and all the people are getting money and letters via the Embassy and the American Express which is going right along through the winter. None of the American residents are leaving and we are all well and contented and being treated just as always.

So all I can do is to urge you earnestly to fix up matters for me so I have a living long ahead and can get things moving. Up to today I haven't had a letter from you since July 22 which reached me August 10th. I have had no other letter either from America except one from my sister announcing my father's death Aug. 4th. I heard this week from Rönnebeck from the field of action—he writes a very interesting letter though he is not in the big siege before Paris as yet. It seems as if it must end soon—for general as well as specific reasons. It is necessary to put an end to all this.

Anyhow I hurry this off so that you may know exactly how I am here—at present I am eating in the pension of an acquaintance so as not to starve. It is all so embarrassing as I must pay my debts immediately. Please therefore see to all this for me and greatly oblige.

Your friend,
Marsden Hartley

Best wishes to Mrs. S. and Kitty—love to Mabel Dodge—and to any and all of my friends. I will go right on here so long as I can keep connections with my money. You understand all this anyhow. Am working regularly and well.

⁓

October 6, 1914
291 Fifth Ave., New York

My dear Hartley:

Just a line to say that I finally have gotten $100.00 off to you by postal order. This is the maximum which can be sent. I have sent it to you care of the American Embassy. For several weeks we tried to send something through the Treasury Department, but the department refused, saying that it would only send money abroad for you if you would come back. The post office department practically says the same thing. You were not forgotten here. On the contrary, everything has been done that was possible. It really looks as if there were nothing left for you to do but to come home, unless you can find some way to make connections in Berlin and not rely on America for cash. I have cash for you but there is no way of getting it over, unless somebody were going from here to Germany and would take the gold with them for you personally. I know of no such person. Moreover I had it from your friend Moeller, that you were returning to America. In view of this I didn't send you anything in August; and as I had no word from you until the cable came on September 18th, I was under the impression that you were on your way home. I wrote you several letters and postals and they, according to your friend Jones who was here yesterday, you never seem to have received. Your own letter I received day before yesterday. It was the first word I had heard from you since the war began. In spite of all the quiet in Berlin, you have no idea of the condition over here. I have been at the telegraph office and tried to cable you. But it was impossible to cable. They would not accept anything for Germany. I suppose you are under the impression that I may have overlooked you, but I assure you you have been on my mind since the war began and nothing has been left undone to do the best for you. This rumor of Moeller undoubtedly threw me off the track. Otherwise I might have cabled to you at a time when cables were still accepted. I wish you had cabled to me during August that you were staying, then at least I would have known exactly where I was at. Knowing you as I do, I really thought you would stay, but when Moeller said you were coming I assumed he had some positive information. The mails were uncertain so I thought that possibly some communication of yours to me had been lost. I don't know

when you will get this and I don't know when you will get the money. It is the best I can do. I know what you must have been suffering. The uncertainty of everything. But at least you have one satisfaction and that is that you are in a boat with many more than you imagine.

Steichen and his family came over here. Steichen had cabled whether we thought it advisable for him to leave Voulangis and we cabled back yes. It certainly wasn't easy for him to leave the beloved home. But there was no alternative.

I will write soon again. I am terribly rushed getting things straightened out. Jones was amazed to find that there was more excitement in this country than there was in Berlin. You ought to know the Americans.

As ever,
Your old,
[Stieglitz]

✑

October 23, 1914
Nassauischestr. 4
Wilmersdorf, Berlin

My Dear Stieglitz,

As it is now by the above date over ten weeks since I have had any word from you whatsoever—and as I do not get a cent of money from you—I must still go on wondering frantically—and at the same time keep as peaceful as possible. I do not fathom the strange fact that I get nothing of any nature from you. I sent word to you through a Miss Kueffner that I was all right—but that I need my money badly. I have heard from her from New York since that—and that she went to 291 to see you—found that you were in the country—but that Marie said she would tell you all this by letter—which surely she did. After that I wrote you two letters telling the facts plainly—asking you to get together all possible cash due me—and send it somehow in a sure way.

Then I also gave a letter to you to a friend Robert Jones—and as he knows me here fairly well—I told him to tell you all plainly that I am badly off—that I am obliged to rely upon the goodness of friends which in these times is difficult—as the Rönnebecks have also their troubles—and I cannot go on in this fashion. I have been obliged to go to the pension of an acquaintance to eat so that I may not starve. All this at a terrible waste of time and energy—so that the days for me since war time are personally speaking a long drawn out hell of anxiety and hope.

I hope that surely by this time that Jones has been to see you and told you all this. I have also written Simonson, Mabel Dodge—and told them all—so that somehow I can create a nucleus of interest on the part of someone or several to get things going for me.

Yesterday I had a letter from Demuth saying that Daniel told him that I was "well fixed" for another year—so that I know that all things are understood. I do not know where Mabel Dodge is or Simonson—they both must be good to me at once and give in their moneys so that I can go on. It is too terrible all this business. On Oct. 6th—my rent for three months was due—it is yet unpaid. I had to go to the *Wirt* and make the statement.

I am now owing Rönnebecks 260 marks and with 160 marks for rent—you see I have obligations—I cannot buy materials—I cannot do anything as it should be done. I take it for granted that the cable I sent you 6 weeks ago did not reach you. I did this at a heavy cost merely in the hope of settling all this business at once—all this has even failed me—other letters come from New York—but I get not a solitary thing from you—do please tell me something. You can well appreciate my position here—and how ironic the situation is knowing I have money to live and cannot get it. Can you not make some arrangement by the bank so that I get cash direct? Will you please do this <u>at once</u>? For days, and weeks I have waited patiently for word from you and so have not written— thinking each day I would get a letter and could then reply directly. You might have to do all this through the American Embassy to insure delivery. I don't know what else— but you know all these things or can find out. In any event—please for God's sake— make some plan to relieve all this misery.

It is difficult to go on from day to day under this pressure—in general gloom of con- tinuous dark weather—and the war—which has also left its mournful impress upon me in the loss of my other good friend here in Berlin—Lieut. Von Freyburg who after win- ning the *Eiserne-Kreuz*—went to a sudden death Oct. 7th, and lies in a war grave in the region of Arras—near Amiens. You know what an intense thing friendship always was and is for me—and can appreciate therefore the acute pain of this experience. He was a cousin of Arnold Rönnebeck sculptor—who is now himself in Berlin—recuperating from wounds in the war. It is the surest of miracles that he is alive and is able to walk about among the living—after having seen so much of the dead—on both sides—when a mere matter of 6 inches alteration in his position would have sent him also spinning into eternity. He has also lost his hearing left ear—and if this is permanent which it may be—he will not return to the war—otherwise he must.

It is all very hard as a friendly spectator to have seen and still see the countless fine specimens of manhood go out and never come back—it gives the imagination a little too much to do. It seems as if in these times there is nothing but eternal grief upon the earth. I look down upon France—and over into Russia—England and Austria as well— and there is little to note—but a terrible slaughter—and nothing but an unendurable agony left behind—and philosophy does little for those who suffer such painful losses. It is certainly a terrible war—and seems fearfully slow to end—and when it is ended— what is there—only some victories and a great agony upon the world—destitution and privation—and heartbreak. It is all beyond discussion in these times. Despite all that—

things go on here without the slightest embarrassment, nothing stopped or curtailed—seemingly as much gaiety as before.

So it goes—and I sit alone much—the spectator of the great tragedy of the heart and soul of mankind. These last days have for me become a little too painful—in the knowledge of the loss of my friend who was in all respects one among a thousand—so fit in every possible sense to survive a long life—and grace society with his charming personality and this is but one instance among countless.

Anyhow—dear Stieglitz—please I beg you earnestly do something definite and quickly in my behalf. I know that you must certainly have done so before this—but I want to state that up to now—Oct. 22nd nothing whatsoever has reached me—and I am in a helpless state. All this effects my entire existence so acutely—I cannot work as I would—and I cannot live as my money would entitle me to—and altogether it is simply fearful. By this time surely you have letters from me also word from Robert Jones—please then act immediately—as even then it will be a long time before I can get connections—though I am thinking that even as I write there is news somewhere on the way for me from you.

Give my best wishes to Mrs. S. and Kitty and to all others the Meyers—Kerfoot—Haviland—and all. Mabel Dodge if she is there—Daniel and the fellow Hartpence who is with him. I hope to write them soon.

I work along—and I like what I am doing. I don't know who else will. It is a logical expression of myself—therefore I like it.

Always to you thanks and best wishes.

As always,
Marsden Hartley

ᦗ

<div align="right">
October 29, 1914<br>
Nassauischestr. 4<br>
Wilmersdorf, Berlin
</div>

My dear Stieglitz,

Day before yesterday I received the *Geldbrief* from you from New York—which I take to be $100 in marks. You cannot know what a relief there lies in this even though it pays only half my bills actually. I am most unpleasantly obligated to several people—and I've simply got to get myself cleared of all this business the whole problem on my hands is so unpleasant at this time that my life is simply a waste of wishes and unrequitements. I know it cannot be helped and yet I know too that you understand well just how it all is with me. I am living under conditions that destroy all attention to work—

and lack of money prevents me from even buying paint. I only want you to know that since Aug. 10th I haven't received one cent until this letter of yours of Oct. 6th. This you can see leaves me $50$^{00}$ short of the two months money ($150$^{−}$) and tomorrow is Nov. 1st time for another month. All I can ask you to do is to somehow get together at least two months living money at a time so that I can go on paying expenses and not having these terrible obligations to people who cannot afford it either.

As letters are coming right along now—there is no reason why I should not get your letters. Then too—I would like ever so much to get a word from you about yourself—about 291 its coming plans—and news in general as well as particular. I have heard recently from Demuth from New York—otherwise not one word except from Miss Kueffner to say that you were not in N.Y. when she called there. I take it that by now Robert Jones has called on you and stated all things about my affairs—I told him to tell you all. You of course know that it is not at all necessary to leave here—and that practically it is impossible—and besides all that I do not wish to leave. I find life here in every way possible—it is as I have long since told you the most practical place in the world probably to live in—and you know something of it yourself. It is probably also the finest place in the world to think in and be alone in.

Aside from the awful sadness of war—nothing is changed whatsoever—everyone goes on living exactly as before—with if possible a still more remarkable calm. Personally I am feeling it keenly these days in the loss of my dear friend Lieut. Von Freyburg—cousin of Rönnebeck—who is himself home in Berlin from the French frontier—wounded, not badly except for the total loss of hearing in one ear. In the next weeks he is to become a real officer whereas before only 'reserve'—and then I suppose he must go again somewhere despite poor hearing. The war goes on daily taking its toll of life—pathetic and necessary youth—pathetic that these which are the only hope a race has must willingly go and give up that which is most precious to any and all living beings. If you knew Freyburg you would understand what true pathos is—there never was anywhere a man more beloved and more necessary to the social well-being of the world—in every way a perfect being—physically—spiritually and mentally beautifully balanced—24 years young—and of all things—necessary. This is for me the most heartrending phase of the war—I seem to have lost all sense of victories and defeats of the great changes in history and in the face of the earth over here. I don't know how races expect to continue thrive and prosper—I do not yet become used to the atrociousness of the very idea of war—that in our highly developed time—such a thing must be. The Germans go on and on in their usual courageous fashion despite all slanders—calumnies and deceits—showing at least that they are something to be reckoned with. I don't know what you are all thinking over there, but you as Germans or of German origin are certain that all that is being said against the Germans is not true—it does not stand to reason. I am entirely neutral in these matters as I have always been always in

all other matters—having no policies to propound or defend. I simply say that the German does not express all the *Gemeinheit* in the world—the whole world knows where to look for it—it is not all this side of the channel. America is finding that out also.

However—I want to forget all this rather than think about it. I am trying to forget the fearful siege of sorrow that spreads over the land—and it is difficult. The great pity too is that everything proceeds as if war were the necessary constituent of well-being over here. It is supposed to be by some the most terrible war—it is said to be by some the last war—I wonder—if war will ever become unpopular? Sometimes it doesn't seem so. One can only hope that the world will soon find greater success in peace and in preservation of life. I only know that the bloom is removed for the present from what has been here for me one of the finest expression of life impulse and universal intuition anywhere in the world. The Germans have shown me what it is to prove oneself necessary—they have as fine an instinct for life as exists—and that is what I find in them— a superb energy—powerful toward creation and powerful toward preservation.

Anyhow dear Stieglitz—do please get these conditions solved for me—for I can't have a moment's freedom until I do. See Daniel if possible and see if he can't arrange two or three months at a time so that I can have a free winter which is absolutely necessary if I am to be up to myself—productive and equal to myself generally. I find it impossible to live under these strains. Have Mabel Dodge ($150⁻) and Simonson ($100)—given you these sums? I do hope so—they certainly are freer than I am in life.

Very best wishes to Mrs. S., Kitty and all—for Daniel—Hartpence—Kerfoot—the Meyers—Marin—and all. Did Walkowitz get back to N.Y. all right? I hope so. Please reply at once and get this money business going straight—I still owe to others—300 marks which must be paid just as soon as possible. Do write me soon and tell me something of yourself.

As always,
Marsden Hartley

ᷡ

October 30, 1914
291 Fifth Ave., New York

My dear Hartley:

I finally have been able to get enclosed. The Trust Company tells me that gold has been sent to Berlin and that you will be able to have this cashed. If nothing unforeseen happens you ought to get your money regularly from now on.

I wonder how many letters of mine to you have been received. I have received two letters from you and one postal since August 1st.

In great haste,
Yours,
[Stieglitz]

I am registering this letter at the advice of the Trust Company.

⌒

November 3, 1914
Nassauischestr. 4
or c/o either American Express
"      Embassy
Berlin

My dear Stieglitz,

I have written once since the *Geldbrief* arrived a week ago today to acknowledge its receipt—and have now been to the Embassy—the Consulate and the American Express Co. to get advice as to the sending of money here. The Consul says any bank in New York will send money when it is deposited with them. The Embassy says that any bank will connect with the Deutsche Bank or the Dresdner Bank here in Berlin—that the Chase National and the Bankers Trust Co. have special connections with the Deutsche Bank here which has an American Dept. and that the National Bank of Commerce has connections with the Dresdner Bank here. The American Express says that they are doing business just the same with the Knickerbocker Trust Co. (your bank) and that drafts can be sent as always. There are no more cables for money leaving here either and more being received since Sept. 15th. I think it might be more advisable to deposit money with the bank and then have them send the requisite papers on here—so that I have nothing to do but go and get it. The money you sent me came directly to my door by ordinary *Geldbrief* post also over two weeks ago there came a *Geldbrief* in my care for Jones which of course had to go back as he was not here and I could not take it and then letters come o.k. all the time, so there is not the slightest reason for my not getting money.

I talked with an American doctor from Chicago last night who is still touring about in spite of the war—and he received yesterday a money telegram direct from Chicago for a large amount—so that there is no difficulty in getting it here now. So do as you think most practical—send whatever I have myself on hand—and if you could arrange with Daniel to send say three months together—that would see things straight again.

You will understand well too that this shifting about is bad for me as a worker. I cannot set up and work—for everything that happens has an effect on me and it often takes weeks to feel things out clearly. I did no work at all for five months after I left New

York—I could not—then the war came when I had but finished four pictures on the idea of Amerika. Now I am working out some war motifs, which people praise highly—I shall later return to the American pictures.[1] All this wants freedom and quiet and this I have here—wonderfully.

I am writing quite some also to express my ideas on art and on the need of new aesthetic—something that will impress just as modern machinery—modern light modern movement impresses one where modern ideas prevail. As soon as the mails go better I will send over some MSS to you which you would I think find good for C.W.[2] I have read some of it to Jones and others and they like the ideas well—anyhow it is myself and that is all I can vouch.

I am sorry about all the rumors that reached you as to my return to Amerika. I cannot think how Phil Moeller could get so much news—I have never to my knowledge even intimated that I was leaving. I haven't had the slightest intention—a day or so before Jones left I had thoughts—but that was under a bad influence—and it is very unusual for me to be influenced. It was because Prof. Rönnebeck wrote me a note saying then that Amerika's neutrality was not so certain and that it stood in the *Zeitung* that the Ambassador was advising all Americans to go home—that worried me a little as I was depending on him for money and I thought he was perhaps getting frightened. Otherwise I hadn't a moment's qualm—and now none whatsoever.

It goes on here in Berlin as if war were hardly heard of as far as peaceful conditions go. Everyone minds his own business which I venture to say is not the case in Amerika. It is too silly anyhow all this hysteria that Americans love to express. It is I suppose known as temperament—I call it rot—prejudices may be fair—but the extravagant expression of them is not only ridiculous but a kind of criminality since it always creates unnecessary rage and violence—but Americans always love any variation of truth for excitement's sake—a fight in any case—because it enervates and excites. You know that I am a thoroughly neutral party—I have not the slightest prejudices for or against—and now I have come to the point where I am mortally ashamed of the human race—that is the first and last wickedness—the first and last barbarianism itself—that there is a war at all. It is now a long and deathly pathetic episode—which is neither to endure in the soul or mention with the tongue. It behooves us all to shame ourselves to decency of speech and conduct if we are ever going to be cultivated the which is doubtful in this era.

I shall not express any opinions except to say that America has shown up its ridiculous side as usual in a crisis. My chief sorrow is war itself—minor phases are personal—I feel the loss of friends keenly, there is no replacement of perfect social creatures, there must ever be a vacancy. However my dear Stieglitz—many thanks for your efforts—I knew that certainly you were doing something or other—I shall get on somehow till you can make these deposits with the bank etc. You can seal letters from America you know.

Only from here must they be open. If you think the bank method safer than posting an American Express draft—do that—but these two methods are open and are the methods of the many Americans residing here, and they all get their money. I should like to have three hundred dollars by me if possible. Then that stops all delays in work and life and all. More would be good—but get at least this if you can manage it. Have I not about $150—cash on hand still—with Mabel Dodge's payment? Has Simonson put up? That he must do—as he is well able—perhaps he has already.

I am so glad the Steichens left Voulangis—though I know it was dreadful for them. In the line of fire there is no seeing who is American—and who is not. It is all too painfully regrettable. I hope the Americans are learning to be sensible and keep their tongues quiet. You hear very very little here of loud talking and absolutely no demonstrations.

Best wishes to all—and for yourself always the same.

As always yours,
Marsden Hartley

Give my kindest regards to Phil Moeller—Simonson—Dasburg—the Steichens—Meyers—Misses Rhoades and Beckett—all my friends and acquaintances. Please also send me Frank Eugene's address as I may go there this winter.

1. *Indian Composition* (c. 1914–15) is based on Hartley's "Amerika" theme. The painting is now in the collection of the Frances Lehman Loeb Art Center, Vassar College, Poughkeepsie, New York (see plate 4).
2. Only four more numbers of *Camera Work* were ever published after this point (47, 48, 49/50). While number 47 reproduced Hartley's statement on 291, and number 48 reprinted his foreword for the catalogue to his exhibition in April 1916, as well as a statement called "Epitaph to Alfred Stieglitz," none featured any of Hartley's essays on art.

ᑎ

November 8, 1914
Nassauischestr. 4
Berlin

I think it best to write again shortly after my letter of last Monday—simply in case one letter is lost another might reach you. I have already said that you can deposit money in the bank there for me and connect with Deutsche Bank or the Dresdner Bank here. I believe the Deutsche has an American Dept. Also the American Express says it goes on doing business in drafts with the Knickerbocker Trust Co. your bank so this is also possible—but as it is more practical all around that you send as large a sum as possible maybe it is better just to connect with the bank here and let them

notify me. Please do this at once as soon as you receive my letters, as I must go on always in a handicapped fashion.

In spite of all this my work goes on well and it is this that makes me so content—I am expressing myself truly—I have perfected what I believe to be pure vision and that is sufficient. Then too I am on the verge of real insight into the imaginative life which is I am certain to produce important things. I am no longer that terror stricken thing with a surfeit of imaginative experience undigested—I am contained in what I feel see and hear and do and a real clarity of light pervades—Berlin produces no false vapours about my head as does N.Y. I suppose it can be said to be 99% clear psychically speaking— for in my own life I find vision and experience becoming one. There is no struggle— there is not alienation—nor hysteria—pure vision out of pure experience. I write quite some on these ideas—and it interests me that people find not the slightest trace of lit- erary subject matter in my present painting "*Reine Empfindung*" one person calls it here—and that a French woman whom I have met. Just now the themes are teutonic I hope later to get other experiences. Then I shall also return to my ideas and sensations upon the word America—which I began with in spring. When you see my pictures again you will see all I say in liberty—I can talk freely because I am well on the verge of understanding which is beyond knowledge.[1]

Get the money started over here and it will help the scheme tremendously—I am one of the very few among artists free to feel and work in the great crises of the day and hour—I am freedom itself—without prejudices without any sense of favor.

Best wishes to you as always and all others.

Yours,
Marsden Hartley

1. Hartley was working on his renowned war motif paintings (see plates 5 and 6).

⌒

November 12, 191[4][1]
Berlin

My dear Stieglitz,

This morning at 10:30 two hours ago came your registered letter with draft, and the notice of the exhibition.[2] You can surely realize—entirely apart from the sight of funds— how good it seems to actually hear from you again and to get a complete breath of the little place at 291. I feel at last restored among the found and no longer among those missing as for so long. You can know well also that as I did not receive a single one of your letters—that with the postal order three weeks ago being the first word from you since the letter you wrote July 22. I myself had also written several letters to say I was

all right except for the money question and doubtless these never reached you. It is possible there was in them references to the war which prevented their arrival.

But now one learns not to speak of these things in letters and one is glad not to talk of them after weeks and weeks of nothing else—but I can only say that here with this usual northern capacity for calm—everyone keeps quiet—one hears nothing public by way of scandalous reference to any nation—that I can vouch for and the people of those countries of the enemy who are still here are being treated with all kindness. This is to know absolutely for I have talked with them. I could only hope that everywhere else as much civility is shown—I am thanking the gods moment by moment that there is one spot on this part of the earth which is devoid of hysteria—and my own land is showing itself up as usual as the genius par excellence of blood and thunder appetite. Amerika is like every other adolescent—all hands feet and mouth—and always at the wrong time mostly mouth. I am thanking the systems here too for lack of <u>news</u>—whereas I think one can safely say that there is in the newspaper <u>real information</u>. It is of course produced slowly and sensibly like all truth—I used to say that all France was a talking woman—speaking only of its genius—but I am thinking that over once noble eagle has taken itself home to more respectable heights and left in its place is nothing but a bellowing ass of a most disgusting order.

I hope by now you are all well immune from the cancer of deceit that has possessed this war on that side of the water. Prejudices are fair—but if there was ever in history a need of openmindedness it is at this time. There is but one evident truth at this moment—everyone directly engaged in this war is suffering terribly—death is taking the most heartrending toll—and there is nothing but silence to offer. I find it personally—the most unspeakable humiliation ever offered to a sincere human being. I find myself wanting to be an Indian—to paint my face with the symbols of that race I adore go to the west and face the sun forever—that would seem the true expression of human dignity. I must say the world has lost its visage. That reason was once prevalent among us heathens is already a fair myth. However one only looks about for the spirit of life to keep one in countenance and one is left to think deeply on the pathos of these present hours and days.

I do not find time helping much to assuage us who were the friends of Lieut. Von Freyburg—that altogether necessary fellow. It still seems the most pathetic sacrifice of our time. I know there are of course hundreds similarly worth while who have lain down to an everlasting stillness—but naturally I who saw much of him here find it impossible to give up so charming a relationship and it is so with all who knew him here—for he was much loved by everyone. I am of course grateful to the ghosts of war that I can still enjoy the companionship of Rönnebeck who is socially speaking my closest friend in the world. There ought to be some method of expression for such gifts bestowed—it is yet the miracle that he walks about among us very little harmed when

the mere whim of the wind or stir of the body would have sent him hurrying into the silence. He is now appointed Lieutenant since his work in the war whereas before he was only officer of the reserve.

You know what my friendships have always been to me—I have loved them and fostered them carefully and devoted myself to them as does the father or mother to the child. I think it is to be my only form of expression in that type of creation. I shall be only too satisfied when I shall have served all of them well—for this reason my grief in the loss of the good fellow Freyburg is most keen. I shall never see his equal again. We had been so much together—he and Rönnebeck and I and only a week before the war R. had made a bas-relief portrait of him which is in itself so good that one thinks the very soul of this good boy is there always—simple, direct—and full of character, just as he himself was.[3] "Whom the gods love die young" seems so fearfully true in these times and the gods are loving plentifully.

So it goes—I go on daily living more happily than ever in my life—with my simple joys—and sorrows too—although this might seem paradoxical—I know more than ever before about all things because somehow many doors have opened and I stand before them all no whit frightened as once I used to do. "The Hound of Heaven" has caught up with me and we are friendly and go about much together.

I am so glad that the season at 291 opens so well and I know it is going to be a fine winter. Even here shows are going on with all the rest of culture. It might be that I myself would give a show in spring. I can't say—I am only interested in work and have done better than either I or you have known. I have gone far into my own ideas and the results are strictly personal and fresh.

I won't write more now except to say thanks that matters can now go on well. You can if you will sometime tell me if I have any moneys on hand and what I have to rely on. I want to take a cheap trip to Vienna—Budapesth and Prague—either before or after Xmas—as I have seen nothing whatever but Berlin. I want other sensations to express also—and I can get fresh ones there. Has Simonson paid? Jones tells me Mabel Dodge has paid hers so that is well. I of course need all I have.

Write soon again when you can and send drafts just the same—as I can keep them by me just the same. Give my kindest wishes to all—the Steichens—Mrs. S., Kitty—De Zayas—Haviland—Zoler—Daniel, Hartpence—all. For yourself always my kindest regard and thanks.

As always,
Marsden Hartley

1. In the original letter, Hartley incorrectly dates it November 12, 1913.
2. Given the date, the 291 announcement was probably for the exhibition with the unfortunate title, *Statuary in Wood by African Savages. The Root of Modern Art* (November 3–December 8, 1914).
3. This sculpture is now presumed lost.

December 9, 1914
291 Fifth Ave., New York

My dear Hartley:

I enclosing you a draft for $100.00 and I hope you will receive it in good stead. I shall write in a day or two. I have been going it day and night; working very hard and really achieving things in spite of the still upset condition of the New York people. Your letters came and I was naturally glad to hear from you. I never doubted for one moment, knowing you as I do, that you intended coming to New York, but Moeller's report naturally led me to believe that I had misjudged you, although at the time I said that I was sure Moeller was not right, or that you had changed completely, which I did not believe.

Greetings from "291,"
[Stieglitz]

ᔐ

n.d. [December 28, 1914, Berlin] (postcard)

My dear Stieglitz,

I send on this card to acknowledge immediately the receipt of your letter with <u>enclosure</u>. Thanks. I shall write soon.

It has been an interesting Christmas here—despite all the terrible undercurrents. The human soul is undergoing a torture which is beyond belief—I wonder if there is a human conscience anywhere untroubled. Yet outwardly overall here an amazing fortitude and courage and love of life. That is the miracle of the Eastern Star at this hour— one marvels at the belief in sacrifice everywhere. I myself just wonder and wonder—at the human soul—its capacity for faith is stupendous. I shall write more lengthily as soon as possible.

Do send on ahead if you can more funds. I am kept at a snail's pace for lack of necessities otherwise I am—well—hoping and believing—doubting and despairing and then despite all believing in life. There is certainly a need of super-human faith.

New Years greetings to you and to Mrs., Kitty—the Steichens—to each and all. I wish only for a high compensation to all who are being shaken with the problem on hand.

As always,
M.H.

1915

My dear Hartley:

During Xmas week your letter came to hand. I was glad to hear that you were again your old self and that you were at work expressing yourself. It is self-understood that you have made progress. My faith in you as an artist has never wavered for one instant as long as I have known you. That really means that I know that you must develop as you grow. In other words you cannot but help be yourself. That is all that means anything to me in anybody.

I am glad to know that you are doing some writing, putting down your ideas on art. Of course when you are ready and you want me to print what you have written send along a copy and it will go into "Camera Work."

As for your financial standing, including the draft I am enclosing and all monies in sight, $844.50. This includes everything. Simonson never materialized, so I kept the painting and have paid $100.00 to your account myself. I am glad to have the painting as it one of my favorites. Of course if Simonson had paid it would have been his. I waited until January 1st for him to pay, although he had promised to pay before July first. As for Daniel's payments, he is very slow. He seems to be pushing things up at his place and is getting a great many newspaper notices, but he must be short of cash. As Lawrence, who has just come in says, the same old story. Within the next two weeks I shall forward you another $100.00 I hope by that time Daniel will have materialized something. Of course it would be a great thing for you if you did get to Vienna and Budapest, to gather new experiences and see new things. Today a week, I believe, Daniel hopes to open up your exhibition.[1] I wonder how New York will accept the things it laughed at a few years ago. I am sure the exhibition will be a success. Although I am not so sure that anything will be sold. New Yorkers are still not buying "art." The women are knitting socks at the Ritz Carlton dinners. So between the dinners, the cost of the elaborate gown, and the wool for the socks, not much money is left for art. The Americans are preoccupied with the poor Belgians. Everything also "poor" does not interest them. That is in regard to "poor" other people. The dislike for Germany is greater than ever. It is all very amusing, although very terrible, to one who sees.

At "291" everything is progressing in the same pure way as it has always progressed. Picasso show was splendid.[2] Today the Picabia show opens up and excuse need be offered.[3] No matter what one may think of Picabia as an artist, one thing is sure, Picabia is developing along his own lines and he has developed most decidedly in the last two

years. The little room doesn't look a bit queer with these three paintings, each at least eight by nine feet, or over. In the other room we have some Rodin drawings, Picasso and Matisse.

Recently I have been wondering, thinking, about you and your work; whether it would not be advisable of you to send two or three of your newer things to me so as to have them here. There is hardly any chance of Daniel's going into "abstraction" in the near future. "291" seems to be the only place really interested in the development of Today. And for that reason it is well to have on hand the work of today of the men we are interested in. Think this over. It has a practical side to it. For you and for us.

Did I write to you that the building is not coming down in May? The hard times undoubtedly decided the Altman estate to wait with putting up a new skyscraper. Of course I am glad from one point of view, while from another, I do not know whether I am quite so glad. The load and the responsibility are great ones. Especially in times like these, when cash is shorter than ever, and when the situation is more complicated than it ever was before. "291" is below the line or respectability—that line is 42nd Street,— and so we are really down town. That means that whoever wants to come here must make an extra trip. And you know how New Yorkers hate to make any extra trips just to see a few pictures.

I wonder if I wrote you that Marin is a father. And he has broken the record. His off-spring is a boy. He is the first 291er to have accomplished anything like that. But the youngster was not born in the ordinary way. Mrs. Marin had to undergo a Cesarean operation; but all is well in the Marin home. Marin is not over happy. First of all he wanted a girl, as long as it had to be a baby, but he didn't want any baby. Now he is busy most of the time scrubbing milk bottles, which keep him from work and he is most anxious to work. He did some very beautiful things in Maine. To add to his troubles he bought an island in Maine. The island would be all right if it didn't need a house on it. And the house would be all right if it didn't need any money to build it. It is always that same infernal question: Money.[4]

The "291" Number of "Camera Work" is finally on the press. It has been a terrible job to whip it into shape. I have been at work on it daily for over seven months. I wonder what you will think of it when it reaches you. Under separate cover I am sending you the De Zayas Number.[5]

All is well at 1111, and the fellows of 291 all wish to be remembered.

Greetings,
Your old,
[Stieglitz]

1. The Daniel Gallery in New York presented *Paintings by Marsden Hartley: The Mountain Series* (January–February 9, 1915) which included seventeen paintings, dark landscapes from 1909 influenced by Ryder, and still lifes from 1911.

2. *Exhibition of Recent Drawings and Paintings by Picasso and by Braque, of Paris* (December 9, 1914–January 11, 1915) featured paintings and charcoals from the collection of Francis and Gabrielle Picabia.

3. *Exhibition of Recent Paintings,–Never Before Exhibited Any Where–by Francis Picabia, of New York* (January 12–26, 1915).

4. Marin purchased an island in Casco Bay off the coast of Maine with funds from the sale of his paintings.

5. See note 3 page 132 for comment on the "What Is '291'?" issue. The war caused problems with sending mail, therefore Stieglitz must have held off sending the "de Zayas number," *Camera Work* 46 (April 1914, published October 1914) which reproduced ten caricatures by de Zayas.

*�征*

February 5, 1915
291 Fifth Ave., New York

My dear Hartley:

I don't know where the days go to. It is rush, rush, rush. Whether anything is accomplished or not I don't know. But I suppose something is being accomplished otherwise I would not feel as I do. Things are moving most decidedly at 291. Much is happening, and people seem to be losing their dazed condition. Some of the work turned out by De Zayas is very remarkable. It is beautiful as some of Picasso's. I say that knowing exactly what I say.

Your show at Daniel's looks very dignified. De Zayas and Mrs. Meyer saw the Weber show first and then went to yours. De Zayas felt that yours was positively refreshing after having seen the Webers. I have not seen Weber's and I don't know whether I shall. At Montross, Matisse holds court. At the Carroll Galleries there is a show of Redon and some other French Moderns. We are just at present having a show of Beckett and Rhoades.¹ It may seem reactionary for "291," but it is not. The girls deserved their chance, and I am glad they have been given it. They are both very remarkable as individuals and as workers. Marin comes next.²

The "291" Number of "Camera Work" is out, thank heavens, and is creating quite a stir. Your copy is being mailed to you under separate cover.

As far as your finances are concerned, let me say Daniel did not pay in January, nor has he paid this month. I wrote to you that his neglect to live up to his obligations won't do. I certainly made the terms very easy for him, and the prices he paid for the pictures, both for yours and Marin's, were ridiculously low. I fear Daniel has possibly bitten off more than he can chew, but I don't see why either you or Marin should suffer. Of course Daniel knows that I will probably advance the money, as I have done, but I was very frank to him about my circumstances, and he ought not to depend upon my good nature. He is in business and I am not. He intends to make money out of you and the

others and, therefore, he ought to live up to his obligations and responsibilities. I like Daniel immensely, but I do think he has some people around him who advise him very badly. But this is none of my business excepting that I am interested in him from the bigger point of view, and of course interested to see you and Marin protected. I suppose everything will come out all right in the end. I merely state these facts to you so that you should know. There is no cause for worry. I hope you are hard at work and satisfied with what you are doing. I say satisfied with what you are doing, for I know you are your own best judge. And if you are satisfied, you are undoubtedly doing something worth while. I hear you have finished a book on art. I don't know who told me, but you know everything finally comes to "291." Of course I am looking forward to seeing what you wrote, for I know whatever you have had to say is worth while and that it is said in a direct and splendid way.

With greetings from all the 291ers.

Your,
[Stieglitz]

N.B. Last week Steichen's decorations were at Knoedlers. They were not a public success. The decorations are not quite finished, as Eugene Meyer has sold his house and in consequence the decorations will have to be stored until they find some home. That means that in the future, possibly, Eugene Meyer, may build a house. Maybe not. Of course the whole matter has been rather a blow to Steichen, as no one can really judge what the work would have looked like if completed and in its proper place. But the whole matter from A to Z was so ideal up to this unforeseen ending that Steichen feels very grateful for the opportunity he has had, although the ending was rather tragic.[3]

1. Max Weber's exhibition of paintings and drawings was at the Print Gallery of the Ehrich Galleries in New York (February 1–13, 1915). Matisse was shown at Montross Gallery (January 20–February 27, 1915) with over seventy works that included drawings, etchings, sculptures and paintings (Gordon, *Modern Art Exhibitions, 1900–1916*, 2: 862–63). *French Modernists and Odilon Redon* was at the Carroll Galleries (January–February, 1915). *Exhibition of Paintings by Marion H. Beckett, of New York, and Paintings by Katharine N. Rhoades, of New York* (January 27–February 22, 1915) at 291 included ten works by each artist.

2. *An Exhibition of Water-Colors, Oils, Etchings, Drawings, Recent and Old, by John Marin, of New York* (February 23–March 26, 1915) showed forty-seven works chronicling the development of the artist.

3. In 1911, Eugene and Agnes Ernst Meyer commissioned Steichen to do a series of large murals for the foyer of their new home on Park Avenue. Although Steichen worked on them for several years, the panels were never installed in the Meyer home because of financial problems that eventually forced them to sell the house. The murals were exhibited at M. Knoedler & Company as part of Steichen's exhibition in January 1915. The show included twenty-one paintings and the seven murals for the Meyers. Afterwards, the panels would lie dormant for many years until the Meyer children gave them to the Museum of Modern Art, New York (Penelope Niven, *Steichen: A Biography* [New York: Clarkson N. Potter, 1997], 393, 415–16).

March 9, 1915
291 Fifth Ave., New York

My dear Hartley:

Enclosed is another $100.00. I hope it will reach you in due season. One never can tell now-a-days what is going to happen as far as European mail, especially to Germany, is concerned.

There is nothing special to report from over here. The excitement over the war is, more or less, subsided. The novelty has worn off, and you know Americans are mainly interested in novelties. I hear that you are, or have been in Frankfurt. That means that you are probably seeing a little of Germany.

At "291" things are very quiet, although we have had some very fine shows. But we do not play the game as New York would like us to, and as we are no longer a novelty, there are fewer visitors this year than ever before. The Marin show is on at present, and it is really very beautiful. It is full of joy and full of real ability. Of course all the fellows are having a very hard time to make both ends meet. Steichen sold nothing at his show. This is the first time that has ever happened to him. Still Prendergast has done very well, and so has Lawson and so has Weber. But Weber stood at his show and told everyone how great his work was and how great he is. His show was the usual Weber thing. Great ability but very little real seeking of his own. That may come in time. Perhaps. To me the show was nothing more than a corroborating of what I had always known about Weber. I am glad he is getting some money and I am glad he continues to think himself the only real artist in America. If he believes that in the depths of his heart it must be a wonderful feeling to have.[1]

All the fellows wish to be remembered, as usual, in haste,
[Stieglitz]

1. Weber severed his relationship with Stieglitz and his circle in January 1913 during the installation of his first, and only, show at 291. Weber wanted to charge inordinately high prices for his pieces, which was contrary to Stieglitz's practice. An argument ensued and he left the gallery only to return at the end of the show to collect his works. Weber had already alienated other 291 loyalists with his opinionated, argumentative, unabashed comments about modern art and the work of 291ers. Thereafter he was associated with other groups, but avoided the Stieglitz coterie. For a further account of the debacle between Weber and Stieglitz, see Lowe, *Stieglitz: A Memoir/Biography,* 149–52.

∽

n.d. [March 10, 1915, Berlin] (postcard)

My dear Stieglitz,

I've simply got to try postal cards—it seems as if I would never get the letter off. I want to talk to you much yet letters are hard when life rushes as you know. The drafts come all right—except that the American Express Co. objects to "+ Co" being written on them and ask me to have the sender omit it as it complicates payment.

The "291" number of *Camera Work* came the other day. It has charm and novelty—certainly to me off here it's all so intimate and friendly. I loved Marie's little contribution it is so human and real—also Marion Beckett's, Agnes Meyer's—E. Meyer's also. But real affection for anything always calls for either austerity or [?]—I think in the main however it is thoroughly good. It interests me to see myself in print the second time—it's like seeing pictures of one's own in other places.

I am so pleased that De Zayas thought well of my show at Daniel's. I would like to have seen it. You must jack up Daniel in that matter. Don't be too kind—but that is silly to tell you that—you always are and must be I suppose. I am writing quite some and shall soon send you a packet of MSS which I hope you will want to print. No one else will.

Love to all,
M.H.

*ᵔ*

n.d. [March 15, 1915]
Berlin

My dear Stieglitz,

It's no use—I shall have to begin again—my conscience troubles me too much. Two letters have gone into oblivion here for want of time to finish them—I have got to get something off to you if only to say *wie geht's*. I didn't suppose I would so soon see the time when letters would be difficult for me—but I suppose it is chiefly when one isn't living very much that one can write more—and I have lived through so much that is gay and grave these past months that I have kept still in all quarters of my spiritual universe and no one has heard much from me.

Doubtless you may have heard through Demuth or someone of that great grief I have—the loss of one of the dearest friends I ever had—Lieut. V. Freyburg—cousin of Rönnebeck *bei* Arras *gefallen*. It seems like a great lie I am always telling when I write or say what I have to accept as truth. You know what friendships are to me—how slowly I make them and when once made how I almost worship them. I had every reason in this wide world to adore the fellow because it was a friendship begun in Paris

the June that I arrived there—we had gone about a deal together there and here in Berlin we three were much together and it was a very beautiful triangle. If there was ever a true representative of all that is lovely and splendid in the German soul and character it was this fellow. At the age of 24 perfectly equipped for a life of joy and strength and beauty—most exceptionally handsome with that rarest accompaniment of soul and character which one finds so often lacking in just beauty. For many weeks I could not do anything or write anything as for me these things take away terribly from my life energy—I live too deeply in them—for friendship is for me my only notion of the marriage state—spiritually speaking—whether it be a man or a woman—I want no other notion of it.

Fortunately I still have Rönnebeck here with me which friendship is the completest thing I ever had because it has long since been realized entirely—he is still in Berlin doing [?] as officer in Döberitz and in the city. I assure you when both these intimate friends of mine went off to the field—I didn't just know what would become of me spiritually—and for weeks I didn't know anything of either of them—and the only news I had from V. Freyburg was a card—*"Es geht mir sehr gut trotz aller Anstrengungen"*—in a week after he had left all earthly things. It has been fortunate too that life has rushed in well upon me in recent times—I have lived rather gayly in the Berlin fashion—with all that implies—a temporary marriage of a very decent nature—without restrictions whatsoever the which has interested me some of course but only emphasizes the more my determination against any fixed conditions. I think it must be so awful all this—I can't see myself into it—I know now that I shall be a wanderer taking what I can take in the way I can take it and ask nothing more. I know the masculine nature so thoroughly—I know the feminine well—and yet I still have to wonder at a woman—abstractly we all know they are lovely—intimately I don't know if anyone knows anything—and I hate intimacy—I myself am too mystically composed. I am certain ever to let any one person walk in wholly into my domain—I can know no other intimacy than myself and that certain freedom which friends may take if they will—etc.

I am glad to have here the '291' number of *Camera Work*—it is of course very interesting and of course conglomerate. I have not read all completely but I like the more intimate and less pretentious ones such as Marie's—Marion Beckett's—Agnes Meyer's—Duncan's I thought very good—Zoler's interested me too—as I am sure it is the first time I ever saw him in print. There is an intention toward personal style there—mature to him. Anyhow it was all full of most intimate connection and one knowing the little place—it is interesting to note that the female phase of it nearly all runs to hyperbole and sentiment and the male phase to indefiniteness and mysticity—and a woman is never mystical of course—or I mean a woman is never a mystic.

I am sure your winter there in the little rooms must have been interesting and pleasant. I suppose too there has been the usual depressing war talk with the accompanying

art talk. You don't know what a blessing it is here—I have steered myself clear all this time of art people and never hear anything and I never listen to or talk or think war except to think how ineffably shameful it is and what suffering comes of it—but if New York is as I know it then there must be the most awful deluge of talk known to mankind—I am glad I am not there—I don't know when I shall ever live there again. I don't know if I shall ever live anywhere else but Berlin—it does not seem possible—it is my world's center—I never tire of it—I never think it banal—just now it is not so nice since the one o'clock closing law came on. You can well understand what that means to a Berliner either born or adopted—but the public accepts all of it with the usual German tendency toward geniality and friendliness. I would be fine to know that all war capitals have deported themselves as splendidly as has Berlin. I hope the people of all of them have had as much freedom and kindness as we have seen—I have not the slightest criticism to offer except the one o'clock matter which is hard on all nightbirds like a real Berliner is. It is to hope it will all be restored before a terribly long time and one can then dance all one wants and stay out.

I will send this letter along now that I have eased my conscience splendidly. I feel free again to have finally gotten off something to you. One thing only—the Am. Exp. Co. complains that the drafts you send me have "+ Co" written across them in red ink which for some mystical reason hinders payment. They pay me the drafts out of courtesy yet say they ought not to—so you see I am saved from dilemmas by good will. Please speak of this next time in order to avoid embarrassments. And don't forget to urge Daniel on to regular payment—there is no legal right there to leniency—and you have enough of your own to do. It is his matter and he must attend to it and not take advantage of good will.

Soon I will be sending you a packet of MSS, which I hope you will want to print—I don't know how much I shall ever write—I shall never deteriorate into a writer any more than I shall deteriorate into just a painter. I believe too well in stopping this side of the mechanical aspect of anything—it is one of the modern defects—prolific promiscuity in production. I work and live and live and work and what I haven't on canvas I have inside of me which only I can value most. I have loved the long siege of freedom. I am having the real chance to create myself and swing rightly into the true sway of the universe. I have achieved a nearness to the primal intention of things never before accomplished by me. The Germans have helped me to this—therefore am I loyal—I understand them and they understand me and we are friends. I think too that it may be true as an American friend once long ago said to me in the mountains—you are outwardly American and inwardly German.

Give my love to everyone—Zoler, Demuth—De Zayas, Marie—Walkowitz—Mabel Dodge—Jones—the Meyers—Steichens, Beckett, Rhoades and Co.—Mrs. S. and Kitty—Kerfoot.

For you always my deepest thanks. I think you must be glad you got out the '291' number—it ought to give you a feeling that you have done something big and are doing it still—it helps always to vitalize us when our friends tell us what they think of us. Write when you can and believe me always to be forever loyally devoted yours.

Marsden Hartley

ᴕ

<div align="right">April 6, 1915<br>Berlin</div>

My dear Stieglitz,

*Heute habe ich wirklich etwas zu erzählen*—a real and splendid surprise has overtaken me in these days—I have sold the last four pictures I have done—only just last week completed—in a way each complementary of the other as is often the case when one works under one spell as it were of whatever sort. They have been bought by a young couple who have recently been married and are to be the only decorations in the music room which I hear is very beautiful—the pictures are in some respects or I would even say all respects the completest I have done both as to intentions and execution and above all execution since I have learned how to eliminate all labor—all effort—all that awful struggling toward <u>art</u>. They are I believe in the region of pure expression which is first and last that which is most necessary to a real artist.

Naturally you will be overjoyed and it speaks well for me to have a room of my own in a smart house in the famous little city of Weimar—he Herr Wolfgang von [Wachsmuth-Harlan?] is a young publisher—and his Frau is a *Lieder* singer with exceptional ability and well known both in so-called upper circles.[1] They have both taken a great fancy to me personally and he is almost a fanatic on Greco having spent three months in Toledo only to look at Greco pictures—and he very flatteringly states that he has looked in vain for pictures to give him just that special thrill until now and has found it in my work which enthusiasm is of course all very sweet and splendid. I believe he is to write something on them later for a magazine which he publishes. The price is very fair for Europe and considering most of all the times equal to $500—for the four which of course I am glad to get even though on the installment plan. The young fellow has also spent some time in China and although only twenty-three is very much developed in mind and soul. I am feeling a high pride in this matter since it gives me an immediate entrée into German art circles and as I am practically unheard of it is indeed good and quite as such things should happen.

I have kept utterly away from all art things and people simply to clarify all my own personal sensations—to hear nothing of it all. There is of course nothing to see of moment

even and especially now in war time though I did see a very beautiful Van Gogh in the Frankfurt museum. I forgot to tell you last time I wrote that I was invited there by American friends Dr. and Mrs. Marks who are New Yorkers and whom I met at Mabel Dodge's though I have long known of her—a very charming intelligent and talented girl—he a chemist of real ability I hear. They are here in Berlin in these months so I have their company daily as well as that of my friend Rönnebeck etc.

I go to Weimar in two weeks to see the pictures in their places and to visit a couple of days—and if the Markses go to Holland in a few weeks as he expects to have to do I may go with them. I need to see something very much—otherwise nothing new to tell. Before you get this letter you will doubtless meet a friend of mine whom I have sent to call on you Miss Phyllis Meltzer daughter of Charles Henry Meltzer critic in New York. I want her to tell you I am all right living well and being happy generally and will see you all myself in October when I expect to go over and have a show at 291. I know you will all be interested in what I have to show—a direct continuance of what I had on a bigger and simpler scale. I can't write more now—I wanted you to know of my fine success and you can of course tell anyone who is interested. There are to be no other pictures but mine there—a kind of young museum for me as it were. I like very much the idea.

Give my kindest wishes to all. Will you please telephone Mrs. Kate Strauss Lennox 4772 and give her especially my love and best wishes and that I will write as soon as I can?

Love and best wishes to each and all.

Yours as always,
Marsden Hartley

1. Current scholarship on Hartley has not addressed this collector or the paintings Hartley sold to him.

☞

May 4, 1915
291 Fifth Ave., New York

My dear Hartley:

Well, that was a great piece of news. No matter how much you yourself must be delighted, I am sure your own delight cannot quite equal mine. And that I am sure you feel and understand. Of course I am looking forward to your coming to New York and having a show at "291." So far there is nothing in view for "291" except three shows. And if no other shows materialize, I shall be more than satisfied that the season 1915–16 will have been well worth while when it is over.[1] There is your show. And I feel that you

have done all you say you have done. I am sure of it. Then there is two years develop-
ment of Walkowitz. He is going his own way, slowly and surely, and is as fine as ever.
And then there is De Zayas. He has done some wonderful things: abstractions. They are
amongst the most beautiful things I have ever seen. And they are entirely his own. So
between you, De Zayas and Walkowitz, it looks as if "291" would be devoted chiefly to
the development of 291ers. And that is as I should like it best. "Modern Art" is being
exploited in so many impure forms over here, that it is disgusting and even dishearten-
ing. But this exploitation was unavoidable. To keep anything pure in New York seems
to be a job which even God himself cannot satisfactorily fulfill. And still we struggle on.
Sometimes hoping against hope. Sometimes simply through the feeling that there must
be some Real light somewhere.

Did I write to you that we are now sole possessors of the whole floor at 291. We have
lots of room and it feels fine to really feel free. To feel that one can stand at the back
windows looking out without feeling that one is in anybody's way. Lawrence was cer-
tainly a kind neighbor. Still at times I felt that he was feeling that we were a nuisance.
And so we were.

"291" is very quiet. Just at present I haven't a single thing on the walls in the little
front room. I feel that at least for three or four weeks to come—if not for more—I shall
put nothing up on those walls. Ten years of pictures—ten years of endless talking and
explaining to everyone who happened up and whose curiosity happened to be aroused.
I simply cannot any more. This endless talking. This feeling that it was a pastime for
others when it was a question of Life for me. Not the talking, but the feeling that oth-
ers might begin to see through this Showing, this talking, this trying to make others feel.
But New York! It has not improved. It is a greater dissipater than ever. And yet the day
must come when feeling—real feeling—will come into its own. Without feeling I do not
see how there can be any real Seeing. I sometimes wish I did not see. The year has been
so full of tragedies all about me that my vitality has been sorely sapped. Few people
seem to stand the test of 291. A straight line seems to be an irksome thing to follow. A
few days ago I took one of your old mountain scenes, one of the large ones from the
first exhibition, the one Simonson wanted and which he did not pay for, and which I
finally kept, home. It looks very wonderful there.

As for Daniel and payments, he is as slow as ever. His intentions are fine and he does
make some payments, but I do wish he would be prompt. It is terrible, this having to
force people to live up to their obligations when they themselves have created obliga-
tions and have made them as easy as possible for themselves. But I suppose if it were
not for Daniel both you and Marin would not be as well off as you are this year. And so
one dare not be too harsh. But it is aggravating all the same. A lot of New Yorkers are
going to the country and gradually I shall be pretty much alone at 291. Even more alone
than in the last few weeks. De Zayas, Haviland, and Walkowitz and Zoler—and of

course Marie who is here—are the ones who are most with me. A great many of the old faces rarely turn up. Even some of the close friends seem no longer attracted for some reason or other. I suppose you do not know that Arthur Hoeber died the other day. He died cranking his auto. Died from heart failure. I facetiously claim "Art Failure."

Special news there is none. Under separate cover I am sending you #2 of "291." I wonder if you got #1. The whole thing is nothing more than an experiment, and a means to give De Zayas, Mrs. Meyer, Katharine Rhoades and some of the others a chance to experiment.[2] It may develop into something bigger. It all depends upon the talent attracted. But as it is, it has already given us some fun and has attracted some attention.

With heartiest greeting, as always,

Your old,

N.B. I am enclosing draft for $100.00.

1. The 1915–16 season at 291 was actually very active, with exhibits of work by Oscar Bluemner, Elie Nadelman, John Marin, Abraham Walkowitz, Paul Strand, Hartley, Georgia O'Keeffe, Charles Duncan and Réné Lafferty. For details about these exhibitions, see Sarah Greenough et al., *Modern Art and America*, 546.
2. Encouraged by Stieglitz, who was beginning to lose enthusiasm in his crusade for modern art after the Armory Show, de Zayas, Agnes Ernst Meyer and Paul Haviland conceived to publish a periodical devoted especially to the most advanced currents in art. This monthly, called *291,* borrowing its name from the gallery, was modeled after *Les Soirées de Paris,* a Parisian journal edited by Guillaume Apollinaire, and was devoted to a cross-section of artists and writers. *291* was printed by Stieglitz's gallery in a large format (20 x 12 inches) and featured an array of literary and visual arts including Picasso, Braque, Picabia, 291 artists, African art and poems by Apollinaire. There were twelve issues published in all, from March 1915 to February 1916.

ᴄᶠ

May 19, 1915
[Berlin]

My dear Stieglitz,

I keep waiting from day to day for the arrival of my draft for May which up to this hour does not come—already three weeks late. I have received two other letters from New York and two copies of Lippmann's paper *New Republic* so that I know the mails are going.[1] I do not of course know what it is that delays a letter with draft from you. There must be somewhere a reason not attributable to you but a sudden halt in non-arrivals of money puts a stop to existence for me and I am simply as if hung up to a tree. I can do nothing—work is difficult and worst of all bills which need payment go on and I live only by borrowing which is still to me the worst state of things I can endure. Is it Daniel's fault or are you ill? I know too well that you are not wishing such things but I hang breathlessly on the morning's mail and still nothing comes. It is too

costly to cable and I just have to sit and hope and despair and watch and wait which is the most taxing of all. When I wrote you of the sale of the four pictures it is to tell you of an artistic success—the money side is a long drawn out thing I had to agree to to get them placed which acts as merely a surplus which <u>helps</u> me merely but doesn't balance monthly accounts. If it had been a lump sum it would have been good but the people are paying for them just as all rich people with no money pay for things in monthly dribbles so that I need my regular moneys the more if that is to make credible.

I have added expenses now which have to be met clothes materials frames which in my new scheme of work must be bought to work on with the pictures and of course must be paid for. If Daniel is the cause of my annoyances here can't you make him somehow come to time? I don't see why I should suffer especially when it belongs to me. I can't possibly think of any other cause unless you are ill—in that case you can arrange with Haviland or someone to send the usual draft. It is all so straining on me and I know for you also but I have not another resource—fortunately thanking the good gods as I have every moment of my life to do.

I have a friend in Dr. Marks and his wife who wouldn't let me starve but for all that I need my own money most of all. Can it be arranged that I get all this business made punctual that on the 15th of the month previous I get the next months draft or in any event I receive it promptly on the first of the month? I do so wish this could be. You know dear Stieglitz knowing me well what all this does to the nerves of me. I have gotten on so well in the last year here in these ways with the German peaceful way of living that I have been much helped even with the general war strain in which the people here are showing even more than the usual calm. I can assure you life is far more peaceful right here in Germany than anywhere else I can think of—I am certain no one living here could complain with the way all things go on as usual—but you know well how this money business simply upsets my whole existence and when one month is late then it takes forever to get straightened out again. I haven't finished paying Prof. R. yet for what he let me have the other time when I was left stranded here. So I just ask you to somehow fix all this up so I get the draft punctually the first of each month—that means according to the way mail comes it needs to be sent the 10th of each month allowing three weeks for the journey.

Now that I have written all I can do is just sit and hope—and when the money does come then do the best I can—as it is it will disturb me now for the next three months to pay back what I owe. There is nothing else to write of. I can't speak of war matters and besides there is enough being said where you are far too much. I am to have a show in Frankfurt open in September together with Rönnebeck's sculpture and possibly one in Berlin also if things go all right. I hope all are well in New York both at 291 and 1111.

Very best wishes to yourself always.

As always,
Hartley

1. Edited by Walter Lippmann, *The New Republic*, first published in November 1914, was founded as a progressive political journal geared toward modern intellectuals, which eventually fostered a strong pro-war position. Later in January 1917 Hartley contributed an article on Odilon Redon.

᷾

n.d. [May 30, 1915, Berlin]

My dear Stieglitz,

Your nice letter with draft reached me here in Berlin four days ago on the 26th May. On the 19th, I wrote you to say that up to then the letter had not arrived and that I had no money. If the letter had a nervous quality it is only because these things do the same to me as always and I can't help it. When one is so far away from everything and things in general of a hysterical nature I may be pardoned I hope if I show a little also. It simply turns my entire universe upside down when money fails to come and gives me the feeling in these times always that something has happened on the way and that I will get nothing. That one lives at all in such heartrending times as these is in its way a kindly dispensation and yet I wonder in my grave moments if life is worth all this humiliation that one must live to see such things as the world perpetuates today in the names of human justice. I must say frankly there is nothing in this world to be proud of in these dreadful hours weeks months (and years too the way it looks now).

In spite of all this I have been glad that I have been here in Berlin—I have been glad that I could show my faith in the German soul by remaining with it—I know it must be awful there in New York where talking is always the fashion—and what must it be now where everyone is by nature nervous excitable and at most impolite in matters not private. You know the German well over here—you know Berlin well—and you know also that if the German has faults he has also charming virtues and that he is of all things one of the most comfortable kindly and altogether decent of human beings in this whole world to live with—you know how well he will preserve peace in ordinary life at any cost simply because he has the manners and a sense of ethics which lives and lets live each according to his own notion. I am sorry for the Germans in Amerika that they must be subjected continually to such hatred and incivility.

There is one thing certain—there is no single criminal in this whole matter—it is just one mass of horrible manipulation—and that is all. It is ridiculous to criticize and hate one nation simply because it shows its efficiency to a maddening degree—the genius is always despised for his peculiar efficiency and Germans do not dream of war—they do it with system and with all the methods of business that any business requires and God knows war is a business these days when one sees to what ends human power can go one becomes ashamed of human intelligence and yet it is the same now as it was in the

very beginning of things and from appearances it will remain so. However all this must be put aside it does no good to anyone to talk and one hears enough as it is.

You have by this time met my friend Phyllis Meltzer in New York—she lives also in Berlin and likes living in Germany also. She writes me that she found you most charming and very intelligent. She is herself a splendid girl in her way—a good pal and altogether a fine sort—we go about quite a good deal together. She expects to come home here soon and I hope she will have no trouble getting here.

As to my affairs in general I am more or less disturbed and am making decisions these days—I don't know if it is advisable to try and hold shows here inasmuch as one knows so little of what can or will happen. Just these days I think strongly of sending my pictures off to Amerika and let them go to you to storage until I come. They are all I have to show for my existence and from a practical point of view it is of course important. In the event of further difficulties with transportation between Europe and Amerika it will complicate all things and then I couldn't hold a show either here or there. I shall think this over seriously and if I decide to send them over care Photo-Secession you will know why they come. I might even go earlier than October myself inasmuch as it is not practical to wait until all my money is gone so perhaps September might see me there personally and the pictures before that. In case I send them I should like to ask that they remain entirely under cover from all eyes except your own the which you understand well. Probably if the customs held them you would have to look at them yourself—but in no case anyone else among artists should—I find a great deal of value in silence in these matters.

I want in some ways very much to go to N.Y. and in others not at all—for when I think of the talkers and the talk there always I dread it. I have had such wonderful peace here and freedom from all rant about art etc., but if nothing intervenes as one never knows in these days and times I shall of course return here and live as usual. I do hope all this can be so—I would hate the idea of not being able to return to the country I like and the people I like to live with.

Only a word more—do arrange if you can to send the draft so it reaches me the first of the month as it makes all things all right for me and when it does not arrive I am simply balled up and I have obligations to meet always. It is lucky I have the Markses here— they are awfully good to me—but you know how I still hate the borrowing business.

Give my love and best wishes to all wherever you think they apply, especially at 1111. I look forward so much to being with you all again for a time at least. From what I hear in other ways you had good shows this year. Yes I received the first number of "291"— and had started a sort of refutation to Agnes Meyer's ideas which is yet not finished.[1] As to my other written matter I shall now doubtless wait and bring it with me and would like best to have it appear in *Camera Work* which is natural of course. It has a quality

of its own certainly even if it shows my literary preferences—if it has a style it is out of those stylists that I love most Thompson—Whitman—Gertrude Stein. Mrs. Marks has been kind enough to typewrite a deal of it for me inasmuch as I couldn't go to a stenographer with it chiefly because I have to read it myself to the writer. It has no punctuation except the natural one of the rhythm it gets when it is read rightly and other characteristics that make it impossible to read with strangers. It has much of the quality of my pictures—that of seizing at the mysticity of the moment—I personally like it— I don't know if anyone else will.

Anyhow very best wishes to you as always. Thanks for all you do and all you have to do for me—you know I am eternally grateful. Keep well and happy and at least peaceful.

As always yours,
Hartley

1. Agnes Ernst Meyer, "How Versus Why," *291*, no. 1 (March 1915): unpaginated.

∽

June 21, 1915
291 Fifth Ave., New York

My dear Hartley:

I am enclosing a draft for $75.00. I received your letter about the non-receipt of remittances. But undoubtedly a few days after you had written a draft must have reached you. All you say is true. Daniel ought to pay regularly. The money is yours. But what are you going to do if you cannot force a man to meet his obligations. The matter has been put before him over and over again. He is desirous of meeting his obligations, but somehow or other he does not seem able to. He is two months behind hand in payment, both for you and Marin. I have advanced moneys. I do not want to start a law suit as it would not help you nor would it help Daniel. And it would be a mighty disagreeable thing. It would also put "291" too in a false position. The whole thing sickens me. There is no one that I know whom I can go to for money. I have borrowed <u>for</u> everyone these last few years. Something I have never done before in my life because I don't believe in it. I have never borrowed a cent for myself and I do not see why I should be forced to borrow for others. Even my good nature has its limits. So you will have to be patient and do the best you know how. I am doing all I can and more. I am sorry if you are inconvenienced, but so are we all in these times. Of course I regret that you cannot work under the conditions, so that your time is really waste. But that is your own affair. I cannot help you. It would be very beautiful if one could arrange one's money affairs so that they could work automatically. But my experience has taught me that even

multi-millionaires are up against it good and hard frequently, and through no fault of their own. Even they resent being inconvenienced. Of course I know your ideas on the subject. You look upon the artist as creative and so of special privilege. I do not see life in that light. When it comes to money I have found practically all people alike. I only know one or two exceptions. I have just written another letter to Daniel restating for the nth time in what a predicament he has put you. Will it do any good? Some people get callous if you are constantly hammering away at them. Well, I hope that you are again at work.

With greetings, as ever,
[Stieglitz]

∂

August 5, 1915
Berlin

My dear Stieglitz,

I hardly know how to begin to write you I feel as if I have so much to say and yet perhaps it is nothing. In the first place I feel as if I must apologize for my last letter—but I know you must understand what the situation is—when I sit here with prospects of nothing whatsoever until a draft comes with debts on my hands and no way to disperse them—it's simply a little hell sitting on my nerves and I can't ever seem to help it, when I get into that state it becomes truly a sickness and one from which I can't rid myself [?] the pity when I've had nothing else all my life except just this sitting on the edges of a crevasse.

I've told you a hundred times easily that I want nothing remarkable—I only want enough in my stomach so that the machinery works well enough to seize the moment for expression and expresses it. I am heartily sorry that Daniel is doing all this—I am unutterably sorry that you have still to be bored with all this for my sake—good God as I think of it I wonder how you keep up courage for friendship alone—to say nothing of the obligations it entails and seems to force upon you regardless of your own will or the wills of your friends and all for what in the name of decency? Just a little useless art— is that to be the substance of the charities of heaven upon you.

I am not ashamed in reality for in the heart issue of things I know that somewhere in the inner crust of all there is a particle of light lighting us all up somewhere into the realm of belief that all is in due time good and right and honorable but there are moments of darkness in me or shall I better call them moments of non-receptivity when I weary under the weight of the obligations that bear down on my being heavily obligations which are never never to be repaid one iota either now or never here or anywhere—just

those obligations on the soul of one for which one can offer nothing whatsoever except the very fluid earnestness of oneself and in these times we are going through what does earnestness count for and who is that honest that he can see the very rottenness of all the states of human being? There is just now no one who can say he is being a human being—we all comfort ourselves with the idea to cover our sins not those conventional sins the world prays over but just those sins we perforce commits upon our friends out of sheer helplessness when the very one and only secret of friendship has personally speaking my life long been that of never demanding anything of friendship—and how is one ever ever to get free of duty in this world. I who am conventionally speaking a pathetically free person suffering in the consciousness that I too am doing just that thing to the world in general, which I am so want to deplore and knowing it every moment is worse than all.

These are the sick moments that come upon me still my dear Stieglitz in spite of myself and gloom my vision into a darkness of days in which I am forced out of sheer respect to myself to my friends and to the world which doesn't know even of my existence to keep that [dioniest?] of beneficiaries—silence—I grow far more in a deeping consciousness of these things than I do in mastery of them. I have but one fear and that is the philosophic moment—that terrible moment in which one sees clearly the husk of all that is lovely in this world and being lovely perishable to the touch. I have only recently said here to an intimate friend of mine—that I haven't the slightest concern over what without appearing banal I can call my expression as an artist—that is the only logical thing I can see in my existence—but I do get these moments when the very ridiculousness of my being looms in upon me like a wraith distraught with the foolishest of fancies and I am after the manner of wraiths hung up on high branches to waver to any wind or just hang listless. I know the reasons and therefore I know why I suffer—it is because I am wanting to affirm to myself daily and hourly my absolute faith in the rationale of the imaginative life which I know to be my being itself. It has nothing to do with dreaming which I have never in my life been guilty of perhaps to the pity of it—it has had nothing to do with the common notion of visions which want to shape the earth in terms of accepted or acceptable heavens—it is just one thing—the brave and difficult idea of seeing life in the real and vivid terms of the moment and making that suffice—never once to lose that beauty of the moment which emblazons itself upon the sky of one's existence and makes that a thing devoutly to be wished. I do not suffer so much from that I am lost only when the moments to which my own life is such a stranger descend upon me so thickly as to make me see all things and all people with an objectivity which is after all nothing but pure horror the very symbol of which is the present state of war we have with us.

So it is my abject being has wondered rather miserably through the last months—there too Death itself has hung more closely to me personally than I have interest for

or pleasure in. I think you know my father died last September—I have told you that one of my two most dearest friends here fell in the war—in May my mother died—and just now I have news of a death of a young nephew.[1] I am not a dweller upon these issues but for all that the consummation of this has its effect upon me. If one has a grief one lives with it just as one does, with a pleasure the only difference being that if a grief has beauty in it its image upon one is the more difficult to wear—and I had an abiding affection for my dear little stepmother as also I had for my friend and it is difficult always to be thinking objectively of something as that it once was whereas it is spiritually more correct to think of something beautiful as never leaving one.

However Stieglitz—it is better that I proceed to some of the more effective facts of my present being—just a moment merely to dwell upon an unpleasantness. I was invited by my friends the Markses who live in Frankfurt for a two weeks rest and visit— in July—I had been there but two days when I developed a most dangerous case of blood poisoning in my right hand middle finger—took at first to be a case of mild rheumatism until it took to swelling up to twice the size of my hand when I went to the doctor—he said of course it would have to be operated at once to stop it from going further. So I was operated under ether and after that was wretchedly ill of course had to remain in bed—with the result that my two weeks was taken up with that business. My hand is now thoroughly healed but as a result of the cutting my finger is awkward at the lower joint and I am always conscious of it as being shorter though the surgeon assures me is not possible—but one's feelings count some. It is really a tightness of the flesh in that spot due to the deep cutting which hinders full freedom—otherwise no less—except that my hand still doesn't endure much—fortunately painting is not too strenuous for the hand and I can of course paint quite some with my left hand as I have always done when my hand was tired being partly left handed. I am of course fortunate that issues developed so well as if one loses a hand in war time one wants it at least to be for a reason as when one sees the poor boys about now one knows that at least they know or at least hope it was for something—and that they are a very sweet lot of invalids any one would say who sees them—they are born to gentleness and trust and peace no matter what anyone says to the contrary.

The next episode I have to relate is far more attractive and picturesque as an idea. I have in these last two months discovered the '291' of Europe—I have found here a galerie which is precisely what 291 would do in N.Y. if it could and I am sure in just this way. It is called strange to say—Münchener Graphik-Verlag—being a house that publishes *Kunstmappen* etc.—also a little *Zeitschrift* called "Zeitecho"—being a *Tagebuch* of war time mostly stuff from those artists in the war—but I shall tell more of the galerie. It is in a fine old house on Pariser Platz at the right corner of Brandenburger Tor on the ground floor of the house Max Liebermann lives in. You know well the spot and can appreciate its attractiveness—its fine location—convenience etc. There are three

large typical old house rooms high ceilings hardwood floors wonderful lighting and absolutely simple effects just a few chairs and a sublime silence which I fancy is even in advance of 291. A friend of mine a Swiss sculptor Friedel Huf—has recently exhibited there and it is through him I found it. The director is a most attractive fellow Haas-Heye by name was a painter himself and is now singularly enough the head of the finest *Modernhaus* for women in Germany a rival of the French houses and designs women's clothes wondrously. He has also taken up this galerie as a side issue—and I am invited by them for the month of October to exhibit my work—all or most of which will be since I left Amerika. I have wished and hoped ever since I've been here for just such a place but there was none.[2]

I somehow wanted to be free of all groups and cliques and for this reason have not once been near Der Sturm who are seemingly <u>the</u> group of Germany. If Kandinsky and Marc had been personally approachable it would have been different but Marc is a long time in the war and K. is of course not in Germany being Russian—and the rest I have no interest in—besides that their rooms are <u>terrible</u>—in a *Gartenhaus* of a business building in Potsdamer Strasse very ugly and dark and most uninviting and Walden himself is not sympathetic to me for no reason. My chief attachment was the possible one of Marc and K. but now I can just beat around as a free agent and as an artist keep free of all clique business which is quite the best.

Haas-Heye has not even seen my work yet but I know he likes me personally and from what I hear likes my mind as he calls it—and he has been told the nature of my work—it will be rather an event from many points of view. I have lived in Berlin two years and no one hardly knows what I am as an artist—I am probably the only American in Germany certainly the only so-called ultra-modern. I don't hope for more than just the artistic success—the critics will howl quite likely as they aren't so very much better than in N.Y. except that everyone over here is generally more intelligent and receptive—but that doesn't matter. It will be strange to see my name on all the affichés corners of Berlin in big letters just like the theatres and *Kinos* etc.—amusing—for this reason therefore I will not get to N.Y. till November as before. I hope for Thanksgiving dinner at your house which would be joyful enough for me—the whole business will be a stiff problem for me practically to hold out until November but I've <u>just got</u> to do it. I can't let a chance slip to make my European debut under such good auspices—and I've got to get my name out the sooner the better. After the war things will be bright again although they are remarkable as it is—nothing stopped much—except dancing and the night life which is of course sad for one who loved it as it was. I don't know how the money is to hold out from the original Daniel money but if you can make it pull through for me until I get to N.Y. I can do this thing which is most important. I have got to buy 100 mks. worth of mouldings now and you see that is a problem besides debts to pay.

I can't write you much of my work but you will be very highly interested—that I know—I have done something which I dare to think is original with me.[3] I don't know of its having actually been done before and I am told so—at least I know it is not done in my way—ever before in the modern sense. I have written a concise preface in English which I hope they will have the courage to publish—courage meaning only to print it in English inasmuch as the kind of English I have written it in could not I am told be done over into German but as it is only for cultured people—I think perhaps the galerie will do it.[4]

I love the idea of your making a number of 291 for me—I have quite enough material for it though I want earnestly to see the essay stuff in *Camera Work* where it really belongs.[5] There are two kinds of writing essay and picture and the picture ones would go so well in 291—I look forward to this very much. I wrote an article which I sent to Louise Norton who with her husband publishes "Rogue." It was a kind of reply to a sentence of hers "the habit of beauty is tiresome" which I thought most eloquent—I sent it to her as they are both friends and I hope she got it? Will you inquire of someone who knows them if she got it? It was a kind of personal letter or I could have kept that also for 291. If she received it—it can still be done—I had no copy of it.[6]

I will of course write you again soon relative to what's going on with me. I mustn't forget also to say that I am to have a show of early drawings in Frankfurt open in September at the Schames Galerie—the modern galerie there—these are drawings which up to now I never showed to anyone—I did them in the landscape period and they have an interest—those who have seen them here like them very much—mostly drawings of woodsmen at work or in the house when I was living that awful winter in Maine.[7] I will bring them when I return to N.Y. and hope to show them separately and maybe sell them outright to someone like Daniel for a decent sum. I sold two here for 100 mks. each which helped to pay small bills and rent.

Anyhow my best wishes to all. I am looking eagerly for the copies of 291—which at this date have not come. Also haven't you gotten out any *Camera Work* this summer—also if you can will you be so good and make me one or two prints of that negative of mine? I must give the one I have to Rönnebecks as they are such good friends. Friedel Huf the sculptor is soon to begin a head of me for my show, so that will have an interest and he works very well.

Write again when you can and give my love to Mrs. and Kitty, to the Steichens, Meyers, Zoler and oh all the others. I look forward so eagerly to seeing the whole push again.

As always,
Marsden Hartley

Special P.S. Just as I mail this the fall of *Warschau* is announced in the papers—streets full of people—all very quiet.

1. Hartley's birth mother died when he was just eight. His father remarried to a woman named Martha Marsden whose maiden name Edmund Hartley assumed as his first to become Marsden Hartley in 1906. It was his stepmother, Martha, who died in May 1915, not his birth mother.
2. The exhibition in October 1915 at the Münchener Graphik-Verlag showed forty-five paintings and a selection of abstract drawings completed in Europe, as well as drawings from 1908.
3. Because of the prevalent emblematic and symbolic military focus associated with Hartley's war paintings, he was well aware that censors would prevent him from describing in detail to Stieglitz the current direction of his work.
4. This preface was later reprinted in an American review of Hartley's exhibition in Berlin (*The New York Times*, "American Artist Astounds Germans," December 19, 1915, 4). See Appendix Four.
5. An issue of *291* devoted to Hartley was never published.
6. *Rogue* was a short-lived periodical published by Allen and Louise Norton. The magazine did not print anything written by Hartley.
7. In September 1915, the Schames Galerie in Frankfurt exhibited forty-five drawings of Maine completed by Hartley in 1908.

❧

October 1, 1915
291 Fifth Ave., New York

My dear Hartley:

Here I am back at 291. Full up. That means going it hard. There is quite a little going on. There is much more life all around than there has been in a long time. By that I mean there is greater activity and less of that horrid down cast feeling which was all pervading in New York last year. Of course that means Americans, or at least some Americans are making a great deal of money and that always is reflected in the general hopefulness of everyone else doing likewise. Americans are really intensely amusing, when one can stand aloof and see them without really feeling anything. Having suffered so much through them that one is evolved into something beyond all feeling and still remains a human being. I have become a mighty bad correspondent. I had plenty of time in Lake George and often the desire, but somehow-or-other the Lake, the water itself, always seemed to call me away. The Waters had a peculiarly powerful fascination for me this summer. It seemed to me more all I really needed. Without words. You don't know how terrifically tired I was of words when I left New York. The whole year had seemed to be nothing but words. And yet I know it was not all words. But words rang in my ears as if the ringing would never stop. Thanks to the Lake and to my own ability to really throw off anything I wished to, if I only will it, I came back to "291" a few days ago a thoroughly rational being with the power to smile at everything disagreeable. Of course your letter gave me a great deal of pleasure. I do hope that your Berlin exhibition will be all that you will have a right to expect of it. And the Frankfurt one too.

I wonder when you will really arrived in New York. "291" will be ready for you at any time you come. As for moneys, I enclose draft for $75.00. There is still a balance due you of $251.50 Daniel is five months behind in payment but I have managed to keep both you and Marin going in spite of his delinquency. Daniel was in to see me the other day. He hopes to be straightened out in the near future. There is no doubt about it, he is a fine fellow, but when it comes to money he does not seem to be relied upon. You see if anything had happened to me both you and Marin would have been in a terrible fix owing to the "miscalculations" of Daniel. I do not say this because of what I have done but merely to show you the danger of relying upon a fine fellow, when it comes to the money question.

"291" is going to open up a second place. A place which is to be devoted solely for the sale of special things.[1] You will hear more about that in due time. Owing to certain things going on in New York 291 was virtually driven into making this new move. 291 as you know it will continue as here-to-fore at the old stand until the building is pulled down. In other words your exhibition, in fact all exhibitions, will take place there.

With heartiest greetings in the hopes of seeing you soon, as ever,

Yours,
[Stieglitz]

1. Developed by de Zayas, Agnes Ernst Meyer and Paul Haviland as a means to sell and promote art, the Modern Gallery opened in October 1915 at 500 Fifth Avenue as a commercial counterpart to 291. The gallery, directed by de Zayas, exhibited 291 American artists and European moderns such as Picasso, Braque, Cézanne, Picabia, and the sculptor Constantin Brancusi. It also focused even greater energy than 291 on African sculpture and Pre-Columbian art. Stieglitz continued to hold strong to his utopian perspective that 291 should be a not-for-profit incubator of intellectualism and modern art, therefore encouraging the Modern Gallery to consider economic facets. Most of the gallery's sales were to John Quinn and Arthur B. Davies. This new venture closed in June 1918 (Homer, *Alfred Stieglitz,* 196).

⌀

October 11, 1915
Berlin

My dear Stieglitz,

Just a word at this time as one of the American boys—the bearer Mr. Harvey Koch is going directly to New York and has kindly offered to take this to you. He has seen my exhibition which opened the day he left Berlin and can at least report to you that it is on and for myself I can say it makes a most excellent showing—the rooms are wonderful

and large and I have 45 pictures a number of late drawings and 45 of the earlier draw-ings out of the landscape period which no one in Amerika has seen—the latter have just come up from Frankfurt where they were on show a month in Sept. As soon as I get press notices I will send them—it will be amusing to hear what they are going to say. There will be a notice also in the American papers before you get this or should be as it is a week on the way—a kind of interview written by people who know me and who have just come over to Berlin again from N.Y.[1] Two Americans Mr. and Mrs. Gilbert Hirsch—good friends—who know my personality rather well—I knew them first in Paris.

I wish you were here to see the show—the only thing that will be missing is that [?] that I am used to at 291. There will be all kinds of press people there—*Holländisch,* Hungarian—Swedish, American—various writers actors etc. If the <u>other</u> phase of things takes care of itself I will be all right until January—if not I shall have to get to N.Y. as soon as possible. I look forward to that too—and yet I dread it in a way—dread hearing so much that is disagreeable against my friends and the country I love to be in—talk is always so fashionable in N.Y. as you know. I think of you often and wonder how you stand so much that is unpleasant.

However—this is only to say *guten Morgen* across the water. I will send you what reports of the show that come in—please watch out and keep anything you get or find in the American papers—I need to keep a collection of these things.

Best wishes as always to you, to Mrs. S., Kitty and all others—Steichen—De Zayas, Marin, Zoler—all that I know—Demuth also. I shall be glad to see once more all these friends.

As always,
Marsden Hartley

1. The article is unidentified.

⌐

November 8, 1915
Berlin

My dear Stieglitz,

Four days ago I posted you a long letter which relieved me very much in my mind for I have long wanted to get at it—this morning it comes back—as only two sheets are allowed from the censors point of view and I didn't know it applied to Amerika.[1] So I hurry up now to get at least a word to you to say my exhibition has been very interesting from all points of view—considering war time—no sales of course as would be expected

for reasons subtle it may be but mostly I fancy because the art viewpoint is too new. They are really only getting Cubism into their system and now here is someone revolting and swinging back to caveman expression.

However—owing to a most vulgar and unkind article in one paper here—the gallery has asked me to continue my show another week—it was to finish yesterday, but now next Saturday.[2] You see there is much that I want to tell you but there is no use starting—enough to tell you that I expect to sail to New York Dec. 11th on the "S.S. Rotterdam" and I hope the pictures will get on the same boat with me—they will be shipped through the Am. Ex. Co. to the Photo-Secession and you can if you will make plans for my show early in February as before. It is all terribly close cutting—thin skating—getting over but it will go all right somehow—only because it must.[3]

I shall be glad to see you all—and I know I shall be glad to get back to Berlin again. It is singular that I have my artistic and personal peace here—but it is so and I shall live here some time I fancy. I must make business plans somehow for the same freedom I have had as it has proven the only way for me. You will see a great advance personally and aesthetically. I will bring criticisms with me along with several letters from private individuals which are most appreciative—the criticism not of course—as usual.

My best wishes to you all—and you can look for me on the *Rotterdam* a few days before Christmas—it will be a happy one for me in many ways. Love and best wishes to all my friends. Telephone to Miss Meltzer if you can as she wanted to know when I come, or perhaps she will be in to see you before I sail. Heartiest greetings to you and all.

As always,
Marsden Hartley

I am invited to exhibit in Buda-Pesth in the Spring. Don't send any more drafts—that is after now—as in Dec. I shall be there myself. You have of course sent one for Nov.

1. There is a return receipt in the Stieglitz archives proving that Hartley's letter was in fact returned; however, Hartley apparently did not keep the letter, nor did he resend it, because this shorter version replaces his longer letter that had been returned.
2. This article was probably "A New American Misfit Genius" in the *Lokal-Anseiger* as quoted in "American Artist Astounds Germans," *The New York Times,* December 19, 1915, 4.
3. Due to shipping problems associated with the war, Hartley's paintings did not arrive until late March 1916, forcing his exhibition at 291 to open the following month. *Exhibition of Paintings by Marsden Hartley* (April 4–May 22, 1916) displayed forty oil paintings from Berlin and some works recently completed upon his return to New York.

# Appendix One

*Excerpt of letter from Gertrude Stein to Alfred Stieglitz as quoted in Donald Gallup, "The Weaving of a Pattern: Marsden Hartley and Gertrude Stein," Magazine of Art 41 (November 1948): 259. The original letter is in the Collection of American Literature at the Beinecke Rare Book and Manuscript Library, Yale University.*

In his painting he has done what in Kandinsky is only a direction. Hartley has really done it. He has used color to express a picture and he has done it so completely that while there is nothing mystic or strange about his production it is genuinely transcendent. Each canvas is a thing in itself and contained within itself, and the accomplishment of it is quite extraordinarily complete. There is another quality in his work which is very striking and that is the lack of fatigue or monotony that one gets in looking at his things. In some way he has managed to keep your attention freshened and as you look you keep on being freshened. There is not motion but there is an absence of the stillness that even in the big men often leads to non-existence. . . .

He seems to me to be entirely on the right tack. He is the only one working in color, that is considering the color as more dominant than line, who is really attempting to create an entity in a picture which is not a copy of light. He deals with his color as actually as Picasso deals with his forms. In this respect he is working in a very different way from the neo-impressionists Delaunay etc. who following out Van Gogh and Matisse are really producing a disguised but poverty stricken realism; the realism of form having been taken away from them they have solaced themselves with the realism of light. Hartley has not done this; he deals with color as a medium for creation and he is doing it really. . . .

# Appendix Two

*Gertrude's Stein foreword for Hartley's exhibition at 291 in January 1914 as reproduced in Camera Work 45 (January 1914, published June 1914): 17–18.*

### FROM A PLAY BY GERTRUDE STEIN

#### MARSDEN HARTLEY

A cook. A cook can see. Pointedly in uniform, exertion in a medium. A cook can see.

Clark which is awful, clark which is shameful, clark and order.

A pin is a plump point and pecking and combined and more much more is in fine.

Rats is, rats is oaken, robber. Height, age, miles, plaster, peddle, more order.

Bake, a barn has cause and more late oak-cake specially.

Spend rubber, holder and coal, high, careful, in a pointed collar. A hideous southwest is always a climb in aged seldom succeeded flavoring untimely, necessity white, hour in a blaze.

Break, sky blue light, obliquely, in a cut carpet, in the pack. A sound.

#### MARSDEN HARTLEY

No noon back. No noon settler, no sun in the slant and carpet utterly surrounded.

No pressed plaster. None.

No pressing pan and pan cake. Not related exactly. Not related.

Matter in the center of single sand and slide in the hut.

No account of gibberish. No skylark utterly.

Perfect lemon and cutting a central black. Not such clouding. A sugar, a lame sugar, certainly. No sobriety no silver as tray.

A co-existence with hard suckling and spoons, and spoons. A co-existence with orange supper. A last mending. A begging. Should the assault be exterminated, should it.

MARSDEN HARTLEY

A sound is in the best society. It hums and moves, it throws the hat in no way away and in no way particularly at paving. The meanness is selection of parts and all of that is no more a handkerchief merely and large.

POINTS

The exchange which is fanciful and righteous and mingled is in the author mostly in the piece.

Hunger is not hurry and a silence and no more than ever, it is not so exactly and the word used is there.

The soon estate and established alternately has bright soldiers and peaceable in the rest of the stretch.

Point, face, canvas, toy, struck off, sense or, weigh coach, soon beak on, so suck in, and an iron.

Shut the chamber in the door, so well and so weak and so buttered. Shut the chest out, do not shut it in.

A sun in shine, and a so and a so helped angle is the same as the whole right.

THE WEDDING

It is not for nothing that the row placed quantity without grinding. Furnishing is something, individual is pointed. Beetles, only aged sounds are hot, a can in ease and a sponge full a can in case and a wax well come, a can, a single hole, a wild suggesting wood, a half carpet and a pillow, a pillow increasing, a shirt in a cloud, a dirty distress, a thing grey, a thing thin, a long shout, a wonder, an over piece of cool oil, a sugar can, a shut open accident, a result in a feat, a copper, any copper. A cape coat, in bold shutters, in bold shutters shutting and not changing shutters not changing climaxes and peelings and hold over the switch, the binding of a pet and a revolver, the chosen loan, the owned cake in pieces the way to swim.

# Appendix Three

"WHAT IS '291?'"
Camera Work 47 (*July* 1914, *published January* 1915): 35–36.

Gertrude Stein once asked me that question. I told her as best I could, but I do not remember telling her adequately. Since that she has learned herself more of its character and personality, for it has served her in quite a similar way it has served so many of us who but for its interests and faith might have continued unnoticed way out of time. When I think of what America has been with "291" I am thinking how strange it would have been without it. It stands unique—by itself. There is nothing anywhere—not in Europe even—that is the equivalent of it. In Germany here there is, of course, the Blaue Reiter which has for its object quite the same end, otherwise there is nothing— not London, not Paris—and I am definitely certain not any other public beside the American in general or the New Yorker in particular knows of such an institution if this it may be called—as "291."

It is difficult to know what the insider can say of "291," for if he speak at all he is in danger of being—carefully putting it—over interested. We know how often it has been denounced as ridiculous, how for long it was considered by some as merely a pose—a kind of aesthetic affectation. It can now be seen after lapses of time and experience and direct contact with it that it no longer appears to any one as that ridiculous, and that, through a fairer increase of tolerance and understanding many who once denounced are now paying tribute more creditably. How it has dispensed with and made absurd that feeble notion of the old gallery and dealer, by exposing at once those who have appeared over its horizon as showing if not completely, at least fragmentary signs of genuineness of talent or it might be genius, and in nearly every instance, how fair has been its eyesight, its judgment and how unfailing its desire to be so. It has been and still is a kind of many headed creature standing firm for every variety of truth and every variety of expression of the same. It has insisted since its birth and to its end is certain to insist on that one essential, the tabooed "sincerity." It has paid severe toll for this ideal, precisely as any ideal pays heavily for the pursuance of its desires, but it has survived all vicissitude, and the survival is splendid. It has come of age and has shown intelligence from the day of its birth. It has doubtless committed many of the so-called errors of youth and frailty, but if there have been errors there has been likewise life

and earnestness in them. I do not as I say know what any one can say about "291." Those who know it with real intimacy speak seldomly about it actually, though often of it, naturally. It is gratifying enough that there is now at least some degree of spiritual sustenance achieved in the full faith of those who know it well on that side of the ocean and of the pleasure that is expressed in the knowledge of its work on this side. It is known in all quarters as a factor in the development of modern art; it has literally contributed to the vigorous growth of that. It has served the ideal and served it without qualification other than the one of earnestness of purpose. Those who have not known it intimately or well have from time to time with delight indulged in petty blasphemy or in a fiercer scorn with here and there an incredible contempt. It may be this has all been justified just as the praises of it are with certainty more justified. It has served its purpose wherever and when it has been privileged to do so, and regretted when it has been denied. It has created and fulfilled its unique and specialized function, that of bringing to the view fairly and without ostent and as completely as conditions have allowed, the artistic searchings of individuals and through its generosity and faith has brought freely before a fairly curious public, the work of artists in various fields of expression who have by reason of this originality for long been excommunicated from the main body both in America and in Europe.

I should like to have intimated more adequately just what "291" means, has meant all along its career and will continue as long as it survives. If I have even insinuated even so vaguely what it has meant to the insider who has found it to be his artistic savior, I shall perhaps have said something of it. It can only, I think, be really intimated what this number has meant to that place in the universe. It can be said, however, that there will always be a strange and invaluable significance in this "291." It has in any event served the mystical purpose of establishing fair values in place of unfair; of pure appreciation in place of contempt, and with regard to itself especially, a genuine faith in place of suspicion too long alert and attentive. It has too well proved at this time its purpose and its efficiency and its readiness to serve where it finds service possible, has long since become one of the little miracles of our day. A pure instrument is certainly sure to give forth pure sound, so has this instrument of "291" kept itself as pure as possible that it might thereby give out pure expression. I think never has a body of individuals—large or small—kept its head more clear, or its hands and feet freer of the fetter of personal gain or group malice than has this "291" body. It has come well of age and its maturity is gratifying. Certainly to the insider and certainly it will sooner or later certify itself in the minds of everyone who has had or will have even so great or even so slight an interest in progressive modern tendencies toward individual expression. This is certainly what "291" is.

<div style="text-align: right">

Marsden Hartley
Berlin, July 4, 1914

</div>

# Appendix Four

*Hartley's statement for his exhibition at Münchener Graphik-Verlag in Berlin as quoted in "American Artist Astounds Germany,"* The New York Times, *December 19, 1915, 4*

"Pictures that I exhibit are without titles and without description. They describe themselves. They are characterizations of the 'Moment,' everyday pictures, of every day, every hour. I am free from all conventional aesthetics, and leave every artist his. Art is or it is not, just as every artist is or is not. What he desires to represent and express is of no great importance, excepting only if he desires to represent ideas that are not personal with him. The reigning tendency of every modern movement is against individuality. With this strongly marked individuals have nothing to do. They have enough to do to create according to their own conceptions of nature, of life, of aesthetics. Art means a sad and sorry fight against conventional ideas. But somehow she manages to go her way in peace. She waits only for visionary individuals, intellectual, spiritual, but in any case soulfully visionary ones. Appearance is to be imitated, reality never."

# Biographical Index

FRA ANGELICO (ca. 1400–1455) was an Italian painter of the early Renaissance.

HAROLD BAUER (1873–1951) was a pianist born in England.

MARION BECKETT, an American painter, moved between the Stieglitz and Steichen circles in New York and Paris, respectively.

BERNARD BERENSON (1865–1959) was a respected art historian of Renaissance painting.

HENRI BERGSON (1859–1941), a French philosopher and writer, championed theories on evolution of mankind based on creativity, ideas embraced by the modernists.

WILLIAM BLAKE (1757–1827) was an English writer, painter, illustrator and printmaker.

LILLIE BLISS (1864–1931), an American patron of modern art, developed a close friendship with Arthur B. Davies who assisted her with building a significant collection of work by the avant-garde.

ALBERT BLOCH (1882–1961), an American artist, worked in Munich and was associated with Kandinsky and his group. He exhibited with the Blaue Reiter artists.

UMBERTO BOCCIONI (1882–1916) was an Italian Futurist painter and sculptor. In 1912 he wrote *Technical Manifesto of Futurist Sculpture*.

ARNOLD BÖCKLIN (1827–1901), a Swiss painter, is recognized for his classical landscapes and mythological subjects.

JACOB BOEHME (1575–1624), German mystic.

PIERRE BONNARD (1867–1947), a French painter and photographer, was associated with the Nabis group of painters in France.

ÉMILE-ANTOINE BOURDELLE (1861–1929), was a French sculptor and painter.

ALBERT BOURSAULT was a photographer and colleague of Stieglitz.

FLORENCE BRADLEY was an actress and friend of Mabel Dodge.

GEORGES BRAQUE (1882–1963), a French painter, developed a formal style of Cubism with Picasso, and was supported by the dealer Daniel-Henry Kahnweiler in Paris.

FORD MADOX BROWN (1821–1893), an English painter, was closely associated with the Pre-Raphaelite painters.

PATRICK HENRY BRUCE (1881–1936) was an American painter living in Europe. He exhibited with the Synchromists.

FRANCIS BRUGUIÈRE (1879–1945) was an American photographer.

RICHARD MAURICE BUCKE (1837–1902), a Canadian psychiatrist and medical doctor, wrote *Cosmic Consciousness: A Study in the Evolution of the Human Mind* in 1901, which proposed that individuals continually seek higher levels of awareness in order to contend with problems in life.

NINA BULL was a friend of Mabel Dodge.

HEINRICH CAMPENDONK (1889–1957), a German artist, exhibited with the Blaue Reiter.

ARTHUR B. CARLES (1882–1952), an American painter following the tradition of Matisse and Cézanne, exhibited with the circle of artists at 291.

MARY CASSATT (1844–1926), an American painter, lived in Paris most of her life and exhibited with the Impressionists.

PAUL CASSIRER (1871–1926) was a dealer and publisher of modern art and champion of the German avant-garde.

JEAN CHARLES CAZIN (1841–1901), a French painter, was an academic painter of biblical scenes, somber landscapes and genre settings.

PAUL CÉZANNE (1839–1906), a French Post-Impressionist artist, significantly influenced many modern painters including the Cubists.

MARC CHAGALL (1887–1985), a Russian-born painter living in Paris, was included in the salons in Paris and exhibited in Germany.

CHARLES COTTET (1863–1925) was a French painter of traditional genre scenes and landscapes.

HENRI CROSS (1856–1910), a French painter and printmaker, followed the Neo-Impressionist style of Paul Signac and Georges Seurat.

CHARLES DANIEL (1878–1971) was the owner of the Daniel Gallery. He supported many emerging American painters.

ANDREW DASBURG (1887–1979), a French-born American painter, studied with the urban realist Robert Henri and was a minor figure in the Synchromist movement.

JO DAVIDSON (1883–1952), an American sculptor, was known for his portrait busts.

ARTHUR B. DAVIES (1862–1928) was an American painter and member of the urban realists group, The Eight. He was the President of the Association of American Painters and Sculptors and organizer of the Armory Show.

CLAUDE DEBUSSY (1862–1918), a French composer, incorporated many ideas of the Impressionists and Symbolists into his compositions.

EDGAR DEGAS (1834–1917) was a French Impressionist painter, printmaker, draughtsman, photographer and sculptor.

ROBERT DELAUNAY (1885–1941), a French painter, originally exhibited with the Salon Cubists, but later developed his own style of color abstraction called Orphism.

SONIA DELAUNAY (1885–1979), a Ukrainian artist, was the wife of Robert Delaunay. She applied the highly abstract Orphist style to textiles, book-bindings, and furnishings. Prior to Delaunay, she was married to Wilhelm Uhde.

CHARLES DEMUTH (1883–1935), an American painter, illustrator and poet, became closely associated with the Stieglitz circle.

ANDRÉ DERAIN (1880–1954), a Fauve painter, worked closely with Matisse.

LÉON DIERX (1838–1912) was a French Poet.

MAX DIETZEL, a German dealer, owned Neue Kunstsalon in Munich.

MABEL DODGE (LUHAN) (1879–1962) was an American writer, patron and socialite.

KEES VAN DONGEN (1877–1968) was a Fauve painter from Holland.

ARTHUR DOVE (1880–1946) was an American painter and member of the 291 circle.

EMILE DRUET exhibited modern art in Paris.

MARCEL DUCHAMP (1887–1968), a French artist and writer, originally associated with the Salon Cubists. He subsequently was a major figure in the Dada movement in New York.

CHARLES DUNCAN (1892–?), an American artist and poet, earned his living as a sign painter.

JOHANNES (MEISTER) ECKHARDT (ca. 1260–1327) was a German writer, philosopher and mystic.

ARTHUR JEROME EDDY (1859–1920) was a writer and collector of modern art. He purchased works from the Armory show, and in 1914 wrote *Cubists and Post-Impressionism*.

RALPH WALDO EMERSON (1803–1882) was an American poet, philosopher and Transcendentalist writer.

GEORGIA S. "BABY" ENGELHARD (1906–?) was Stieglitz's niece, daughter of his sister Agnes.

JACOB EPSTEIN (1880–1959), an American-born British sculptor, was associated with the Vorticists in London and contributed to their short-lived periodical, *Blast*.

ADOLF ERBSLÖH (1881–1947), a painter, was born in New York City but raised in Germany, and was a member of the New Artists' Association in Munich with Kandinsky, which dissolved in 1911.

FRANK EUGENE (1865–1936), an American photographer and painter trained in Germany, was an original member of Stieglitz's Photo-Secession.

DONALD EVANS (1885–1921) was an American journalist, publisher and *ver libre* poet.

LYONEL FEININGER (1871–1956), a French painter, associated with the Salon Cubists.

JOHN DUNCAN FERGUSSON (1874–1961) was a Scottish painter and publisher.

ANSELM FEUERBACH (1829–1880) was a German painter and draughtsman known for his traditional historic scenes and landscapes.

JULES FLANDRIN (1871–1947), a French painter and draughtsman, studied under Gustav Moreau at the École des Beaux-Arts in Paris.

JOHN FLAXMAN (1755–1826) was an English sculptor and illustrator.

JEAN-LOUIS FORAIN (1852–1931), a French painter, caricaturist and graphic artist, exhibited with the Impressionists.

PAUL FORT (1872–1960) was a leading Symbolist poet and writer.

KARL VON FREYBURG (1889/90–1914) was a German officer and cousin of Arnold Rönnebeck.

FRIEDRICH DER GROSSE (1712–1786) reigned as King of Prussia from 1740 to 1786.

OTHON FRIESZ (1879–1949), a French painter, worked under the influence of Matisse and the group of Fauve artists.

ALFRED J. FRUEH (1880–1968) was an American artist and cartoonist.

ROGER FRY (1866–1934), an English painter and critic, played an influential role in introducing artistic developments in England.

JOHN GALSWORTHY (1867–1933) was a British novelist and playwright.

PAUL GAUGUIN (1848–1903) was a French Post-Impressionist artist.

STEFAN GEORGE (1868–1933) was a German Symbolist poet.

GIOTTO DI BONDONE (ca. 1267–1337) was an important pre-Renaissance Italian painter.

WILLIAM GLACKENS (1870–1938) was an American painter and member of the urban realist artists, the Eight.

ALBERT GLEIZES (1881–1953) a French painter and important Salon Cubist, wrote *Du Cubisme* with Jean Metzinger in 1912.

VINCENT VAN GOGH (1853–1890), a Post-Impressionist painter of Dutch birth, was highly influential to the modern artists with his expressive technique and color.

HANS GOLTZ (1873–1927), a German dealer, owned Galerie Goltz in Munich and showed the work of the Blaue Reiter.

EL GRECO (1541–1614), a Greek artist, was a student of Titian and later worked in a Mannerist style. His highly personal and unique style, incorporating expressive use of color and line and evoking strong mystical qualities, was admired by the moderns.

JUAN GRIS (1887–1927), a Spanish painter, lived in Paris and painted in the style of Cubism.

ALBERT GROLL (1866–1952) was an American landscape painter.

OTTO HAAS-HEYE, a German dealer, publisher and designer of women's clothing, owned the gallery Münchener-Graphik Verlag in Berlin.

SAMUEL HALPERT (1884–1930) was a Russian-born American painter and member of the 291 circle.

HUTCHINS HAPGOOD (1869–1944) was an American journalist and writer.

ALANSON HARTPENCE (1883–1946), a writer and poet, was the director of the Daniel Gallery in New York.

LOUISINE HAVENMEYER (1855–1929), an American collector and patron, along with her husband, amassed an important collection of modern French artists. She eventually owned eleven canvases by Cézanne.

FRANK BURTY HAVILAND (1886–1971) was a French painter and photographer living in Paris. The brother of Paul Haviland, he was a significant conduit between the Stieglitz milieu and the French moderns.

PAUL HAVILAND (1850–1950) was the French head in America of the Limoges porcelain company which his family owned. He was an associate editor for *Camera Work*.

AUGUSTE HERBIN (1882–1960), a French painter, experimented with Cubism.

FERDINAND HODLER (1853–1918) was a Swiss painter.

ARTHUR HOEBER (1854–1915) was a New York art critic and landscape painter.

FRIEDEL HUF (1888–1970) was a Swiss sculptor, worked in Berlin and was associated with artists of Der Sturm.

WILLIAM JAMES (1842–1901) was an American philosopher, psychologist and writer. He was the brother of writer Henry James.

ALEXEI VON JAWLENSKY (1864–1941), a Russian painter, exhibited with the German moderns in Berlin, Munich and Cologne.

AUGUSTUS JOHN (1878–1961) was a British painter, a member of the Camden Town Group in London, and regularly exhibited at the New English Art Club.

ROBERT EDMOND JONES (1887–1954) was an American student of theater who studied in Berlin. He later returned to America for a notable career in New York theater.

FRANCIS JOURDAIN (1876–1958), a French painter, associated with the Nabis artists Pierre Bonnard and Édouard Vuillard.

DANIEL-HENRY KAHNWEILER (1884–1979), a Parisian art dealer from Mannheim, Germany, was a significant supporter of Cubism. He was the exclusive dealer of work by Picasso, Braque, Gris and Léger.

WASSILY KANDINSKY (1866–1944), a Russian-born artist and writer, published the influential treatise on art, *Über das Geistige in der Kunst,* in 1912. Along with Franz Marc, he founded the artist group and periodical, the Blaue Reiter.

ALEXANDER KANOLDT (1881–1939), a German artist, exhibited with members of the Blaue Reiter.

DORIS KEANE was an American actress.

JOSEPH TURNER KEILEY (1869–1914) was a lawyer, photographer and a close friend of Stieglitz. He was an associate editor for *Camera Work.*

ROCKWELL KENT (1882–1971) was an American painter, writer and illustrator.

JOHN BARRETT KERFOOT, a New York literary critic, served as an associate editor for *Camera Work.*

PAUL KLEE (1879–1940), a Swiss painter, associated with Kandinsky and exhibited with the Blaue Reiter.

BERNARD KOEHLER (1849–1927), a wealthy German industrialist from Berlin, was a collector and patron of modern art, particularly of work by Kandinsky and his circle.

OSCAR KOKOSCHKA (1886–1980) was an Austrian painter and graphic artist.

WALT KUHN (1877–1949), an American painter, assisted Davies with organizing the Armory Show.

FRANTIŠEK (FRANÇOIS) KUPKA (1871–1957), a Czech artist, was a leading Orphist painter.

SIEGFRIED LANG (1887–1970) was a Swiss poet.

JOHN NILSEN LAURVIK (?–1953), a Norwegian-born photographer, writer and critic of modern art, published *Is it Art? Post-Impressionism, Futurism, Cubism* (1913) which was available at the Armory Show.

STEPHEN LAWRENCE, a decorator, shared the fourth floor with Stieglitz's gallery, 291.

ERNST LAWSON (1873–1939) was an American painter and member of the urban realist group, The Eight.

HENRI LE FAUCONNIER (1881–1946), a French artist, exhibited with the Salon Cubists

FERNAND LÉGER (1881–1955), a French painter, initially exhibited semi-abstract paintings with the Salon Cubists. He was eventually supported under exclusive contract with Kahnweiler.

WILHELM LEIBL (1844–1900), a German painter, followed a traditional style of painting landscapes and peasant scenes.

MAX LIEBERMANN (1847–1935), a German artist, founded the Berlin Secession in 1898 and was a leading member until 1911.

WALTER LIPPMANN (1889–1974), was a journalist and political writer.

LORENZO DI CREDI (ca. 1459–1536) was an Italian painter and draughtsman who studied under Leonardo da Vinci.

JEAN LORRAIN, (1855–1906) was a French writer.

AUGUST MACKE (1887–1914), a German artist, showed with members of the Blaue Reiter. His wife's uncle was Bernard Koehler.

DODGE MACKNIGHT (1860–1950) was an American painter.

MAURICE MAETERLINCK (1862–1949), a Belgian poet and playwright, was a leading figure in the Symbolist movement in Paris and was respected by the moderns for connecting the natural and psychological worlds.

ARISTIDE MAILLOL (1861–1944) was a French sculptor and painter.

STÉPHANE MALLARMÉ (1842–1898) was a French poet and leader of the Symbolist movement.

ÉDOUARD MANET (1832–1883) was a French painter.

HENRI MANGUIN (1874–1943) was a Fauve painter.

EDWARD MIDDLETON MANIGAULT (1889–1922), an American painter, exhibited at the Daniel Gallery.

MANOLO (MANUEL MARTÍNEZ HUGUÉ) (1872–1945) was a Spanish sculptor.

RICHARD MANSFIELD (1857–1907) was an American actor of the Romance stage.

FRANZ MARC (1880–1916), a German painter, was a founding member along with Kandinsky of the Blaue Reiter.

JOHN MARIN (1870–1953) was an American painter and member of the Stieglitz circle.

FILIPPO TOMMASO MARINETTI (1876–1944), an Italian painter and writer, was a leading figure in the Italian Futurist movement. As an homage to the modern age of machinery and technology, he published his Futurist Manifesto on the front page of *Le Figaro* in 1909.

HENRI MATISSE (1869–1954), a French painter and sculptor, was the leader of the Fauvist painters, or "Wild Beasts."

ALFRED MAURER (1868–1932) was an American artist associated with the 291 circle.

JULIUS MEIER-GRAEFE (1867–1935) was a German art critic, publisher and art historian of 19th-century French painting.

CHARLES HENRY MELTZER was an art critic.

JEAN METZINGER (1883–1956), a French painter, associated with the Salon Cubists and showed in the Cubist exhibition of the Section d'Or in 1912. That year he also wrote *Du Cubisme* with Albert Gleizes.

EUGENE MEYER AND AGNES ERNST MEYER (1887–1970) were American collectors and significant patrons of 291.

JOHN EVERETT MILLAIS (1829–1896) was a Pre-Raphaelite painter from England.

KENNETH HAYES MILLER (1876–1952) was an American painter and art teacher in New York.

PHILLIP MOELLER was an American artist.

CLAUDE MONET (1840–1926) was the pre-eminent French Impressionist painter.

ADOLPHE MONTICELLI (1824–1886) was a French painter.

NEWMAN E. MONTROSS, an American art dealer, had a gallery in New York at 550 Fifth Avenue.

GUSTAVE MOREAU (1826–1898), a French painter, was a progressive instructor at the École des Beaux Arts.

BERTHE MORISOT (1841–1895) was a French Impressionist painter.

EDVARD MUNCH (1863–1944) was a Norwegian artist whose work foreshadowed Expressionism.

GABRIELE MÜNTER (1877–1962), a German painter, was the companion of Kandinsky and a member of the Blaue Reiter.

ELIE NADELMAN (1882–1946), a Polish-born sculptor, lived in Paris between 1904 and 1914 and settled in the United States after World War I.

LOUISE NORTON (1890–1990) was a poet and columnist.

NOVALIS (FRIEDRICH LEOPOLD HARDENBERG) (1772–1801) was a German poet.

JOSEPH OBERMEYER (1862?–1943), a long-time friend of Stieglitz, was the older brother of Emmeline Obermeyer, Stieglitz's wife.

CARL ERNST OSTHAUS (1874–1921) was a German collector of modern art and founder of the Folkwang Museum, Hagen.

WALTER PACH (1883–1958), an American painter, was the European liaison for the organizers of the Armory Show.

AUGUSTE PELLERIN (1852–1929) was a French collector, particularly of paintings by Paul Cézanne.

FRANCIS PICABIA (1879–1953), a Cuban-born Parisian artist and writer, associated with the Salon Cubists in Paris and was a significant figure in the Dada movement.

PABLO PICASSO (1881–1973), a Spanish painter, pioneered along with Georges Braque the influential style of Cubism.

PIERO DELLA FRANCESCA (1415–1492) was an Italian Renaissance painter.

EDGAR ALLAN POE (1809–1849) was an American writer of poetry and prose.

EZRA POUND (1885–1972), an American poet, was associated with the Vorticist movement in London.

MAURICE PRENDERGAST (1858–1924), an American painter, exhibited with the urban realist group, The Eight.

JOHN QUINN (1870–1924), a prominent New York lawyer, was a patron of and advocate for modern art. He partially financed the Armory Show and bought several works from the exhibition.

MARIE RAPP (1892/93–?) was Stieglitz's secretary at 291 and long-time friend.

ODILON REDON (1840–1916), a French draughtsman, printmaker and painter, was a master colorist known for his magical and sensual still lifes.

HENRI DE RÉGNIER (1864–1936) was a French Symbolist poet of the circle of Stéphane Mallarmé.

MAX REINHARDT (1873–1943) was an Austrian theater director who used non-traditional stage design for his productions.

ERNST REINMANN was a German writer.

PIERRE-AUGUSTE RENOIR (1841–1919) was a French Impressionist painter.

KATHARINE NASH RHOADES (1885–1965), an American painter and poet, was a member of the Stieglitz and Steichen circles in New York and Paris.

ANNE ESTELLE RICE (1879–1959) was an American artist.

PIERRE-AUGUSTE RODIN (1840–1917) was a French sculptor and draughtsman.

ARNOLD RÖNNEBECK (1885–1947) was a German sculptor and son of a professor of architecture. Rönnebeck eventually came to the United States in 1923 and became a professor of sculpture at the University of Denver, then the director of the Denver Art Museum.

DANTE GABRIEL ROSSETTI (1828–1882) was an English poet and painter.

HENRI ROUSSEAU (1844–1910), a French painter, was favored by the modernists and surrealist painters of Europe and America. He was considered a great naïve painter because of his sensitive, exotic, mystical and dreamlike scenes of landscapes and animals.

KER-XAVIER ROUSSEL (1867–1944), a French painter, associated with the group of Nabis artists.

WALTER RUMMEL (1887–1953) was a German composer.

MORGAN RUSSELL (1886–1953), an American painter, founded the movement Synchromism with Stanton Macdonald-Wright.

JAN VAN RUYSBROECK (1293–1381) was a Flemish mystic.

CLOVIS SAGOT (1854–1913) was a French dealer of books and paintings.

EGON SCHIELE (1890–1918) was an Austrian painter with a highly distinctive and expressionistic style.

ARNOLD SCHOENBERG (1874–1951), an Austrian composer and theorist, strongly influenced Kandinsky and the Blaue Reiter with his musical compositions.

EDUARD SCHURÉ (1841–1929) was an occultist writer.

GEORGES SEURAT (1859–1891), a French painter, was a leading figure of the Neo-Impressionists.

PAUL SIGNAC (1863–1935) was a French Neo-Impressionist.

ANGELUS SILESIUS (1624–1677) was a German mystic philosopher and poet.

LEE SIMONSON (1888–1967), an American artist and stage designer, played a minor role in the Synchromist movement of the Macdonald-Wright–Russell clique.

EDUARD STEICHEN (1879–1973), an American painter and photographer, was a founding member of the Photo-Secessionists and played a major role with introducing modern art to Stieglitz and 291.

GERTRUDE STEIN (1874–1946) was an American writer and collector of modern art. She lived in Paris with her brother Leo Stein and companion Alice B. Toklas at 27 rue de Fleurus.

LEO STEIN (1872–1947), an American collector and early patron of modern art. He was the older brother of Getrude Stein.

RUDOLF STEINER (1861–1925) was an Austrian philosopher and scientist.

EMMELINE OBERMEYER STIEGLITZ (1873–1953) was the wife of Alfred Stieglitz until their divorce in 1924.

KATHERINE "KITTY" STIEGLITZ (1898–1971) was the daughter of Alfred and Emmeline Stieglitz.

MAX STIRNER (1806–1856) was a German writer.

KATE STRAUSS was a friend of Hartley's from Maine.

HEINRICH SUSO (ca. 1295–1366) was a German mystic and writer.

EMANUEL SWEDENBORG (1688–1772) was a Swedish scientist, mystic and philosopher.

JOHANN TAULER (ca. 1300–1361) was a German philosopher and mystic.

HEINRICH THANNHAUSER owned a gallery in Munich and was an early dealer of the German avant-garde.

FRANCIS THOMPSON (1859–1907) was an English poet whose works often included spiritual and religious themes.

ALICE B. TOKLAS (1877–1967) was an American writer, companion and secretary of Gertrude Stein.

HENRI DE TOULOUSE-LAUTREC (1864–1901), a French Post-Impressionist, depicted café scenes and dancehalls in late 19th-century Paris.

WILHELM TRÜBNER (1851–1917), a German painter, was a founding member of the German Secessionist movement in Munich in the 1890s.

SERGEI TSCHOUKIND (SHCHUKIN) (1851–1936), a wealthy Russian importer, aggressively collected paintings of the Fauves, particularly Matisse, who painted two large panels for his palace in Moscow. In 1918, the palace was nationalized as a museum of modern Western art.

JOSEPH M. W. TURNER (1775–1851) was an English painter known for his landscapes and exceptional watercolors.

PAOLO UCCELLO (1397–1475), an Italian Renaissance painter, incorporated his fascination with perspective in his works.

WILHELM UHDE (1874–1947) was a writer, collector and dealer of modern art.

FRITZ VANDERPYL (1876–?) a French critic and poet, was part of the circle of the Fauve painters.

FRANCIS VIELÉ-GRIFFIN (1864–1937), an American-born French Symbolist poet, was a pioneer in the style of *vers libre*.

AMBROISE VOLLARD (1867–1939) was a dealer of modern art in Paris, especially in work by Cézanne and Renoir.

ÉDOUARD VUILLARD (1868–1940) was the leader of the French Nabis painters.

HERWATH WALDEN (BORN GEORG LEVIN) (1879–1941), a German writer, composer, critic and impresario, founded the periodical and gallery Der Sturm, which supported the European avant-garde.

ABRAHAM WALKOWITZ (1878–1965) was an American artist of Russian birth and member of the Stieglitz circle.

FREDERICK GEORGE WATTS (1817–1904), an English painter, worked in the style of the Pre-Raphaelites.

MAX WEBER (1881–1961) was an American painter of Russian birth.

FRANZ WEDEKIND (1864–1918), a German playwright, founded a cabaret called the Eleven Executioners in Munich and was a leading figure in the German modernist movement.

H.G. WELLS (1866–1946), an English novelist, was an early writer of science fiction with a focus on technology and its sociological consequences for the future.

MARIANNE VON WEREFKIN (1860–1938), a Russian painter, was active with the members of the Blaue Reiter.

JAMES ABBOTT MCNEIL WHISTLER (1834–1903), an American painter recognized for his portraits and landscapes.

WALT WHITMAN (1819–1892), an American poet and writer, was strongly influenced by the Transcendentalists and was an early writer of *vers libre*. His *Leaves of Grass* was published in 1855.

GERTRUDE VANDERBILT WHITNEY (1875–1942), an American patron and collector, provided support to selected American artists living and painting in Europe.

OSCAR WILDE (1854–1900) was an Irish-born poet and writer known for his commentary and wit.

KARL WOLFSKEHL (1869–1948), a German poet, was an intimate of Stefan George and part of his circle.

MARIUS DE ZAYAS (1880–1961), a caricaturist and writer from Veracruz, Mexico, was a member of the Stieglitz circle, exhibited at 291, and contributed to *Camera Work*. He was a founding editor, along with Paul Haviland, of the periodical *291*.

EMIL ZOLER was a young painter introduced to Stieglitz by Hartley in 1909. He assisted Stieglitz with installing and dismantling exhibitions at 291.

# Bibliography

Altshuler, Bruce. *The Avant-Garde in Exhibition: New Art in the 20th Century*. New York: Harry N. Abrams, 1994.

Apollinaire, Guillaume. *Apollinaire on Art: Essays and Reviews, 1902–1918*. Ed. Leroy C. Breunig, trans. Susan Suleiman. New York: Viking Press, 1972.

Assouline, Pierre. *An Artful Life: A Biography of D. H. Kahnweiler, 1884–1979*. Trans. Charles Ruas. New York: Fromm International Publishing Corporation, 1991.

Barr, Alfred H., Jr. *Matisse: His Art and His Public*. New York: The Museum of Modern Art, 1951.

Barry, Roxana. "The Age of Blood and Iron: Marsden Hartley in Berlin." *Arts Magazine* 54 (October 1979): 166–71.

Bentley, G. E. and Martin K. Nurmi. *A Blake Biography: Annotated Lists of Works, Studies and Blakeana*. Minneapolis: University of Minnesota Press, 1964.

Bilski, Emily D. et al. *Berlin Metropolis: Jews and the New Culture, 1890–1918*. Berkeley and Los Angeles: University of California Press in association with The Jewish Museum, 1999.

Brettell, Richard et al., *The Art of Paul Gauguin*. Washington, D.C.: National Gallery of Art in association with The Art Institute of Chicago, 1988.

Brown, Milton W. *The Story of the Armory Show*. 2d ed. New York: Abbeville Press, 1988.

Centre Georges Pompidou. *Robert Delaunay: 1906–1914, De l'Impressionnisme à l'Abstraction*. Paris: Centre Georges Pompidou, 1999.

Cooper, Douglas. *The Cubist Epoch*. New York: Phaidon Press in association with The Los Angeles County Museum of Art and The Metropolitan Museum of Art, 1971.

Cox, Neil. *Cubism*. London: Phaidon Press, 2000.

Craig, Gordon A. *Germany: 1866–1945*. New York: Oxford University Press, 1978.

Crunden, Robert M. *American Salons: Encounters with European Modernism, 1885–1917*. New York: Oxford University Press, 1993.

Eddy, Arthur Jerome. *Cubists and Post-Impressionism*. Chicago: A. C. McClurg and Co., 1914.

Eldredge, Charles C. "Nature Symbolized: American Painting from Ryder to Hartley." In *The Spiritual in Art: Abstract Painting, 1890–1985*. New York: Abbeville Press in association with The Los Angeles Museum of Art, 1986.

Ergang, Robert. *Europe since Waterloo*. 3d ed. Boston: D. C. Heath and Co., 1967.

Everdell, William R. *The First Moderns: Profiles in Origins of Twentieth-Century Thought*. Chicago: University of Chicago Press, 1997.

Fahlman, Betsy. *Arnold Rönnebeck, 1885–1947*. New York: Conner Rosenkranz, 1998.

Gallup, Donald. "The Weaving of a Pattern: Marsden Hartley and Gertrude Stein." *Magazine of Art* 41 (November 1948): 256–61.

_____, ed. *The Flowers of Friendship: Letters Written to Gertrude Stein*. New York: Alfred A. Knopf, 1953.

Gordon, Donald E. *Modern Art Exhibitions, 1900–1916*. 2 vols. Munich: Prestel-Verlag, 1974.

Green, Martin. *New York 1913: The Story of the Armory Show and the Paterson Strike Pageant*. New York: Charles Scribner's Sons, 1988.

Greenough, Sarah et al. *Modern Art and America: Alfred Stieglitz and His New York Galleries*. Washington, D.C.: National Gallery of Art in association with Bulfinch Press, 2000.

Hapgood, Hutchins. *A Victorian in the Modern World*. 1939. Reprint, with introduction by Robert Allen Skotheim. Seattle: University of Washington Press, 1967.

Hartley, Marsden. *On Art*. Ed. Gail R. Scott. New York: Horizon Press, 1982.

_____. *Somehow a Past: The Autobiography of Marsden Hartley*. Ed. Susan Elizabeth Ryan. Cambridge, Mass.: MIT Press, 1997.

Haskell, Barbara. *Marsden Hartley*. New York: Whitney Museum of American Art in association with New York University Press, 1980.

Heller, Reinhold. *Gabriele Münter: The Years of Expressionism, 1903–1920*. Munich: Prestel-Verlag, 1997.

Homer, William Innes. *Alfred Stieglitz and the American Avant-Garde*. Boston: New York Graphic Society, 1977.

_____, ed. *Heart's Gate: Letters Between Marsden Hartley and Horace Traubel, 1906–1915*. Highlands, N.C.: The Jargon Society, 1982.

Hyland, Douglas K. S. "Agnes Ernst Meyer, Patron of American Modernism." *American Art Journal* 12 (winter 1980): 64–81.

Kandinsky, Wassily. *Concerning the Spiritual in Art*. Trans. M. T. H. Sadler. New York: Dover Publications, 1977. Originally published in English as *The Art of Spiritual Harmony*. London: Constable and Company, 1914.

Kellner, Bruce, ed. *Letters of Charles Demuth: American Artist, 1883–1935*. Philadelphia: Temple University Press, 2000.

Kruty, Paul. "Arthur Jerome Eddy and His Collection: Prelude and Postscript to the Armory Show," *Arts Magazine* 61 (February 1987): 40–47.

Lankheit, Klaus, ed. *Wassily Kandinsky–Franz Marc Briefwechsel*. Munich: Piper Verlag, 1983.

Levin, Gail. "Wassily Kandinsky and the American Avant-Garde, 1912–1950." Ph.D. diss., Rutgers University, 1976.

_____. "Marsden Hartley, Kandinsky, and Der Blaue Reiter." *Arts Magazine* 52 (November 1977): 156–60.

_____. "Marsden Hartley and the European Avant-Garde." *Arts Magazine* 54 (September 1979): 158–63.

_____. "Hidden Symbolism in Marsden Hartley's Military Pictures." *Arts Magazine* 54 (October 1979): 154–58.

_____. "Marsden Hartley and Mysticism." *Arts Magazine* 60 (November 1985): 16–21.

Levin, Gail and Marianne Lorenz. *Theme and Improvisation: Kandinsky and the American Avant-Garde, 1912–1950*. Boston: Bulfinch Press, 1992.

Levine, Frederick S. *The Apocalyptic Vision: The Art of Franz Marc as German Expressionism*. New York: Harper and Row, 1979.

Lowe, Sue Davidson. *Stieglitz: A Memoir/Biography*. New York: Farrar Straus Giroux, 1983.

Ludington, Townsend. *Marsden Hartley: The Biography of an American Artist*. Boston: Little, Brown and Co., 1992.

_____. *Seeking the Spiritual: The Paintings of Marsden Hartley*. Ithaca: Cornell University Press in association with the Ackland Art Museum and Babcock Galleries, 1998.

McCausland, Elizabeth. "The Daniel Gallery and Modern American Art." *Magazine of Art* 44 (November 1951), 280–85.

_____. *Marsden Hartley*. Minneapolis: University of Minnesota Press, 1952.

McDonnell, Patricia. "'Dictated by Life': Spirituality in the Art of Marsden Hartley and Wassily Kandinsky, 1910–1915." *Archives of American Art Journal* 29 (1989): 27–34.

_____, ed. "Marsden Hartley's Letters to Franz Marc and Wassily Kandinsky, 1913–1914." *Archives of American Art Journal* 29 (1989): 35–44.

_____. "Representation in Early American Abstraction: Paradox in the Painting of Marsden Hartley, Stanton Macdonald-Wright and Morgan Russell." In *Over*

*Here: Modernism, The First Exile, 1914–1919.* Providence, R.I.: David Winton Bell Gallery, Brown University, 1989.

_____. *Dictated by Life: Marsden Hartley's German Paintings and Robert Indiana's Hartley Elegies.* Minneapolis: Frederick R. Weisman Art Museum, University of Minnesota, 1995.

_____. *Marsden Hartley: American Modern.* Minneapolis: Frederick R. Weisman Art Museum, University of Minnesota, 1997.

Mellow, James R. *Charmed Circle: Gertrude Stein and Company.* New York: Praeger, 1974.

Meyer, Agnes E. *Out of These Roots: The Autobiography of an American Woman.* Boston: Little, Brown and Co., 1953.

Morgan, Ann Lee, ed. *Dear Stieglitz, Dear Dove.* Newark: University of Delaware Press in association with Associated University Presses, 1988.

Niven, Penelope. *Steichen: A Biography.* New York: Clarkson N. Potter, 1997.

Norman, Dorothy. *Alfred Stieglitz: An American Seer.* New York: Aperture Foundations, 1960.

North, Percy. *Max Weber: The Cubist Decade, 1910–20.* Atlanta: High Museum of Art, 1991.

Paret, Peter. *The Berlin Secession: Modernism and Its Enemies in Imperial Germany.* Cambridge, Mass.: Belknap Press of Harvard University Press, 1980.

Phillips, Duncan. "Marsden Hartley." *Magazine of Art* 37 (March 1944): 82–87.

Pohlmann, Ulrich et al. *Frank Eugene: The Dream of Beauty.* Munich: Nazraeli Press in collaboration with Fotomuseum im Münchner Stadtmuseum, 1995.

Redon, Odilon. *To Myself.* Trans. Mira Jacob and Jeanne L. Wasserman. New York: George Braziller, 1986.

Reid, B. L. *The Man from New York: John Quinn and His Friends.* New York: Oxford University Press, 1968.

Rewald, John. "Odilon Redon." In *Odilon Redon, Gustave Moreau, Rodolphe Bresdin.* New York: Museum of Modern Art in collaboration with The Art Institute of Chicago, 1961.

_____. *Paul Cézanne, The Watercolors: A Catalogue Raisonné.* Boston: Little, Brown and Co., 1983.

_____. *Studies in Post-Impressionism.* New York: Harry N. Abrams, 1986.

_____. *Cézanne and America: Dealers, Collectors, Artists and Critics, 1891–1921.* Princeton: Princeton University Press, 1989.

Rewald, John, Walter Feilchenfeldt and Jayne Warman. *The Paintings of Paul Cézanne: A Catalogue Raisonné*. 2 vols. New York: Harry N. Abrams, 1996.

Risatti, Howard. "Music and the Development of Abstraction in America: The Decade Surrounding the Armory Show." *Art Journal* 39 (fall 1979): 8–13.

Robertson, Bruce. *Marsden Hartley*. New York: Harry N. Abrams in association with The National Museum of American Art, 1995.

Robinson, William H. "Marsden Hartley's *Military*." *The Bulletin of the Cleveland Museum of Art* 76 (January 1989): 2–26.

Rubin, William, ed. *Pablo Picasso: A Retrospective*. New York: Museum of Modern Art, 1980.

_____. *Picasso and Braque: Pioneering Cubism*. New York: Museum of Modern Art, 1989.

Ryan, Susan Elizabeth. "Elegy for an Exile." *Arts and Antiques* 8 (May 1991): 84–89, 106, 109.

Selz, Peter. *German Expressionist Painting*. 1957. Reprint, Berkeley and Los Angeles: University of California Press, 1974.

Scott, Gail R. *Marsden Hartley*. New York: Abbeville Press, 1988.

South, Will et al. *Color, Myth, and Music: Stanton Macdonald-Wirght and Synchromism*. Raleigh: North Carolina Museum of Art, 2001.

Spate, Virginia. *Orphism: The Evolution of Non-Figurative Painting in Paris 1910–1914*. Oxford: Clarendon Press, 1979.

Stansell Christine. *American Moderns: Bohemian New York and the Creation of a New Century*. New York: Metropolitan Books, 2000.

Stein, Gertrude. *Geography and Plays*. 1922. Reprint, New York: Something Else Press, 1968.

Tomkins, Calvin. *Marcel Duchamp: A Biography*. New York: Henry Holt and Co., 1996.

Turner, Elizabeth Hutton. *In the American Grain: Arthur Dove, Marsden Hartley, John Marin, Georgia O'Keeffe, and Alfred Stieglitz. The Stieglitz Circle at the Phillips Collection*. Washington, D.C.: Counterpoint in association with the Phillips Collection, 1995.

Walden, Nell, and Lothar Schreyer. *Der Sturm: Ein Erinnerungsbuch an Herwath Walden und die Künstler aus dem Sturmkreis*. Baden-Baden: Woldemar Klein Verlag, 1954.

Watson, Steven. *Strange Bedfellows: The First American Avant-Garde*. New York: Abbeville Press, 1991.

Weinberg, Jonathan. *Speaking for Vice: Homosexuality in the Art of Charles Demuth, Marsden Hartley, and the First American Avant-Garde*. New Haven: Yale University Press, 1993.

Whelan, Richard. *Alfred Stieglitz: A Biography*. Boston: Little, Brown and Co., 1995.

Zayas, Marius de, and Paul Haviland. *A Study of the Modern Evolution of Plastic Expression*. New York: 291, 1913.

Zayas, Marius de. *How, When and Why Modern Art came to New York*. Ed. Francis M. Naumann. Cambridge, Mass.: MIT Press, 1996.

Zilczer, Judith. "'The World's New Art Center': Modern Art Exhibitions in New York City, 1913–1918," *Archives of American Art Journal* 14 (1974): 2–7.

_____. "John Quinn and Modern Art Collectors in America, 1913–1924," *American Art Journal* 14 (1982): 56–71.

_____. "Alfred Stieglitz and John Quinn: Allies in the American Avant-Garde," *American Art Journal* 17 (1985): 1–33.

# Index

*Entries in bold type denote illustrations/plates*